The Complete
DRAWING
Course

Stan Smith

The Complete
DRAWING
Course

C&B

Contents

Tools and Materials

The Fundamentals of Drawing

First published in Great Britain in 1994
by Collins & Brown Limited, London House,
Great Eastern Wharf, Parkgate Road, London SW 11 4NQ

Copyright © Collins & Brown Limited 1994

Text Copyright © Stan Smith 1994

3 5 7 9 8 6 4 2

British Library Cataloguing-in-Publication Data:
A catalogue record for this book is available from the British Library

ISBN 1 85585 211 X (hardback)
ISBN 1 85585 212 8 (paperback)

The Projects

Advanced Techniques

Conceived, edited and designed by Collins & Brown Limited

Managing Editor and Associate Writer: Sarah Hoggett
Art Director: Roger Bristow
Designer: Sarah Davies
Picture Researcher: Philippa Lewis
Studio Photographer: Geoff Dann

Filmset by Spectrum
Reproduction by Daylight, Singapore
Printed and bound in Germany by Mohndruck

Introduction

THE PRACTICE OF DRAWING LINES that can be recognized as three-dimensional forms goes back to prehistoric times when cave dwellers, using earth pigments and charcoal sticks from their fires, drew pictures of bison and other animals with incredible accuracy and energy. People have made linear representations of places and objects ever since, refining and honing their skills and constantly looking for new media and ways of conveying what they see to others. It is an astonishing concept. Think of, say, a drawing of a nude by Henri Matisse or a cartoon by an artist such as James Thurber or Ralph Steadman. A few deft strokes of the pen and there it is, instantly recognizable – yet all we are looking at are lines on a piece of paper.

Moreover, art is not concerned merely with producing accurate visual representations of the world around us. By choosing to concentrate on particular aspects of their subject, artists can bring our attention to things we might otherwise overlook. By developing their own personal style and interpreting their subject in a very individual fashion, they can make us see things in a new way. Competent artists have developed the ability to convey intangible qualities, too: moods and emotions, nuances of feeling. This is the magic of drawing.

Drawing has many uses. An architect's plan will develop into a building; an engineer's drawing will be the working pattern for a bridge; film directors use a storyboard to sketch out the visual progression of the film; fashion designers note the shape, hang, and overall effect of their new creation. The ability to draw also underpins a number of other art forms. For many artists, the first stage in planning a painting is often to underdraw the subject on the canvas – to sketch the composition lightly before beginning to apply the paint. Sculptors, too, often sketch their design before modelling it. And the act of drawing well is, in itself, a source of endless joy.

In the 18th and 19th centuries, drawing was a part of basic schooling for all educated people. People drew portraits of their family and friends; they made sketches of the places they visited, both as a personal memento and to show to people back home. In the 19th century countless line drawings of far-flung places and events appeared in newspapers and journals. In more recent years photography has taken over and drawing has become a hobby practiced by relatively few rather than the main way of conveying visual information. As a result, drawing is seen as something out of the ordinary. People tend to assume that you need a special talent to draw. But drawing is no different than any other skill. Just like reading, writing, cooking, or driving a car, drawing is something that you can learn.

Below: Movement in Line
A charcoal drawing of a dancer in rehearsal. One of the most exciting things about drawing is that you can convey a strong sense of energy and movement with just a few skilfully placed lines.

So where do you start? The only things you need are something to draw with and something to draw on. When people take up a new hobby, they sometimes feel they have to go out and buy the best and most expensive equipment available. The choice is bewildering: a good art supply store is like an Aladdin's cave, packed with treasures from floor to ceiling. But before you succumb to temptation, stop and think for a little while. Having a fully equipped studio with vast arrays of pens, pencils, and fine sable brushes won't make you a better artist. One of the joys of drawing is that you can make pictures using almost anything. You can use everyday writing tools such as ballpoint and felt-tip pens; you can draw on any scrap of paper you can find, from a used envelope to a pristine sheet of handmade vellum.

Initially it may be best to limit yourself to a small range of equipment: graphite pencils of different hardnesses, perhaps, and a plastic eraser. As you acquire more skill and confidence, start to experiment with other media — charcoal sticks, pen and India ink, colored pencils, watercolor pencils, and pastels. Each medium produces lines of very different qualities and feels and behaves very differently in your hand.

As you get used to using new drawing tools, you will slowly expand your repertoire of skills. Different media require different techniques. If you are using charcoal, for example, you can produce subtle variations in shading by smudging the marks with your finger; in pen-and-ink work, however, you will have

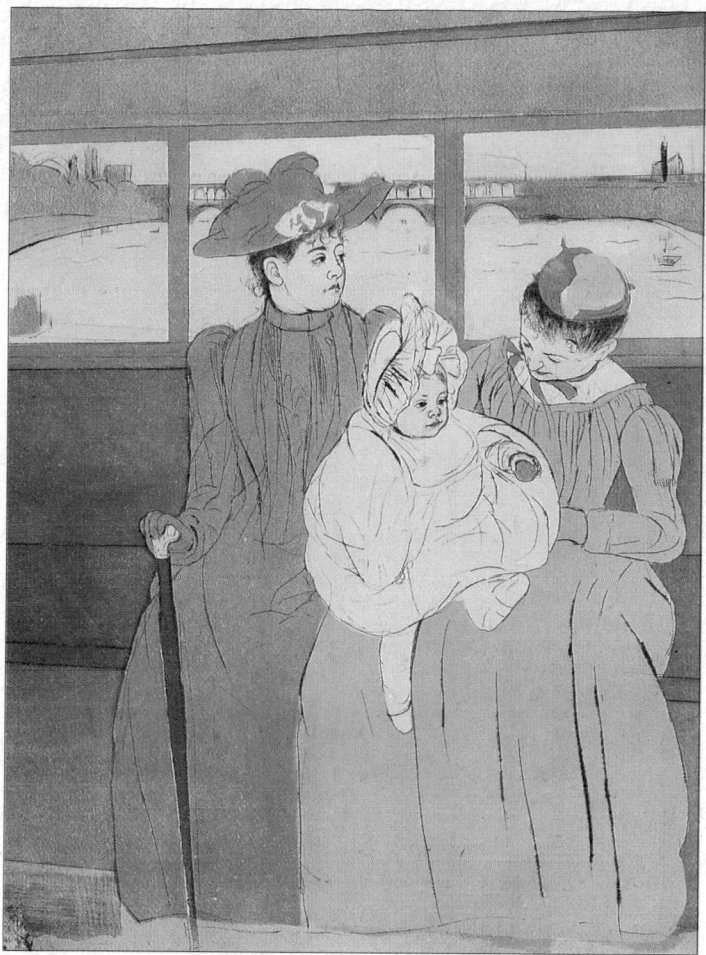

Above: "In the Omnibus," Mary Cassatt
You can use color in drawings, and here flat color washes have been added to selected areas. None the less, the soft contours of the women and child, and their billowing dresses, are all expressed in a few simple lines. This linear quality is what sets drawing apart from painting.

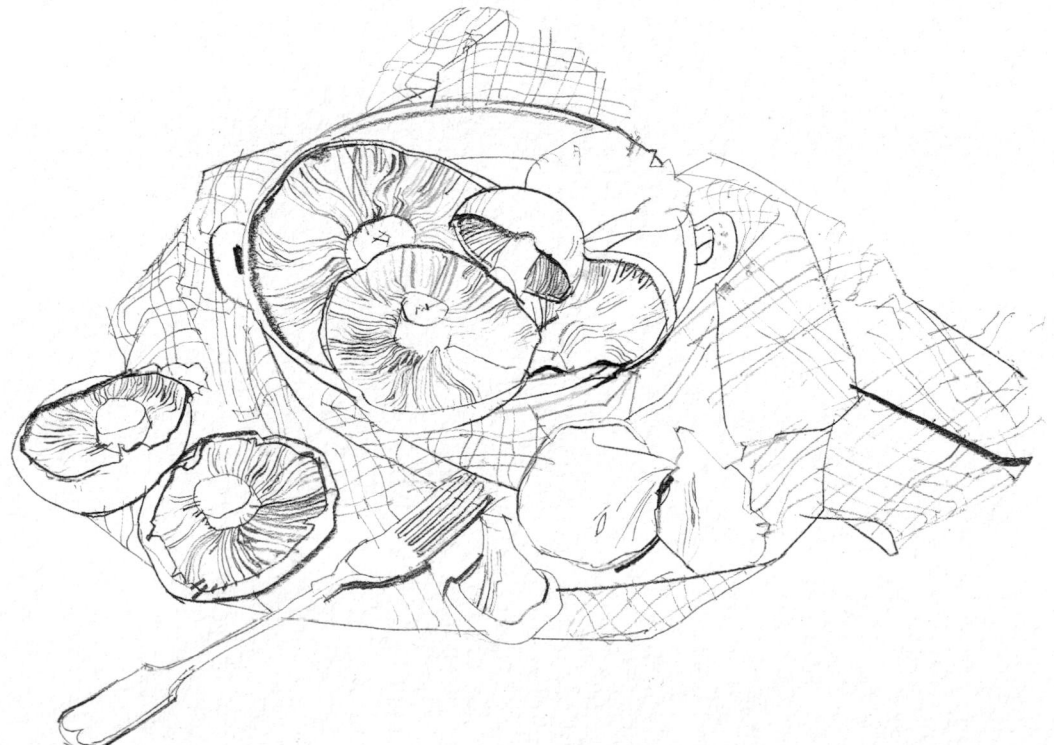

Left: Three Dimensions in Line
A loosely drawn pencil sketch of mushrooms in a dish. No color or shading are used here, but a three-dimensional quality comes across very strongly. You can achieve this by varying the weight and thickness of the pencil marks and by paying careful attention to the contours of your subject.

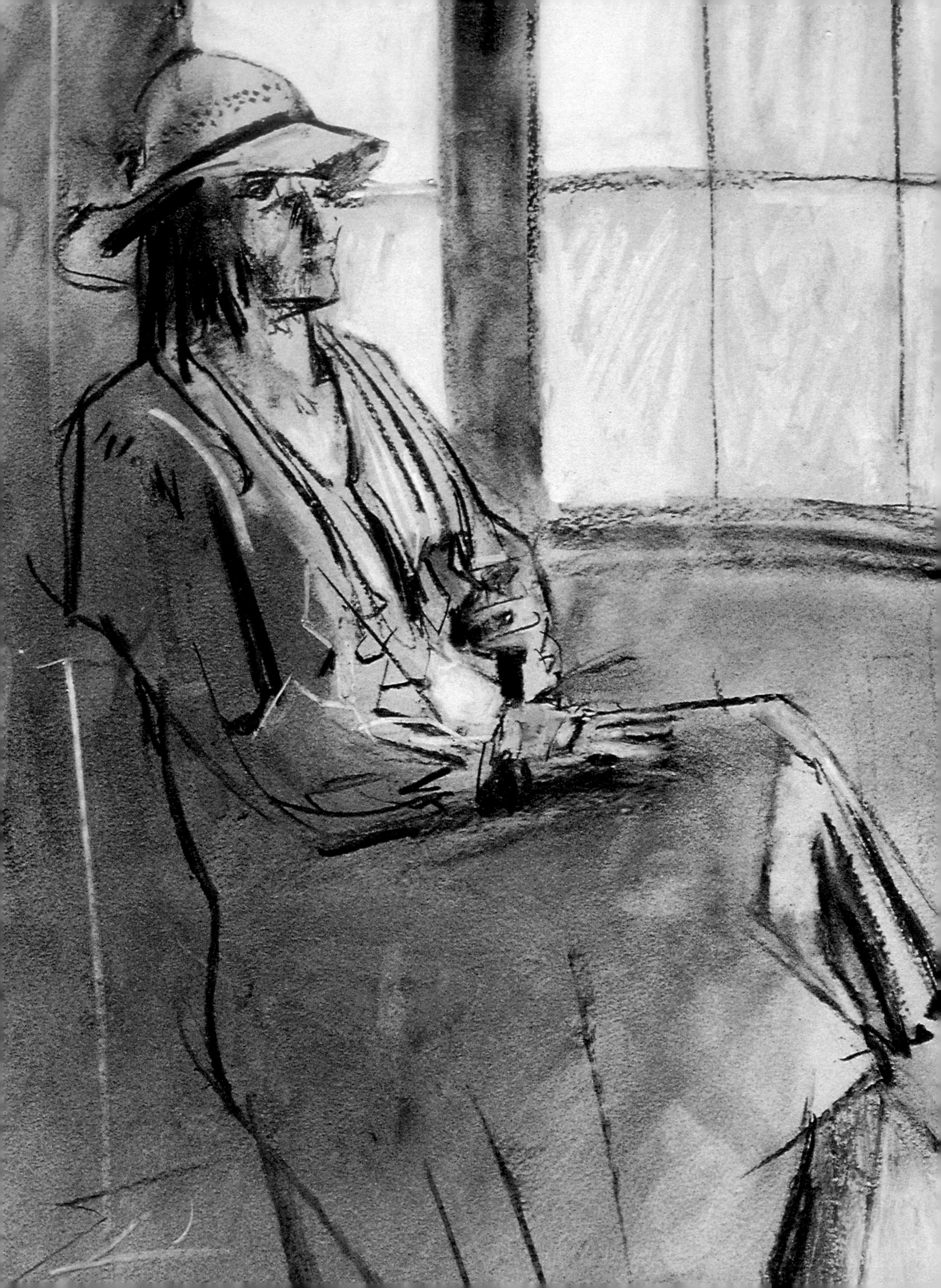

Left: Paper Color
*Don't restrict yourself to white
paper. On mid-gray paper,
shown here, the contrasts between
very light and very dark areas
are softened, which suits the
romantic, introspective mood
of the pose.*

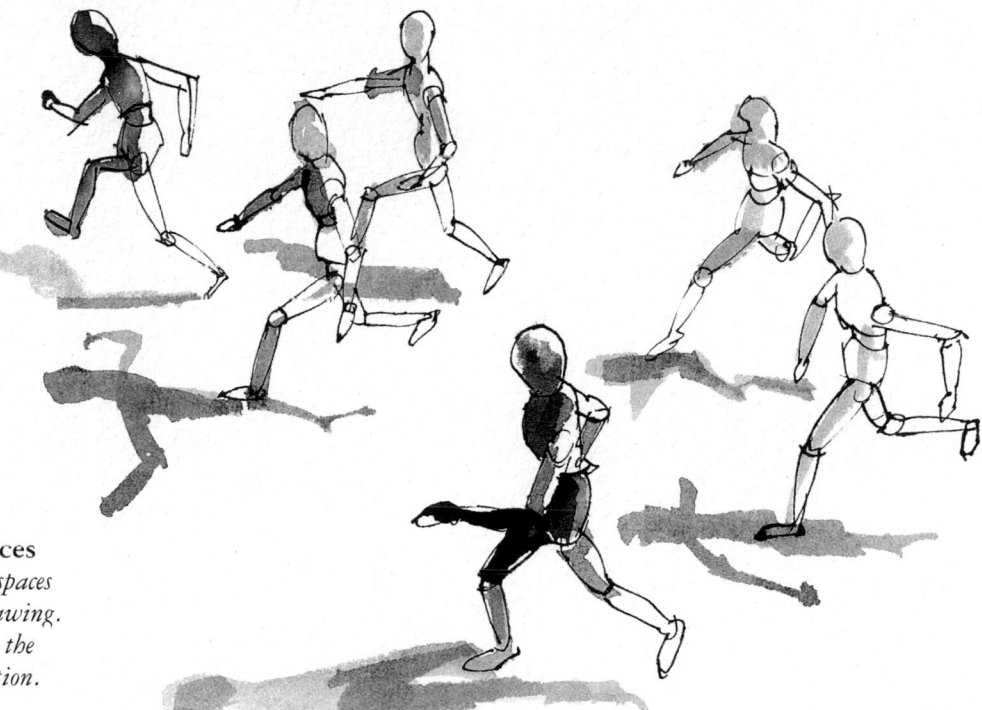

Right: Shadows and Spaces
*Look at the shadows and the spaces
between the objects you are drawing.
They are just as important as the
main subjects in your composition.*

to use one of the hatching techniques demonstrated on pp. 44–45 to achieve a similar effect.

Don't expect good results right away. You wouldn't be able to win an Olympic medal or play the leading role in a stage play without prior training, but surprisingly this is exactly what some people seem to expect when it comes to drawing. A myth seems to have evolved that artists, whether writers, musicians, or painters, produce their work solely through divine inspiration. Nothing could be further from the truth. All artists, whatever their chosen field, need to put in a great deal of hard work.

Concentrate on mastering the basics before you try to do anything else. Technical exercises are not just a ploy devised by art teachers to spoil your fun and stop you from doing more interesting things: they're designed for a purpose. Just as a pianist has to practice

scales and arpeggios, so you need to practice basic drawing skills in order to develop a good technique. These basic skills are the foundations that will support all your future work. Try to set aside some time for drawing every day, even if it's only 10 minutes or so. If you draw for just an hour or two a week at an art class, you're likely to forget what you've learned from one week to the next. Regular practice will enable you to master the basics far more quickly. Keep a small sketchbook with you at all times and draw whenever you have a few minutes to spare – on the train or bus on your way to work or during your lunch break.

Always think about why you're being asked to do something in a particular way. Half the battle is understanding exactly what a particular technique can help you achieve. Then, when you're faced with a similar situation in the future, you can mentally run through your repertoire of skills and select the one that will work best. Little by little, you will develop an almost instinctive grasp of the technicalities. This is important. If you have to stop and worry about what pencil to use to produce a particular mark or what proportion of the face to devote to the eyes, much of the spontaneity of your drawings will be lost.

Acquiring these basic skills, however, is only a means to an end. Once you feel confident that you've mastered them, begin your drawings by deciding what media and techniques would best suit your subject. An artist rarely begins a work by thinking,

**Below: The Marks of
the Medium**
*Each drawing tool makes a
different mark and feels and
behaves very differently in your
hand. Experiment until you are
confident that you know what
each one can do.*

Above: Unexpected Media
A splash of color brings this drawing to life. Acrylic paint, used here, might seem an unusual medium for a drawing, but there are no hard-and-fast rules about what you can and can't use.

"Today I'm going to make a drawing using a water-color wash and pen-and-ink work." Instead, choose a subject that appeals to you and then think about what qualities and mood you want to convey. Is your subject one that is best rendered in fine pen or pencil lines, or would broad sweeps of charcoal be more appropriate? How dense will the various shadings and tones need to be? Mentally run through the media and skills at your disposal and select the ones that you feel will work best in that particular situation.

Of course, individual styles differ considerably from one artist to another. Consider for a moment some examples: a fine line portrait by Ingres, the thick chalk drawings of Tintoretto, the incisive pen drawings of Picasso and Hockney, or the compositional notes of Goya and Rembrandt. The one thing that drawings by all these artists have in common, however, is that their creator really looked at his subject. The most common mistake is to spend more time looking at what's taking shape on the paper than at what you're drawing. How can you hope to re-create anything, far less put your own personal stamp on it, if you haven't examined it closely?

Looking intently is, in fact, the only way to draw. If you can train yourself to look at things properly, lingering over every detail, everything else will follow. Get into the habit of looking for potential pictures everywhere you go; you will soon find that your visual recall becomes much sharper and that you notice things that other people might overlook.

"What should I draw?" is a common question. The answer is anything you like. There is no such thing as a right or wrong subject; if you find something interesting, go ahead and draw it. From time to time, however, set yourself the task of drawing something that doesn't appear to have any artistic merit or potential whatsoever, simply to see what you can get out of it. By forcing yourself to study it closely, you may discover things you hadn't previously noticed. Artists find pictures in the most unlikely places. This is not because they see the world in a different way; it is simply that they have trained themselves to look hard at what's around them. There is beauty in even the most prosaic of objects if you search hard enough.

Below: Use Your Eyes
Both hands are the same size, but the near hand appears to be the larger of the two. Use this fact to create a convincing impression of scale and distance.

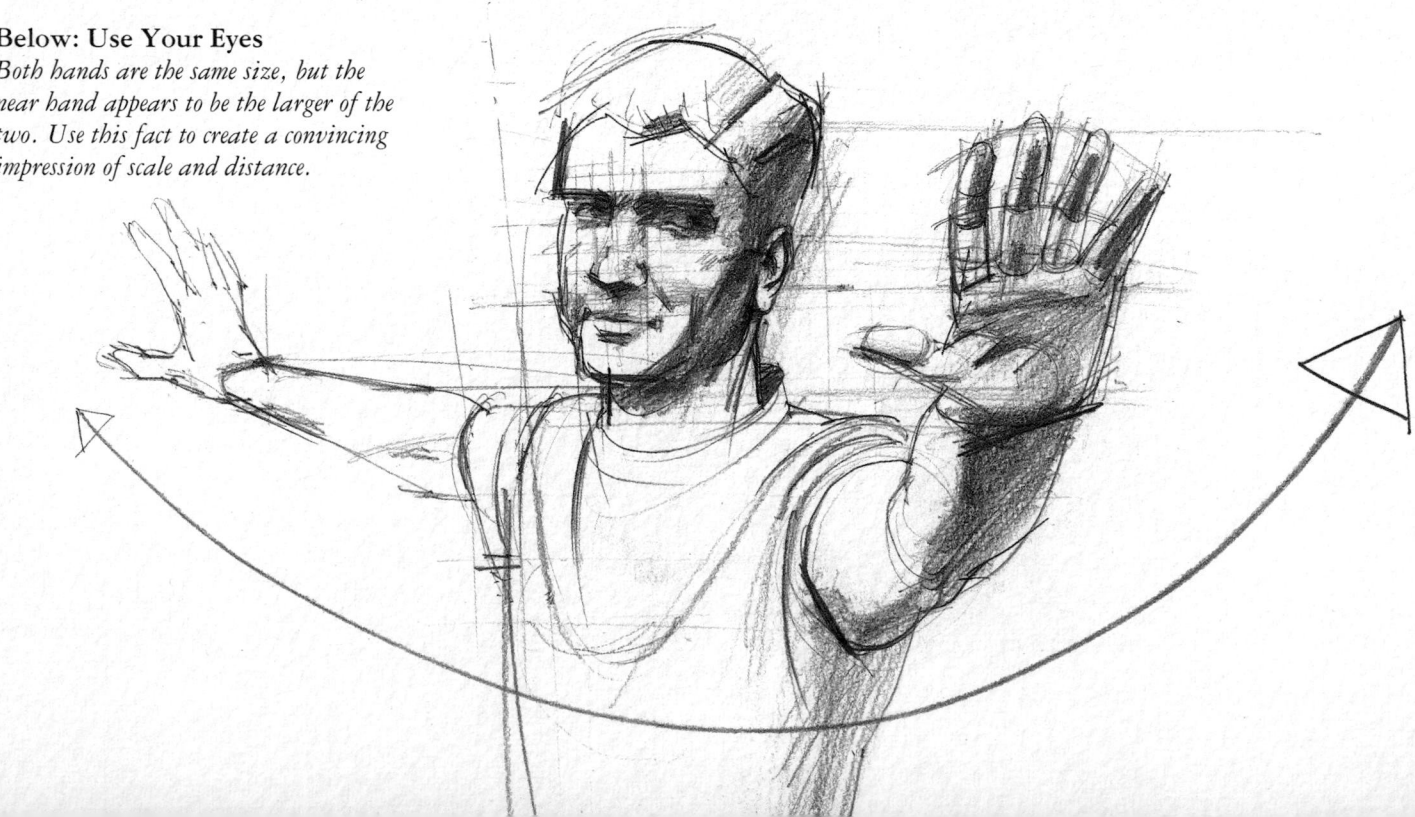

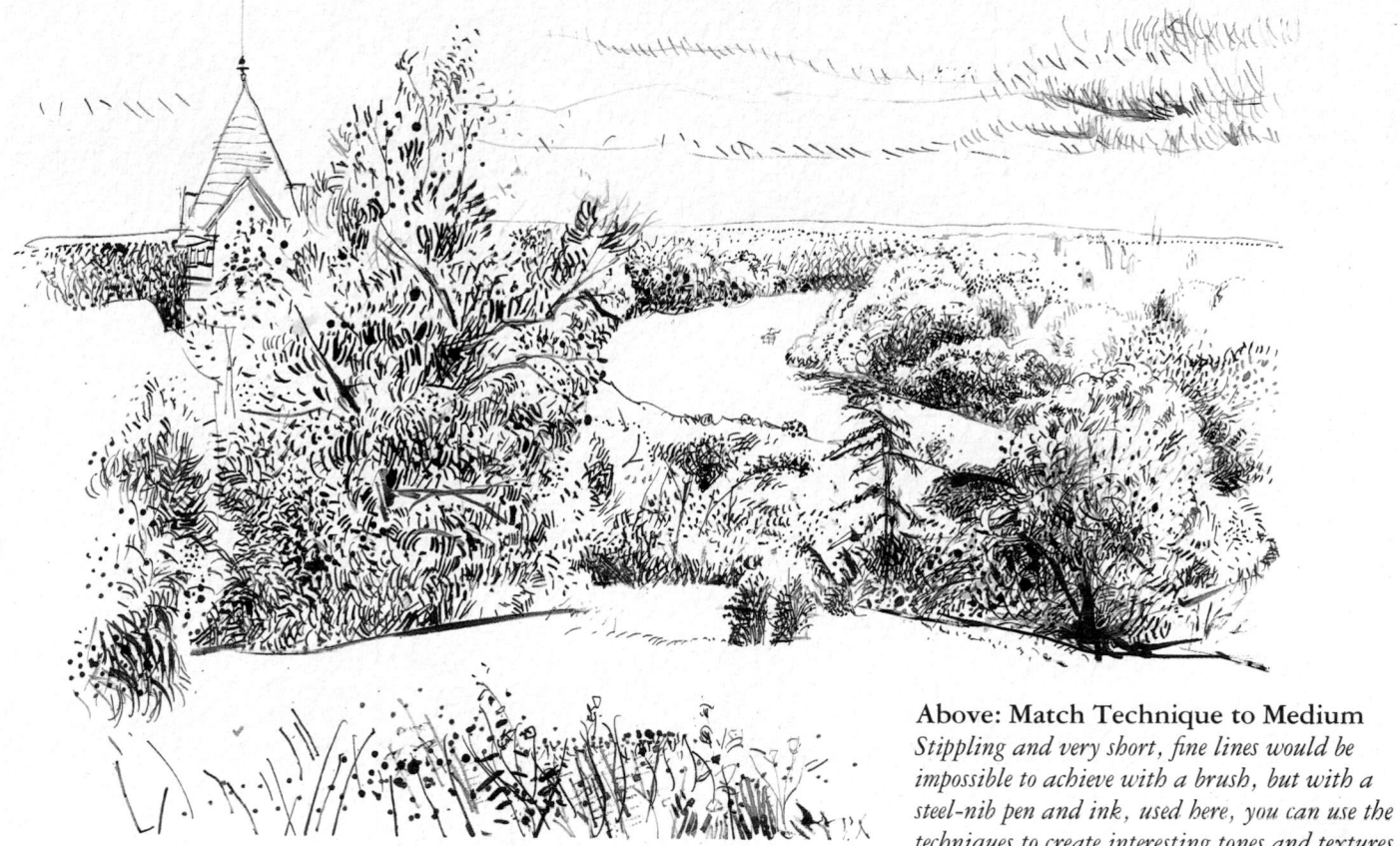

Above: Match Technique to Medium
Stippling and very short, fine lines would be impossible to achieve with a brush, but with a steel-nib pen and ink, used here, you can use the techniques to create interesting tones and textures.

If you're disappointed in your first drawings, don't give up. Try to work out where you went wrong and then do the exercise again, paying particular attention to what you know to be problem areas. You are drawing for your own satisfaction, not for anyone else, and you can take as long as you like and repeat the exercise as often as you like. You are bound to make mistakes. Everyone does. The important thing is to be willing to learn from them.

To become skilled at drawing, you need two qualities above all others. One is dedication since, like any other skill, the ability to draw doesn't come to you without work and application. The other is understanding the basic principles upon which the craft is based. That's why this book is arranged in the way it is. Chapter 1, "Tools and Materials," provides an introduction to the range of equipment available and the results that you can achieve. The next chapter, "The Fundamentals of Drawing," underpins all the rest of the book — and, indeed, all the work that you are ever likely to do. It sets out basic skills such as seeing things in terms of simple geometric shapes, composing your picture, measuring systems, viewpoints and perspective, shading and creating a three-dimensional illusion, and the proportions of the human figure. Chapter 3, "The

Projects," takes a wide range of popular drawing subjects and, building on the basic techniques, shows how to elaborate your drawings into finished works of art. The final chapter looks at more advanced techniques: some are technically demanding (capturing movement, foreshortening); others (using a distressed surface, making blot prints) introduce unusual ways of working that can bring a new dimension to your work.

This book is a structured course, aimed at giving you the skills you need to draw the world around you. The demonstrations are designed to instill good working habits, and by working through them you will gradually build up a repertoire of skills that will enable you to tackle any subject with confidence. They will show you how an experienced professional artist has responded to the challenge of that particular subject. They will also open your eyes to many simple tricks of the trade that you can fall back on whenever the need arises. Each demonstration is, however, only a suggested way of handling a particular topic, a starting point for your own investigation. Once you have acquired the basics, you can make your own drawings, choosing media and techniques to suit the subject and your own personal tastes. This book will point you in the right direction, but there is no substitute for practical, hands-on experience.

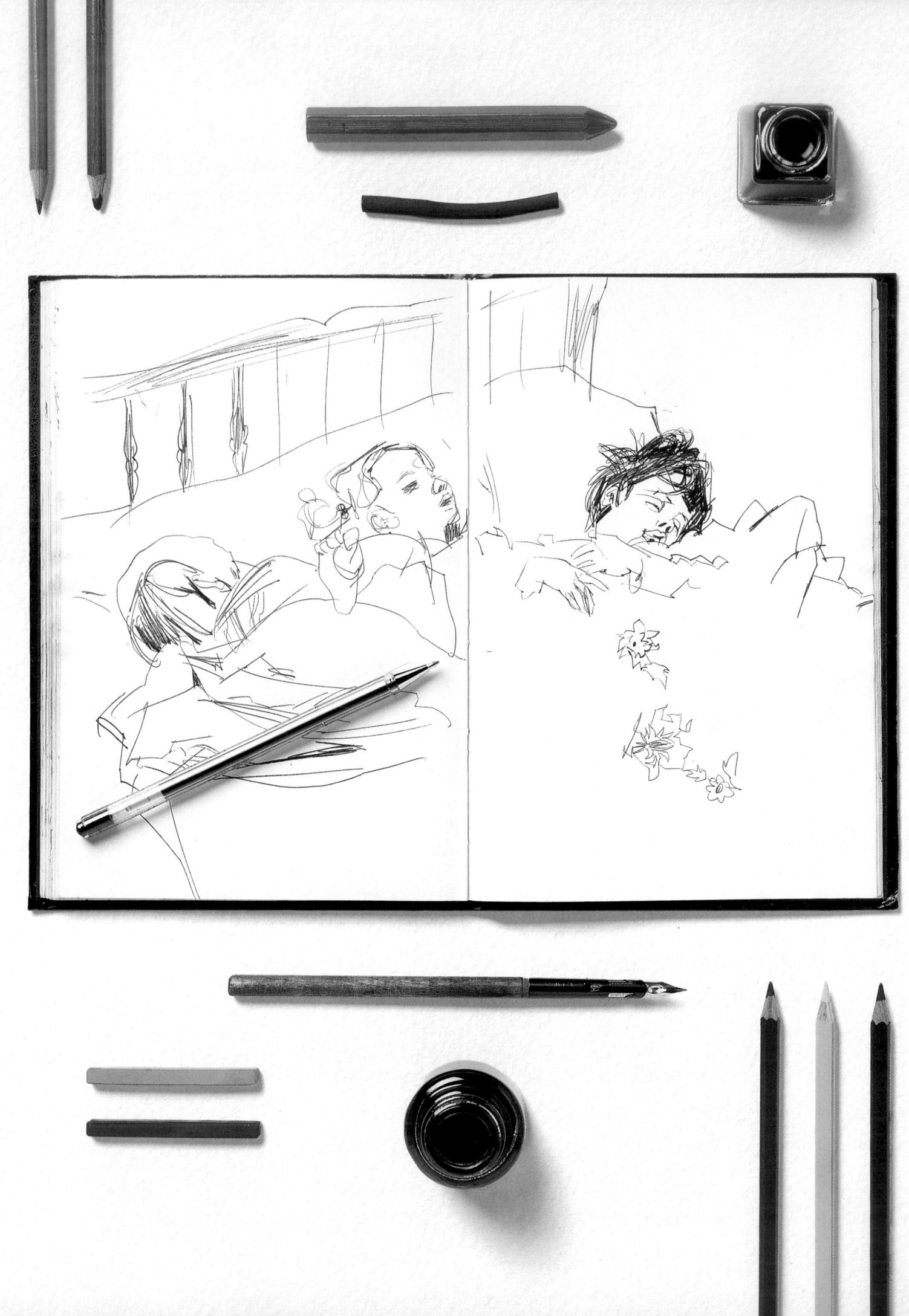

Tools and Materials

The Colors of Black

IN A LETTER TO HIS BROTHER, Theo, Vincent van Gogh explained that he had been studying the Dutch painter Franz Hals in the museum. "Hals has no less than twenty-seven blacks," he wrote. This observation could well apply to the pencils and other markers we use today in black-and-white drawing. Graphite, lead, carbon, and pastels range from mid-gray to a black of great intensity.

Charcoal dates back to prehistoric times. Today it is mainly made from vine and willow and is widely available in a range of thicknesses and lengths. Powdered charcoal is a useful by-product of stick charcoal; it is often used to tone a ground (see pp. 64–65) or to build up tonal areas. A tortillon stump made of rolled-up blotting paper is useful for blending and rubbing the charcoal.

The lead pencil is a relatively recent addition to the range of drawing tools. It should more accurately be called a graphite pencil, since this is the material from which it is made. Graphite deposits were at one time thought to be lead, hence the name. Pencils come in a range of gradings, from 10B (very soft) to 10H (very hard). The pencil is ideal for detail and very close work. It can be brought to a fine point by the use of an emery or sandpaper pad. An earlier version of the modern medium-grade pencil was the silverpoint, used by Leonardo and Botticelli among others. This narrow rod, made from lead and tin, was capable of producing fine lines and a wide range of tones.

Carbon pencils, wax and watercolor pencils, compressed charcoal, artists' pastels, and graphite powder are all readily available. Quality varies considerably, so make sure you use the best available. Graphite sticks, Conté pencils, and charcoal sticks are important drawing tools, each making its own characteristic mark and tone on differing

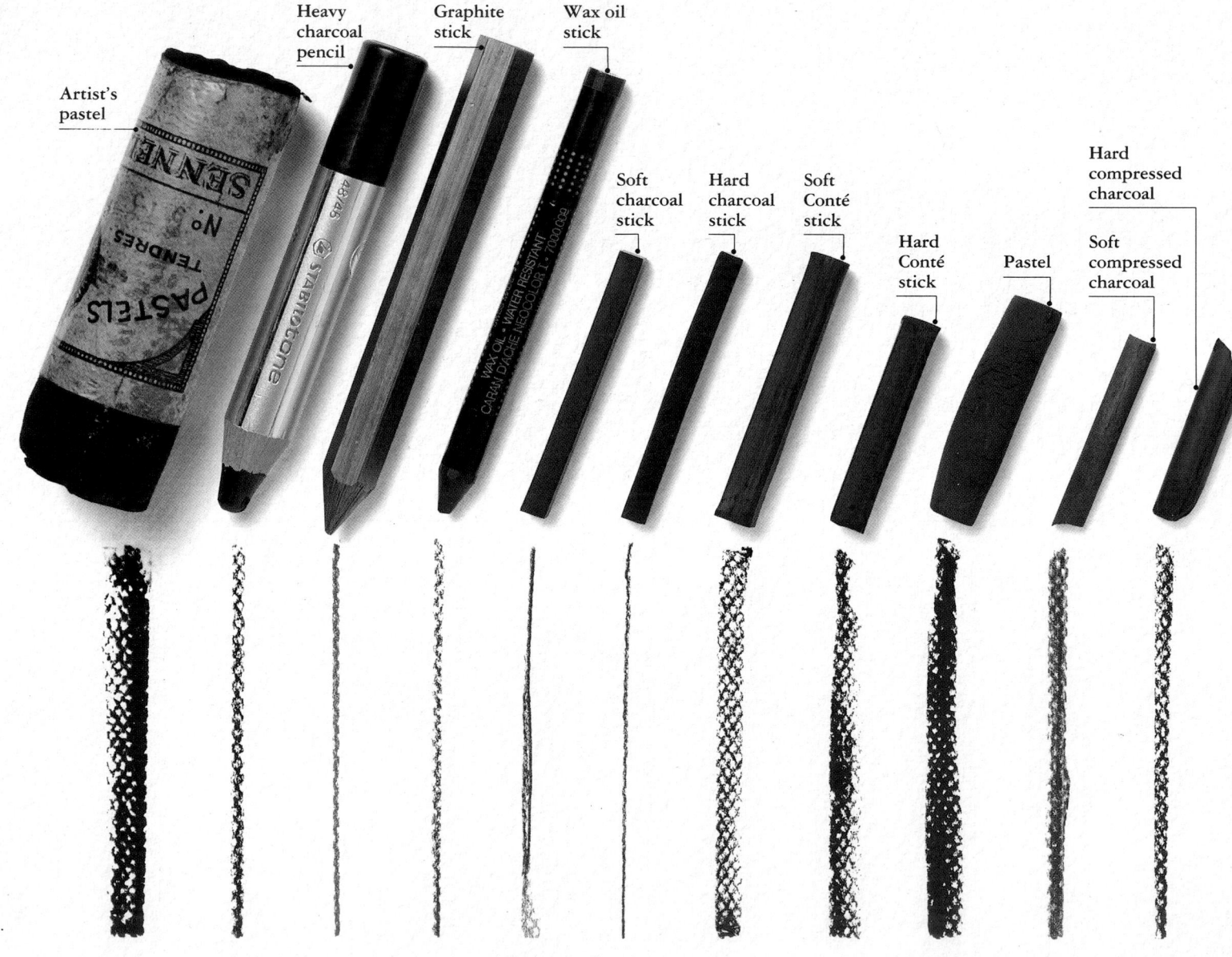

Artist's pastel

Heavy charcoal pencil

Graphite stick

Wax oil stick

Soft charcoal stick

Hard charcoal stick

Soft Conté stick

Hard Conté stick

Pastel

Hard compressed charcoal

Soft compressed charcoal

papers. The faintly shiny quality of pencil on smooth paper is a long way from the charcoal ghost left after corrections have been dusted off by the artist. Black as a color in painting is a powerful way of linking images and creating a rich, inviting mood.

Try to get into the habit of using more than one tool – combining wax with graphite and charcoal, perhaps, or graphite powder with compressed charcoal. The availability of such a broad range of instruments means that different features within a drawing can be expressed by different marks. For certain work fine points are essential, and this would require the use of one of the pencils; an action sketch at the zoo or theater, on the other hand, might need a charcoal, Conté, wax or pastel to keep the lines broad. Exploit the variations in the colors of black. Look hard for the middle and light grays of some pencils, and the dense blue-black – cold and strong – of beech charcoal. Contrasting these and the shiny surface of wax with the flat surface of charcoal can bring life and interest to a drawing, and even help to suggest new ways of working.

Tools of the Trade

Here is a representative range of black markers. Never be content to select just one drawing tool and consider it your only way of working. Without trying a broader range, aspects of your talent might well go undiscovered.

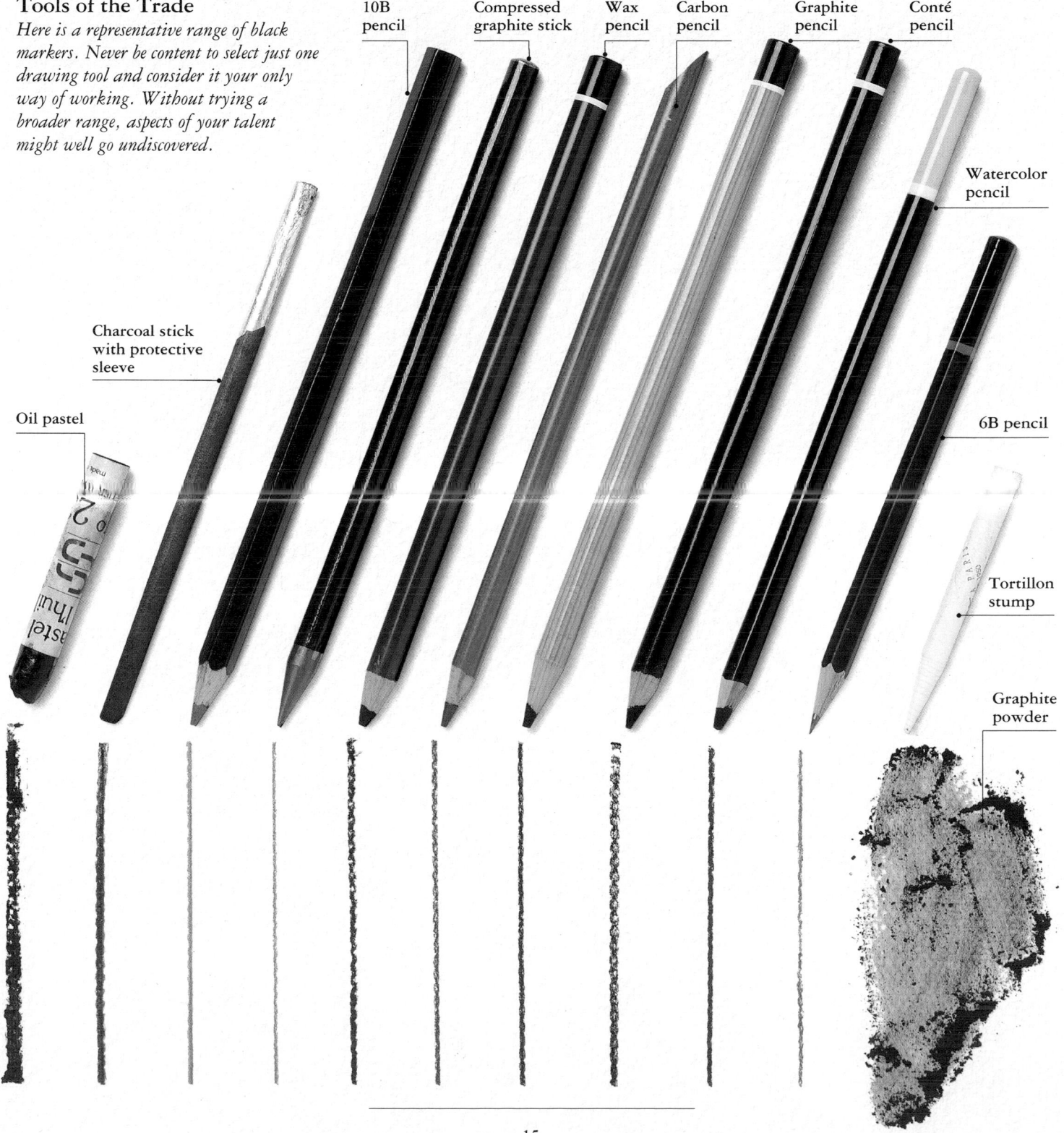

10B pencil

Compressed graphite stick

Wax pencil

Carbon pencil

Graphite pencil

Conté pencil

Watercolor pencil

Charcoal stick with protective sleeve

Oil pastel

6B pencil

Tortillon stump

Graphite powder

Pencils and Crayons

WALK INTO ANY ART SUPPLY STORE, and you will be confronted by a bewildering choice of drawing media. Each item has its own characteristics, and only by experimenting with a variety of different tools will you find out what each can do.

The graphite pencil is one of the most versatile drawing instruments, yet it is a relatively recent arrival. Pure graphite was not discovered until the 16th century, and it was not until the 18th century that it was used in pencil form. Graphite pencils are available in soft, medium, and hard leads. They are graded from 10H (very hard) to 10B (extremely soft); in the middle of the range is the HB grade. There is also an F grade pencil, which is very similar to an HB pencil, but its mark has a slightly different tone of gray. Pencils in the H series make fine, hard gray marks, whereas B pencils make a rich, dark line. Think of H for hardness and B for blackness.

Colored pencils – an even more recent innovation – are made in the same way as graphite pencils, with a colored pigment taking the place of the graphite. Although they are often sold as boxed sets, you can of course buy them individually. Colored pencils are available in many different shades, but they do not come in the same range of hardnesses as graphite pencils.

Watercolor pencils further expand the artist's repertoire. With them, you can produce the same fine lines as with graphite and colored pencils. In addition, you can blend the colors together and "melt" them into washes by brushing clean water over the marks.

The words "chalk," "pastel," and "crayon" are often confused. Chalks are made from natural materials – iron oxide (red), chalk or gypsum (white), and carbon (black). By the 15th century, they were in common use.

Pastels were introduced in the 18th century and are made from pigments bound together with gum or resin to form a stiff paste – hence the name. The paste is then rolled into a stick shape and left to dry. Pastels make a soft, powdery mark, very similar to chalk, but have the advantage of being available in an enormous range of colors. You can buy pastels individually or in boxed sets of various sizes. Put your pastels back in a box when you have finished using them. Because they are so soft, pastels break very easily. You can also buy oil pastels (a pigment bound with oil in stick form) and pastel pencils, both of which are less crumbly than conventional artists' pastels.

Color sticks are a harder drawing material than pastels. They can be made from charcoal, wax, clay, or chalk mixed with colored pigment.

Graphite Pencils

The marks made by the various graphite pencils range from dense black blurs at the softest end to sharp gray lines at the hard end. Within this range, you can find a pencil for almost any task. Using pencils of different grades in the same work is a way to add variety to your drawings.

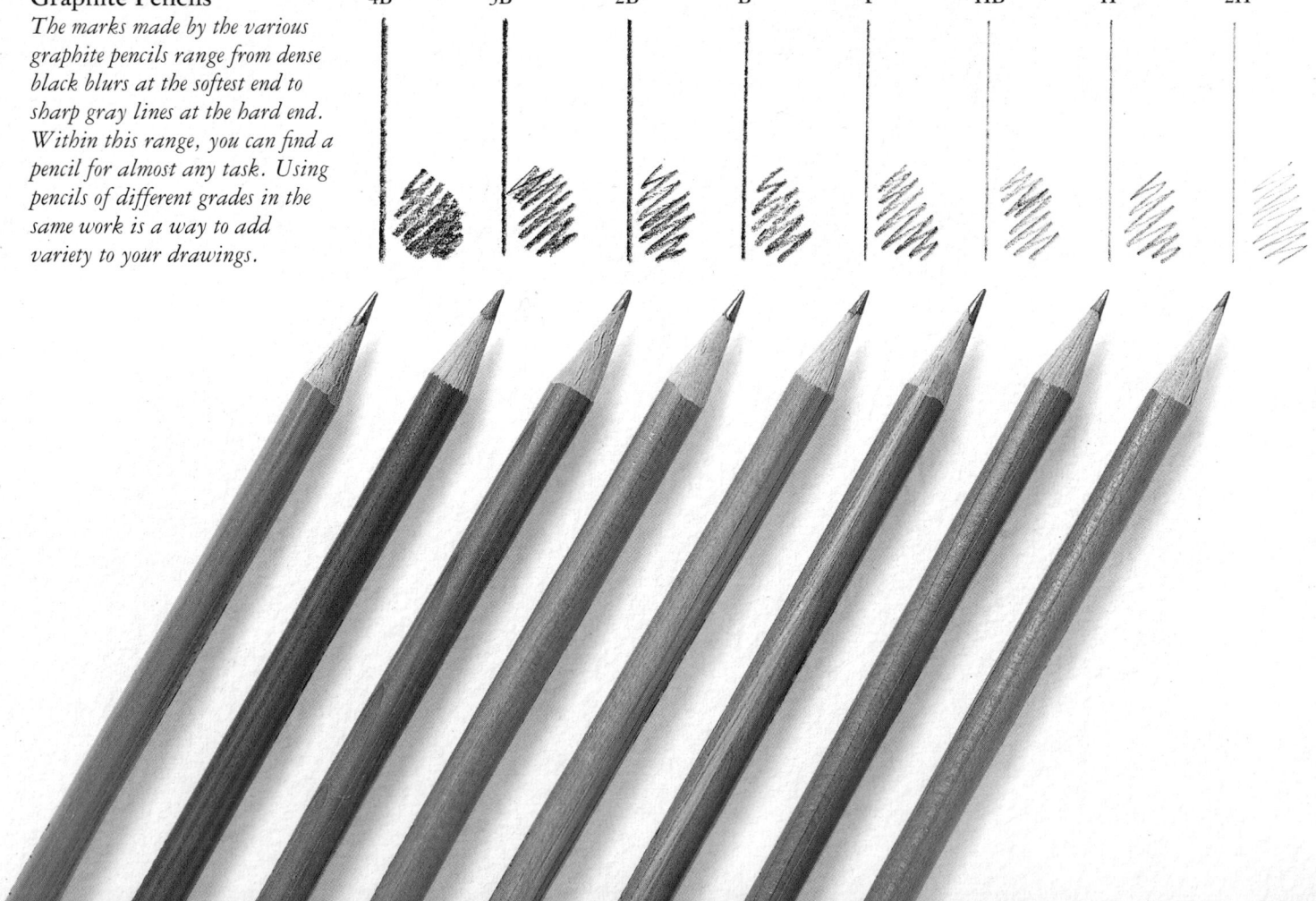

Conté Pencils

Conté is available in either pencil form (shown here) or sticks. With this versatile medium you can make light or dark marks by varying the amount of pressure you apply. Conté pencils and crayons come in a wide range of colors. The stick breaks easily, so take care not to drop it.

Conté pencils

Oil Pastels

A fairly recent development, oil pastels are now used extensively by many artists. These pastels lend themselves to broad marks and are therefore suitable for large-scale work.

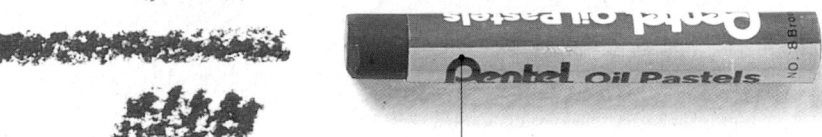

Oil pastels

Wax Crayons

Wax crayons leave a strong, firm, and rich line on the paper. They are usually water-resistant.

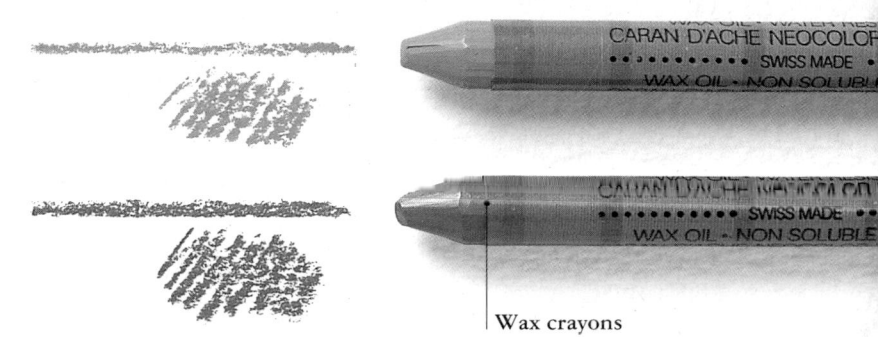

Wax crayons

Colored Pencils

You can use colored pencils in the same way as graphite pencils. They range from bright primary colors to earthy or grayed, soft hues.

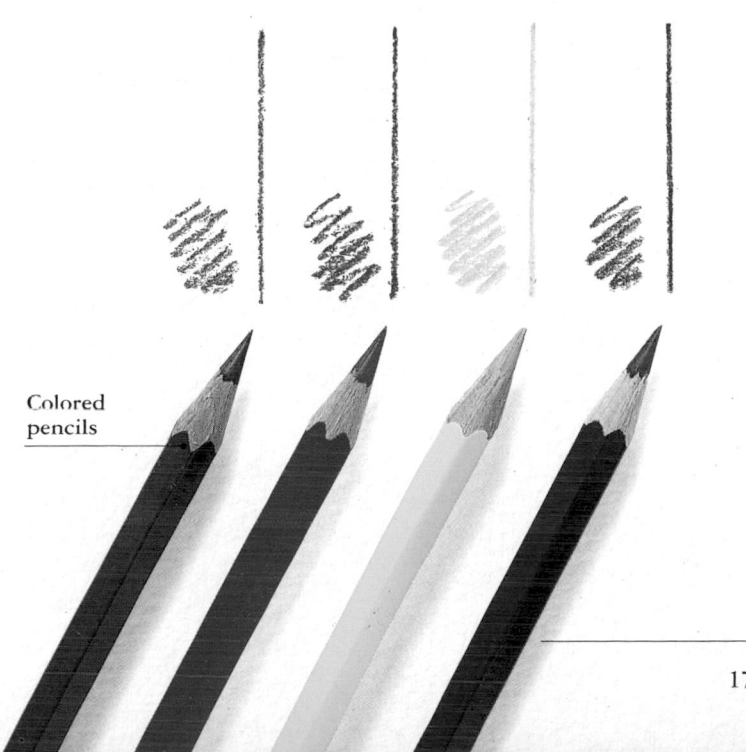

Colored pencils

Watercolor Pencils

You can work with watercolor pencils in the same way as conventional colored pencils, although they produce a richer, softer mark. You can also brush water over watercolor pencil marks to create a wash or use them on dampened paper for more unusual effects.

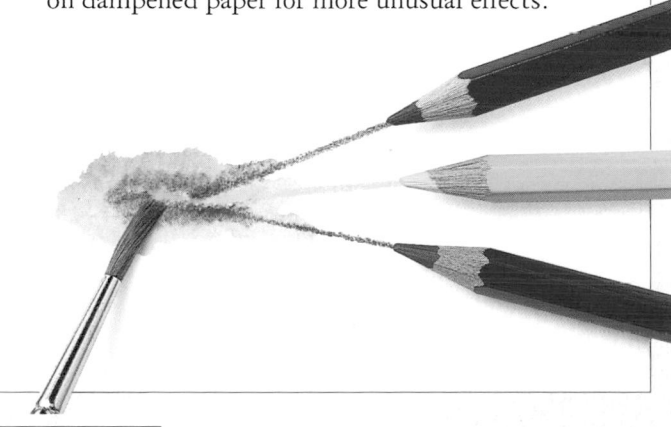

Brushes and Pens

BRUSHES ARE MADE from a carefully selected bunch of hair or bristles, which is clamped onto the end of a wooden handle with a metal sleeve, called a ferrule. In good-quality brushes, the ferrule is firmly attached to both the handle and the hairs. In cheap brushes this is not the case, which is why the hairs often separate from the brush and stick on the paper.

Watercolor brushes – the brushes most frequently used in drawing – are made from soft, pliable hairs because they are very flexible. The best-quality hair is sable, which comes from the tail of an Asian mink. Sable brushes are expensive, but if you take good care of them, they can last for many years. Other types of brush are made from ox or squirrel hair. In recent years, synthetic hair has also been used, often mixed with animal hair. As a general rule, you should aim to buy the best-quality brushes you can afford – particularly with small brushes. Any flaws or loose hairs are most likely to be noticed in fine, detailed work.

Pens have been used as a drawing instrument for centuries, and there is a huge range available. Steel-nib and sketching pens come with a range of interchangeable nibs of varying shapes and sizes. Sketching pens cost more than most pens, but have better ink flow, making them a joy to use. Technical pens – used in drafting and architectural drawing – produce lines of uniform width. They cannot be used quickly since the ink flow is fixed at a relatively slow speed and the nib is delicate. You can also draw with everyday writing tools such as ballpoint and felt-tip pens. The important thing is to experiment and be aware of the different marks that each tool can make.

Round Brushes
Named for their round ferrules, round brushes taper to a point. They are ideal for most general purposes. The side can be used for broad areas, while the tip, even on large brushes, can produce a fine line.

Chisel Brushes
As the name implies, a chisel brush has a flat, chisel-shaped edge. The large sizes are excellent for laying down broad washes and for creating sharp lines and edges. The small sizes make crisp, angular lines.

Chinese brushes

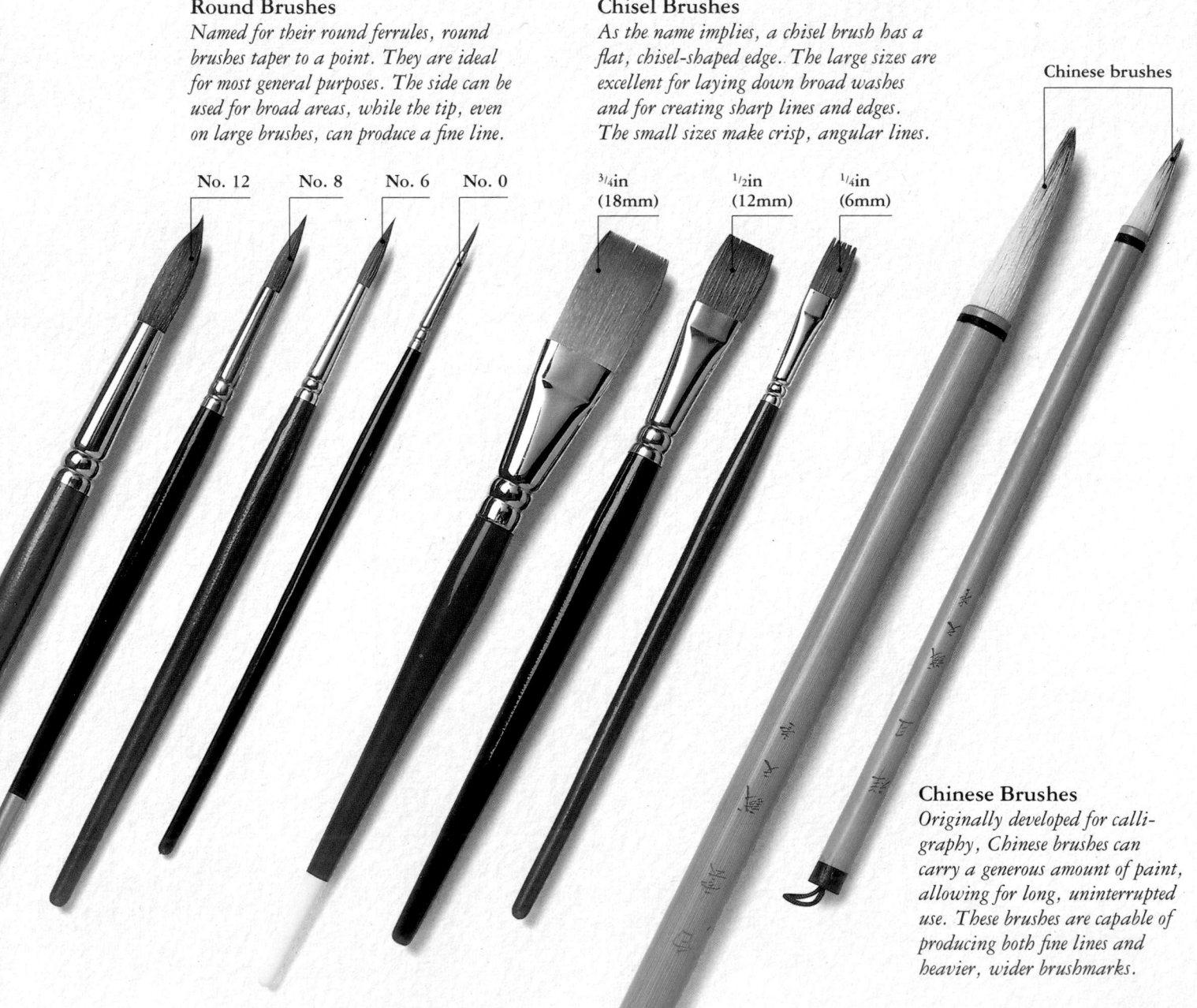

No. 12 No. 8 No. 6 No. 0

³/₄in (18mm) ¹/₂in (12mm) ¹/₄in (6mm)

Chinese Brushes
Originally developed for calligraphy, Chinese brushes can carry a generous amount of paint, allowing for long, uninterrupted use. These brushes are capable of producing both fine lines and heavier, wider brushmarks.

Cutting a Quill Pen

1 Large feathers – from a goose, turkey, or swan – are best. Fresh feathers need to be hung in a dry, airy place for a year to cure.

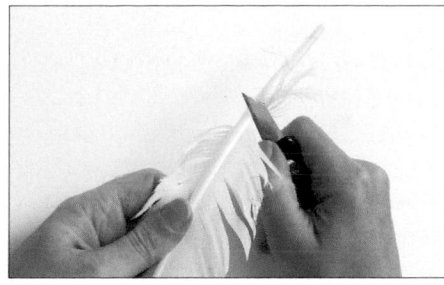

2 Cut off the barbs to provide enough room to hold the pen, and scrape the barrel to remove any loose skin.

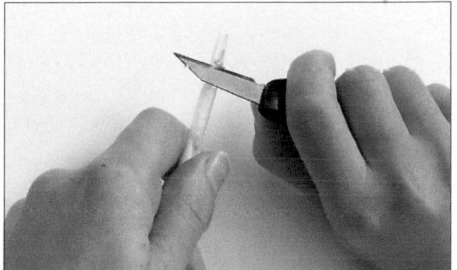

3 Using a thin blade, make an oblique cut on the underside. Try to follow the natural curve of the quill.

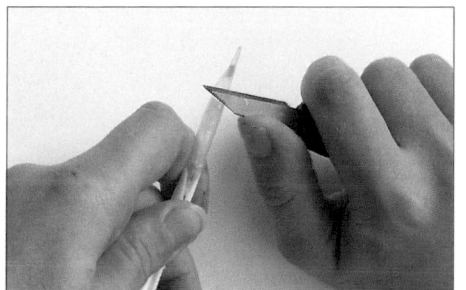

4 Make a less acute cut and hollow out the sides of the quill. This adds spring to the pen and makes it smoother to use.

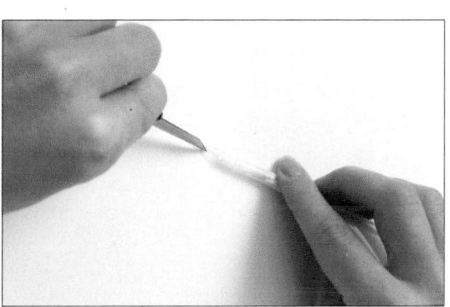

5 Cutting away from you, make a small slit along the length of the pen, and trim the end of the nib.

Bamboo Pen

The marks made by a bamboo pen tend to be very fluid and rich. This pen is very useful for drawing continuous lines. The model shown here incorporates a brush at the other end.

Toothbrush

With a toothbrush, you can create interesting marks and texture. Often used with masking fluid, it is a good spattering tool.

Bamboo pen

Ballpoint pen

Felt-tip pen

Technical pen

Sketching pen

Steel-nib pen

Pens and Nibs

Pens fall into two general categories: mechanical (ballpoint, felt-tip, and technical pens), which are sold containing ink and cannot be refilled, and refillable pens (such as fountain, sketching and dip pens). The latter have interchangeable nibs. Nibs can have rounded, pointed, and square (flat) tips.

Inks and Paints

PAINT IS ONE WAY to introduce color into your drawings. You can use it to establish an underdrawing (see pp. 112–113), to lay a color wash over preliminary pen or pencil work, or to put in delicate touches of local color. By definition, paint is a pigment (a colored powder) that is mixed with a binding agent to form a liquid or paste. Sometimes a thickening or a thinning agent is added. Watercolor, oil, and acrylic paints are all in common use, and each has its own characteristics.

The main characteristics of watercolor paint are its transparency and its fluidity. Because it is transparent, you have to build up from light to dark shades: a light color will not cover a dark one. Watercolor paint can be applied with a dry brush, leaving a crumbly texture, or diluted with water for washes. If necessary, gouache can be added to watercolor paint to make it opaque. You can work over gouache, putting light shades on top of dark. Oil paint is slow to dry but has great covering power. It can be diluted or thinned with linseed or another oil and turpentine (or with just turpentine if it is being used on paper) to give thinner coverage. Acrylic paint shares some of the characteristics of both watercolor and oil paints: it has good covering qualities yet can be used diluted with water for washes.

Inks are ideal for producing crisp, clear lines and intricate detailing (as in technical or architectural drawings, for example). The medium can also create surprisingly subtle and delicate effects. Inks can be used at full strength or diluted with distilled or clean tap water to vary the tone and color; you may want to use several different dilutions of ink within the same drawing. Thin washes of dilute ink can be applied to selected parts of the paper or even over the whole drawing to achieve a unifying background color. Unlike watercolor paint, dry waterproof ink does not redissolve when a wash or another color is brushed over it, so it is possible to overlay other inks and paints without spoiling the original inkwork. You can also experiment with applying wet ink to damp areas of paper: the ink will spread slightly beyond the edges of the line you draw, producing a slight blur, which can be very effective.

Inks, like paints, are now available in a surprisingly wide range of colors. They are usually waterproof and contain shellac, which makes them shiny. You can apply inks with rags, brushes (using the tip for fine lines and the flat of a broad brush for washes), dip pens, and fountain pens, taking advantage of the various styles of interchangeable nib to create different effects.

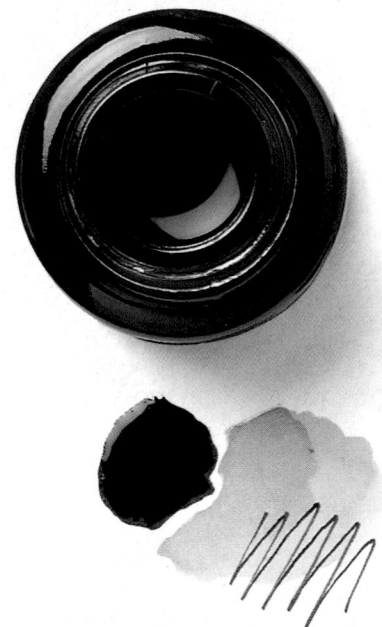

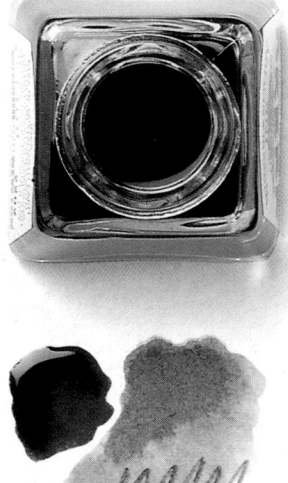

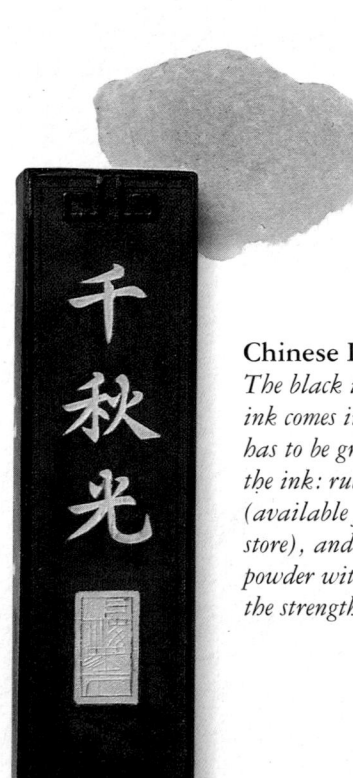

Black India Ink
Traditionally used with a steel-nib pen, black India ink dries to a slight gloss. You can also use it with a brush, producing a fluent line with a fine brush and a broad wash with a fuller brush. Dilute it slightly (using distilled water) to increase its fluidity. The color is also softer when diluted, becoming a sepia shade.

Colored Inks
You can choose from a considerable variety of colored inks since each manufacturer offers its own range of colors. The basic colors are much the same as for paints – reds, browns, blues, greens, and yellows. The pigment in colored inks tends to settle to the bottom of the bottle, so it is advisable to shake the bottle gently before use.

Chinese Ink
The black ink known as Chinese ink comes in stick form. The stick has to be ground down to make the ink: rub it with an ink stone (available from an art supply store), and mix the resultant powder with water until you get the strength of black you want.

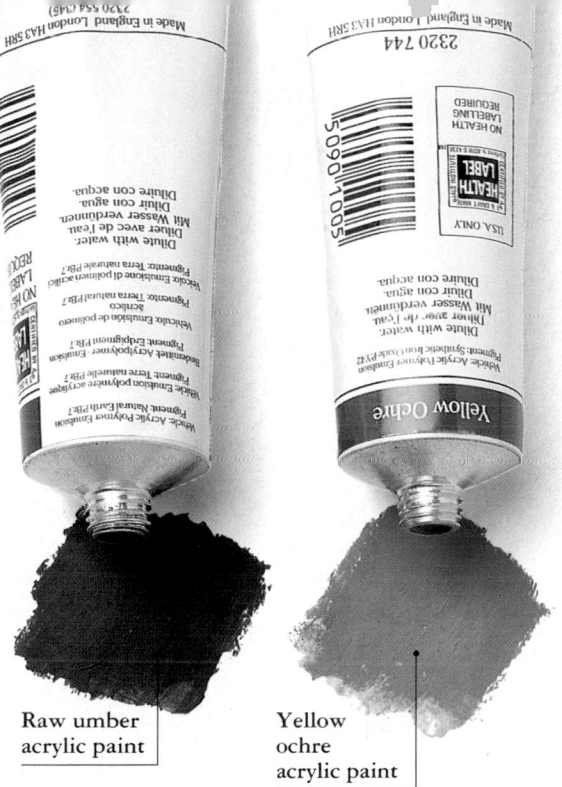

Acrylic Paint

In acrylic paint, the pigment is suspended in a synthetic resin, usually polyvinyl acetate (PVA). It dries quickly, although it can be mixed with a special medium to slow down the drying time. When used straight from the tube, acrylic paint is similar in consistency to oil paint. Usually, however, it is put on a palette and thinned with water or another medium. Acrylic paint can even be diluted to the consistency of watercolor paint simply by adding water.

Raw umber acrylic paint

Yellow ochre acrylic paint

Watercolor Paint

Watercolor paint comes in a tube or pan – a solid block of color in a rectangular dish. If you are using a tube, put a little paint on a clean, white palette first, in order to dilute it to the right consistency. If your palette is a color other than white, that color will show through making the paint look different from the way it will look on white paper. If you are using a pan of paint instead of a tube, you can load the brush directly from the pan after softening the paint with water.

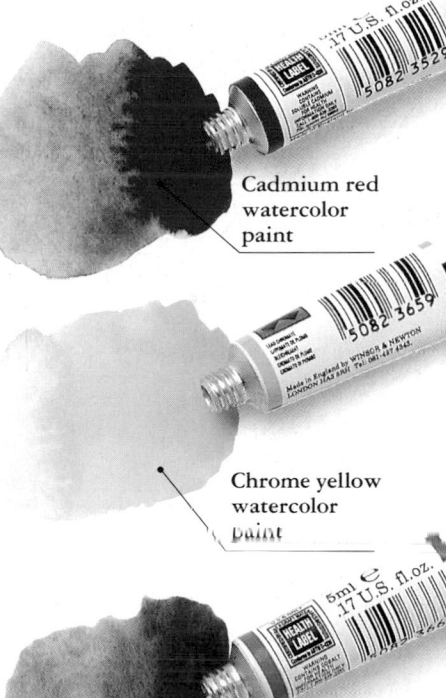

Cadmium red watercolor paint

Chrome yellow watercolor paint

Cobalt blue watercolor paint

Chinese white

Other Equipment

Turpentine
Oil paints are not soluble in water, so you cannot clean your brushes with water alone. Turpentine is essential – always buy the best you can afford.

Rags
Use clean rags to spread oil paint diluted with turpentine or acrylic paint thinned with water onto the paper. This allows you to cover a broad area quickly.

Sponge
Used to apply a wash of water based paints, make textures, or wipe off paint. Artificial sponges create a more mechanical texture than natural ones.

Raw sienna oil paint

Payne's gray oil paint

Oil Paint

In oil paint the pigment is bound with an oil – usually linseed oil. This paint is very rich in color and texture but slow to dry. With it you can produce effects ranging from transparent (heavily diluted with turpentine) to opaque. For drawings, oil paint is usually diluted with turpentine to a consistency similar to that of watercolor; however, its appearance is unmistakable. Put it on a palette, and mix it to the right consistency with linseed or another oil.

Chinese White

Made from calcined zinc oxide bound with gum, Chinese white has good covering power. It is more fluid and finer than poster paint or gouache whites.

Types of Paper

THE SURFACE THE ARTIST USES to make a picture is sometimes called the support. The usual support for drawings is paper. Invented by the Chinese, paper made from cloth rags was introduced to Europe by the Arabs, who learned the secret of making it from Chinese prisoners of war. Most paper manufactured today is made from wood, which is reduced to a fibrous pulp and pressed flat to dry on wire screens. The surface of the paper is then prepared in a variety of ways, depending on its future use. All kinds of weights, textures, and strengths of paper are available to the artist, and choosing which type to use for the job in hand is part of the process of drawing. For a freely drawn pencil sketch, a coarsely textured paper may be best, whereas finely detailed, closely observed work requires a smoother surface. As always in drawing, experiment with different types to find what works best.

Paper is measured by its weight per ream – 480 sheets. Its weight also refers to its thickness. A 200-pound paper is thick, while a 60-pound paper is obviously much thinner. Most papers are coated with sizing to seal the surface and make it less absorbent. Unsized paper is known as water-leaf and is similar to blotting paper.

Some papers are better suited to particular media than others. For black-and-white work in pencil, Conté, charcoal, and crayon, use a general-purpose sketching paper, neither very rough nor very smooth, which will hold the mark of the drawing tool well. For pens, brushes, and washes, a watercolor paper is generally better.

Most watercolor papers are machine-made and come in three standard types. Hot-pressed paper (HP) is probably most frequently used for watercolors and wash drawings. It is fairly smooth and takes the mark of the pen, charcoal, and pencils of various grades extremely well. Cold-pressed paper, often called "NOT" because it is not hot-pressed, has a textured surface with a slight "tooth" – useful for when you are working with washes. When drawing on this surface, allow for broad strokes of the pencil and fine detailing. Always stretch watercolor paper before you start working on it. This will ensure that the paper remains smooth and flat when you apply paints and washes.

Hand-made paper is usually made from rag. Made one sheet at a time, it is thin and irregular at the edges. Hand-made paper has a right and a wrong side, which can be easily identified by the manufacturer's watermark.

Marks on Paper

The texture of the paper affects the marks you make. The rich, dark feel of the strokes on rough, pitted paper, for example, contrasts sharply with the lighter mood of the same medium used on a smoother surface.

Rough	Medium	Smooth
Charcoal		
Crayon		
Soft pencil		
Pen		
Brush		

Commonly Used Paper Types

Medium watercolor paper

Rough watercolor paper

Smooth watercolor paper

Stretching Paper

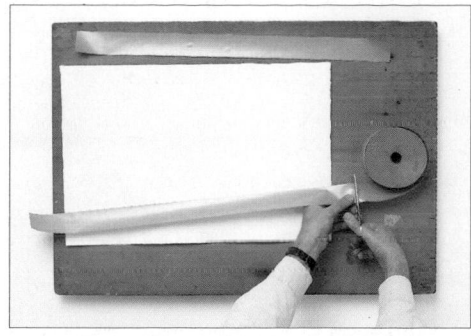

1 *Cut the paper to the size required and lay it on the board. This board must be thick enough not to warp but not so heavy that it is cumbersome to lift. Leave a margin around the edge for pieces of masking or paper tape.*

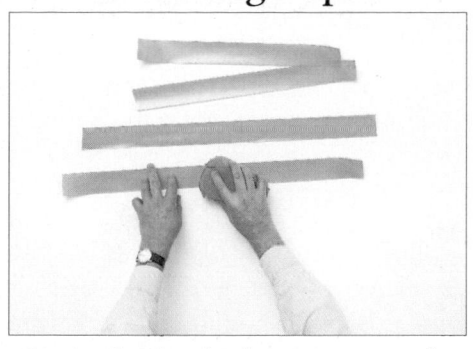

2 *Cut four lengths of paper tape – one for each side of the paper. Each piece should overlap the side of the paper slightly. Lay them on a separate surface and dampen with a clean sponge.*

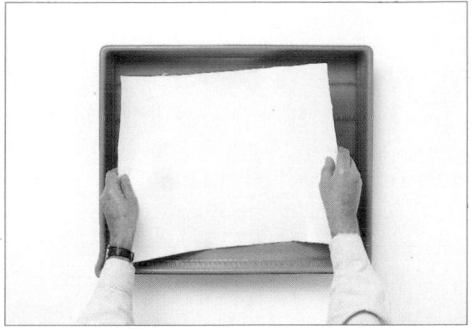

3 *Soak the paper for a few minutes in a bowl or tray filled with clean water. When it is thoroughly wet, lift it out carefully and allow the excess moisture to drain off the paper.*

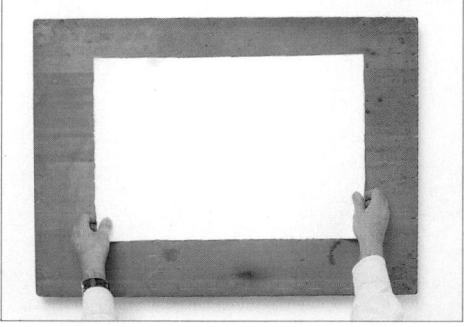

4 *Lay the wet paper carefully on the board, making sure that it is flat. Use a sponge or clean rag if necessary to ease out any bubbles.*

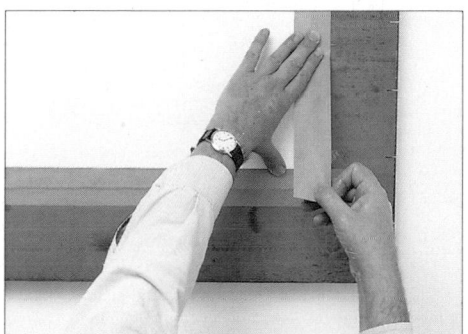

5 *Take one of the longer tape pieces and stick it along the top edge. Repeat on the lower edge and the two shorter edges. Each length of tape must sit equally on the paper and board. Allow the paper to dry.*

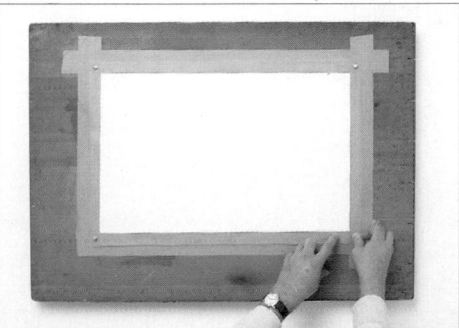

6 *To make sure the paper does not lift the tape off the board as it dries, thumbtacks can be pushed into the four corners. These secure both the two overlapping strips and the paper.*

Black Ingres paper

Colored Ingres papers

Heavy sketching paper

Medium-weight sketching paper

Bristol board

Easels and Supports

UNLESS YOU ARE making quick reference sketches in a sketchbook, you need a firm support for your paper. A drawing board – either store-bought or home-made – is the usual solution.

You can rest the drawing board on your lap, but this is not very comfortable or practical. Whatever subject you are drawing, you need to be able to walk away and look at your work from a distance at regular intervals to check how it is progressing. The cheapest solution is to prop the drawing board up on a table against a few heavy books – but it can be difficult to get the desired angle. You must also make sure that whatever the drawing board is resting on will not slide off the table or collapse when you press hard on the paper.

If you can afford it, you should consider buying an easel. There are many different types available, so make sure you buy one that suits your needs and price range. A good easel will last you a lifetime and is a worthwhile investment.

Think about how you may want to adjust the easel. On some easels the boards can be tipped to any number of angles, while others have a more limited range. If you work

frequently in watercolor or ink, you will need only a slight angle to the drawing board – otherwise the paint will run off the paper. Artists who draw or paint standing up tend to work with their boards almost vertical, while those who work sitting down prefer to have the board sloping at an angle. Most easels can be adjusted to several heights and positions, which means that you can work either standing up or sitting down.

Stability is of prime concern. There is no point in setting up an easel only to have it collapse when you start work. If you work entirely indoors and have your own studio or workroom, you might prefer a very solid easel that can remain in position more or less permanently. The main requirements for an easel to be used when working outdoors are compactness and portability.

Although most easels are made of wood, folding metal easels are available. Folding easels are ideal if you do a lot of work in the field – drawing landscapes, for example. They are usually made of aluminum and are thus both lightweight and sturdy – suitable for carrying considerable distances if necessary.

Drawing Board
The drawing boards available in art supply stores come in different sizes, which are related to paper sizes. They are made of wood, which is stable enough not to warp when stretching paper and soft enough to allow thumbtacks to be pressed into it to secure the paper. You can also make your own drawing board by cutting a piece of wood or fiberboard to size. Make sure the surface is clean and smooth. A home-made board may need to be sanded and covered with several coats of varnish – particularly if you are going to stretch paper on it.

Clips and Fasteners
Thumbtacks and masking tape are the cheapest method of fastening paper to the board. Their main drawback is that they can leave holes or tear the paper. Binder clips are also effective. Sliding clips (see left) are available from art supply stores and do not damage the paper.

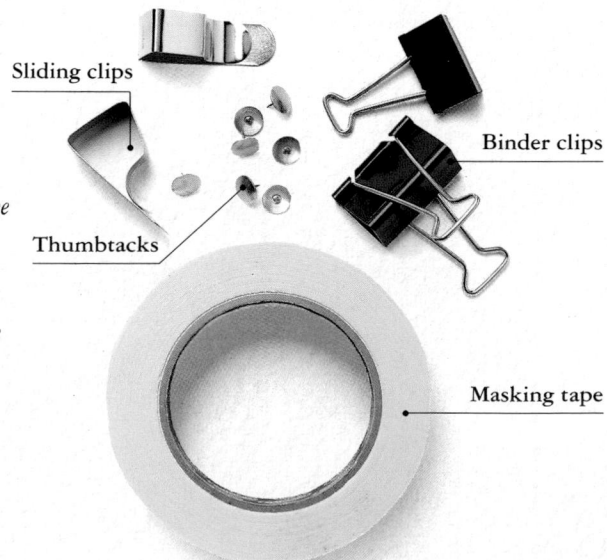

Sliding clips

Binder clips

Thumbtacks

Masking tape

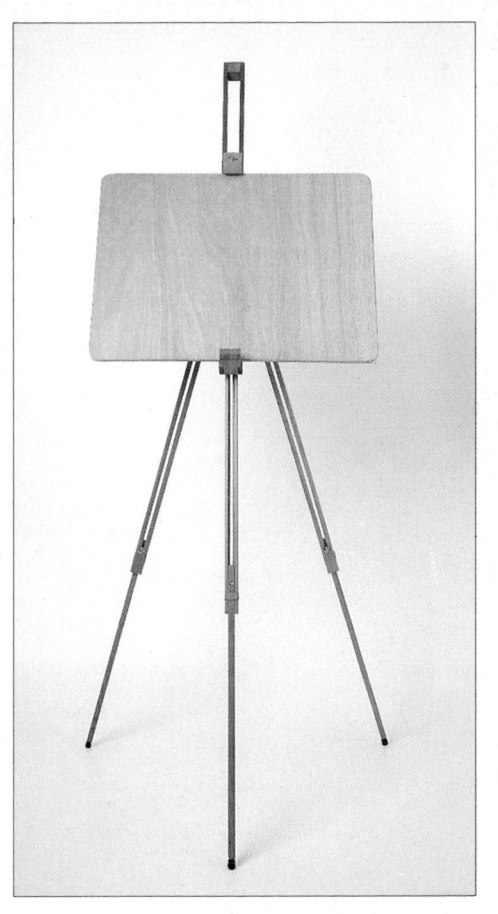

Folding Easel

Most easels fold into a neat package to allow for easy transport and storage (see left). The legs on a folding easel are longer than on a conventional studio easel, and they can be adjusted to different heights, so that even if you set up on a slope, it will remain stable (see right). Always be sure to tighten the joints securely to prevent the easel from collapsing or the board from sliding down on one side.

The drawing board is placed on the ledge.

The thumb screw is used to stabilize the upper and lower parts of the easel at the points where they join.

The wing nuts fix the legs at the desired height.

The hollow legs are telescopic to keep weight to a minimum and aid portability.

Table Easel

A table easel (left) can be adjusted to a number of pre-set angles, ranging from completely flat to almost vertical. It is compact and ideal for working at home. Below left: The drawing board rests on a retaining lip.

Sketchbooks

SKETCHBOOKS ARE INVALUABLE TO ARTISTS. You can use them to jot down visual notes – a facial expression, perhaps, or a dramatic lighting effect – for a future larger scale drawing or painting. You can experiment with different viewpoints or compositions, and decide what you like and dislike about each, before committing yourself to a particular approach. You can also use your sketchbook to make detailed, finished drawings without setting up an easel.

The size of your sketchbook has some influence on which media you choose to draw with. In a very small sketchbook, drawing tools capable of making delicate lines, such as sharp pencils or fine-nibbed pens, may be best. However, it is often harder to draw on a smaller scale; a larger sketchbook enables you to use drawing tools such as felt-tip pens or charcoal that make sweeping lines and broad marks. Most sketchbooks contain good-quality white drawing paper, which suits most media. Books of colored drawing paper and watercolor paper are also available.

If you are using a loose-textured drawing medium such as charcoal or pastel, you must devise a means of keeping the drawing from smudging when you close the sketchbook. It is not always feasible to "fix" the drawing (see pp. 152–153) in the field. As a temporary measure, you can place thin sheets of paper (tracing paper is ideal) between the pages of your sketchbook, then fix the drawing properly when you arrive back home.

Carrying a sketchbook is a good habit to cultivate. You can slip one into your pocket and practice drawing anywhere, whenever you have a few minutes to spare. Sketching constantly helps to sharpen your visual recall. You begin to notice things that you might otherwise overlook – and you remember them much more vividly because of the intensity with which you studied them.

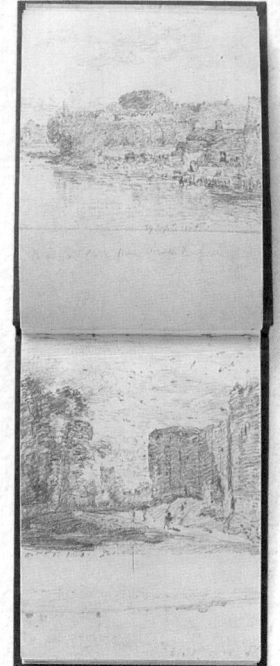

Constable's Sketchbooks
The English landscape painter John Constable (1776–1837) kept sketchbooks throughout his life. His sense of composition and eye for detail are evident even in his pocket-size sketchbooks (left and right).

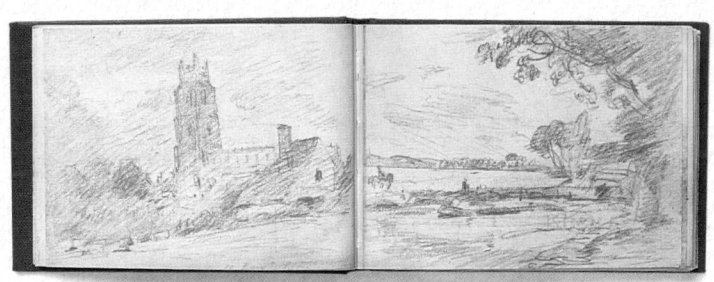

Types of Sketchbook

Choosing a Sketchbook
Before you buy a sketchbook, think about how you will use it. Do you want a sketchbook small enough to fit into a pocket for taking quick visual notes, or a pad for larger drawings? Are you planning to make finished drawings in situ? A spiral-bound or loose-leaf sketchbook, from which you can easily remove pages for framing, is your best option. For most media, a sketchbook containing good-quality drawing paper is suitable. If you are likely to be using lots of watercolor paint, buy one that contains watercolor paper.

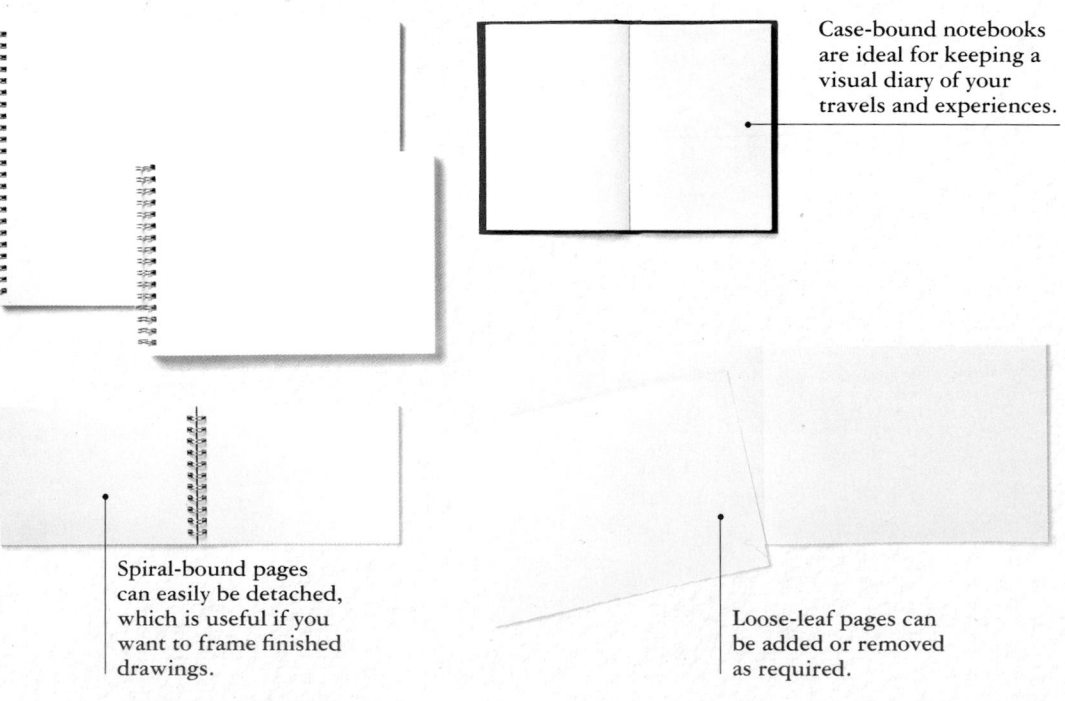

Case-bound notebooks are ideal for keeping a visual diary of your travels and experiences.

Spiral-bound pages can easily be detached, which is useful if you want to frame finished drawings.

Loose-leaf pages can be added or removed as required.

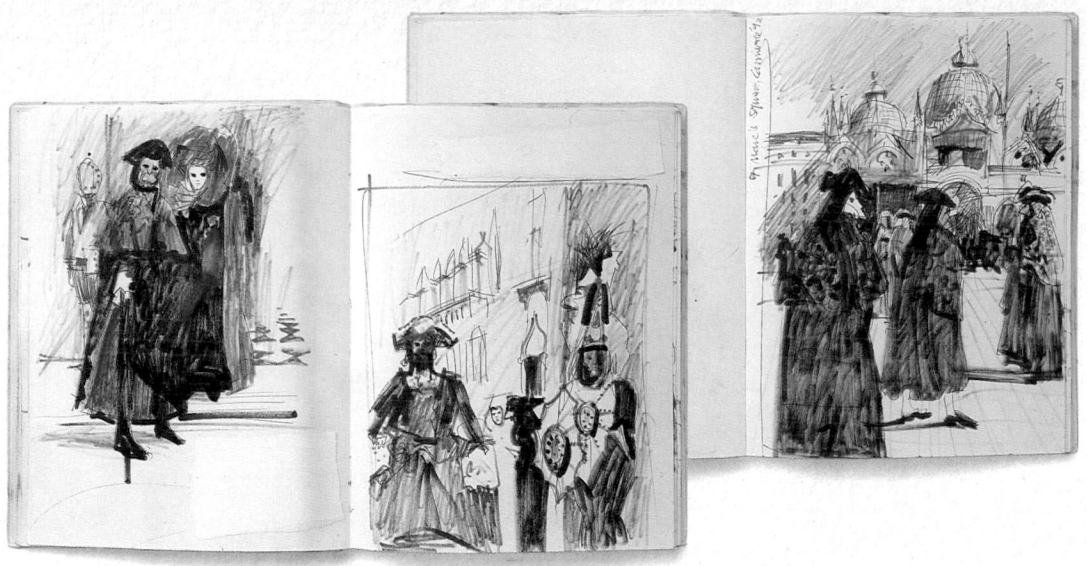

Carnival in Venice

These are preliminary sketches for full-size paintings. They are made using ballpoint and felt-tip pens, which are ideal for working quickly and capturing the ever-changing scene and characters. If you put the background in later, as the artist did here, make sure that the lighting remains the same, and take care to relate the sizes of the buildings to the people.

St. Jean de Col, France

This tranquil river scene and the typical Périgordian buildings in the background bring back memories of an enjoyable vacation. In the sketch watercolor pencils are used without adding water to blend the colors together in order to achieve a more intense color. Note that the shadows under the bridge are not solid black but are made up of many colors. The foreground foliage is deliberately made darker and stronger than that in the background in order to convey a sense of distance.

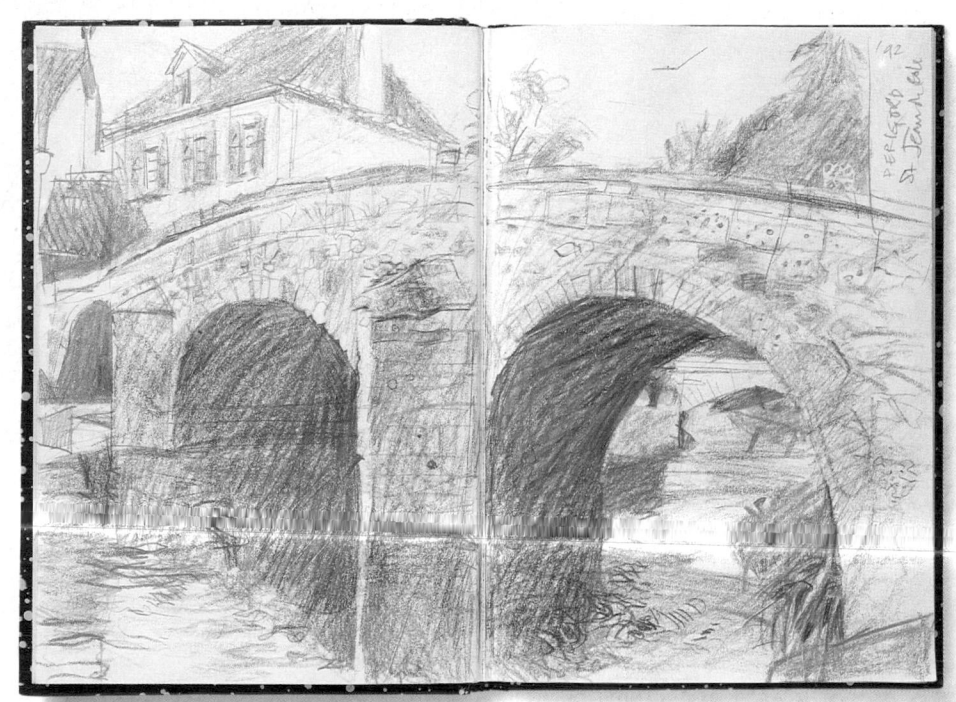

Children Sleeping

This quick ballpoint-pen sketch of children sleeping could either be used as a study for a more elaborate work or left as it is, as a charming family "snapshot." Although it is in a case-bound sketchbook, with care the pages can be removed, sealed together along the centerfold, and mounted. If you draw across two pages, as here, make sure that you compose the picture so that nothing essential is positioned on the fold.

The Fundamentals of Drawing

Holding Drawing Tools

SELECTING THE APPROPRIATE TOOL for the job is part of the joy of drawing; a great range of implements is available, and each tool has its own characteristics. For more flexibility, thin and thick lines, for example, a steel-nib pen is best, while broad energetic lines are better suited to charcoal and brush. Many artists use a mixture of instruments within one drawing.

Having made your choice, vary the way you hold the implement. Your grip has a fundamental effect on the qualities of the marks you make on the paper. These two pages show a variety of tools and suggest alternatives to the orthodox grip. Experiment with different grips to discover what works best for the medium you are using and the style of the drawing you are working on.

Pencils

The most common form of drawing implement, the pencil, comes in a wide range of grades, from very soft (black and rich) to very hard (gray and fine). Pencils are made of a core of graphite bound with gum within a wooden case.

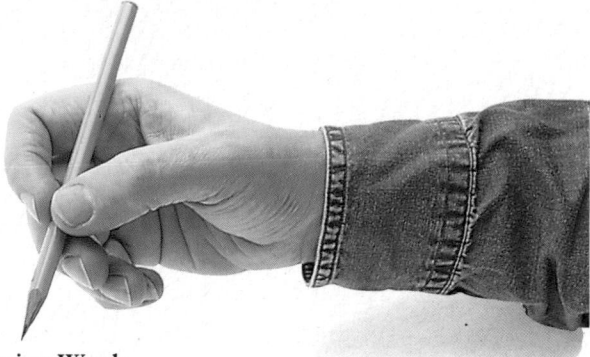

Descriptive Work
Hold the pencil firmly in an ordinary grip – between your thumb and forefinger – and balance your hand gently on the little finger. In this way, you are able to use the pencil for fairly close, descriptive work.

Detailed Work
A stub of pencil held in the ordinary grip enables you to make small, controlled wrist movements. This method is ideal for close, detailed work.

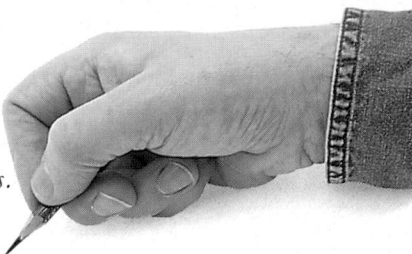

Controlled Shading
For more controlled shading, loosen your grip by holding the pencil halfway down the shaft instead of at the end. Use your third and fourth fingers as a support when you want to change the angle of the shading.

Loose Shading
Hold the pencil at the end of the shaft while resting on the knuckle of your little finger. This enables a sweeping movement – advantageous for loose shading.

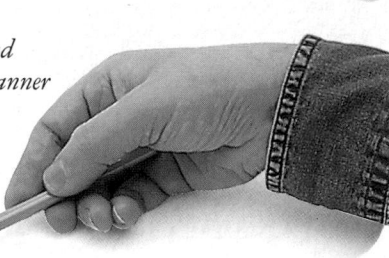

Linear Marks
For making linear marks and shading in the "classical" manner as used by artists such as da Vinci, hold the pencil toward the end using a good, firm grip.

Charcoal

Charcoal is made by burning wood: vine, willow, and beech are all suitable. The color of the mark the charcoal makes will vary from a brownish hue to a dense blue-black, depending on the type of wood.

Shading Large Areas
For shading and making broad strokes, hold the charcoal stick in the middle and rub it horizontally across the paper.

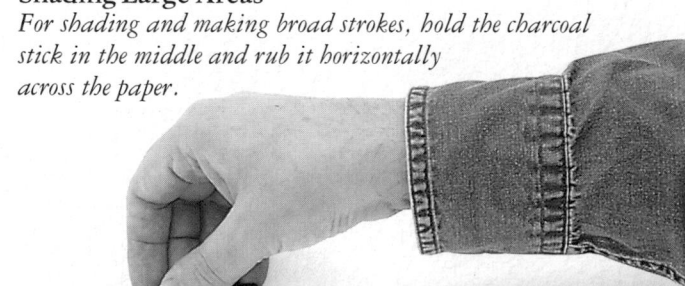

Detailed Work
Inset: *Use a short piece of charcoal for greater control.* Below: *For short lines and strokes hold the charcoal close to the drawing end. This helps to prevent it from breaking.*

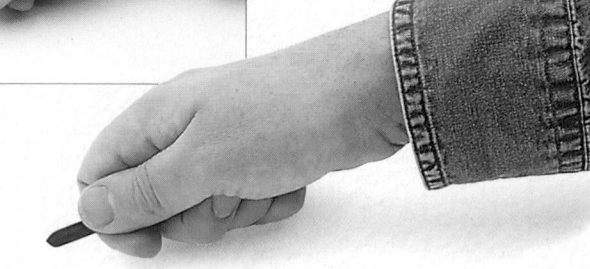

Pens

A wide range of pens is available. Steel-nib pens often have a reservoir that holds enough ink to enable you to continue drawing for some time. Quill pens have been used for centuries, as have reeds. Both are useful for cross-hatching and building up form with diluted ink.

Various Lines
Hold the pen between the second and third fingers for a rich, rough line. For a more rigid line, place more pressure on the nib, and for a fluid line, use small wrist movements.

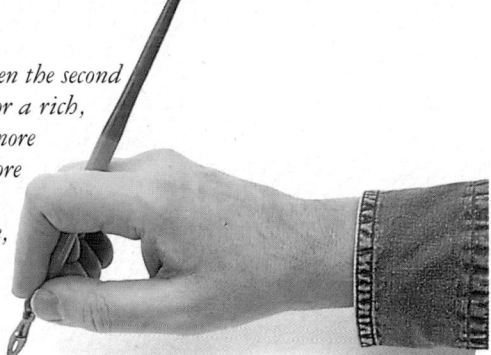

Laying Large Areas
Use the reverse side of the pen nib to lay large areas of color. Dipping and twisting the pen through your fingers will offer up a wide and interesting range of possibilities.

Lines and Details
Inset:
For detailing, or when working over wet ink, use the little finger as a lift to elevate both hand and pen. Below: To create the greater pressure necessary for making strong and sharp lines, support the pen on two fingers.

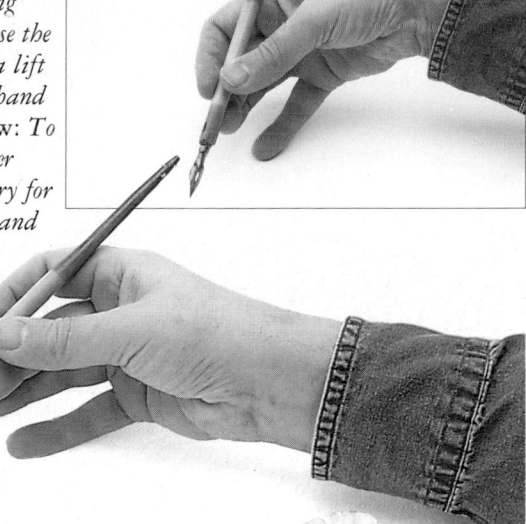

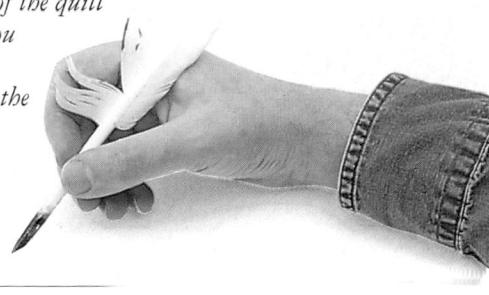

Quill Marks
Hold the quill gently but firmly between your thumb and forefinger. The shape of the quill and the pressure you exert on it make a great difference in the marks produced — from thin lines to broad strokes.

Brushes

Some artists draw exclusively with brushes, while others combine pens with brush and a wash of ink or watercolor paint. Nowadays the best brushes are made of sable hair or a mixture including sable. The sizes range from very fine to full, either round-ended or chisel-shaped.

Fine Line Work
For fine lines, balance the brush gently between thumb and forefinger. Even though this is a light hold it still enables you to keep control.

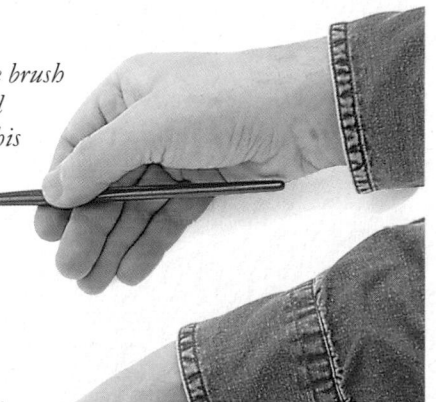

Chisel Marks
For a richly lined texture, feather out and separate the hairs on the ferrule. Hold the chisel brush close to the ferrule for greater control.

Japanese Marks
For a different effect, hold this Japanese calligrapher's brush vertically, as shown here, to make dots, blobs, and flowing lines.

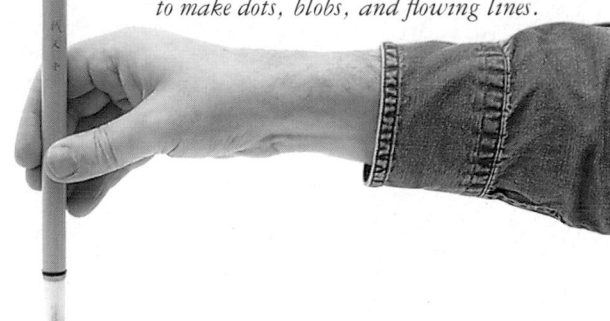

Brush and Ink
When using a brush dipped in ink, lift your drawing hand above the paper surface so that the brush can traverse the wet ink.

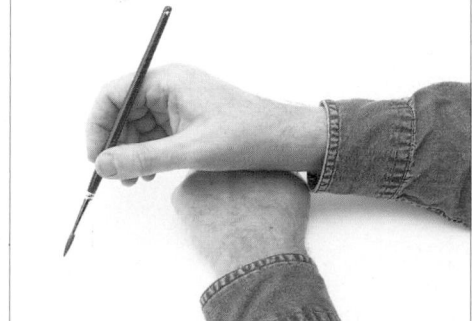

Training the Eye

BEGINNERS OFTEN WORRY about making mistakes: they stop halfway through a drawing and try to correct something that has gone "wrong." But drawing well is more than a question of using the right pencil or making a mark on the paper in a particular way. Usually, drawings seem "wrong" because you have not studied your subject carefully enough. Take time to look at your subject without any preconceived ideas. If you can train yourself to observe everything closely, as if you had never seen it before, you are on your way to becoming a competent artist.

A good way to train your eye and your hand is to draw something without looking at the paper to see how your work is progressing. This technique is sometimes called "blind" contour drawing. Keep your eyes focused on the object as you trace its outline in pencil. Lift your pencil only when you need to move to a new part of the drawing. Then – and only then – you can steal a glance at the paper to check that you are starting again in the right place.

HB pencil

To begin, choose a subject with a simple outline shape, such as a piece of fruit or a slice of bread. Then, as you gain confidence, you can move on to more complicated subjects with lines inside the silhouette, such as a closed umbrella or a coat hanging on a hook. You will soon find that you are becoming more adept at noticing every little undulation on the surface and determining how all these variations build into the overall shape.

Your hand and eye should travel at the same speed, so that at any given moment your eye is looking at exactly the same part of the subject that your pencil is drawing on paper. Imagine that your pencil point is touching the object rather than the paper. Make a conscious effort to look and draw slowly, lingering over every detail. Most people tend to work much too fast, and this defeats the whole purpose of the exercise.

At first your blind contour drawings may bear very little resemblance to your subject, but persevere. Getting into the habit of looking intensely is a skill that will prove invaluable in all your future work.

Simple Still Life

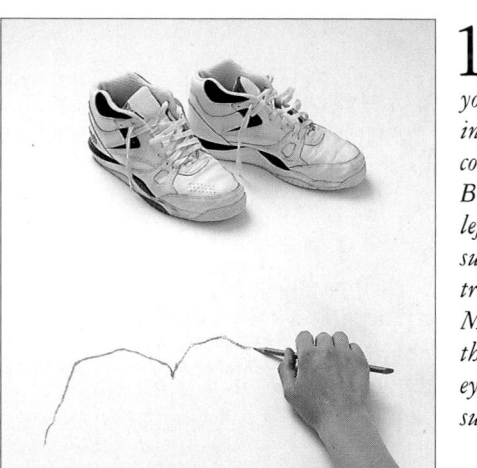

1 Hold the pencil loosely, so that you can move it in a smooth and continuous line. Begin near the top left-hand side of the subject and carefully trace its outline. Move the pencil at the same speed as your eye travels over the subject – slowly.

2 Without lifting the pencil from the paper, you can create different tones. Roll the pencil over a little to vary the thickness of the line, and press harder to get darker lines.

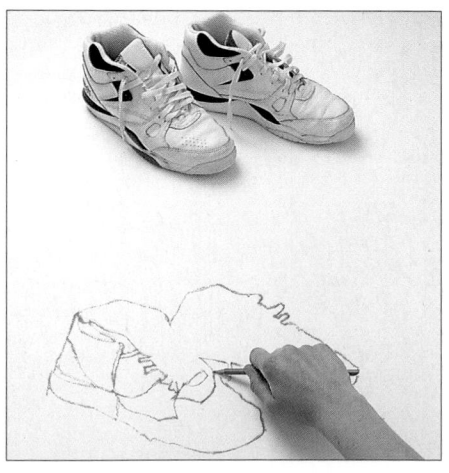

3 When you want a strong tone, such as that around the laces, slip your hand forward and hold the pencil closer to the tip. In this way you can make a darker mark. You can make an even richer mark by using the side of the pencil.

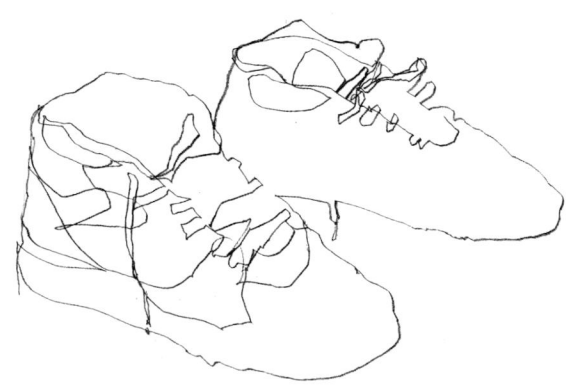

Studying a Profile

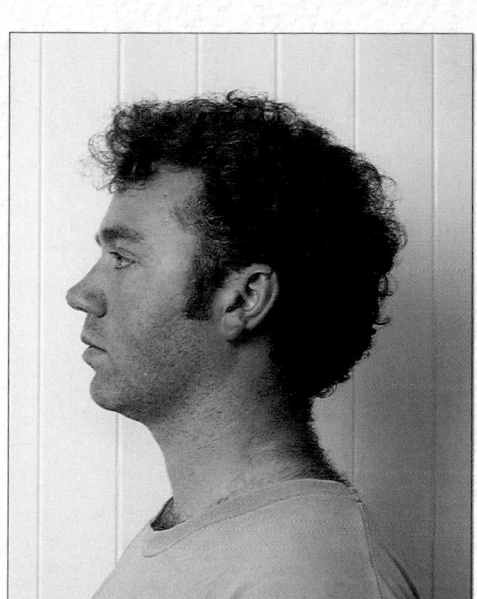

Positioning Your Subject

Position your subject in profile against a background that gives you points of reference from which you can begin the sketch – a wall with a series of vertical panels, for example.

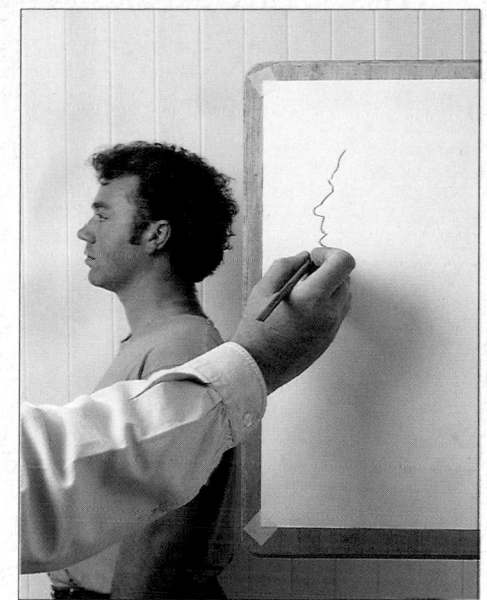

1 *Place the left edge of the paper (if you are right-handed) close to the edge of the board. Place the board on an easel that is positioned so that it allows you to view your subject clearly and to make your drawing on the paper at the same time. Start at the top left-hand edge of your subject's profile, choosing a point that is easy to relocate, and work down.*

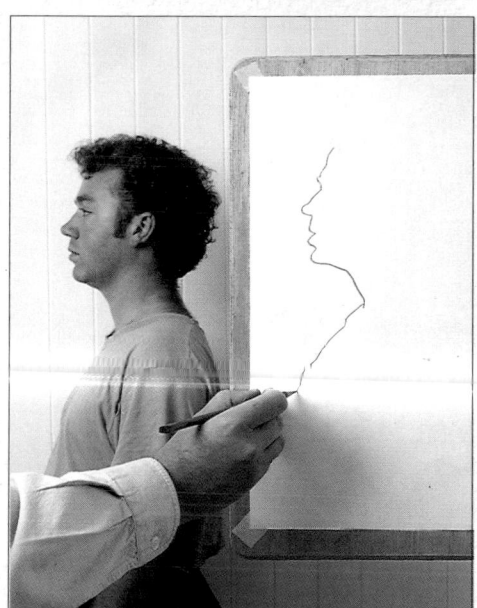

2 *Keeping your eyes fixed on the subject at all times, carefully draw the left-hand edge of the profile onto the paper. Move down to the subject's throat and then to the neck and chest. Work slowly, examining every feature closely, so that you transfer it accurately onto the paper.*

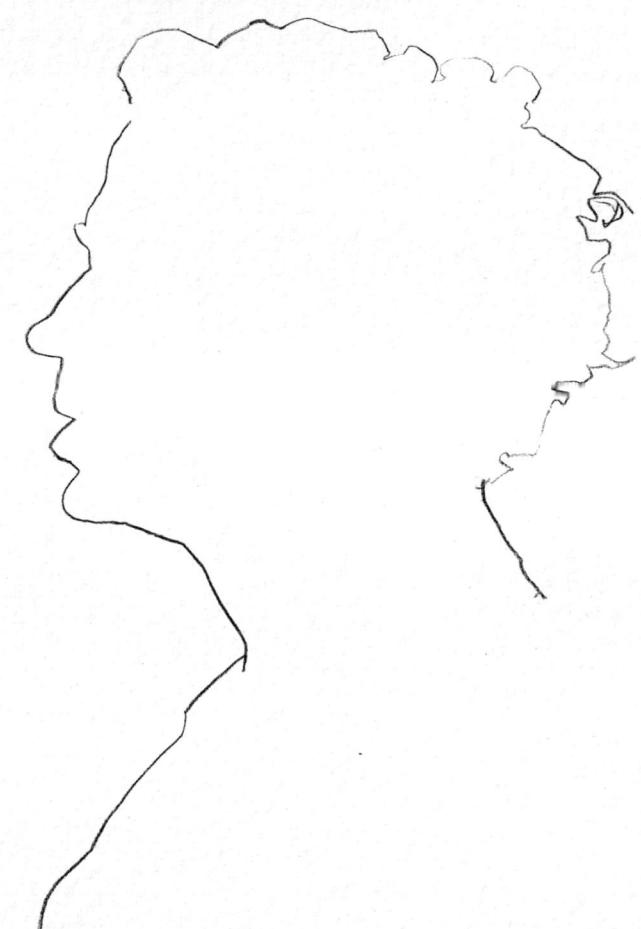

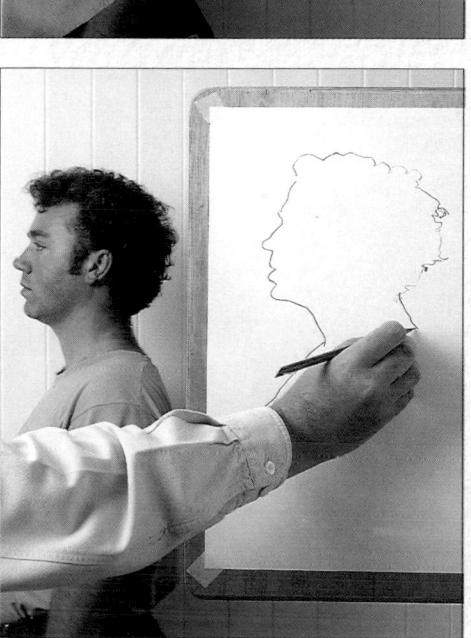

3 *When you have finished the left-hand side of the drawing, take your pencil off the paper and – with only a glance at what you have drawn so far – place it at the top of the paper where the hairline should begin. Continue working downward until you have completed the profile.*

Finished Drawing

By paying less attention to what is happening on the paper and more to studying whatever it is you are drawing, you will gradually improve your eye-hand coordination and get into the habit of looking carefully at your subject. Although initially your drawings may look hopelessly muddled, keep at it – eventually your drawings will be far more accurate.

Basic Composition

COMPOSITION IS ABOUT how you arrange your subject within the picture area. The best way to learn about it is by looking at other people's pictures. Start by deciding what is the most important part of the picture; you will almost certainly find that your eye is led to it in some way. Sometimes there will be a curving "path" through the picture leading to the center of interest. In other pictures the main elements may be positioned on or close to a strong diagonal line. Each type of line produces a different overall mood. Circles encourage the viewer's eye to move around the picture. Jagged lines and diagonals produce a feeling of energy. A horizontal line usually evokes a mood of peace and calm.

The overall balance of the picture is something to consider, too. Balance does not necessarily mean symmetry, however. Positioning your subject in the center of the picture space might seem the most obvious way of balancing the composition, but centrally placed subjects can look very static and lifeless. With objects placed on the "third," we instinctively feel that we are looking at a picture of harmonious proportions. Positioning your subject way off-center, perhaps near the edge of the paper, can create tension and energy. Decide which of these approaches best suits your subject: there is no "right" or "wrong" way.

A feeling for composition is something that you will develop with practice. Artists rarely stop to theorize about why they are arranging their subject in a particular way but it is amazing how often pictures correspond to one of the conventions described on these two pages.

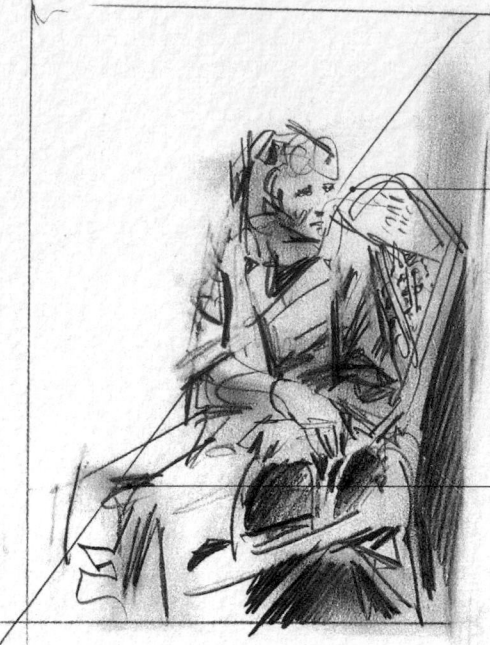

The model is looking out of the picture space, which produces a feeling of tension and unease.

All the main features – knee, elbow, and eyes – are positioned on or near an implied diagonal line that runs from bottom left to top right.

Diagonal Line

This picture contains a strong implied diagonal line from bottom left to top right, with the most important features – the eyes and elbow – placed on or near it. The viewer's eye is swept along it to the focal point of the image – the woman's face and slightly downcast expression. Most of the subject lies to the right of the diagonal, but the space to the left is also important. The viewer needs to be able to linger over the detail in the figure. Similar detail on the left side would distract attention from the main subject.

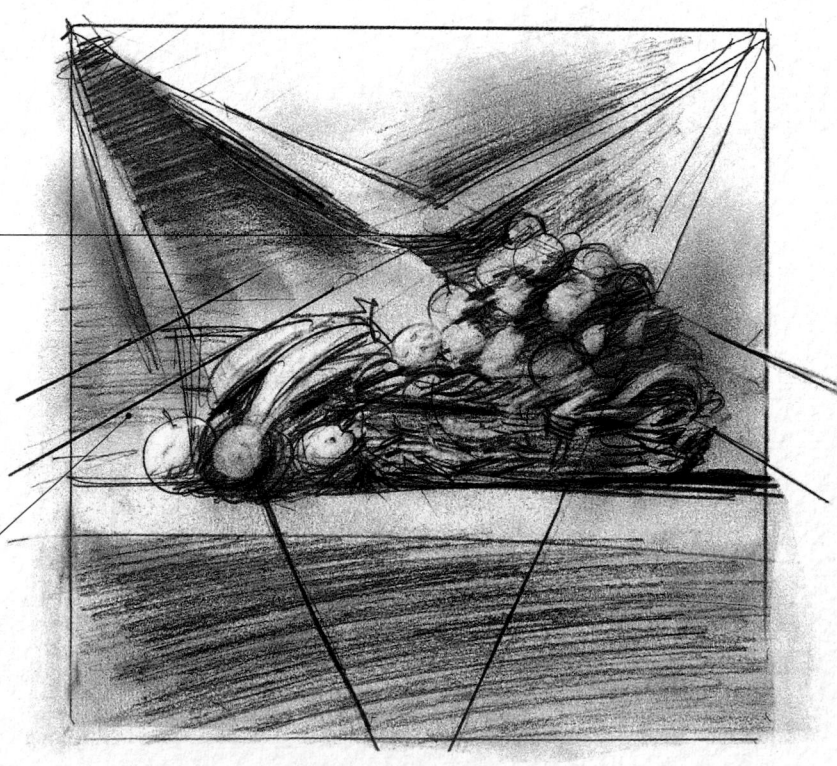

The soft, flowing lines of the cloth draped in the background contrast with the strong geometric shapes of the fruit.

The eye is led from the base line, up to the top of the pile of fruit, and down again.

Centrally-placed Subject

One of the so-called "rules" of art is that placing a subject in the center of the picture space makes a very boring, static composition. This is not always so; a subject that contains interesting shapes and angles within it has lots to entertain the eye. Although the overall motif is centrally placed, the most important elements within it – the summit of the pile of fruit, and the table edge – are positioned approximately on the thirds (see opposite). The curved shapes of the individual fruits encourage the eye to travel around the composition. The table provides a strong horizontal line on which the composition rests. Square pictures tend to have a certain classic dignity and simplicity.

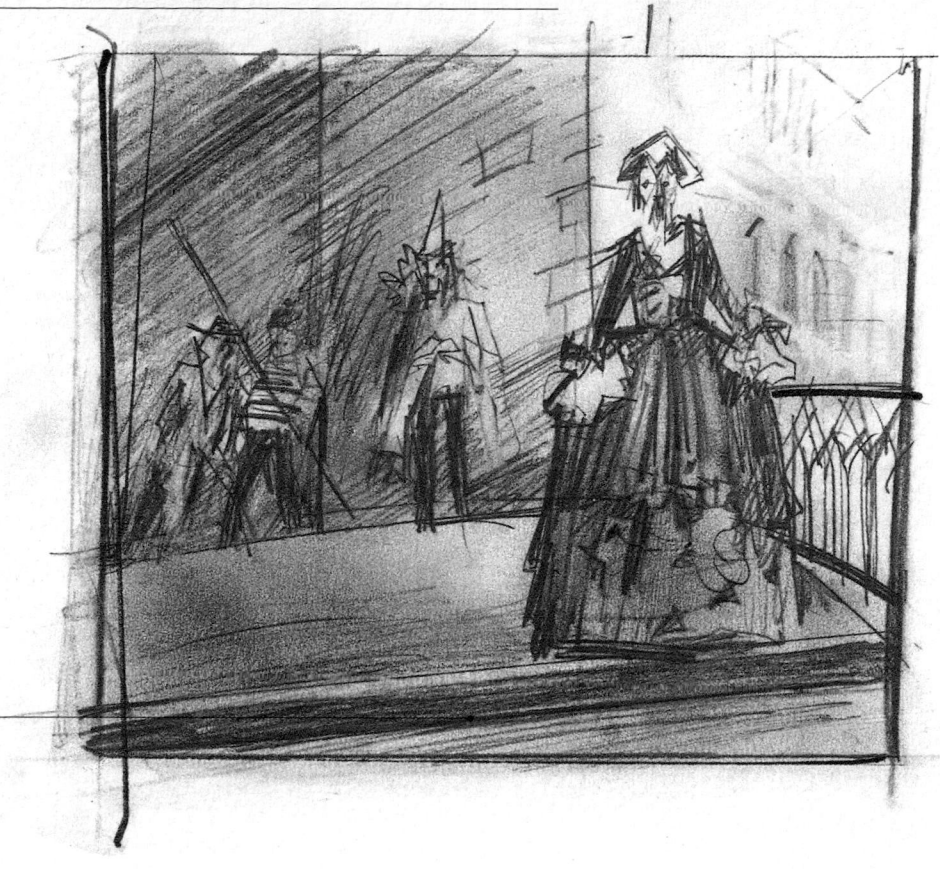

Asymmetry

This composition is asymmetrical, with one large figure placed off-center and dominating the foreground. None the less, the eye is led through the picture plane in a sweeping curve from the foreground through the middle distance to the far distance. Only the handrail of the bridge is parallel to the edge of the drawing; other horizontal lines are slightly angled, adding interest and a sense of dynamism to the picture.

Because of perspective, the horizontal planks of the bridge appear to be slanting upward. This adds interest and a sense of energy to the composition.

Division of Thirds

This is a system of composition in which the picture space is divided roughly into thirds, both horizontally and vertically. Any subject placed on or near the points where the vertical and horizontal divisions intersect, such as the boat in this picture, automatically attracts the viewer's eye. The triangular shape of the boat's sails is repeated in the cliff, and these angular forms contrast with the much softer, rolling, circular cloud forms in the upper two-thirds of the picture space.

The lighter tones of the cliff in the middle distance help to suggest a three-dimensional feeling.

The focal point – the boat – is positioned on the horizontal and vertical divisions into thirds.

Measuring Systems

IN THE MIDDLE AGES correct scale was not considered important in Western works of art. Pictures were not realistic in the photographic sense: they represented ideas and visions, and they had their own standards of truth and reality. The more important an element or a figure was, the greater the amount of picture space devoted to it — regardless of its physical relation to the rest of the image. In religious art, for example, Christ was considered to be more important than an ordinary man, so the artist made Christ's figure larger.

During the Renaissance artists became fascinated by the world around them and struggled to interpret three-dimensional forms on a two-dimensional plane in a way that mirrored how we actually see things. The challenge was to find ways of positioning the different elements of a drawing in the proper relation to each other and making sure that their relative sizes were correct. This is one of the most important things to master in drawing. Scale

HB pencil

Ruler

is very deceptive, and without some method of checking what you see in front of you, mistakes are almost inevitable. Since the Renaissance, several well-established methods of checking proportions have evolved. All involve some system of measuring what you are drawing. Learning to trust the measurements that you take, rather than what your instincts tell you, is vital.

The simplest method, known as sight-size drawing, is to position your subject alongside your drawing board, so that you can mark guidelines for the height of various features directly on the paper. This approach works well for portraits and small-scale subjects such as still lifes. Another common method of measuring is one that you have probably seen artists using, even if you have not known exactly what they were doing. It involves holding a pencil at arm's length, closing one eye, and measuring the relative sizes of the objects or features you are drawing against the length of the pencil, and then transferring this measurement to the paper.

Sight-size Drawing

A common mistake in portraiture is making the central face area too big in proportion to the rest of the skull. Because the brain interprets the face as being more important than the forehead or the cap of hair covering the skull, your natural instinct is to allocate more space to it. Similarly, the eyes are often positioned too high on the forehead. Take direct measurements from your subject, and rely on these rather than on your instincts. Establish the position of various features first before elaborating the details.

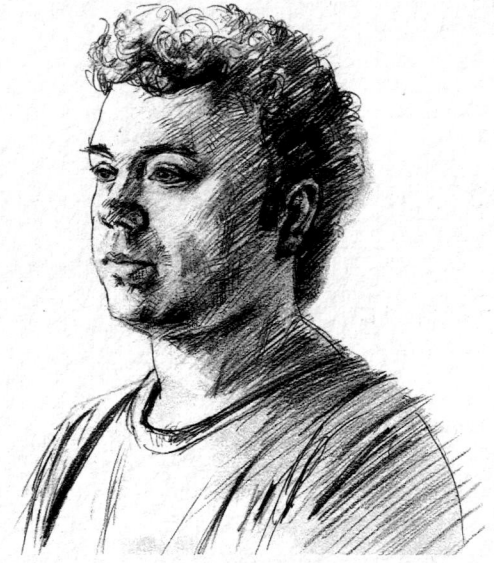

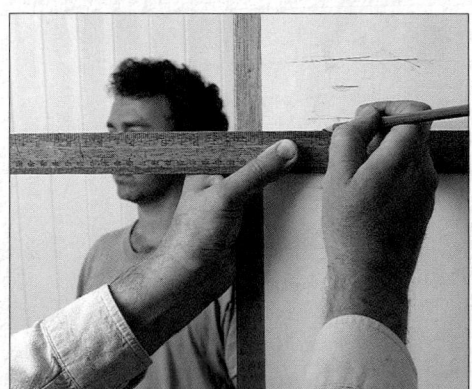

1 *Place your drawing board so that it lines up visually with your subject. Guided by a ruler or straightedge, lightly pencil in the position of the major features of the face.*

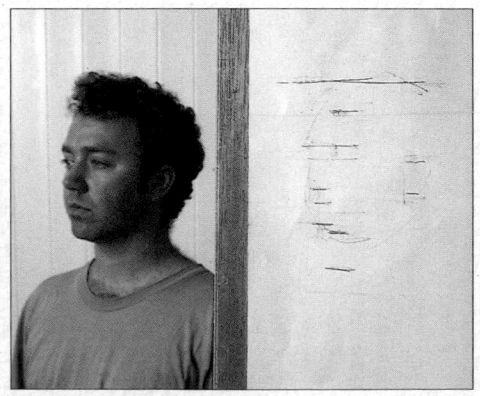

2 *After you have marked in the location of the nose, eyes, and ears, check again with the ruler to make sure that you have positioned the marks accurately.*

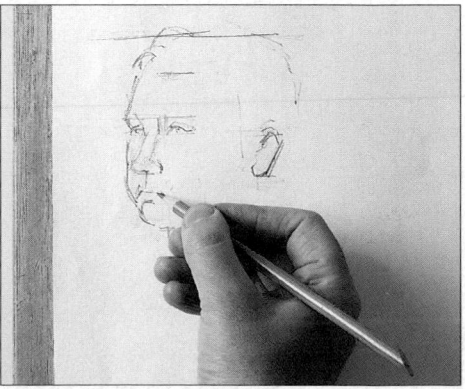

3 *Use the marks only as an understructure for the placement of the facial features, not as a guide to their actual shape. Once satisfied, start the drawing.*

Sighting with the Pencil

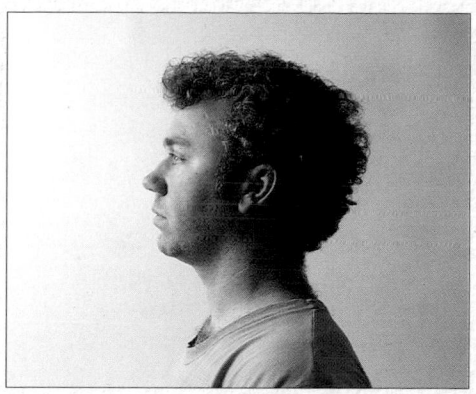

1 *Position your subject in profile. Light the head from the left and slightly above to show up the contrasts between light and dark areas more clearly.*

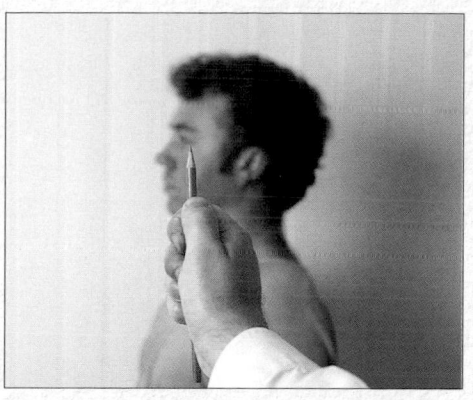

2 *Hold the pencil vertically at arm's length, keeping your arm straight. Take vertical measurements (forehead to eye, eye to mouth), marking the length on the pencil.*

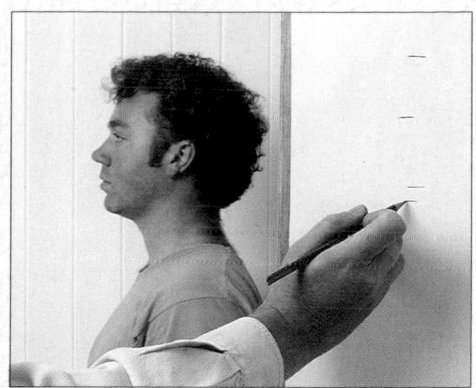

3 *Still holding the pencil at arm's length, measure, then lightly mark in the position of the eyes, nose, mouth, and other facial features.*

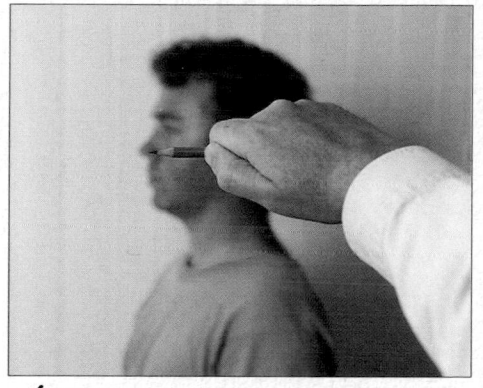

4 *Holding the pencil horizontally, measure the distance from the nose to the edge of the ear. Transfer this measurement to your drawing. Repeat with the remaining features.*

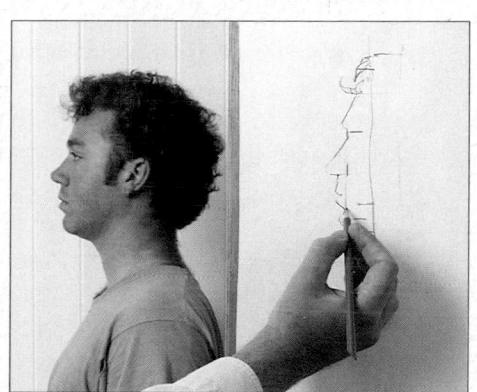

5 *Check the measurements again. Once you have made sure that they are correct, draw the features.*

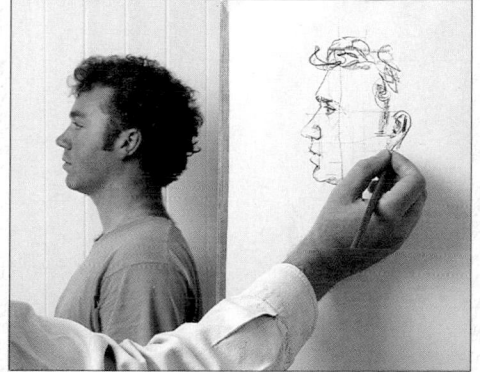

6 *Stand some distance away from your drawing, taking care to keep the same viewpoint and carefully assess the angle and position of each feature. Transfer to the paper.*

Sighting with the Pencil

It is important to keep your arm straight when taking measurements so that the pencil remains a constant distance from the subject you are measuring. Close one eye to make it easier to focus, and concentrate on looking at the pencil. Your subject will look slightly blurred but that does not matter: taking measurements will help you to get the general proportions right. You will add the details to your drawing later. The measurements can be of small areas (the height of the eye socket, for example) or the length or height of the whole object.

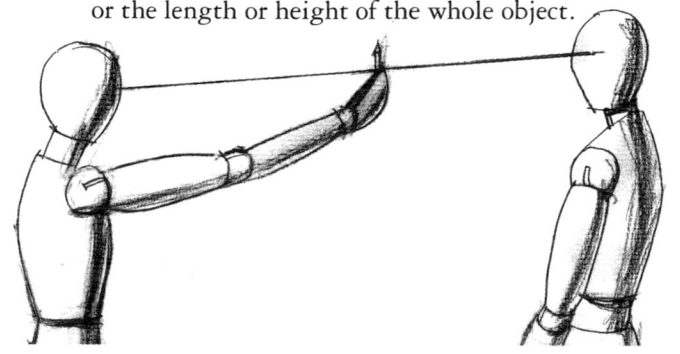

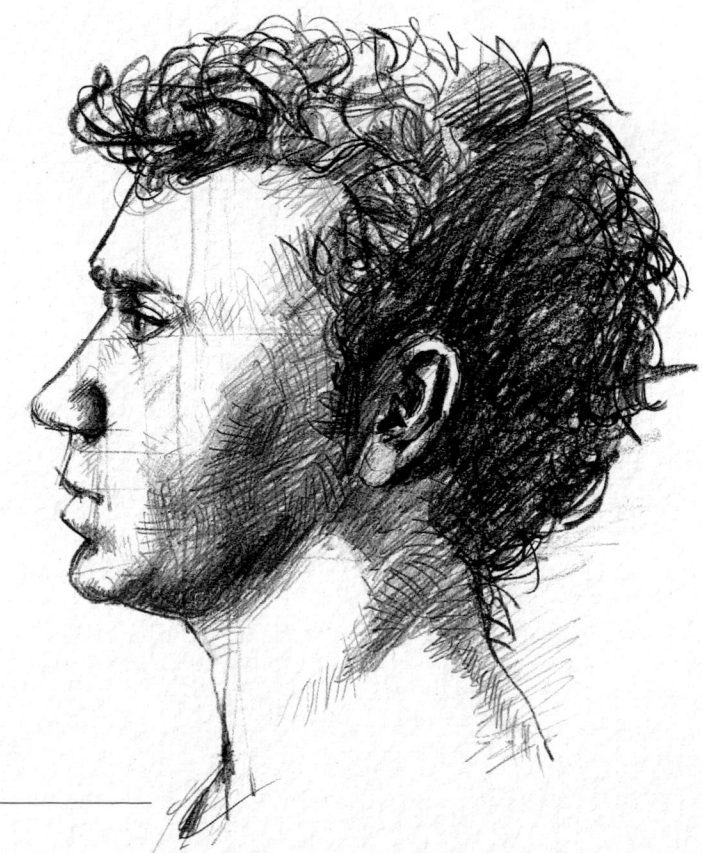

One of the most efficient methods of making sure that different parts of your picture are in proportion to one another is to use a grid. As you build up the drawing, you can use the horizontal and vertical lines of the grid as reference points for transferring what you see to the paper. The reason a grid system is so valuable to the artist is that objects appear changed when seen in perspective. If we look at a table in perspective – across the room, for example – we tend to draw it as a rectangle, as though we were seeing it from above, simply because we know tables to be rectangular. The grid system trains the eye to see the world as it appears to us visually and not base it on our spatial and physical knowledge.

The simplest method is to use a ready-made grid. Graph paper is both inexpensive to buy and readily available. Alternatively, you can make your own grid by marking off points at regular intervals along the top, bottom, and sides of the paper, and then connecting these marks with ruled lines. One advantage of making a grid yourself is that you

HB pencil

2B pencil

Charcoal stick

can make the grid lines as close or as far apart as you want. If you want to concentrate on a particularly complicated area, you can make further subdivisions on the grid in that area. You can also rule the lines faintly, so that they are easy to remove later. Another advantage of making your own grid is that, by adjusting the size of the grid squares, you can increase or decrease

the size of your drawing – so you do not always have to draw things life size.

Imagine that there is also a grid over your subject. (It helps if your subject contains very obvious vertical or horizontal lines that you can use as points of reference.) Hold out a pencil either horizontally or vertically, as in pencil sight drawing (see pp. 36–37), to check the size of one detail in relation to another. Try to fix your imaginary grid in your mind and mentally lay it over your graph paper as you draw.

The grid system is designed to help you to see, understand, and draw with greater confidence and accuracy. It is particularly suitable for complex pictures – such as a series of buildings in a townscape or a figure composition using manikins on a tabletop – where the spatial relationship of one object to another is critical. As your fluency in drawing increases, this way of drawing will become automatic and you will be able to use imaginary lines rather than grids. The more often you use the grid system, the more confidence and skill you will gain in drawing. This will eventually lead you to trust your own eye in interpreting the world correctly. This process may seem tedious and mechanical to begin with, but remember that it is only intended to give you a base from which to work. Just as a carpenter cuts wood to size before starting to assemble a piece of furniture, so you must work out the basic understructure and proportions of your drawing before you can go on to interpret the subject in your own way, refining the details and creating an appropriate mood.

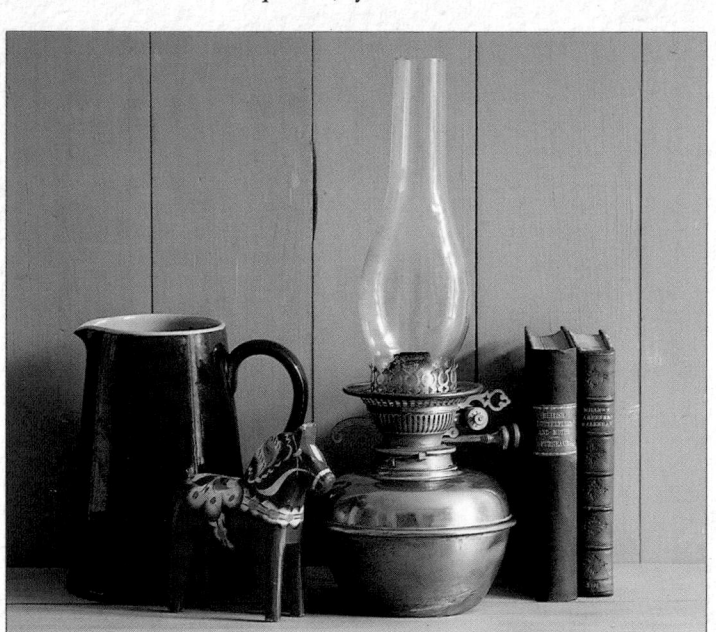

Still-Life Composition
Drawing the correct proportions of objects within a still-life group is always a challenge. Here the tall chimney of the oil lamp is placed on the "third" (see pp. 34–35) and the other objects arranged around it. The wooden horse is set at an angle to create a more dynamic baseline, and this in turn is balanced by the position of the books on the opposite side. The spaces between the objects are equally important in balancing the composition.

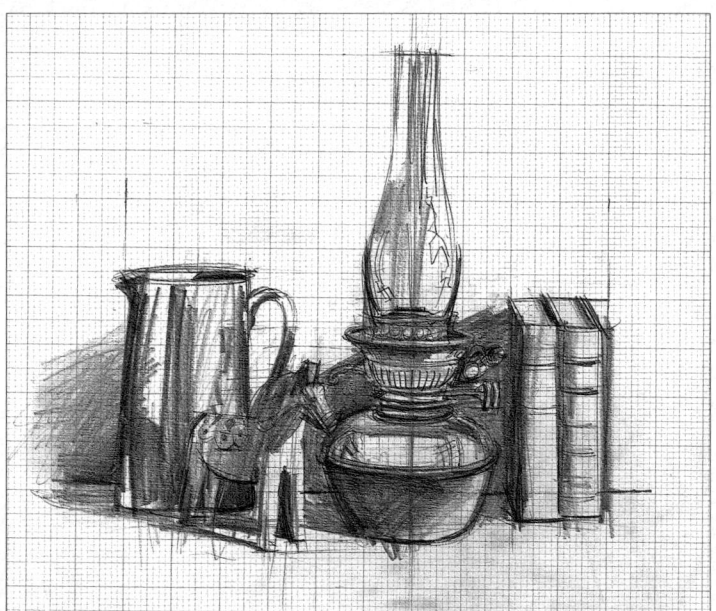

Using the Graph Paper
The different levels and angles within this composition make it quite a complex setup. A sketch like this, made using the horizontal and vertical lines of the graph paper as reference points, is a useful preliminary study for a later work. It enables you to work out the composition, tones, and shadows in advance. By concentrating on the grid, you are forced to look at one thing in relation to another in a more analytical way.

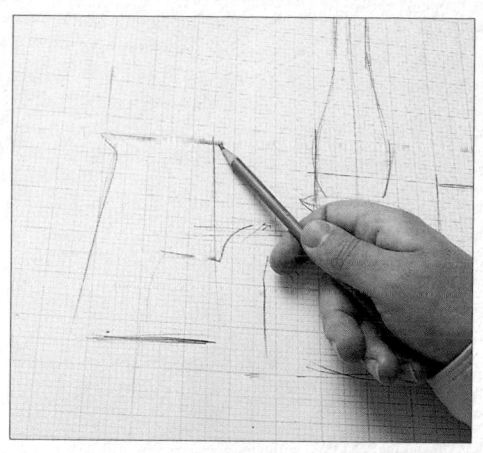

1 Use a 2B pencil to put in the main structural lines. Put a vertical line through the center of the glass chimney and a horizontal line along the top of the pitcher, so that you can use them as points of reference.

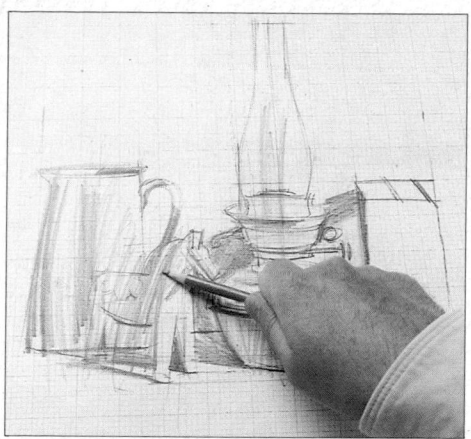

2 Now start adding the tones. Hold the 2B pencil lightly, and use a sweeping movement so that you can add tone over the whole picture area.

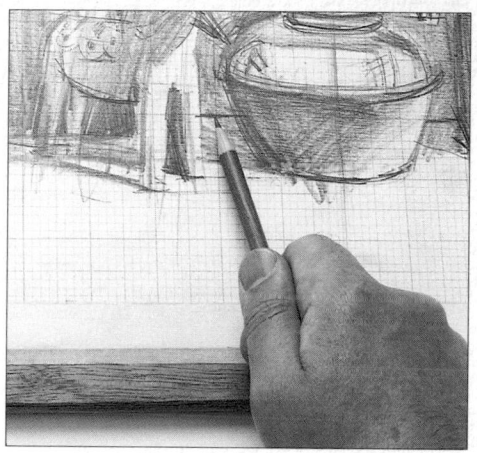

3 Still using the 2B pencil, carefully draw in the details within the shadowed areas, but don't linger too long in any one area. The graph paper sketch is only a working drawing which you will elaborate later.

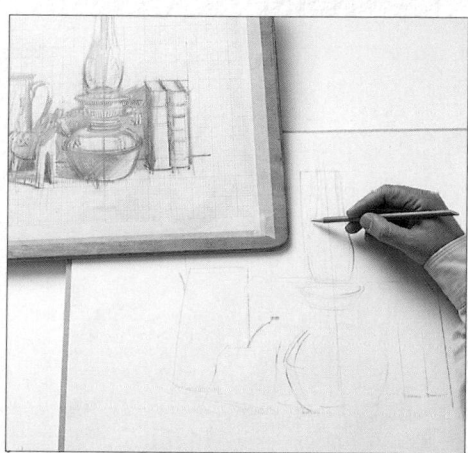

4 Now start to transfer the sketch onto your final drawing paper. Use an HB pencil to lightly draw the center horizontal and vertical lines as you did in step 1. Refer to the grid picture for the relative proportions and to the still-life grouping for the tones and detailing.

The Finished Drawing

This richly toned drawing has a lot of texture and depth. The darker areas have been defined further by the addition of charcoal. All the objects are linked visually by the shadows and tones between them. The shape along the bottom of the row of items has been given as much consideration as the silhouette at the top of the composition.

Linear Perspective

THE WORLD EXISTS IN THREE DIMENSIONS: the difficulty in making a drawing or a painting look real is that it is produced on a two-dimensional surface such as a piece of paper or a canvas. During the Renaissance artists used a system based on perspective to create a three-dimensional effect in their drawings.

The theories behind perspective are highly complex. Some people have devoted years to studying it. Unless you plan to do technical drawing, however, you can get away with knowing some basic rules and applying them sensibly. As in all drawing, it's remembering to look intently at your subject that's important.

There are three points to bear in mind. The first is the idea that objects look smaller as they get further away; eventually they appear so small they vanish from sight altogether. Look at a straight line of objects the same size stretching out in front of you: the nearest one looks much larger than the one that's furthest away, even though you know they're both the same size. The second idea to remember is that parallel lines appear to get closer together as they recede from you into the distance. Eventually, when they reach the point at which objects disappear from sight (the "vanishing point"), they seem to converge. Finally, keep in mind that the shape and angles of the same object vary depending on where you are standing in relation to that object. If you are looking at something head-on, so that it is parallel to the picture plane, there is no problem: horizontal lines will look horizontal. If you can see more than one side, however, only horizontal lines that coincide with your eye level will look horizontal; all others will appear to be slanting. To suggest three dimensions in your drawing, you have to forget what you know to be true.

Single-Point Perspective

Single-point perspective occurs with things that are parallel to the picture plane. The points to remember are that objects appear to diminish in scale the further away from you they are, and that parallel lines at 90 degrees to the picture plane converge while lines parallel to the picture plane remain parallel.

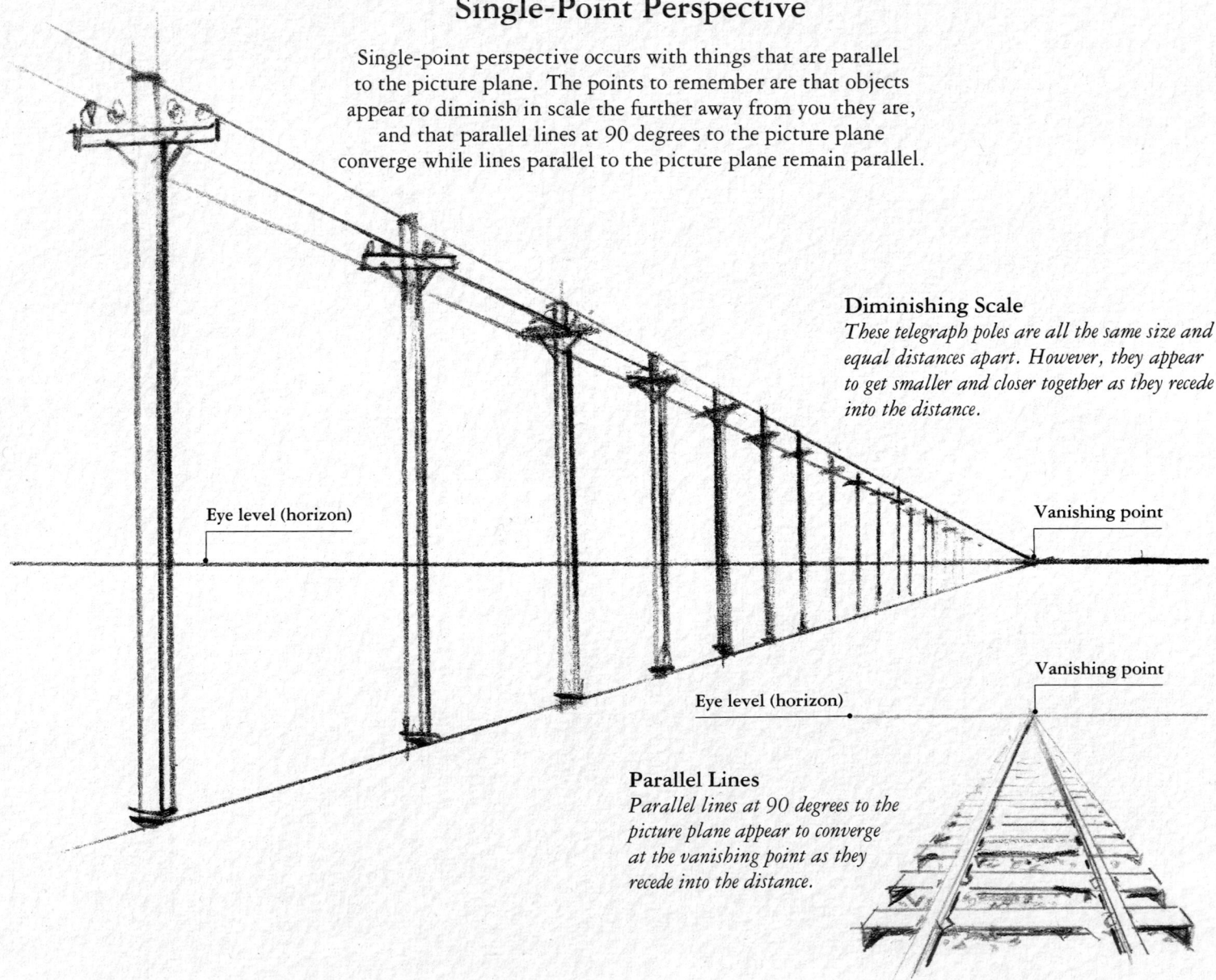

Eye level (horizon)

Vanishing point

Diminishing Scale
These telegraph poles are all the same size and equal distances apart. However, they appear to get smaller and closer together as they recede into the distance.

Eye level (horizon)

Vanishing point

Parallel Lines
Parallel lines at 90 degrees to the picture plane appear to converge at the vanishing point as they recede into the distance.

Drawing an Ellipse

If a circle is seen in perspective, it becomes an ellipse. One common mistake is to draw ellipses with pointed ends. The guidelines below will help you to avoid this error.

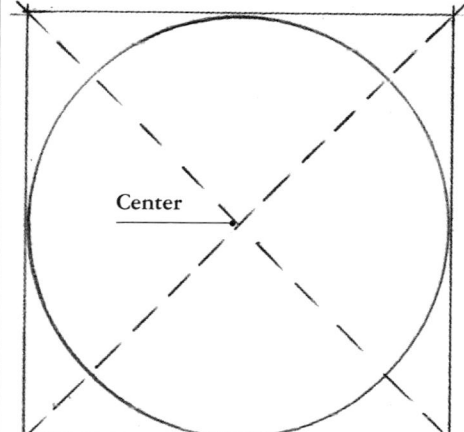

Center

A circle fits perfectly into a square, touching it at the halfway point along each side. Diagonal lines drawn from corner to corner will intersect at the center of both the square and the circle.

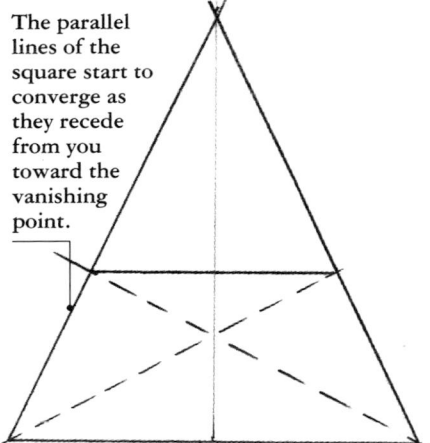

The parallel lines of the square start to converge as they recede from you toward the vanishing point.

Faintly sketch a square in perspective enclosing the area of the ellipse. Draw diagonal lines from corner to corner: they will intersect at the center of the square in perspective. The physical measurements of each half of the square will not be the same because the square appears to diminish in size as it recedes away from you.

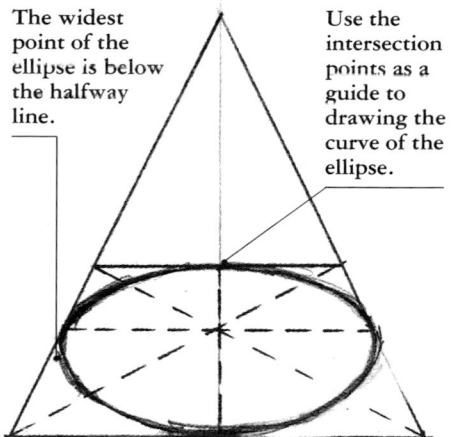

The widest point of the ellipse is below the halfway line.

Use the intersection points as a guide to drawing the curve of the ellipse.

Draw a horizontal and a vertical line through the center of the square in perspective to establish the halfway point along each side of the square in perspective. (The physical measurements of each half are not the same, because the square appears to diminish in size as it recedes away from you.) Draw the ellipse so that it touches these points.

Cylinders and Ellipses

The top and bottom of any cylinder are circular; when viewed in perspective they become ellipses. However, how flat or round the ellipse is depends on the angle from which you view it. If all this seems very theoretical, stop and think about how many objects are basically cylindrical in shape (see pp. 46–47).

Eye level (horizon)

A circle seen from directly overhead or head-on has no distortion.

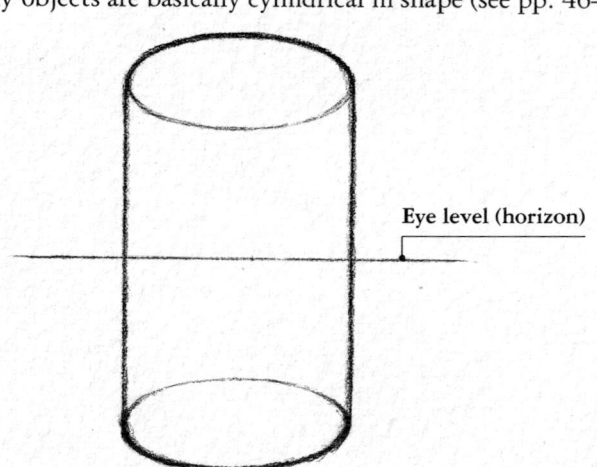

Eye level (horizon)

If your eye level is approximately halfway up a cylinder, the top and bottom of the cylinder will become quite shallow ellipses because they are so close to eye level.

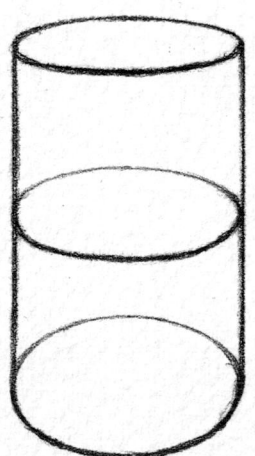

If your eye level is slightly above the top of the cylinder, the top is a comparatively shallow ellipse. As you work downward, the ellipses gradually become broader and more rounded.

Instead, use your eyes and keep the points already mentioned in mind when you look at your subject.

Once you've grasped these points, you're halfway there – but there are some simple technical rules you can follow in order to transfer what you see to the paper accurately. Start by drawing a line that represents your eye level, which is also the horizon line. Any horizontal line in your subject that is not seen head-on and does not coincide with the horizon will appear to be slanting. All parallel lines go to the same vanishing point. By establishing the vanishing point and extending any parallel lines in your subject so

that they converge at this point, you can make sure that any lines you draw slant at the correct angle.

Objects also look lighter in tone the farther away they are. This phenomenon is known as aerial perspective. It is perhaps most obvious in landscapes, where you tend to be dealing with much greater distances than in most drawing subjects. Think, for example, of a mountain range at dawn: the mountains nearest to you will be a dark shade of pink or purple, while those farthest away will be blue and gray in tone. Even if you are not using color in your work, the same principle of gradations in tone applies: always include a full range of tones, from black or dark gray, through the midgrays, to light gray or even white as you move from foreground to background.

In a very complex scene – houses on a hillside, for example, with all the buildings on different levels and facing in different directions – there is more to consider. You could spend hours plotting the angles and extending every line to its vanishing point. But it is a mistake to get so engrossed in technicalities that you forget to look at what you're drawing. Be aware of the potential difficulties and have a basic understanding of the concepts involved – but, most important, use your eyes.

Two-point Perspective

We very rarely view things head-on: in the real world, objects tend to be placed at a series of angles. If you can see two sides of an object, you must use two-point perspective. Each side is at a different angle to you and has its own vanishing point. Parallel lines, which converge at a vanishing point, will slant at different angles on each side. If you establish each side's vanishing point and extend all parallel lines until they reach them, you will get the angle of the lines right.

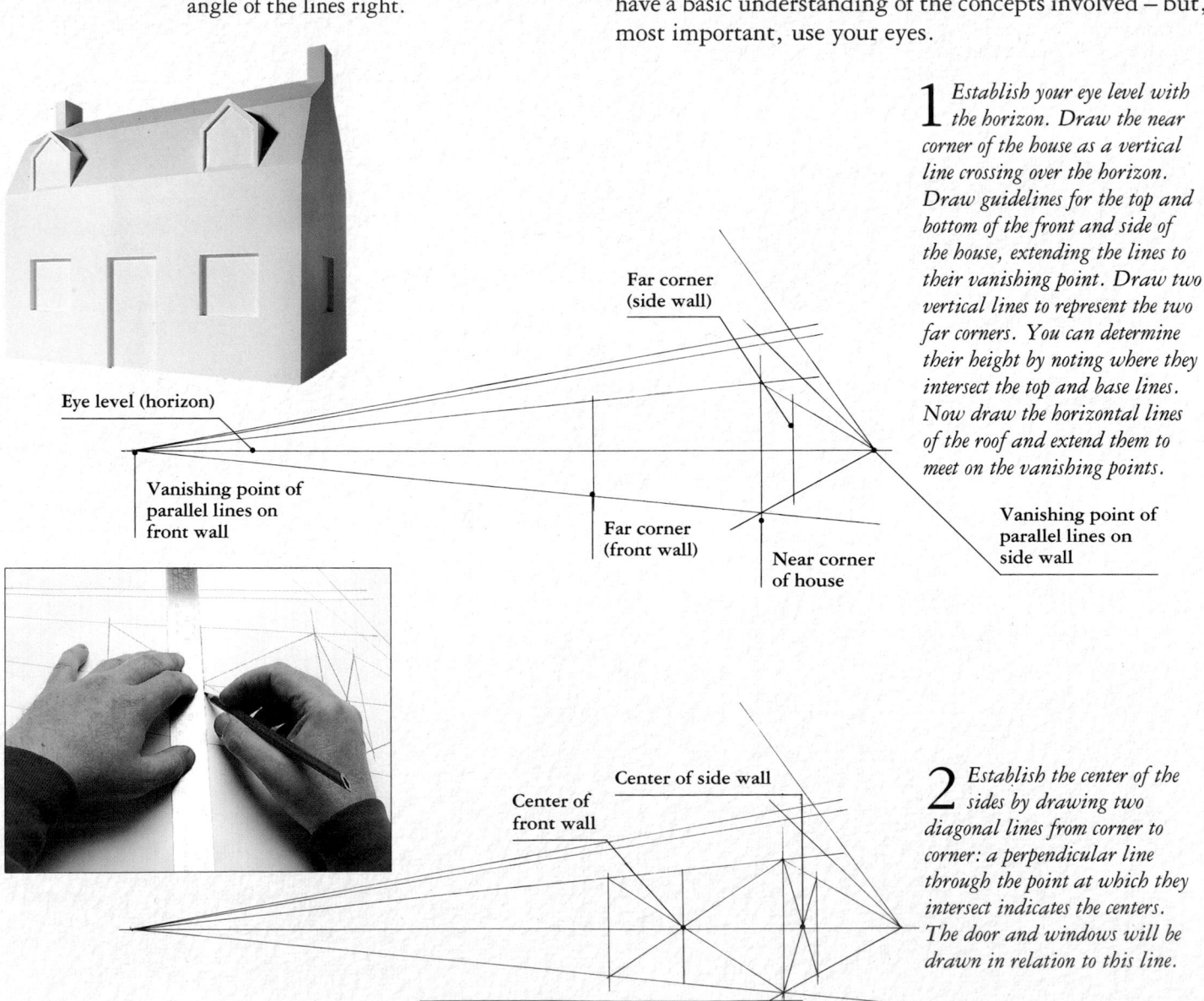

Far corner
(side wall)

Eye level (horizon)

Vanishing point of
parallel lines on
front wall

Far corner
(front wall)

Near corner
of house

Vanishing point of
parallel lines on
side wall

1 *Establish your eye level with the horizon. Draw the near corner of the house as a vertical line crossing over the horizon. Draw guidelines for the top and bottom of the front and side of the house, extending the lines to their vanishing point. Draw two vertical lines to represent the two far corners. You can determine their height by noting where they intersect the top and base lines. Now draw the horizontal lines of the roof and extend them to meet on the vanishing points.*

Center of side wall

Center of
front wall

2 *Establish the center of the sides by drawing two diagonal lines from corner to corner: a perpendicular line through the point at which they intersect indicates the centers. The door and windows will be drawn in relation to this line.*

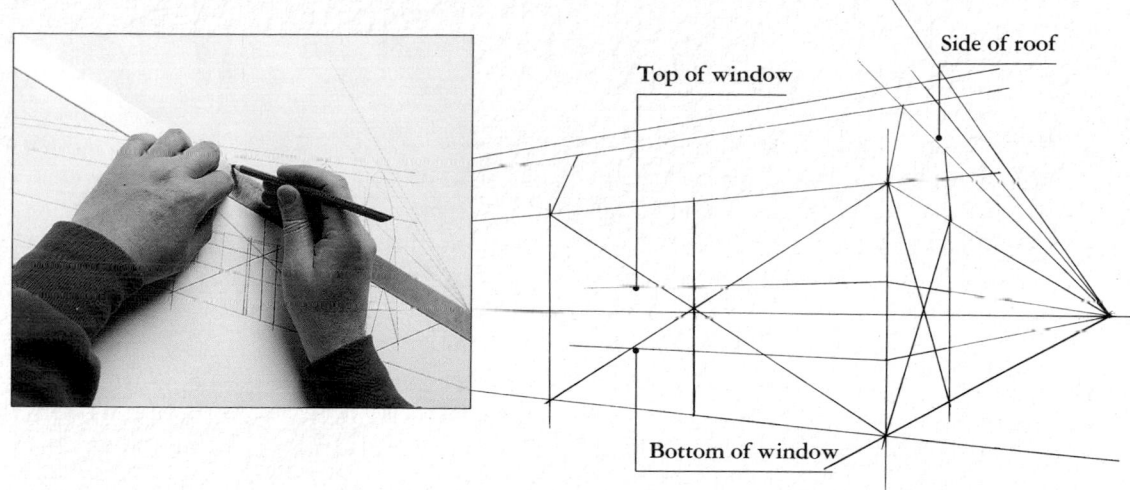

3 Draw lines above and below the horizon line to indicate the top and bottom of the windows. (Do this by sight rather than by measuring.) They are parallel to the front of the house, so the lines go to the same vanishing point. Estimate the diagonals forming the roof's sides, and draw in the lines using the vanishing points.

Side of roof

Top of window

Bottom of window

4 Sketch in the position of the door and windows, using the lines of the roof and horizon as a guide. Because of diminishing scale (see p.40), the two windows look different sizes.

The Finished Drawing

In reality, the front of the house is a true rectangle. When seen in perspective, however, the corner farthest away from the viewer looks smaller than the near corner. By using the vanishing point, you can make sure that the line linking the top corners slants at the right angle. Establishing the center line of the facade makes it easy to position features such as the door, which is centered on this central line.

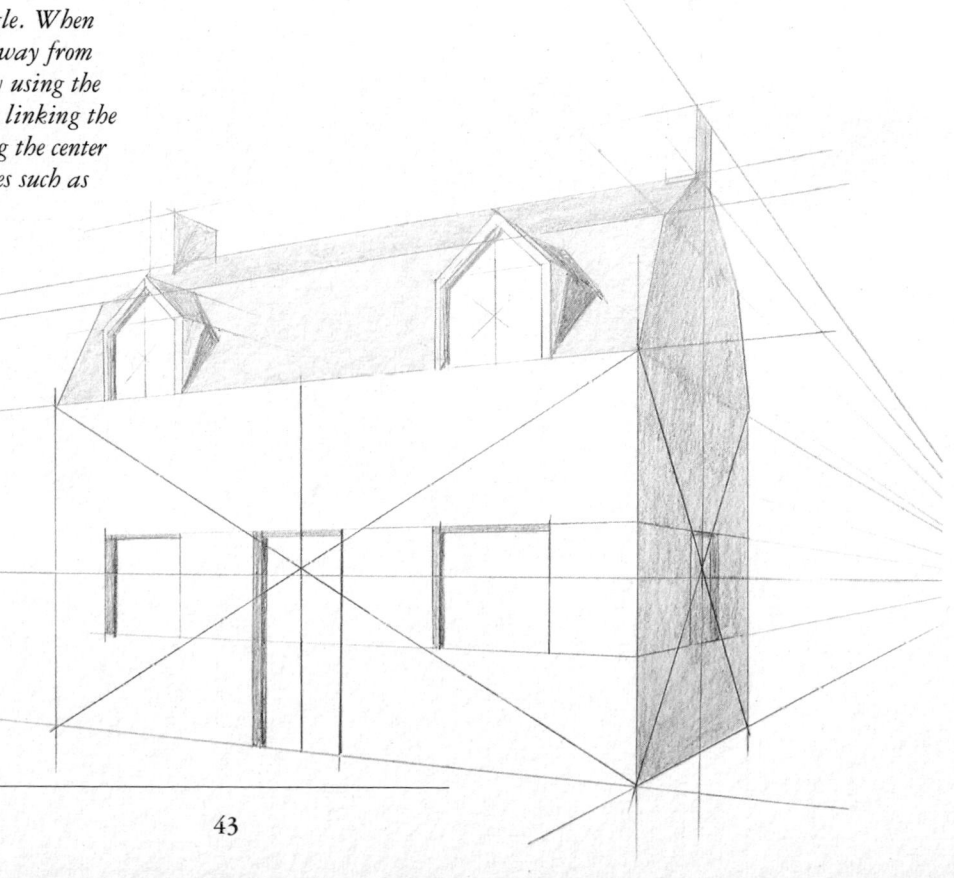

Shading Techniques

SHADING IS USED TO MAKE THE OBJECTS you draw look three-dimensional. There are many ways of shading – almost as many as there are artists – yet certain systems have become established as the most appropriate for particular needs. The simplest method is to vary the amount of pressure you exert on the pencil or charcoal, so that the lines show up as different tones of gray. Using different grades of pencil will also increase the range of tones you can create (see pp. 14–15). You can soften charcoal lines into shading simply by smudging the charcoal with your finger; this is suitable for relatively large areas, where you don't necessarily need crisply defined areas of tone.

Classical shading is a technique developed by the great artists of the Renaissance in 15th- to 16th-century Italy – Michelangelo and Leonardo da Vinci, among others. It involves drawing a series of parallel lines at an angle of about 45 degrees over the area you want to shade. The closer together the lines are, the denser the shading will be. You can vary the density within the same drawing.

Cross-hatching involves drawing lines in a criss-cross pattern. The usual way to do this is to draw one series of parallel lines at 45 degrees, as for classical shading, and then superimpose another series of lines running at right angles to the first. You can also get some interesting effects by varying the angle at which the lines cross or even by having short, curved lines cross each other.

Both chalk and Conté crayons are good for shading. The point of the chalk or crayon can be used for coarse linear shading. For shading broad areas, use the edge.

When shading with an ink wash, decide how dark you want the wash to be before diluting the ink. If the wash looks lighter than needed when it has dried, repeat the process by laying a second wash over the first, either using the same dilution or darkening it as necessary.

It is perfectly feasible to combine different media and methods of shading on the same picture. Your personal preferences will quickly emerge as you experiment with different ideas and techniques.

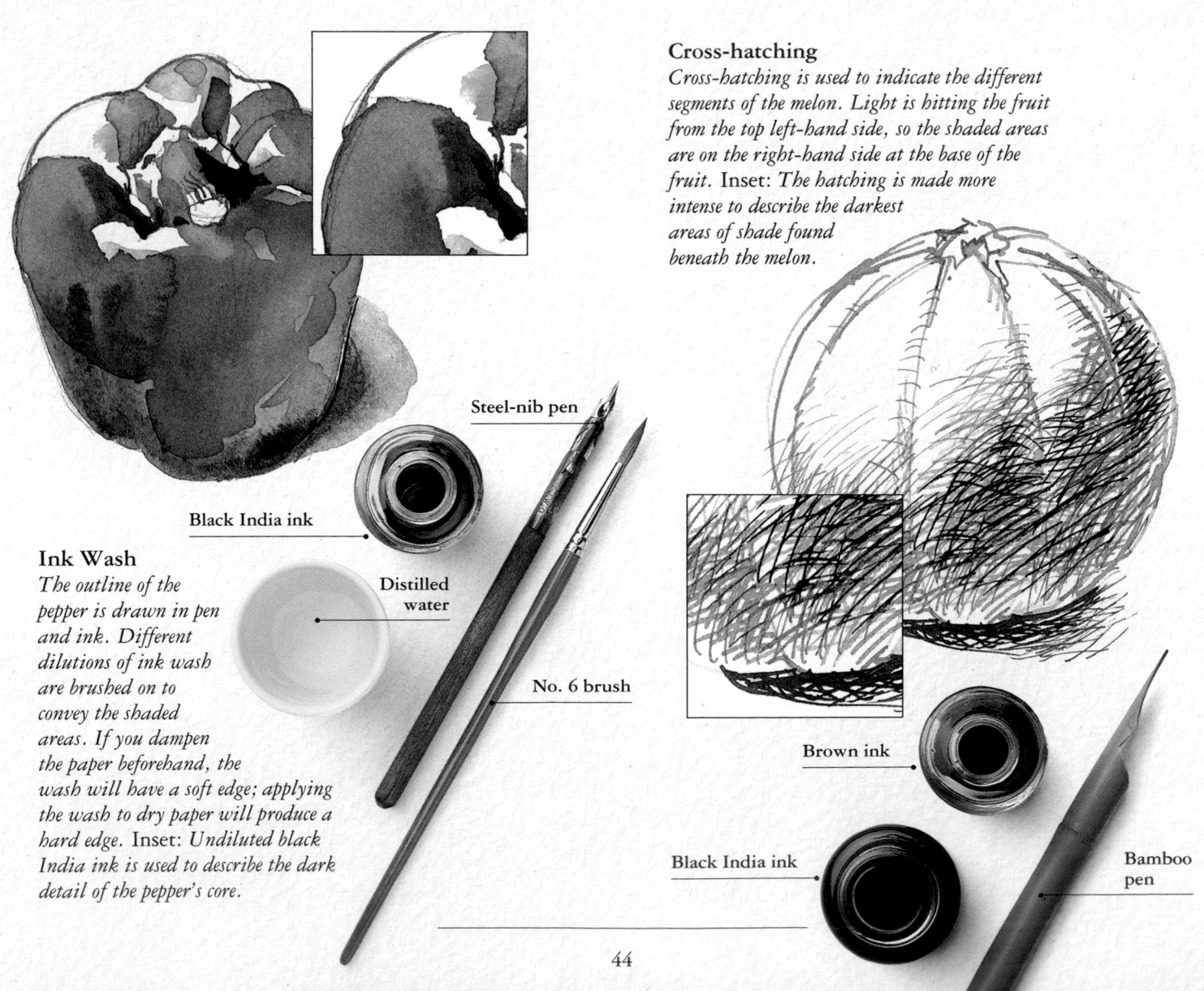

Cross-hatching
Cross-hatching is used to indicate the different segments of the melon. Light is hitting the fruit from the top left-hand side, so the shaded areas are on the right-hand side at the base of the fruit. Inset: The hatching is made more intense to describe the darkest areas of shade found beneath the melon.

Steel-nib pen

Black India ink

Ink Wash
The outline of the pepper is drawn in pen and ink. Different dilutions of ink wash are brushed on to convey the shaded areas. If you dampen the paper beforehand, the wash will have a soft edge; applying the wash to dry paper will produce a hard edge. Inset: Undiluted black India ink is used to describe the dark detail of the pepper's core.

Distilled water

No. 6 brush

Brown ink

Black India ink

Bamboo pen

Hatching

Here, the hatching lines are curved to echo the curves of the pepper. Note that only half of each segment on the darker side of the pepper is shaded. This helps to show that the pepper is not a pure cylinder or sphere, but a rather uneven form with clearly differentiated segments. Inset: The pencil strokes follow the vertical curve of the individual pepper segments as they go down to join the core.

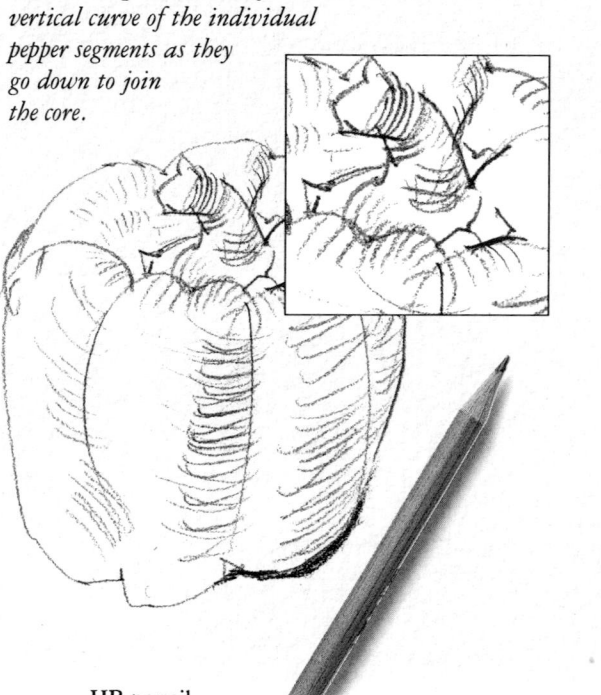

HB pencil

Soft Pencil

With a gently handled 4B pencil, the direction, tone, and shape of the pencil strokes can become almost imperceptible. Light is striking the pear from above and from the left, so the darkest tone is underneath the fruit. Inset: Heavy pressure produces a rich, dark tone for the core of the pear.

4B pencil

Watercolor Pencil Wash

Watercolor pencil can produce both well-defined lines and a continuous tone. Here, the lines are blended with a brush and clean water. Inset: The combination of a solid outline and continuous tone demonstrates the medium's versatility.

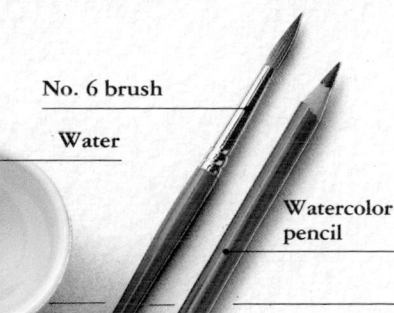

No. 6 brush

Water

Watercolor pencil

Classical Shading

The pear is shaded with a red Conté pencil using the classical shading technique. The lines are finer and closer together in the center. Inset: Varying intensities of tone are used to describe the way the light hits the pear.

Red Conté pencil

Simple Geometric Shapes

ONE OF THE FUNDAMENTALS of drawing is making objects appear solid; objects must appear to be three-dimensional, and yet you must achieve this on a two-dimensional surface.

A good way to learn how to do this is to practice drawing basic geometric shapes. Often you will find that you can recognize these basic shapes in more complex objects. When you have mastered the basic concept, you will be able to move on to more complicated shapes and objects. The trunk of a tree, for example, is similar to a basic cylinder, a sphere to apples and oranges, a cone to several natural forms, and the cube to a whole range of objects, from buildings to a slab of cheese.

HB pencil

Plastic eraser

The trick is to understand and interpret how light falls. This can enable you to produce drawings that deceive the eye into believing that what is shown occupies a three-dimensional space.

If the light is coming from above and from the right, then the top and right-hand side of the object will be brightly lit, and the side opposite the light source will be in shadow. Sometimes light from the main source carries beyond the object, glances off other things, and bounces back, leaving a lighter strip against the edge on the darker side of the object. This is known as reflected light. The strength and intensity of the shadow areas are important in making a form stand out on the paper. A useful trick is to look at the subject with your eyes half closed; this makes the tones more distinct.

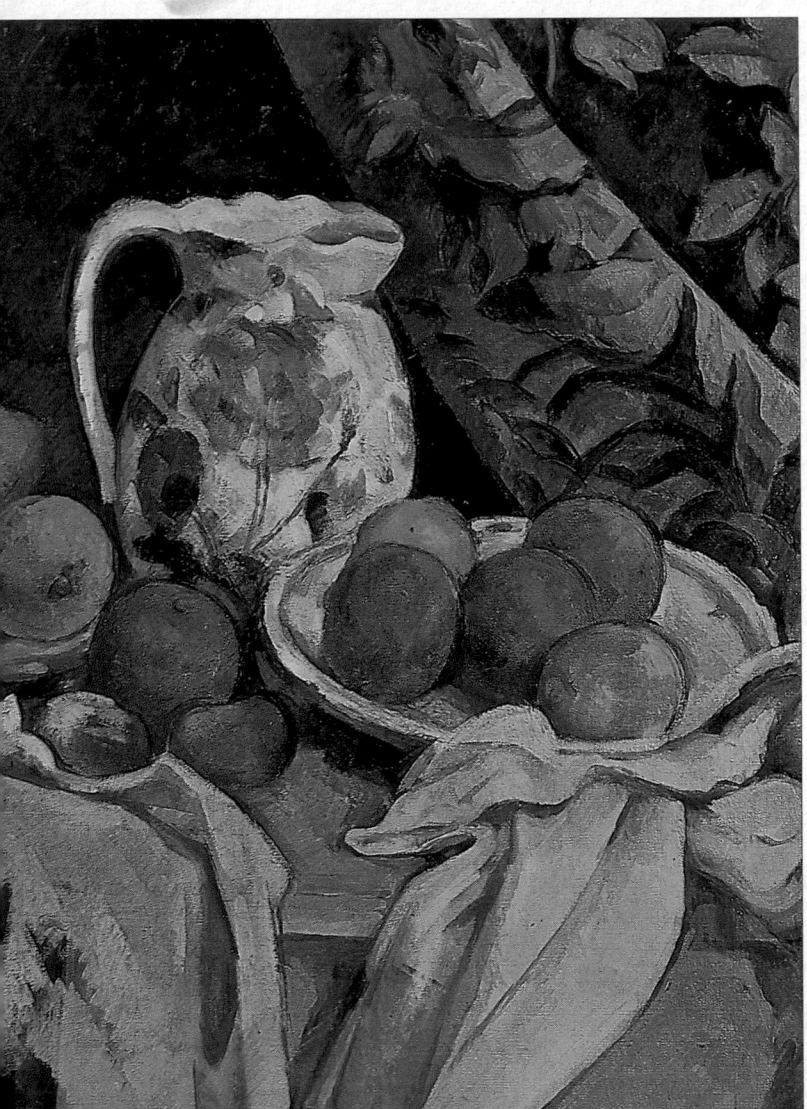

"Still Life with Apples and a Jug," Paul Cézanne
Each fruit is reduced to its simplest geometric equivalent – in this case, the sphere. The result is a magnificent painting from everyday household items.

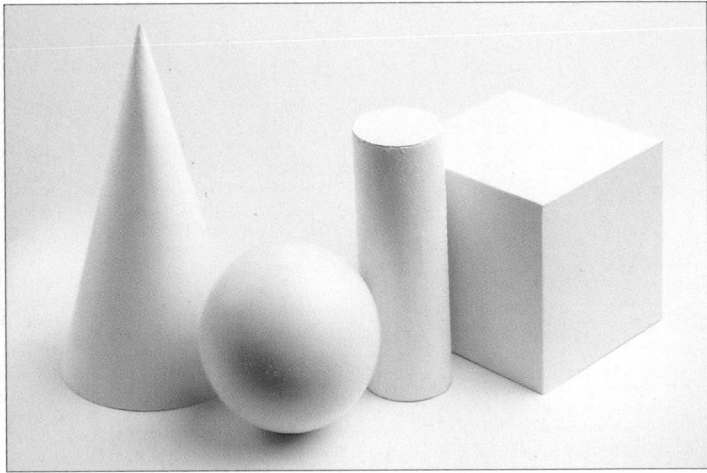

Light and Shade
The light source is from the upper right-hand side. Note how the upper, or top, surfaces of the forms take the light. The darkest areas are on the side opposite the light source.

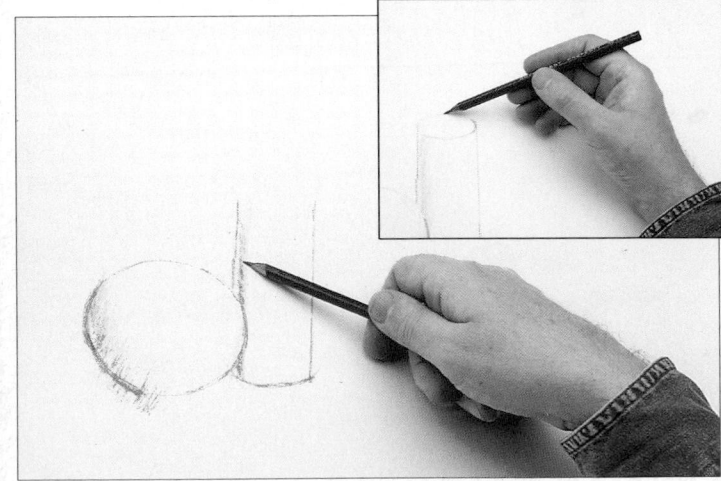

1 Inset: *Hold the pencil balanced lightly between thumb and forefinger halfway along the shaft.* Above: *Begin to place the objects in position on the paper, starting with the foremost element. Be sure to allow enough space for each element to fit on the paper.*

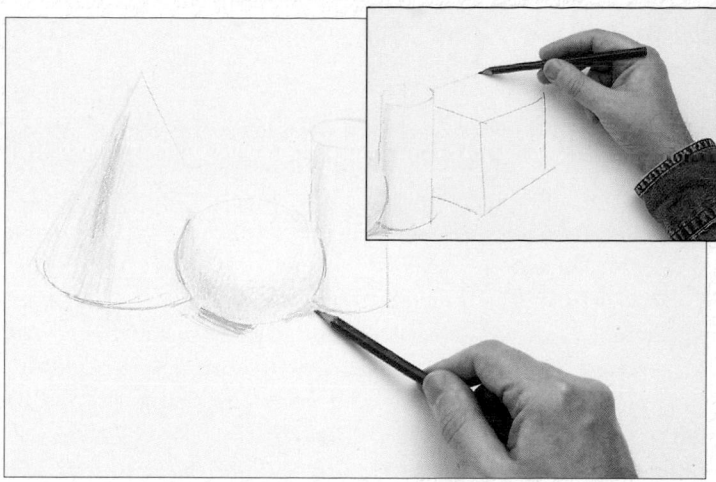

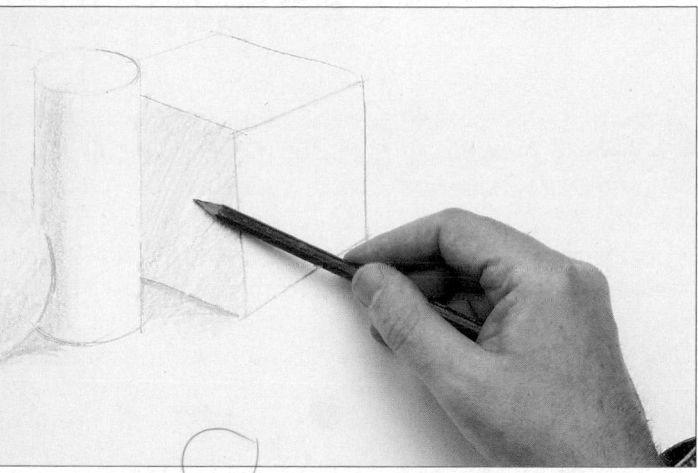

2 Inset: *After placing the sphere satisfactorily, sketch in the other objects. Below: Sketch in the lower line of the group of shapes, thinking of it as a silhouette. This method of looking along the top, bottom, and sides of a group of objects is a valuable aid to accuracy.*

3 *Use pencil shading to describe the tones of the cube and some of the shadows. Remember: tone is a means of giving solids a three-dimensional effect, while shadow is the result of the object obstructing the light source.*

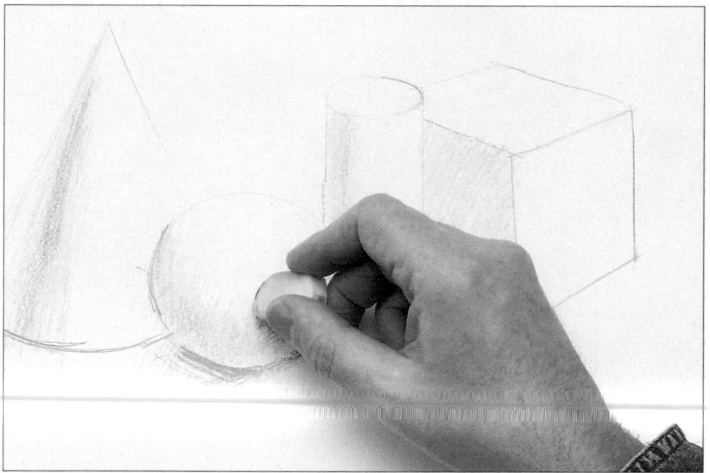

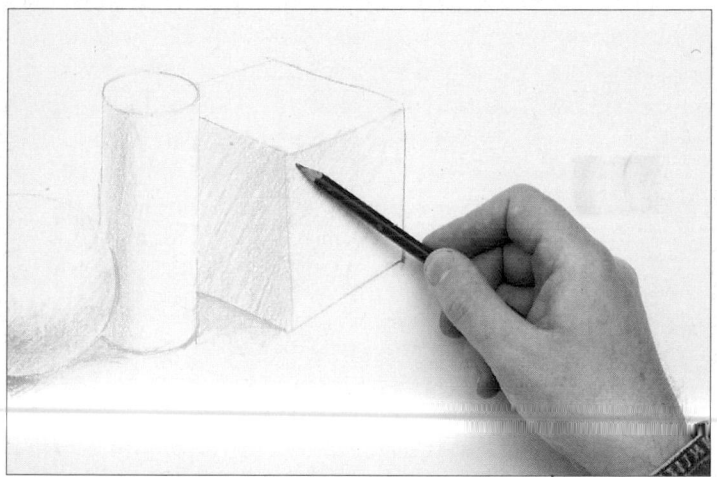

4 *Carefully stroke an eraser across the pencil shading to lighten it and soften the tones. This technique is particularly useful when drawing rounded forms.*

5 *Most light strikes the horizontal areas, with the darkest tones on the opposite side. Middle tones, too, are important. The vertical side of the cube is given a light overall tone to complete the three-dimensional rendering.*

The Finished Drawing
The four basic forms are seen as individual shapes, but they also relate to each other as a group. The light, tone, and shadows combine to create an illusion of solidity. The line along the top — from the point of the cone across the sharp angles of the cube via the roundness of the sphere and cylinder — holds the group together.

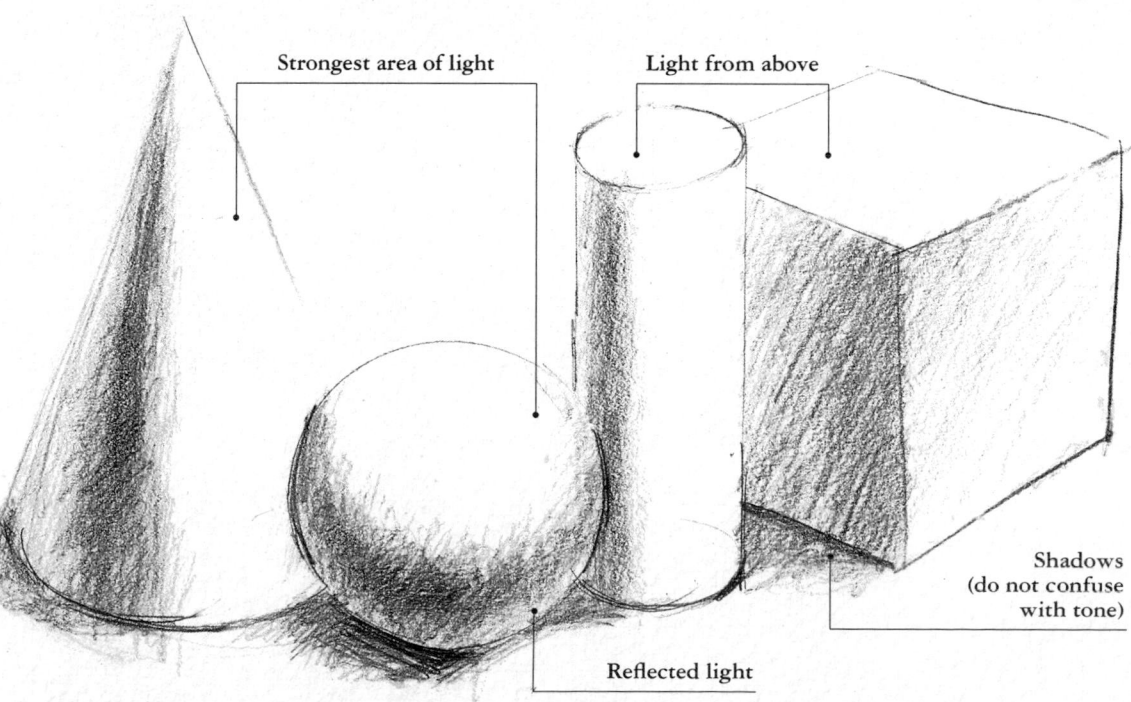

Strongest area of light

Light from above

Shadows (do not confuse with tone)

Reflected light

Contour Drawing

CONTOUR DRAWING — depicting objects using lines but no shading — is one of the most sophisticated and rewarding of drawing techniques. A contour drawing differs from an outline, which is simply a flat, two-dimensional depiction of the subject's silhouette. A contour drawing conveys a three-dimensional feeling, and it often includes lines that go across and around the object to help represent it. The lines of a contour drawing can be compared to the contour lines of a map, measuring the rise and fall of hills and valleys and representing the shape of the landscape. Remember that the lines you are drawing represent the various "edges" — internal and external — of your subject. While you are drawing, you should feel as if you are touching these edges, running your fingers over them to trace their angles and curves.

The secret of successful contour pictures lies in the "looking" rather than the actual drawing. This technique is an excellent way of training your hand to interpret what your eyes see. You will find that the "Training the Eye" exercises (see pp. 32–33) are invaluable when it comes to contour drawing, as they get you into the habit of looking intensely at your subject and its shape as you draw.

The way to give your contour drawing a three-dimensional feeling is to vary the quality and thickness of the lines. The pencil is an extremely useful drawing tool, allowing you to increase the range of marks simply by varying the amount of pressure you exert. By using different pencils — soft (B to 10B), midtone (HB), hard (H to 6H), and very hard (7H to 10H) — you can expand this range

HB pencil

H pencil

2B pencil

4B pencil

of marks still further to create drawings of great richness, conveying not only the three-dimensional form of the object but also suggesting color. Each grade of pencil carries its own "color" — from gray to black, with countless shades in between.

A slight difference in your viewpoint can make a bigger difference than you might expect to the contour line. An interesting exercize is to work slowly around your subject. Complete one contour drawing, move perhaps 1 foot (30 cm) to the left or right, and draw the contour again on the same piece of paper. The resulting drawing is something like a sectional representation of your subject.

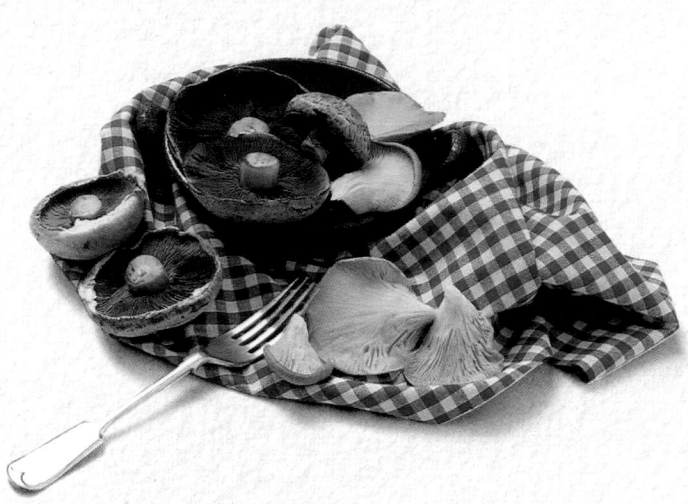

The Composition
This seemingly simple still-life group consists of several different objects. The main feature is a group of mushrooms. The soft roundness of the mushrooms contrasts aesthetically with the hard, shiny cooking pot in which some have been placed. In turn, the pot is set off against the soft folds of the checked cloth.

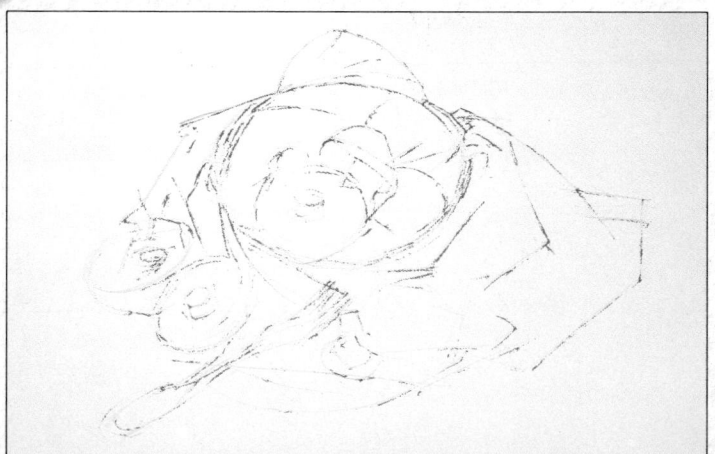

1 *To start the drawing, hold an H pencil loosely, so that you can make broad, sweeping lines of the main contours. Be sure to include the connecting lines of the cloth, the ellipse of the dish, and the individual mushrooms.*

2 *Start to introduce detail. Use a 4B pencil to create a rich, dark line that contrasts well with the fine, light line of the H pencil. To draw the inside of the mushroom caps use the 4B pencil on its side, making sure the lines describing the gills run in the right direction.*

3 *The shape of the fork demands careful examination. Use an HB pencil for the light side of the fork and a 4B pencil for the shadows on the fork. Alternate between the two pencils to give it a three-dimensional feeling.*

4 *Use a 2B pencil to draw the finely detailed texture within the mushroom caps. One advantage of using a variety of pencil grades is that you can vary the thickness and darkness of line without having to apply different amounts of pressure to the pencil.*

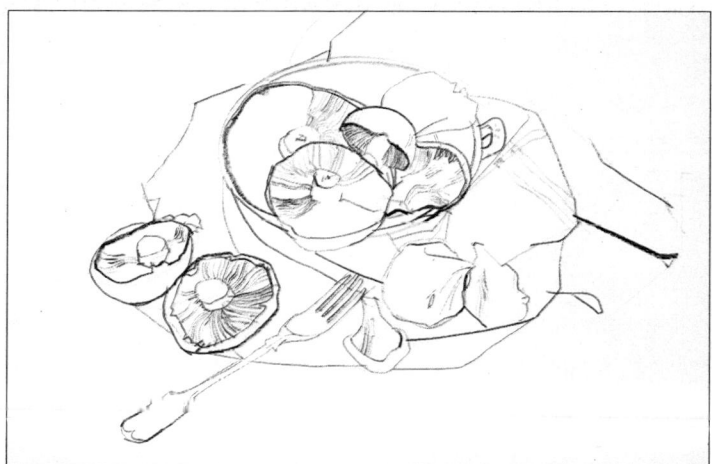

5 *By making use of many pencils, you can create a complex, rich texture of lines, adding depth and interest. The shadow lines define items so that they stand out from the background, while the finer marks on the well lit mushrooms and the cloth create a three-dimensional effect and an interesting texture.*

6 *Use an HB pencil for the fine line segment of the middle mushroom and an H pencil for the pattern on the cloth. Give only minimal detail to the cloth so as not to distract from the dish and mushrooms.*

The Finished Drawing
The finished work demonstrates the qualities that can be achieved by drawing in line. The lines — some short and strong, some fine and long — combine to entertain the eye and describe the scene. Within the lines that define the edges of the various objects, other lines have been used to draw the details. Rich, dark grays contrast with the lighter grays made with the harder pencils. Each detail is used to maintain the three-dimensional illusion as well as to suggest the different textures and tones.

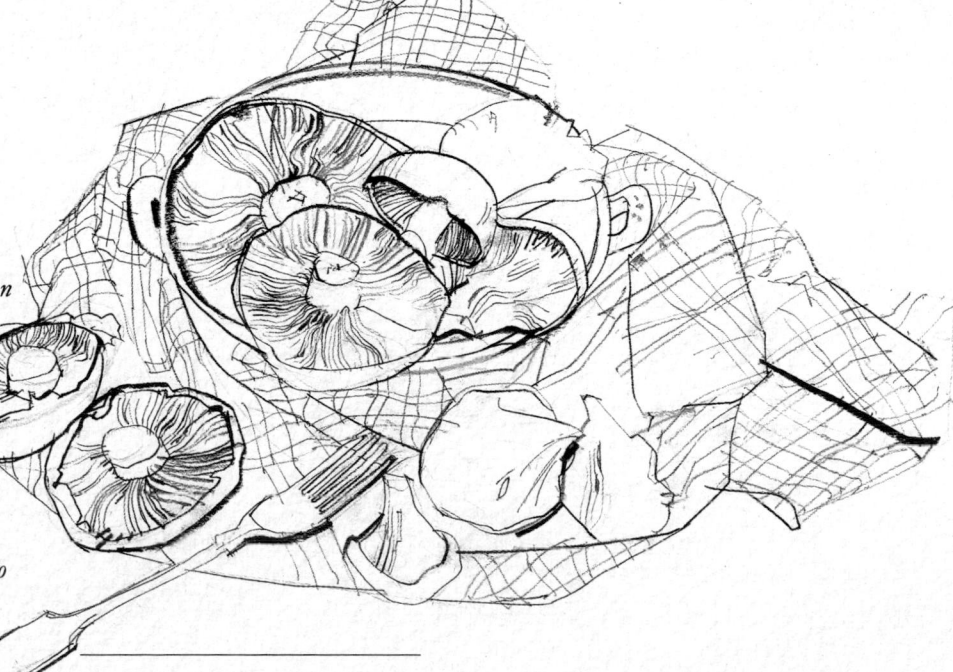

Drawing with an Eraser

IN THIS TECHNIQUE the eraser is used in exactly the same way as a pencil or any other drawing tool – the difference is that marks are removed rather than added. You are looking for areas that need to be highlighted, rather than areas that need to be shaded, and wiping out dark tones to arrive at a lighter tone or a pure white.

You can use this technique with pencil, charcoal, and graphite powder – in fact, with any drawing tool whose marks can be removed with an eraser. However, it is difficult to remove very hard pencil marks (7H to 10H). Pastel or chalk marks cannot be removed with an eraser, as they smudge too easily. With watercolor pencil marks, you may manage to remove a little of the mark, but you will not be able to remove it all. The eraser technique works best on smooth paper: on very coarse paper the pencil lead tends to work itself into the pitted surface and it is very difficult to remove the pencil marks evenly.

There are two types of eraser – the kneaded and the plastic variety. Kneaded erasers are very soft and pliable, and can be formed into different shapes, such as points, allowing you to make subtle changes when using them. It is also much easier to control how much of the pencil or charcoal mark you remove. Plastic erasers are much harder. They are generally used to clean up marks around the edges of a drawing and to give the drawing a crisp outline.

As with shading techniques (see pp. 44–45), try to vary the way you use erasers. If you always rub the eraser in the same direction, your drawing may look static and flat. Try altering the angle at which you hold the eraser, or wiping it across the paper in lines that run at right angles to each other – this is very effective when drawing dappled light.

Drawing with an eraser is most appropriate with subjects that have a high degree of contrast between light and dark areas – dramatically lit interiors and still-life setups, for example. It is also particularly useful on renderings of metallic objects, where you may want to imply extremely bright highlights.

Of course, you can add highlights by using, for example, white gouache or Conté crayons, but often such highlights look too obvious, as if they had been put in as an afterthought. The advantage of using an eraser is that the highlights are integrated into the picture from the very beginning – and you can repeat the process of putting in and removing tone until you are satisfied with the result.

HB pencil

Plastic eraser

Graphite powder

Graphite pencil

Kneaded eraser

The Arrangement
This arrangement has just enough contrasts to create interest. The long vertical handle of the skillet contrasts with the horizontal metal bar. The colanders are tilted slightly, creating interesting angles and giving an impression of depth in contrast to the flat base of the skillet.

1 *Using an HB pencil, lightly outline the shapes. Make sure that the spaces between the elements are accurate as these contribute to the overall balance of the picture. Take care to draw the angles of the hooks and the ellipses of the colanders accurately (see p. 41).*

2 *Lightly shade the bases of the colanders to consolidate the forms. Using your fingertips, carefully rub graphite powder over the dark base of the skillet. Do not try to make the tone uniform over the whole area – you can build up more tone where necessary later on. Blow or shake off any excess powder.*

3 Rub graphite powder into the darker sides and shadows of the two colanders. Use a graphite pencil to strengthen the handle of the skillet, the hooks, the ellipses of the colanders, and the horizontal metal bar.

4 Use a graphite pencil to put in the holes in the various handles and in the colanders. Draw in the white highlights by removing graphite powder with a kneaded eraser, taking care to vary the direction of the eraser and thus avoid a rigid look to your drawing.

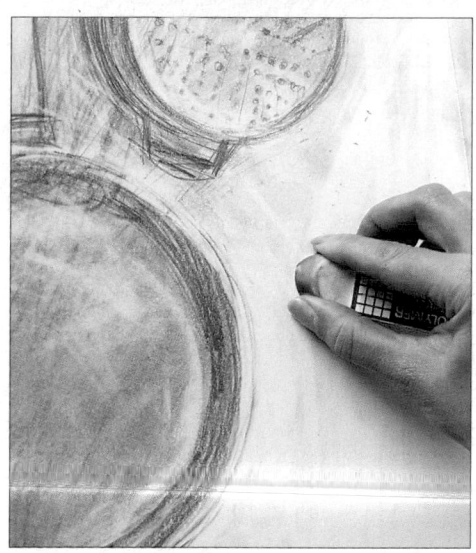

5 Use a plastic eraser to clean up the edges of the implements and the wall in the background. A plastic eraser is harder than a kneaded eraser and therefore removes marks more cleanly.

The Finished Drawing

Rather than being a mechanical reproduction of the items, the finished drawing is an interesting and lively composition. The bright highlights produced by wiping away graphite powder and leaving some areas of the paper blank perfectly convey the harsh metallic nature of the objects. The erasers have been used in the same way as a pencil can be used for "random" shading (see pp. 44–45): the lines run in different directions, enlivening the drawing and hinting at the constantly changing play of light and shade.

Using Light

THE ART OF DRAWING is all about seeing — and you cannot see anything without light. Beyond that, light can help you clarify and define objects in your drawings. Learning how to exploit light in your work is essential. You can use the shadows cast by light, for example, to create a three-dimensional effect.

The first thing to remember is that unlike artificial illumination, natural light (light from the sun) is not constant. The quality of this light depends partly on the weather. On a gray, cloudy day, for instance, things tend to look dark and somber, and somehow flatter; on a bright, sunny day in mid-summer, colors seem more intense and everything looks crisper and more sharply defined.

The quality of natural light also depends on the time of day. Colors change as the day progresses. Think, for example, of snow-covered mountains — dazzlingly white under midday sunshine, glowing pink with the setting sun. You need to think about the color of light even if you are drawing in black ink or pencil: tones vary depending on the time of day. More important for the artist, the angle of the light changes as the sun arcs through the sky. At midday, with the sun directly overhead, shadows are short. In early morning or late afternoon, the sun is lower in the sky and casts long, oblique shadows. You will find that a picture drawn at midday and one drawn at dusk evoke very different moods. Make sketchbook notes (see pp. 26–27) about interesting lighting, specifying the time of day and the weather conditions in which it occurred, so that you learn to predict how light will affect your subject.

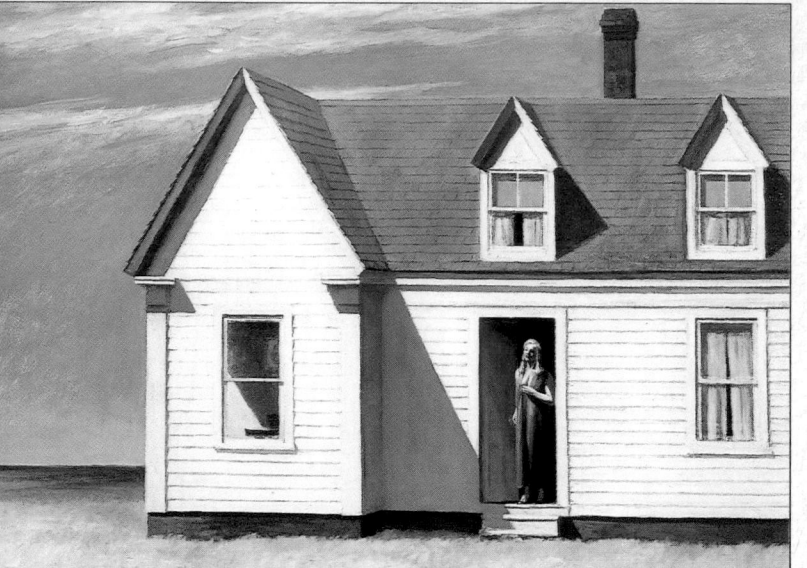

"High Noon," Edward Hopper
This painting of a simple clapboard building has a surreal quality, created by the unusual lighting. The shadows form powerful diagonal lines across the building. The strong light also makes the colors look particularly intense. The head-on view of a flat facade further increases the abstract, remote mood.

The Direction of Light

The direction of light (which, outdoors, depends on the time of day) profoundly affects the mood of your drawing. Consider this before you start to draw, and look for or set up lighting conditions that will give you the effect you want.

Side Lighting
If the light source is to the side of your subject, light grazes across the surface and picks up interesting textures and details. The mood is dramatic. Note the interesting shape of the shadow in this example.

Backlighting
Light coming from behind the subject produces a quiet mood. Far less detail is evident in the front facade of the house. The tone on the facade and the shadow cast by the building merge to produce a strong shape, which is an important part of the overall picture.

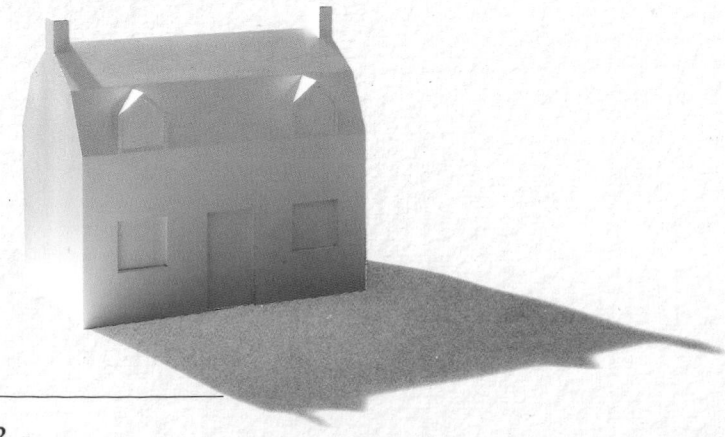

Times of Day

Morning Light

The light is coming from the top left side of the image, slightly behind the skyscraper. As a result, the skyscraper is thrown partly into silhouette. Features on the hillside and in the street below are clearly delineated, but nothing has so much detail that it distracts from the picture as a whole. The front facade of the foreground building is not illuminated and is therefore darker in tone than the rest of the picture. The light is soft and diffused, producing a calm mood that evokes the tranquillity of early morning.

Graphite powder

2B pencil

Kneaded eraser

Late Afternoon Light

The same scene is shown from the same viewpoint, but with the light coming from the right. The front facades of the foreground building and skyscraper are brightly lit, but as the light is striking them head-on rather than from the side, few details are visible. The three-dimensional feeling in the drawing comes instead from the contrast between the brightly lit facades and the shadowed sides – accentuated by the harsh light. The weather conditions are more dramatic, too: the dark sky merges with the shadows on the buildings, fusing the sky and buildings into a moody whole. The racing windblown clouds provide a dynamic contrast to the solid buildings.

Figure Construction

THE HUMAN BODY IS A BEAUTIFULLY organized piece of machinery, capable of a whole range of movement and action. To draw it well, you need some knowledge of how the body works. This does not mean that you need to study anatomy in extreme detail – it is sufficient just to become familiar with the basic proportions. By using a few simple structural devices, the interpretation of the figure – both nude and clothed – becomes far less formidable, and you can concentrate on making the likeness ring true.

The proportions and dimensions of the human form have been studied and analyzed by artists for over 2,500 years. According to Leonardo da Vinci in his *Treatise on Painting*, the artists of the Renaissance visited hospitals and morgues, risking illness and disease in their quest to discover the secrets of human anatomy. Underpinning all good figure interpretation is a sense of construction.

The manikin, traditionally made out of wood, is an invaluable aid to figure drawing. It will imitate all the poses and positions that the human body can assume. By adjusting the joints of the head, trunk, and extremities, you will quickly discover the body's full range of movement and balance. It is also useful for experimenting with foreshortening (see pp. 146–147) and the figure in action (see pp. 130–133). In former times, life-size manikins draped in costumes were used so that the sitters were spared the agony of extensive posing sessions; the painter would need only a limited number of sittings for the head and hands.

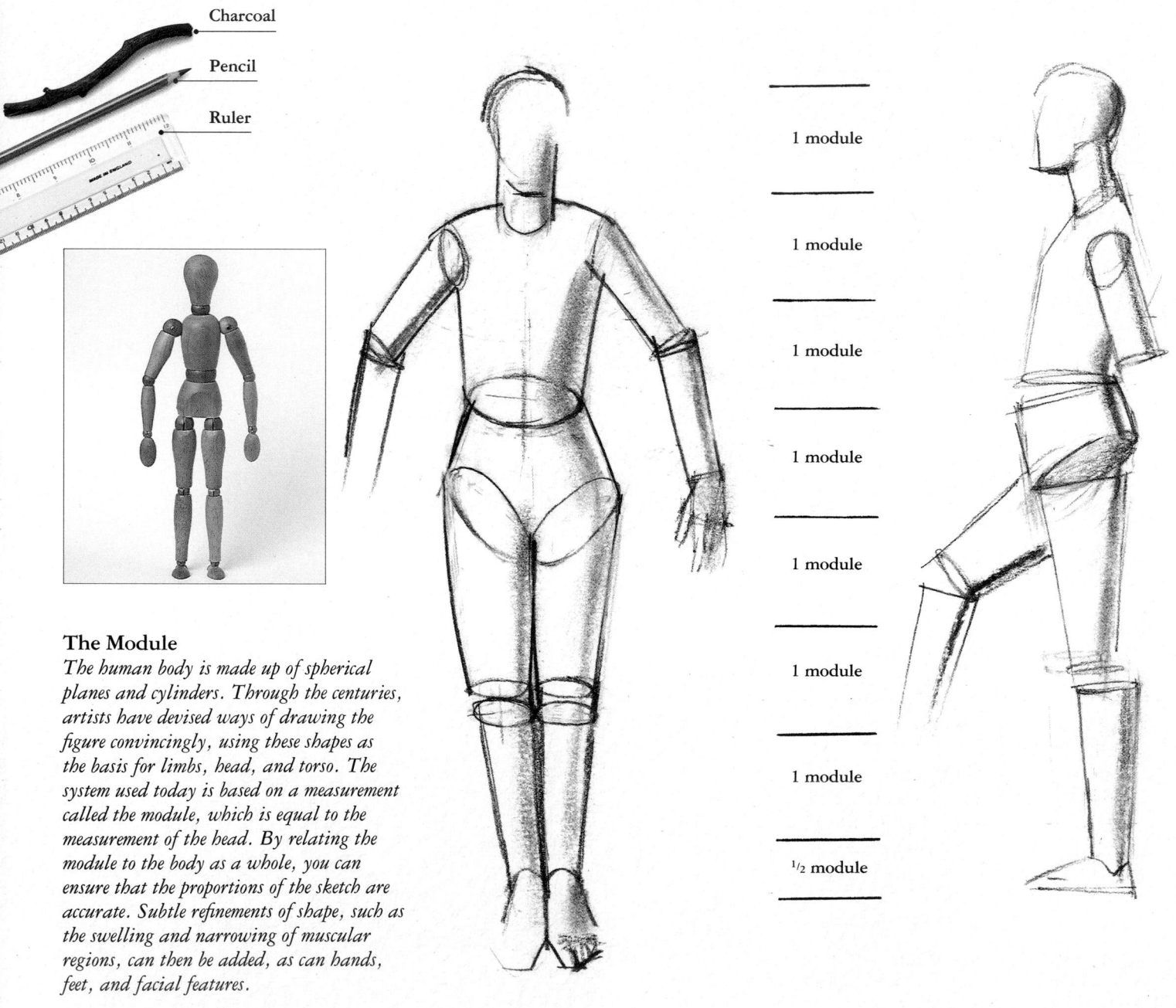

Charcoal

Pencil

Ruler

1 module

1 module

1 module

1 module

1 module

1 module

1 module

1 module

1/2 module

The Module
The human body is made up of spherical planes and cylinders. Through the centuries, artists have devised ways of drawing the figure convincingly, using these shapes as the basis for limbs, head, and torso. The system used today is based on a measurement called the module, which is equal to the measurement of the head. By relating the module to the body as a whole, you can ensure that the proportions of the sketch are accurate. Subtle refinements of shape, such as the swelling and narrowing of muscular regions, can then be added, as can hands, feet, and facial features.

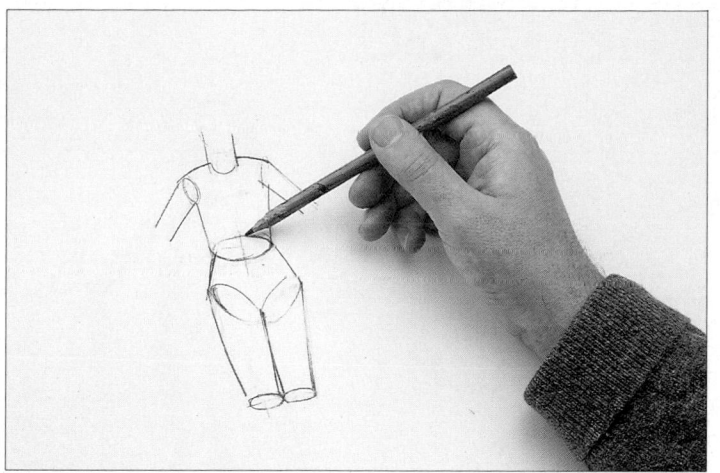

1 *Begin by planning the basic structure of the figure in cylindrical and spherical forms. Draw the torso as a slightly adjusted cylinder, tapering as it interlocks with the pelvic region. The pelvis is also cylindrical but the taper is reversed.*

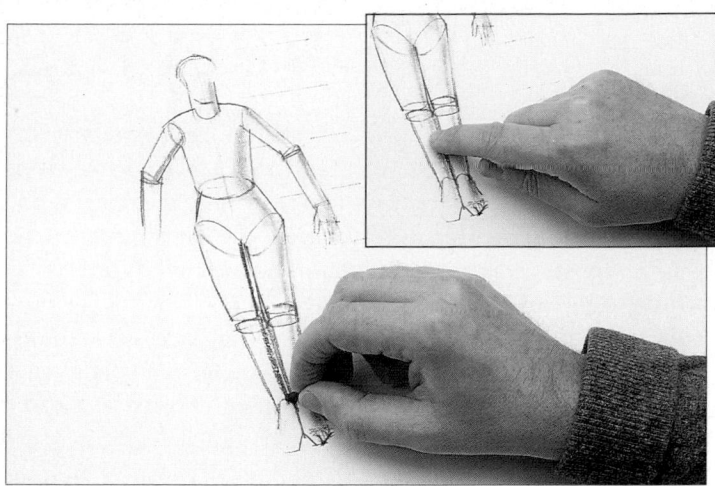

2 *Using bold lines, draw in the thighs, legs, and arms. Make sure everything is symmetrical and seen as a section. Check elliptical forms. Inset: To suggest a source of light (see pp. 52–53), add tone using charcoal and then soften the line with your finger.*

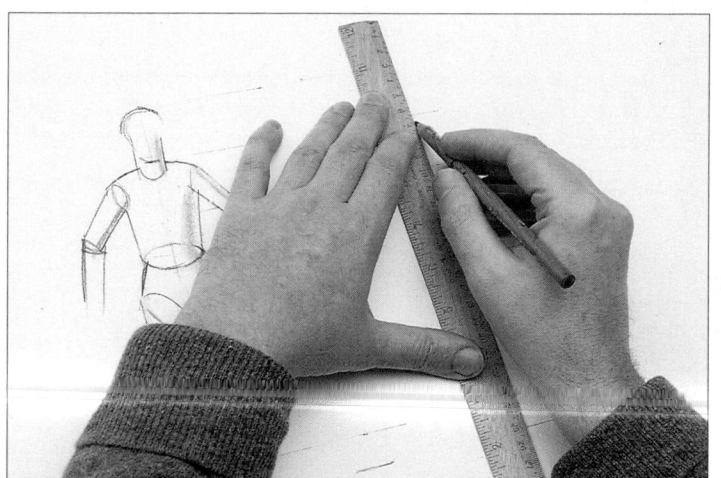

3 *Use a ruler to divide the figure into heads, or modules. Basic structural proportions vary little between men and women. The main difference is in children, where the length of the arm in relation to the leg and size of the head changes with the age of the child.*

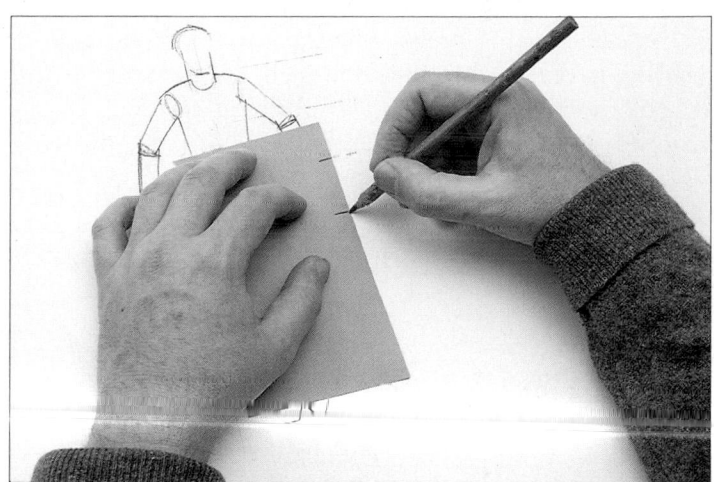

4 *Marks on a piece of paper can also be used to divide the figure into modules. Here, the proportions are being transferred to a profile view. Continue to observe the simple rules of structure and balance. Every part must relate to the rest to make up the overall figure.*

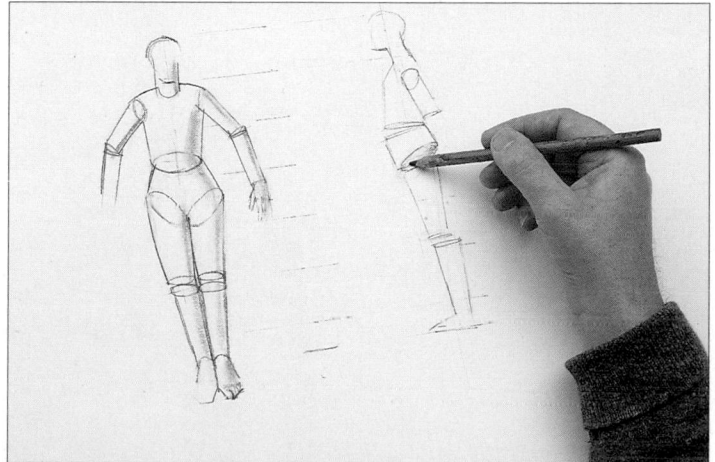

5 *This side view of the same figure uses exactly the same rules. Note where the modified cylinders meet — torso, hip area, thighs, and lower leg. The angle of the neck is particularly important: in order to support the weight of the head, it tips forward over the chest.*

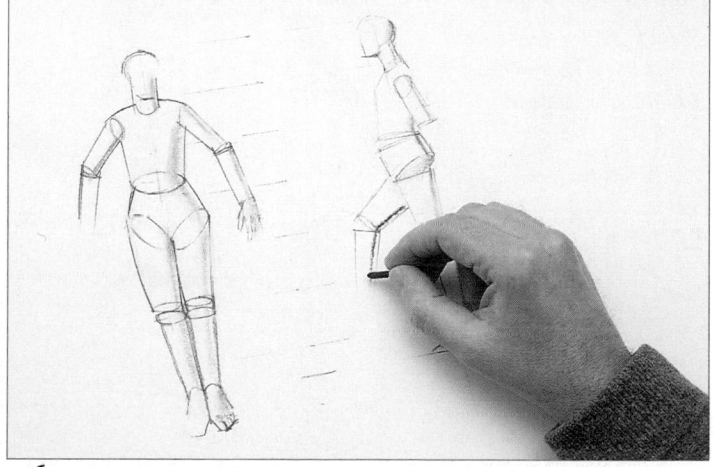

6 *Once your figure drawing is accurate, give it a three-dimensional illusion by adding shade with the charcoal pencil and rubbing the marks softly with your fingers.*

Varying the Pose

BALANCE AND THE RANGE OF LIMB movements are important in figure interpretation. Using a manikin, you can experiment and learn from experience. The manikin articulates at approximately the same places as the human form – waist, hips, shoulders, and neck – allowing a huge range of stances to be convincingly set up. Try putting the manikin in all kinds of poses and actions – standing, sitting, bending, kicking, and dancing. It is always worth overdoing the pose and bringing it back to a more realistically balanced one. This implies an energy and sense of precipitated movement that can be easily lost by making a simple copy of a stiffly conventional pose. The figures can also be useful when working out compositions where you will eventually be using a human model.

Always consider which tool to use carefully. Even though your subject remains basically the same – a wooden doll with movable limbs – various materials bring contrasting effects to the manikin. A chalk line drawing will echo softness, whereas the use of a hard pencil gives the manikin an almost robotic character.

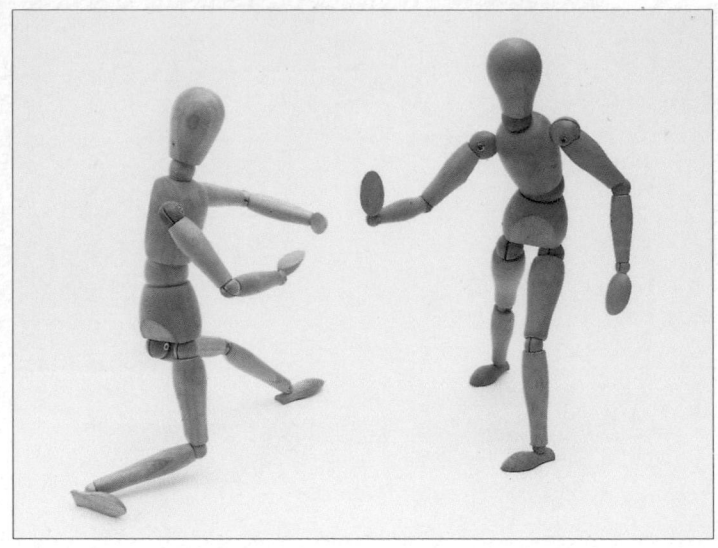

Arranging the manikins

Try to make the spaces between the figures interesting. Often the success of a pose depends on the negatives – that is, on the shapes of gaps between the main features.

Mixed Media

The figure on the near right was freely drawn in pen and ink. Tones and shadows are indicated with diluted ink. Connections are made using white gouache. The random shape of the gray figure on the far right lends energy to the drawing. Pen line, chalk strokes, diluted and solid touches of white gouache combine to describe the forms. Ink wash creates a mid-tone ground. Any corrections to the lines are incorporated into the overall image.

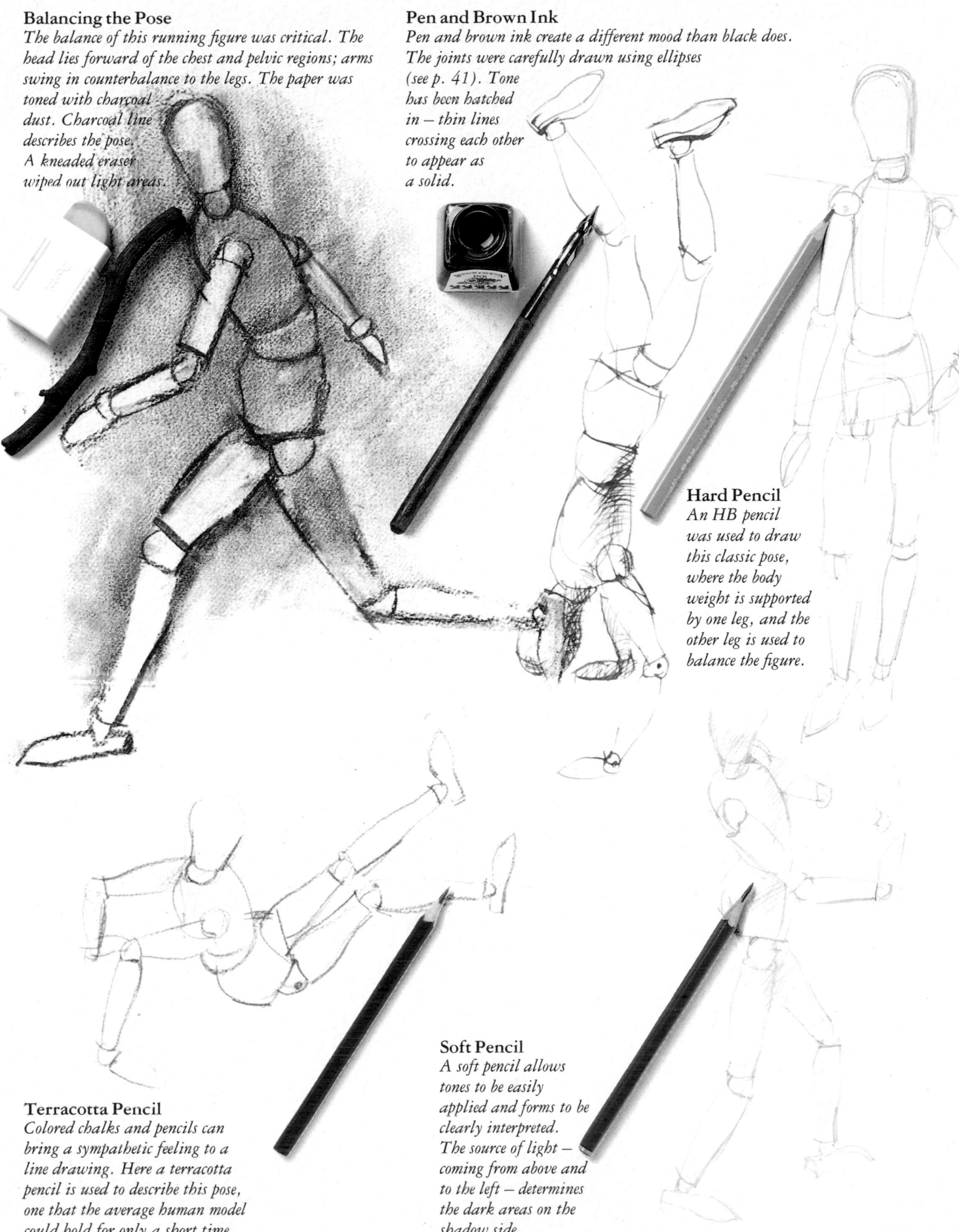

Balancing the Pose
The balance of this running figure was critical. The head lies forward of the chest and pelvic regions; arms swing in counterbalance to the legs. The paper was toned with charcoal dust. Charcoal line describes the pose. A kneaded eraser wiped out light areas.

Pen and Brown Ink
Pen and brown ink create a different mood than black does. The joints were carefully drawn using ellipses (see p. 41). Tone has been hatched in — thin lines crossing each other to appear as a solid.

Hard Pencil
An HB pencil was used to draw this classic pose, where the body weight is supported by one leg, and the other leg is used to balance the figure.

Terracotta Pencil
Colored chalks and pencils can bring a sympathetic feeling to a line drawing. Here a terracotta pencil is used to describe this pose, one that the average human model could hold for only a short time.

Soft Pencil
A soft pencil allows tones to be easily applied and forms to be clearly interpreted. The source of light — coming from above and to the left — determines the dark areas on the shadow side.

High and Low Viewpoints

MOST PEOPLE TEND TO LOOK straight ahead of them when drawing, viewing their subject head-on. But you can also look on your subject from above or below. Objects look very different depending on the level from which you view them. Prove this to yourself by carrying out the following experiment.

Place a half-full cup of coffee near the edge of a table, and stand over it, looking down on it. You will see the rim of the cup as a complete circle with a smaller circle (the coffee) inside it. The handle is a straight line going off to

one side, and the main bulk of the cup appears as shadowed shapes underneath the circles. Now crouch down so that your eye level is slightly above the rim of the cup. The rim of the cup becomes a shallow ellipse and none of the coffee is visible. The profile of the cup and its handle is clearly defined. Finally, sit on the floor and look up at the table. The profile is still clearly defined, although the overall shape is slightly distorted. None of the inside of the cup can be seen, and the rim appears as a gentle, two-dimensional curve.

Over the centuries artists have used different eye levels to create particular moods and effects. A "normal" eye level – that is, from the height of an average person – can be useful for quiet and simple descriptive pictures.

A high eye level separates the various elements of the scene from each other. Pieter Breughel, a 16th-century Flemish painter, often used a high viewpoint because it allowed him to isolate individual elements and describe the characteristics of each one.

In complex scenes drawn from a low eye level, there is a tendency for the various elements to overlap. This approach is often used for events such as battle scenes. Théodore Géricault's painting, *The Raft of the Medusa*, based on a horrific shipwreck in 1816, is a wonderful example of how effective a low eye level can be.

The next time you go to a gallery or museum, try to imagine how the picture would have looked if a different eye level had been chosen. Then experiment to see how you can use the same technique in your own work.

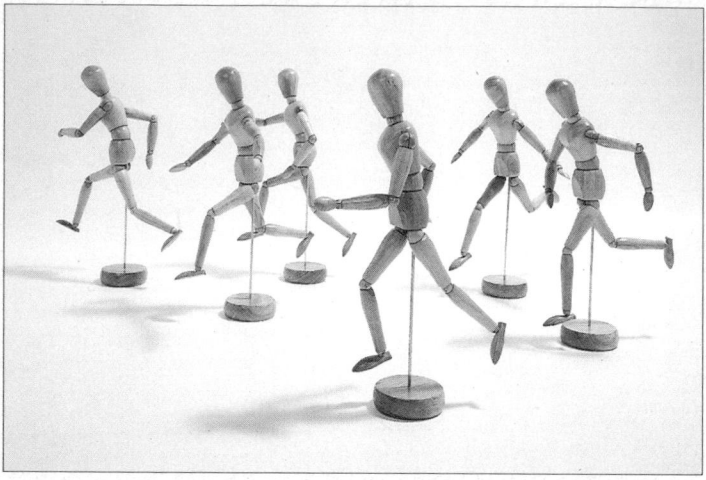

The Composition
On these two pages the same configuration of manikins has been drawn from normal, high, and low viewpoints to show the changes that can be achieved by viewing the same scene from different eye levels.

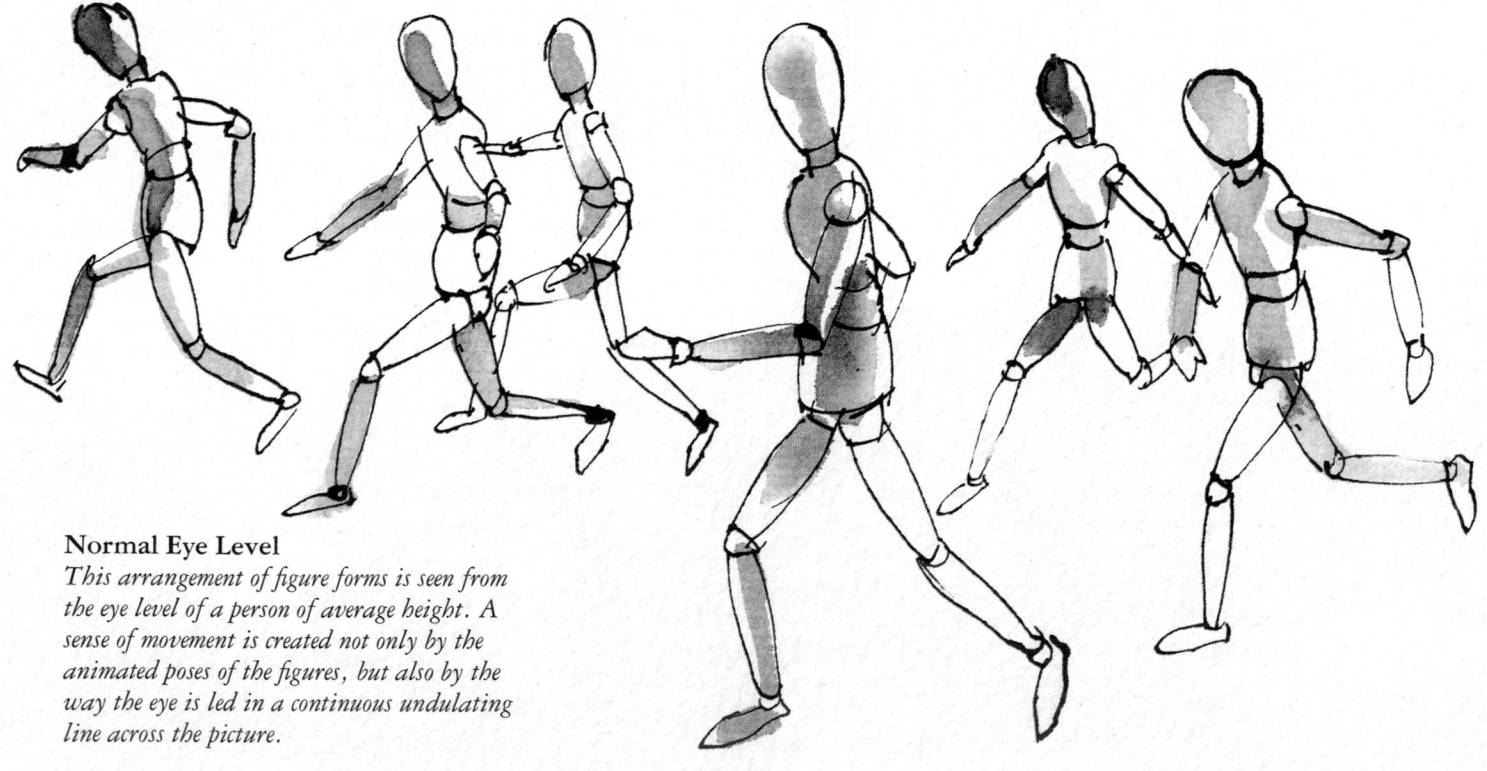

Normal Eye Level
This arrangement of figure forms is seen from the eye level of a person of average height. A sense of movement is created not only by the animated poses of the figures, but also by the way the eye is led in a continuous undulating line across the picture.

High Eye Level

A high eye level tends to separate the objects or figures from one another and allows you to play with the spaces in between. The spaces are always important in a picture – too much or too little empty space can destroy the balance of a composition, so when setting up an arrangement you should pay just as much attention to this as to the figures.

Low Eye Level

A low eye level results in a dramatic change of scale and tends to create strong diagonal lines that lead the eye into the picture. It is a useful way of creating a sense of urgency in a composition of figures. Note the clusters of figures along with the occasional single figure within the grouping. This clustering should be exploited to bring additional interest and contrast to the composition.

Drawing the Head

As with all figure drawing (see pp. 54–55), when drawing the head you need to start by thinking in terms of basic shapes. The head is not a perfect circle but an egg shape. Begin by lightly sketching this basic shape, then draw a line up from the bottom of the chin (between the eyes) to the top of the head. The features are positioned symmetrically on either side of the face, and you will use this line in your drawing to check that you are placing them correctly.

Draw a series of lines across the width of the face to represent the placement of the corners of the eyes, the top and bottom of the nose, and the corners of the mouth. As the drawing progresses, use these lines to check the positioning of the features. Use the same lines to assess the position of the ears: generally, the corners of the eyes line up with the tips of the ears, and the bottom of the nose roughly aligns with the ear lobes. Note that the distance between these lines varies depending on the perspective from which you are viewing the head. If the head is tilted back from you, the features will appear to be closer together; if the head is tilted toward you, the nose will seem longer. To get the size of the different features right, use one of the measuring systems described on pages 36–39.

Another helpful way of checking the position of the facial features is to draw a line across to the outer corner of each eye and two more lines down from the corner of each eye to the middle of the chin, to form an inverted triangle. All the facial features should be contained within this triangle. Use it to check that you haven't made the mouth too wide or placed the chin too far from the eyes and nose.

Positioning the Facial Features

Once you have drawn the basic shape of the head, draw a faint line from the center of the forehead to the bottom of the chin. Place the facial features symmetrically on either side of the nose.

Many people make the mistake of positioning the eyes too high up on the forehead. They are actually only halfway up the face. Make sure you leave enough space between the eyes – approximately the width of one eye.

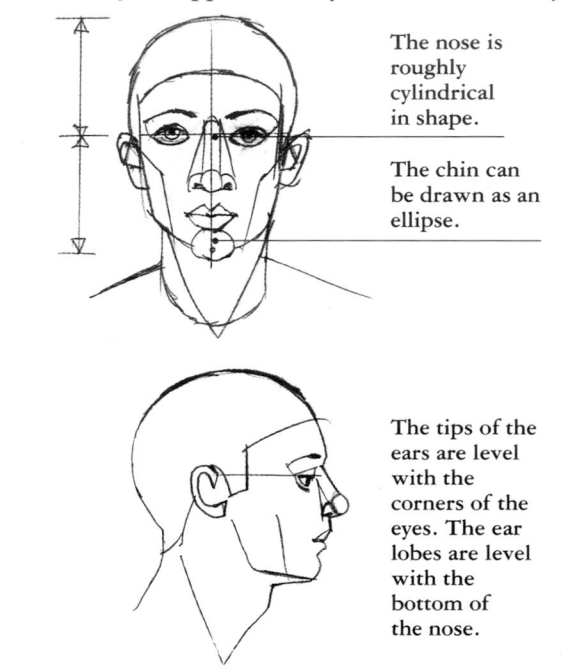

The nose is roughly cylindrical in shape.

The chin can be drawn as an ellipse.

The tips of the ears are level with the corners of the eyes. The ear lobes are level with the bottom of the nose.

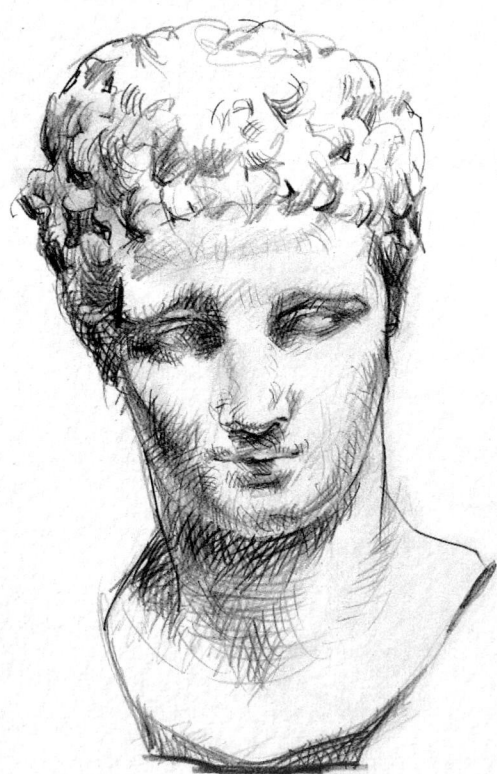

Front View
This view is frequently used for portraits. When the face is viewed head-on, the basic symmetry of the features, all neatly contained within an inverted triangle, is obvious. The pools of shadow under the eyes, nose, and mouth are important in suggesting a three-dimensional effect, as is the use of tone on the side of the face.

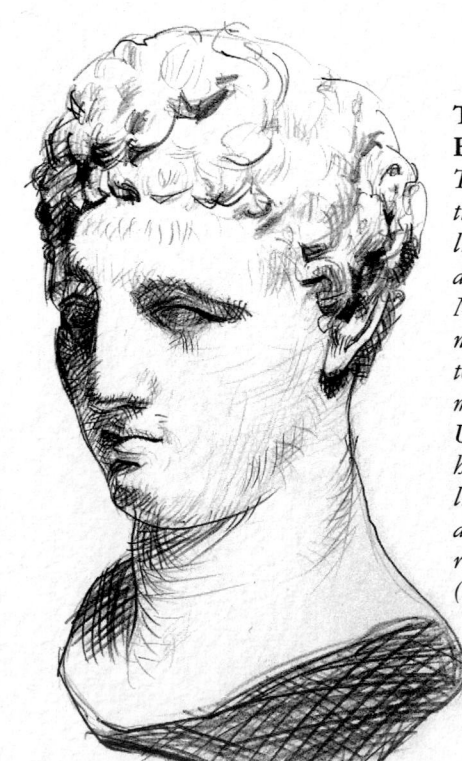

Three-Quarters Front View
The slight turn of the head produces a livelier pose than a flat, frontal view. Make sure that the nose does not protrude too far and that the mouth is not too wide. Use faint vertical and horizontal reference lines to guide you, and remember the rules of perspective (see pp. 40-43).

Male and Female Heads

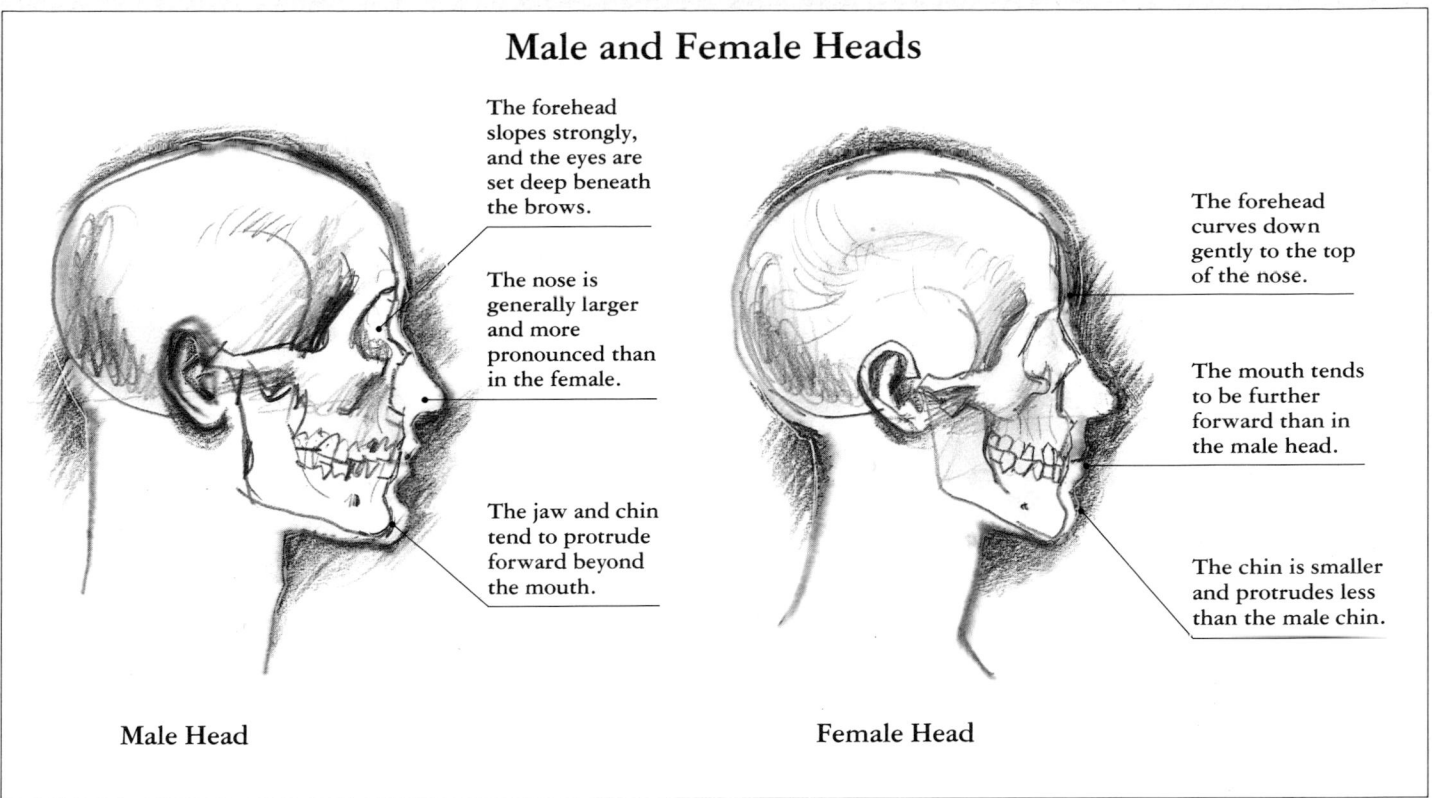

The forehead slopes strongly, and the eyes are set deep beneath the brows.

The nose is generally larger and more pronounced than in the female.

The jaw and chin tend to protrude forward beyond the mouth.

The forehead curves down gently to the top of the nose.

The mouth tends to be further forward than in the male head.

The chin is smaller and protrudes less than the male chin.

Male Head

Female Head

Side View

The facial features occupy a relatively small area; most of the image depicts the hair covering the skull. The head is tipped slightly forward: note the angle of the neck in relation to the shoulders. Draw faint reference lines to make it easier to position the features. Note the position of the ear in relation to the eye and nose, and of the eye in relation to the nose.

Three-Quarters Back View

This view is often used to lead the eye into complicated compositions. The overall emphasis is on the neck supporting the head and on the hair covering the skull. The ear must stand out at the correct angle from the side of the head. Note also how the ear aligns roughly with the corner of the eye and the bottom of the nose.

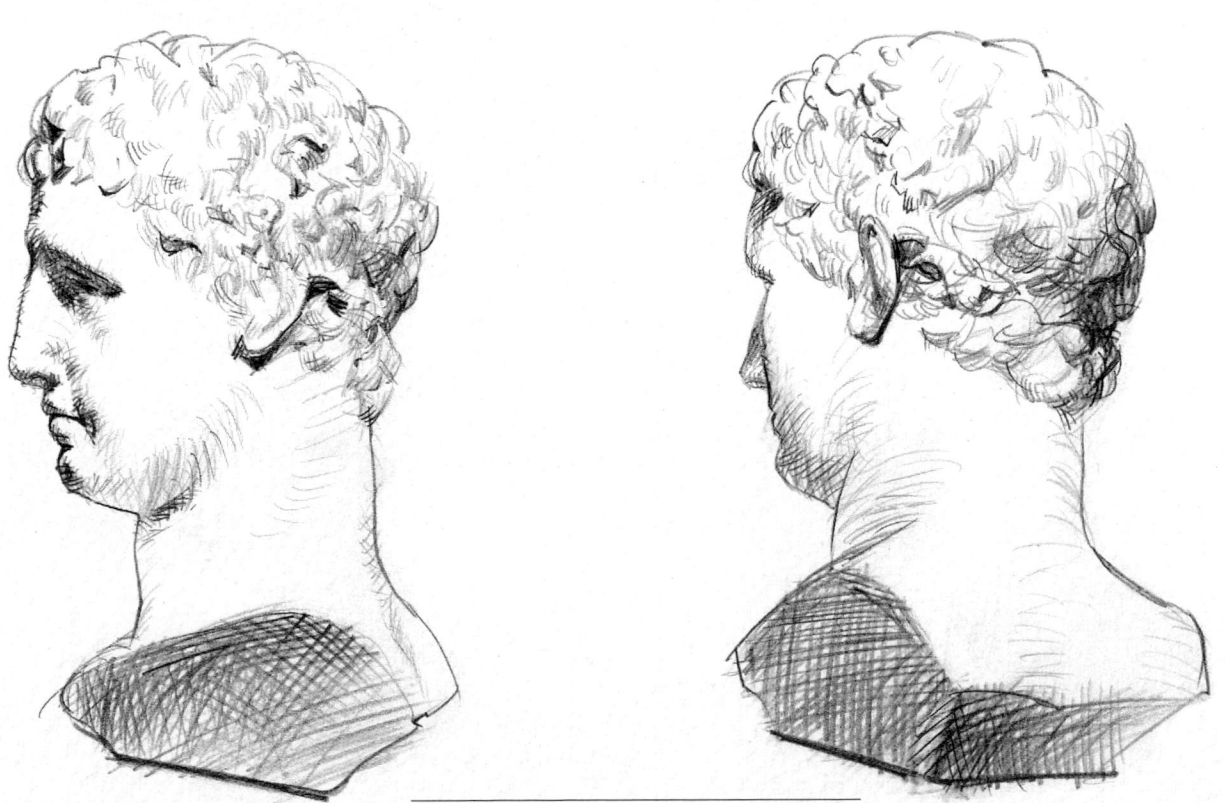

The head is a very heavy form, which is supported by the neck and shoulders. You need to convey this connection in your drawings. It is disconcerting to see a drawing in which someone's head is "floating" without any visible means of support. Think of the shoulders as the base on which both the neck and head rest. It often helps to draw the shoulders first, so that you can see how the neck is positioned in relation to them. The neck is a cylinder form set into the shoulders. Look carefully at the angle it forms: it is not an upright tube shape but is tipped slightly forward. Finally, look at the angle of the head in relation to the neck: if you move your head slightly, you will find that the angle of the neck changes too.

Once you have established the basic shape of the head and the position of the various facial features, look for the shadows. Light, whether natural or artificial, usually comes from above. As a result there tend to be pools of shadow below the eyebrows, nose, upper and lower lips, and chin, which you can exploit in your drawings to give a three-dimensional effect.

Finally, turn your attention to the detailing – to the individual features and characteristics that differentiate one person from another.

Lighting from Below
Adopting unusual lighting – as here, where the subject is lit from below – is a useful technical exercise: it forces you to examine your subject more closely to see where the shadows fall. In portraits, this lighting produces an eerie mood, and it is often used in horror movies.

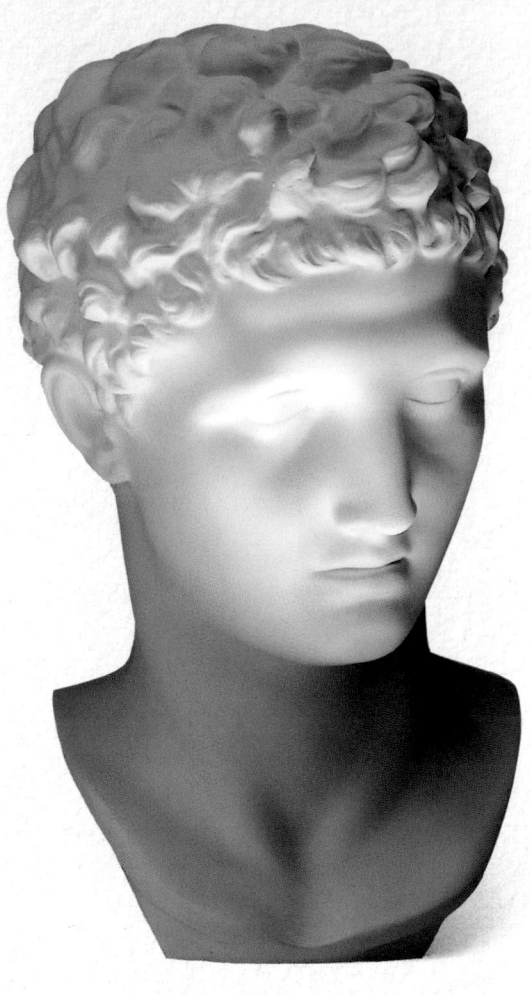

HB pencil

Kneaded eraser

Conventional Lighting
Light usually comes from above, producing pools of shadow below the eyebrows, nose, upper and lower lips, and chin.

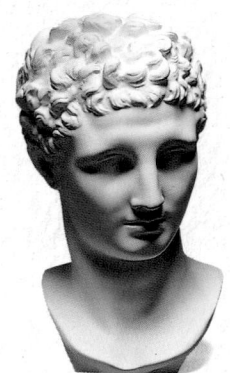

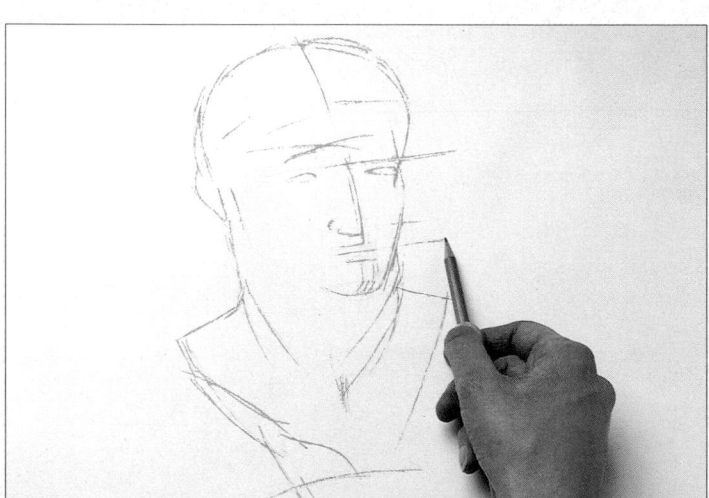

1 *Using an HB pencil, sketch in the outer lines of the face, head, and shoulders. Then draw lines down through the center and across the width of the face as guidelines to help you establish the position of the facial features.*

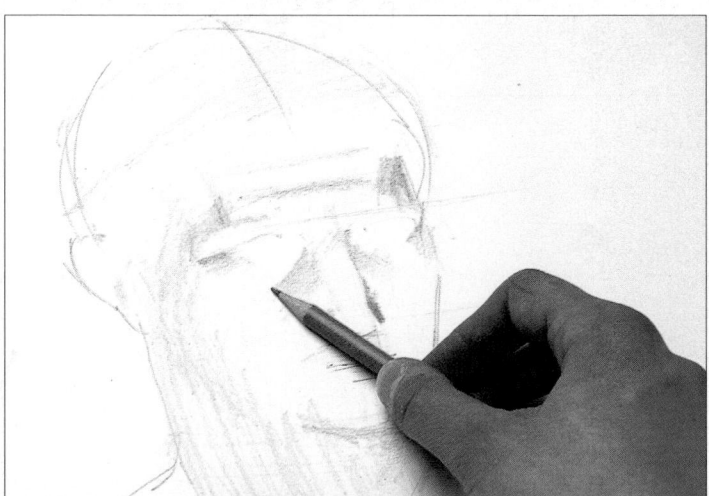

2 *Begin putting in the tones to give a feeling of solidity to the overall form of the head. Build up the tones gradually across the whole face rather than completely darkening one area and then moving on to the next.*

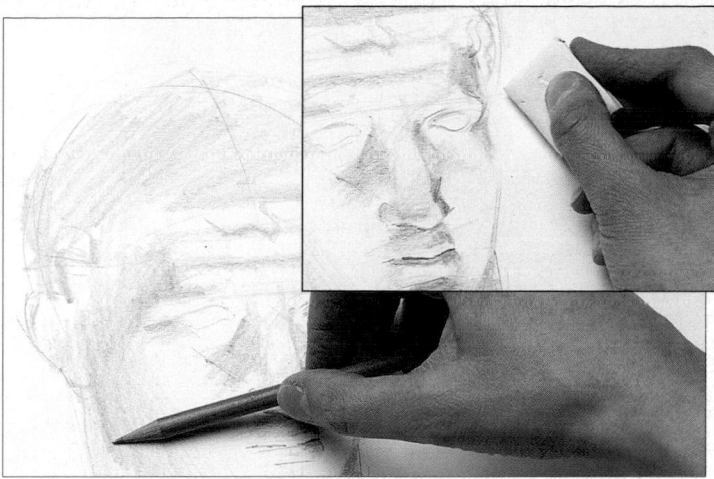

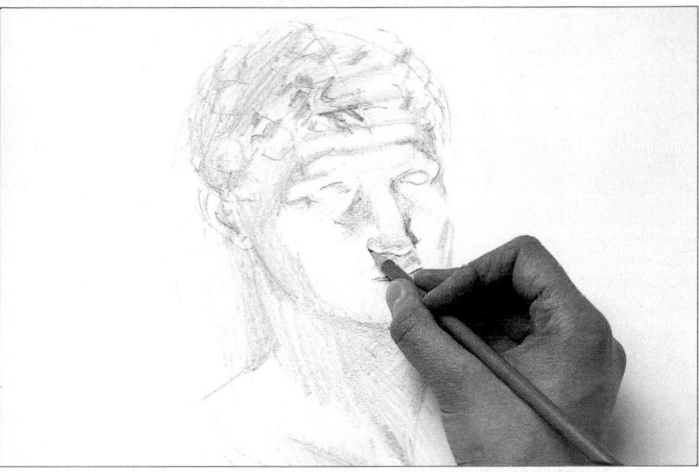

3 For broad areas of tone – across the forehead, the top of the hair, and the side of the face – use the side of the pencil rather than the point. Inset: Work with a kneaded eraser to remove any pencil marks that have gone beyond the confines of the face.

4 Add tone to the left side of the head, behind the ear. Use the point of the pencil, rather than the side, to put in small areas of tone around the nose and other details.

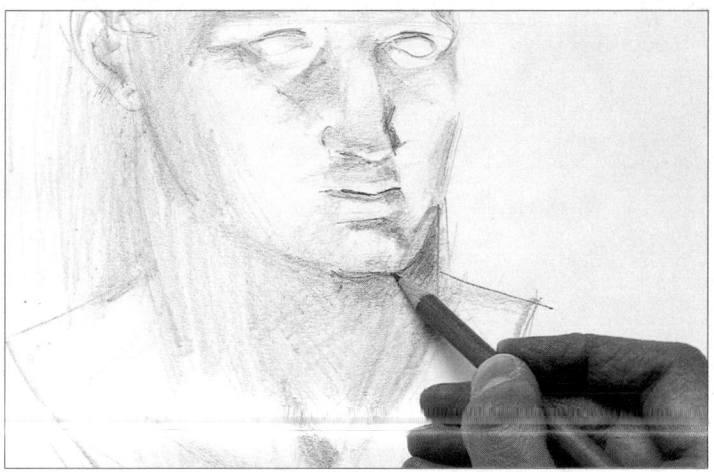

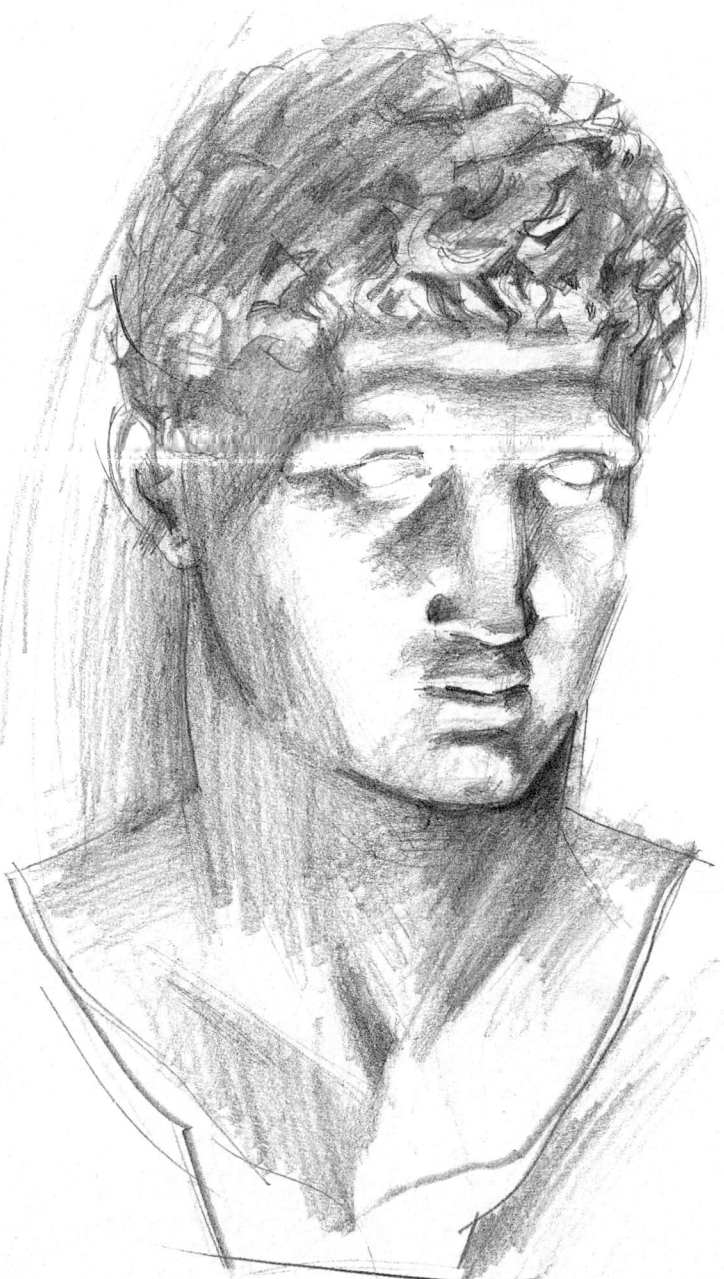

5 Gradually, working across the whole picture, build up the tones until you reach the density you want. Add emphasis and detail where necessary, using the point of the pencil and varying the amount of pressure you apply.

The Finished Drawing

The finished drawing has a very strong sculptural feeling, which comes from carefully assessing where the shadows fall. The pencil strokes used to convey shading run in different directions, following the form of the head, face, and neck. These marks lead the viewer's eye around the drawing in a circular motion, culminating at the focal point – the eyes.

Preparing a Toned Ground

THE COLOR OF THE PAPER YOU CHOOSE to draw on must be given full consideration, as it not only serves as a foundation on which to make marks – it also provides the background to your work.

For toning with watercolor paint, choose a sheet of stretched hot-pressed or cold-pressed watercolor paper. Use a sponge or rag dipped in clean water to dampen the whole surface. Mix the watercolor paint in a ceramic or metal dish. Load a sponge with the paint. Beginning at the top of the paper, wipe the sponge from one corner across to the other side; tipping the board toward you at a gentle angle will help to lay the wash more evenly. Continue down the surface, making sure each band melts into the one above so that no seams show. Do not be tempted to go back or try to correct areas that have not quite worked. Perfection is not too important, and small flaws will often disappear as the surface dries. Watercolor paint always looks darker when first applied; it will dry to a lighter shade. The paint can be further diluted on the paper.

For toning with charcoal, the ground should be laid on a previously stretched sheet of hot-pressed or other smooth paper. Use a stick of charcoal that is fat enough to allow you a good, firm grip and with a gentle series of strokes, using the side rather than the edge of the charcoal, massage it across the surface of the paper. The idea is to cover the ground evenly with a mid-tone – one that is sufficiently dark for white to show on it, but light enough for black and the darker grays to be seen.

Preparing a Watercolor Ground

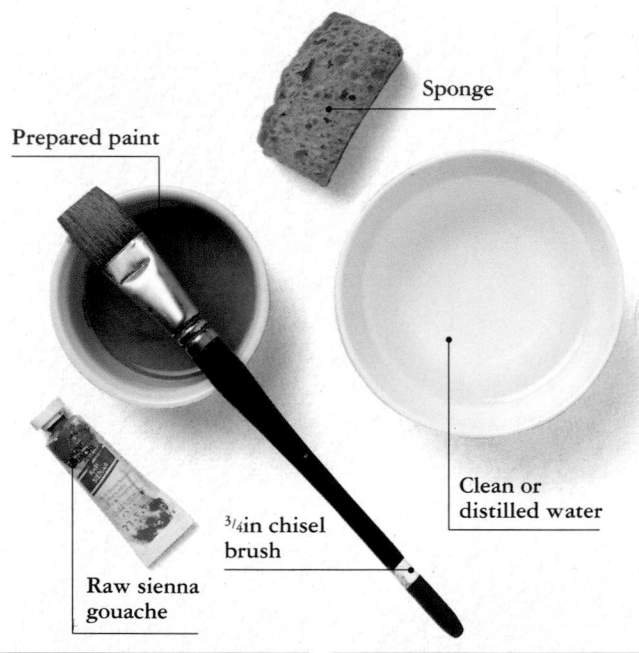

Prepared paint

Sponge

Raw sienna
gouache

³/₄in chisel
brush

Clean or
distilled water

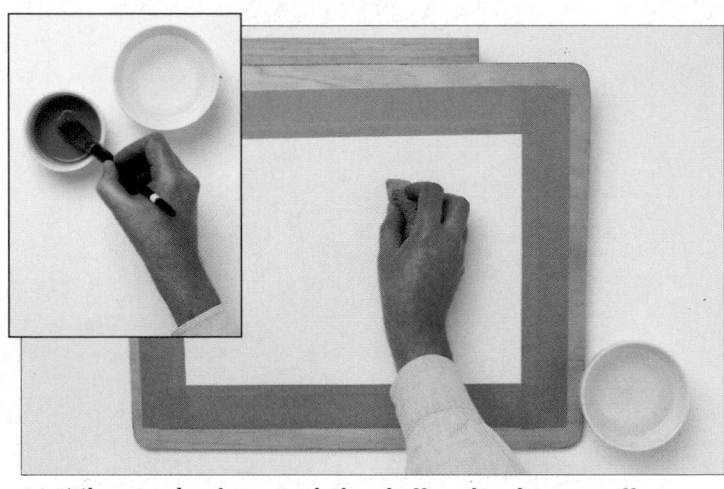

1 *The paper has been stretched and allowed to dry naturally (see p.23). Use a natural or synthetic sponge to dampen the surface. Inset: Mix your chosen watercolor paint with water to make a creamy consistency. Prepare enough to cover the whole area.*

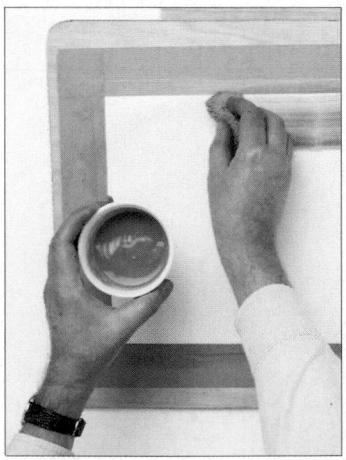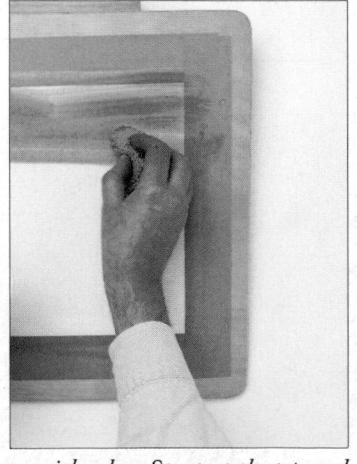

2 *Dampen, do not soak, the sponge with color. Start at the top and work across (above left). Take care not to drop blots onto the clean paper below. Bring the sponge back across to make the second band of wash (above right). Continue until the whole surface is covered.*

3 *Allow to dry thoroughly. The toned surface must be light enough for the final drawing to be clearly visible, but dark enough to allow the white of the paper to show through. It is important to choose a middle tone – terre verte and raw sienna are both ideal.*

Preparing a Charcoal Ground

1 Use a charcoal stick, held on its side, to cover the hot-pressed paper with a thin, dark gray skin of charcoal dust. You could also use compressed charcoal, made from charcoal powder, rubbing it over the paper with your fingers.

Charcoal sticks

2 Cover the paper evenly, using sweeping bands of charcoal. Keep the charcoal dust moving across the complete surface, traveling to all four corners. It is most important to work the whole plane at the same time in order to achieve an even ground.

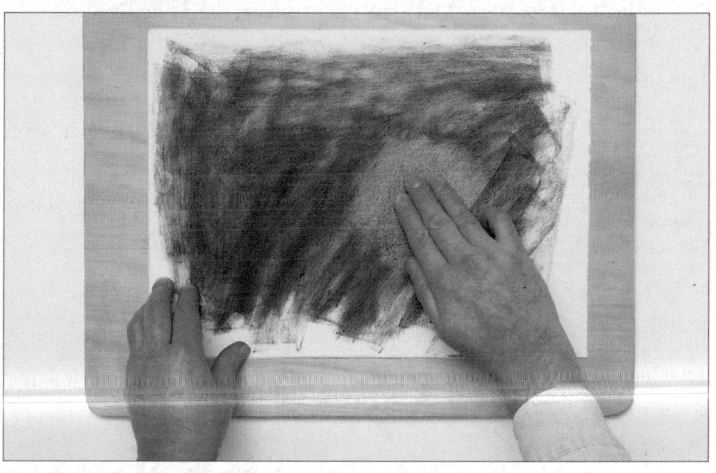

3 Massage the loose charcoal dust into the surface with your fingertips. This will use up any surplus, and any remaining dust can be blown or shaken off.

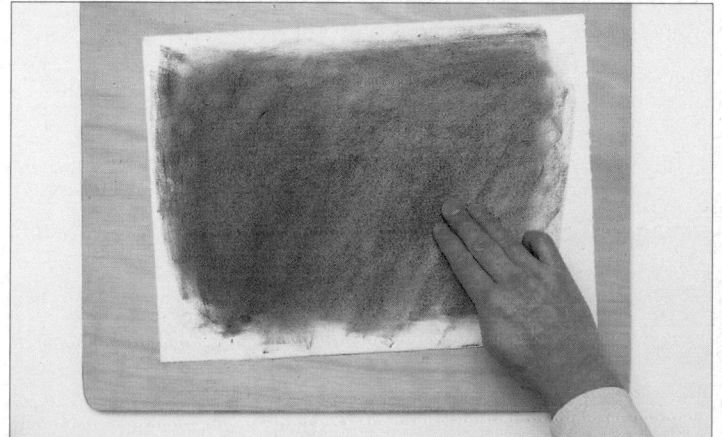

4 The rubbed surface leaves a perfect mid-tone. As with the colored ground, the tonality is critical. It must allow for dark marks right up to black, as well as for whites and lighter grays.

5 The finished surface will not be perfectly even. You do not always need to tone the whole sheet — certain subjects may be better drawn on smaller toned areas within a sheet of white paper.

Learning from the Masters

FOR CENTURIES, traditional art teaching has included imitating the masterpieces of great artists. It is a useful way of trying to understand an artist you admire – why and how he or she chose a particular viewpoint, made certain marks, or used certain colors. You will not always notice immediately where lines become thicker, thinner, more angular or flowing by looking at a work. Imitating it will increase your powers of observation and can lead you to question and analyze the picture more closely. You may also learn to reproduce a greater range of marks than were previously in your drawing repertoire. Through your examination of the works of other artists, you yourself may paradoxically discover new and more personal ways of working.

When starting a study of a work you admire, imagine how the artist would have gone about drawing the picture. Ask yourself where the starting point was and how the drawing progressed. Lightly sketch in the main shapes, paying attention to the relative proportions of the different elements: looking at the spaces between the elements will help you to render them more accurately. If the drawing is complicated and you are working from a book or a postcard, take a photocopy of the work and superimpose a grid over it so that you can be sure of getting the proportions right (see pp. 38–39).

The Drawing
This preliminary sketch for a painting, with its abrupt dots and strokes, is typical of van Gogh's pen-and-ink work.

Painting from the Drawing

Van Gogh made a painting from his drawing the very next day. It is not a straightforward copy: elements within the room have been altered or omitted.

Always remember that a drawing made as a prelude to a painting is an aid rather than a rigid understructure. Its purpose is to help you to clarify your ideas on the composition and the techniques and media that might be appropriate. Think of it as being similar to reading a paragraph, closing the book, and paraphrasing it instead of repeating the text word for word, parrot fashion.

The portrait of van Gogh's mother above the bed in the drawing has been replaced with a landscape scene in the painting.

The chair has been brought forward in front of the door – obviously, van Gogh thought the objects cluttered the area in the upper left of the picture.

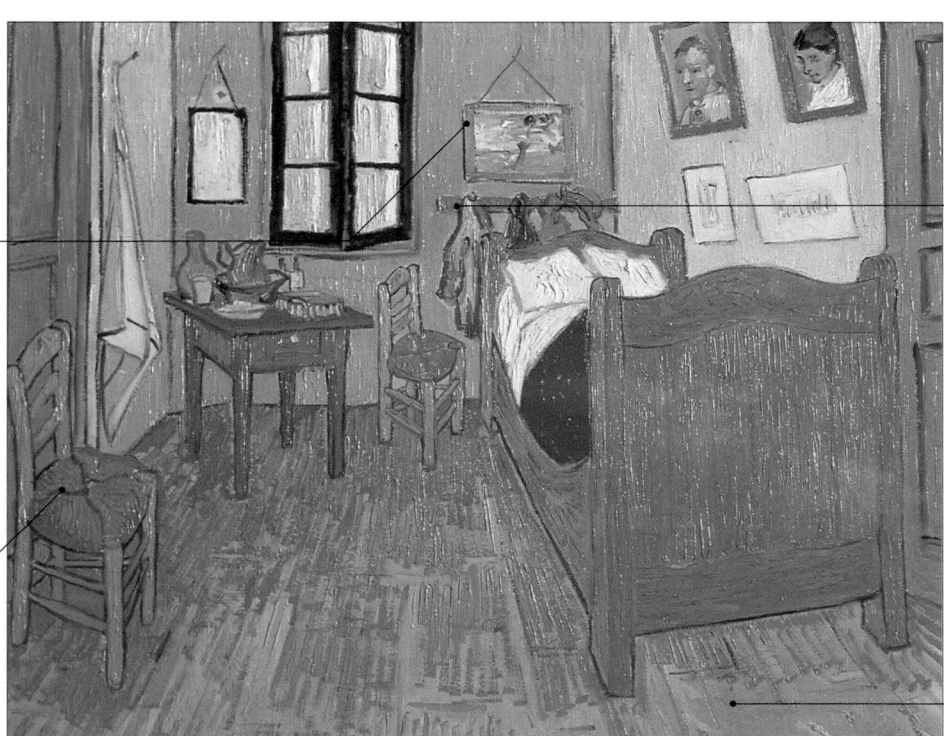

The hat has been removed from the hook behind the head of the bed and the items hanging up are given less emphasis.

The angle of the floor has been tipped forward slightly so that it is on a slant, and the woven texture indicated in the drawing has been replaced with a simpler pattern.

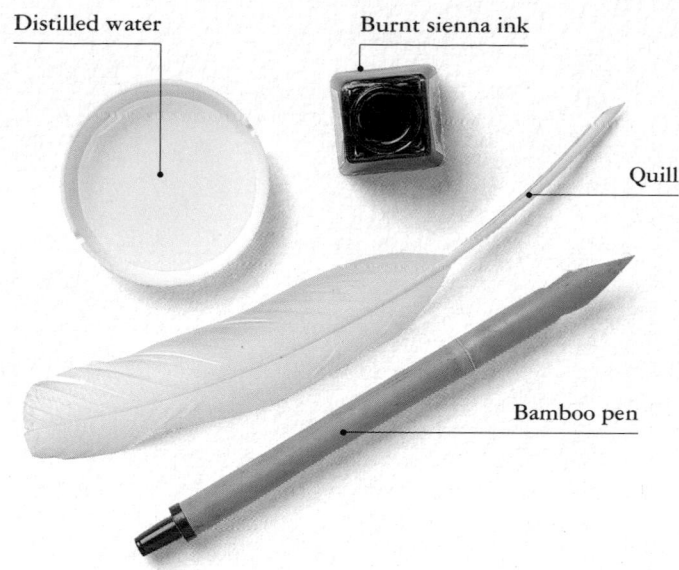

Distilled water

Burnt sienna ink

Quill

Bamboo pen

1 The bamboo pen has a soft quality. Exert firm pressure on the pen to create dark, rich lines. Create finer, lighter marks by using less pressure. Work across the drawing, giving the main features equal attention.

2 The quill can produce both thick and thin lines: use the point for thin lines, and turn it on its side for a thicker mark. Make a series of short pen strokes for the texture on the bedcover and floor pattern.

The Master's Tools

Using the same media as those used in the original work will help you to echo the spirit of the master's work more authentically. But using other media may also be advantageous and produce interesting results. Experiment to see which you prefer — it is your "copy" after all.

The Finished Drawing

This drawing is an attempt to understand some of van Gogh's thought processes and see how he approached his subject. Abrupt, fairly coarse pen lines are characteristic of his work, and the same technique is used here to give the drawing a sense of great energy.

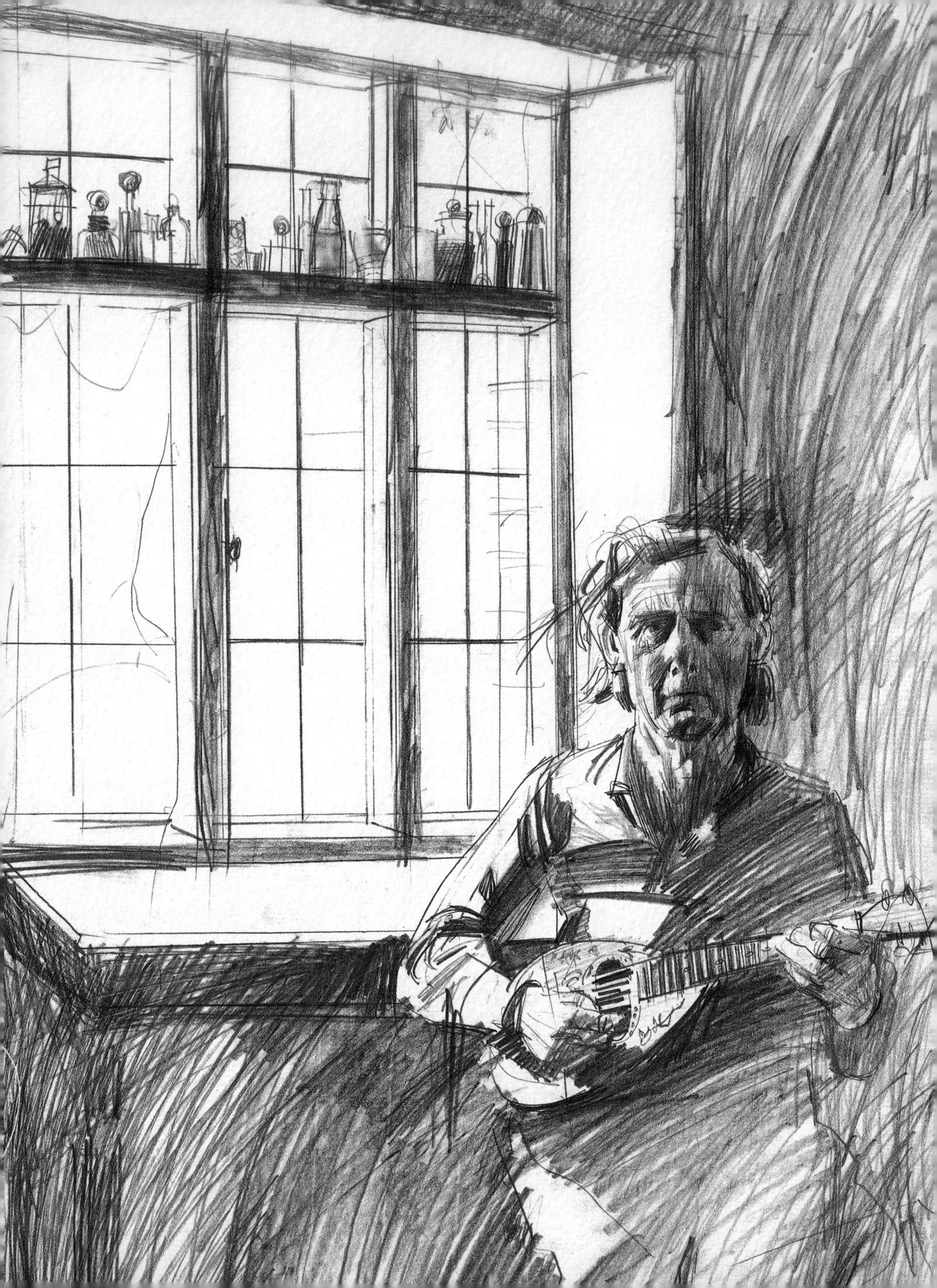

The Projects

Simple Still Lifes

THE STILL LIFE IS ONE OF THE most popular subjects in the history of art. Roman wall painters were masters at depicting the objects of their time – kitchen artifacts, flowers, and fruits. Since then, the still-life theme has fascinated artists such as Diego Velásquez and Jean-Baptiste Chardin and taken on a role of primary importance in the work of Paul Cézanne, Henri Fantin-Latour, and many others. The Dutch still-life artists of the 17th century made closely observed and carefully executed pictures of fruits, vegetables, and flowers. In fact, small still-life objects often took on great significance in the background of large domestic interior scenes. Jan Vermeer painted with such precision that many of his genre paintings are really still lifes with human beings.

You do not need to spend a great deal of time looking for a subject when constructing a still-life group. Items from your kitchen or items you have collected often make an interesting arrangement. Fantin-Latour would paint a cup and saucer, William Nicholson a few mushrooms and Cézanne a pile of apples. The objects you put together are merely a starting point. The colors, tones, shapes, and forms combine so that your pencil or brush can create a picture. By deliberately selecting objects within a range of harmonizing colors (a variety of reds or blues, for example), you can create an atmosphere of harmony. You can also create a scene of contrasts, not only in the colors of the items you choose for your arrangements, but also in the scale of things: large vases alongside cherries and grapes, for example. Contrasting textures are important, too. Use features such as these to link items within your still-life group in an interesting and appealing way.

1 *Sketch in the main structural lines of the drawing. It is important at this stage to make the basic forms work. In this group, the critical element is the ellipse (oval) of the ceramic bowl. An ellipse is simply a circle seen in perspective (see pp. 40–41).*

2 *Continue to build up the basic structures of the drawing. The objects should relate to each other and appear to sit comfortably within the bowl.*

Colored pencils

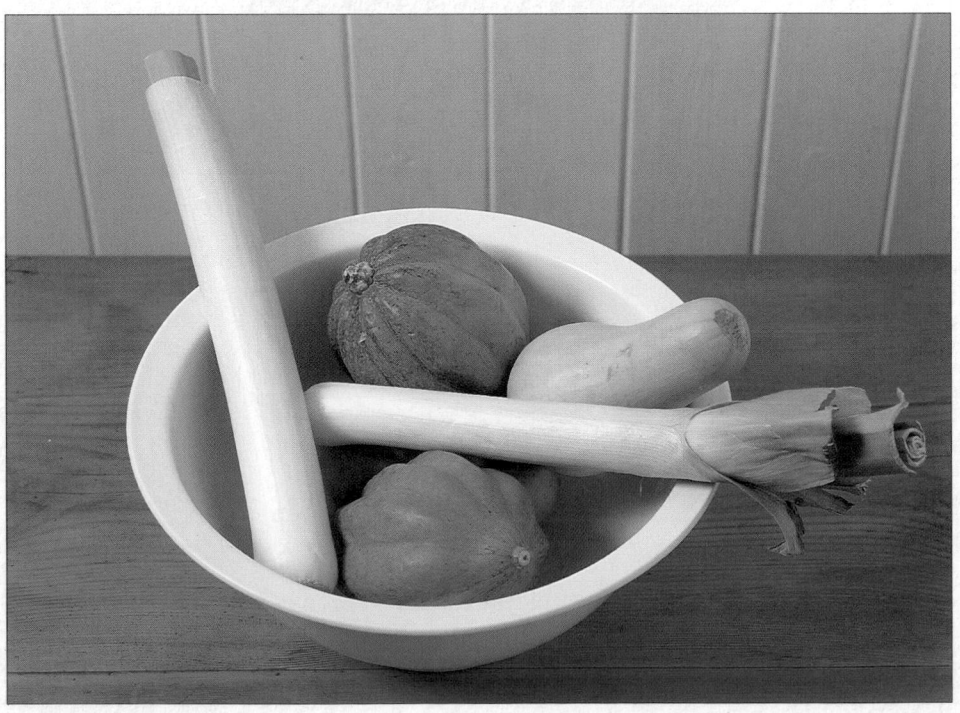

The Arrangement
A selection of vegetables in a white ceramic bowl. The roundness of the gourds is balanced by the strong lines of the leeks, which have an overall diagonal stress. The kitchen table provides a mellow, rich base.

3 Use soft and colored pencils to build up form. The idea is to make a colored drawing while retaining the feel of the pencil mark. Every line has to help the eye go around the form to describe the solid. Vary the tones and exploit the color by using warm and cool tints; each color is reflected against the object nearest to it.

4 To help make the two-dimensional image appear solid, the leeks are described as cylinders. Reflected light coming from the left strikes the leek and creates a large area of light tone. The dark tone on the other side gives the three-dimensional illusion. Warm colors tend to come forward; cooler ones often recede.

5 Work across the piece rather than finishing one part at a time. Don't rely on ready-made color, but combine strokes of various colored pencils to create your own shades.

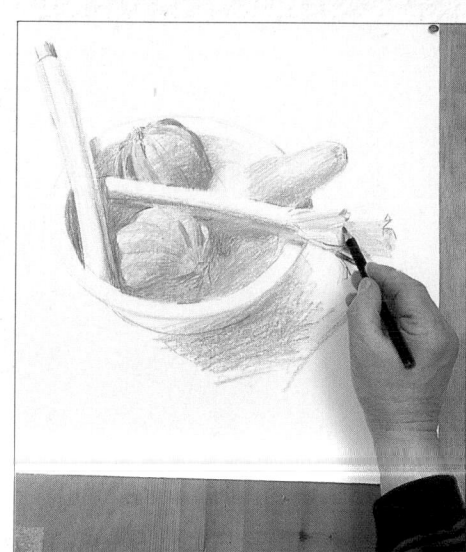

6 Relate each object to a geometric equivalent, using shadows to half-describe secondary forms. With a soft pencil, pick up some of the darker shadows in areas of detail. Do not overwork the drawing or the end result will appear labored.

The Finished Drawing
The final picture demonstrates how the lights, darks, and reflected lights describing the solids are strengthened by the use of this kind of line drawing. The diagram below shows how basic cylinders, spheres, and a cone can be used as the starting point for your drawing (see pp. 46–47).

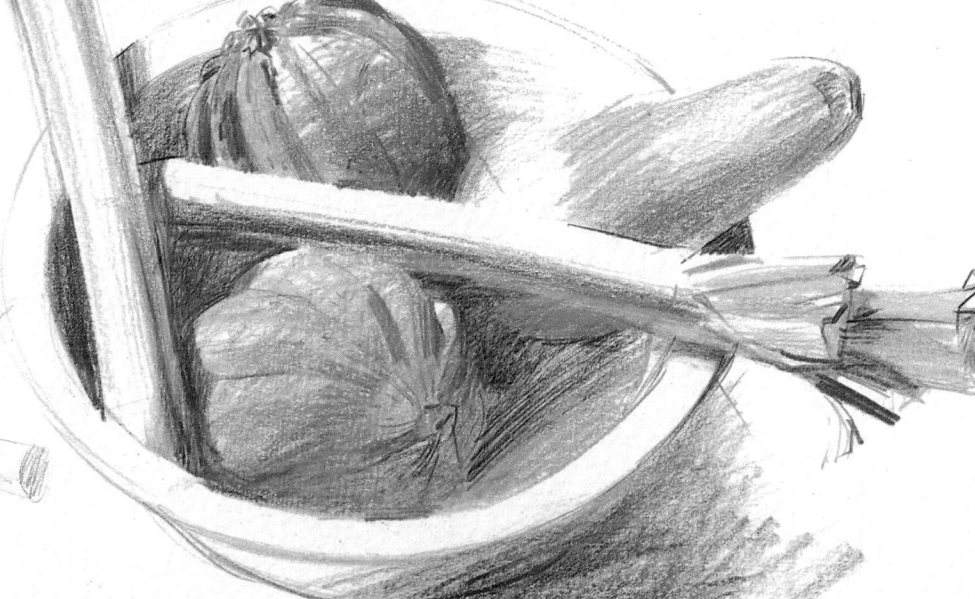

Still Life in Mixed Media

MANY GREAT ARTISTS have taken small domestic items such as vegetables lying on a kitchen counter and transformed them into lovely still-life pictures. The objects selected are generally associated in some way to tell a "story" in the picture – vegetables and other foodstuffs are seen with the pot in which they will be cooked, for example, or a leather-bound diary appears with a quill pen and bottle of ink.

Look for objects that contrast in scale and shape. Thinking of your still-life objects as basic geometric shapes (see pp. 46–47) is a useful starting point, encouraging you to consider how the shapes will work together on paper, as three-dimensional images. You should also look for interesting contrasts in texture.

Move the objects around until you have a composition you are happy with. Allow them to overlap a little to establish a visual, as well as a thematic, link between them. But don't let the items overlap so much that they become a confusing jumble. The overall silhouette of your arrangement is also important: your eye should be led across and around the group to see how each component relates to the others.

Lighting is crucial in still lifes. Shaded areas and long shadows can contribute enormously to the overall mood of your drawing. You can add light by placing a table lamp in the right place. You don't need to include it in your drawing – simply exploit the light it throws.

Now think about which media you are going to draw with. Obviously your choice will depend largely on the subjects that you have chosen: fine pen-and-ink detailing might be suitable for one subject, while another might demand broad strokes of charcoal or soft pencil.

Don't start out with fixed ideas about what you are going to do. Leaving some aspects of your drawing to chance, or even turning your "errors" into "discoveries," can actually help improve your work.

The Composition
The trout are put in an oval dish and then placed on a folded cloth for a contrast in texture. The angles of the folds, as well as the position of the fish in the dish and of the dish on the cloth, are all carefully planned to create an interesting arrangement.

Charcoal Sketch
Make a quick sketch setting out the composition. Charcoal is used here. Make sure that the angles of the cloth, along with the main feature – the fish – are correctly positioned.

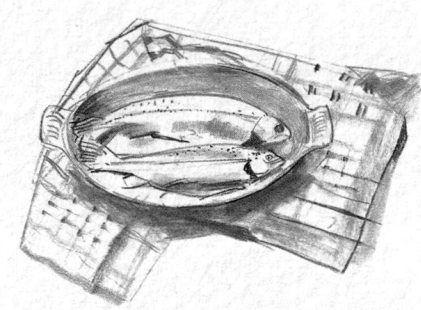

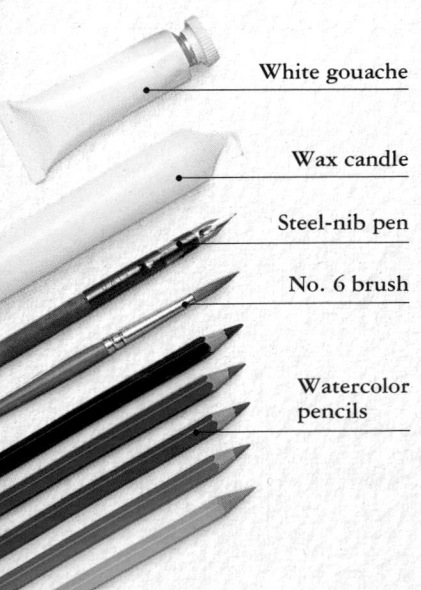

White gouache

Wax candle

Steel-nib pen

No. 6 brush

Watercolor pencils

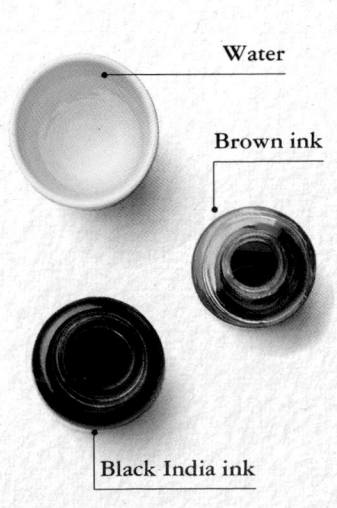

Water

Brown ink

Black India ink

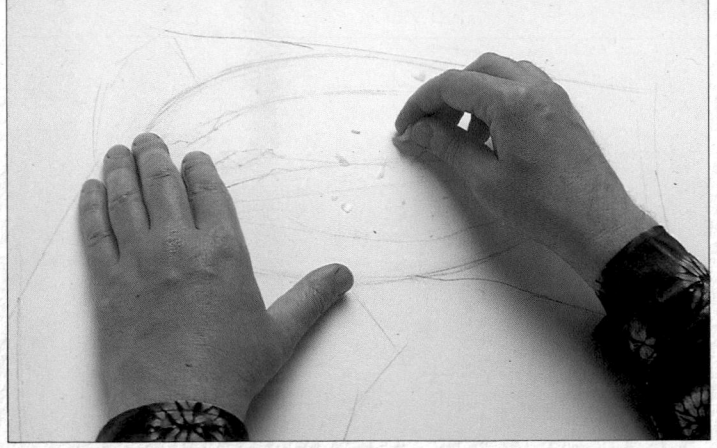

1 *Once satisfied with your sketch, use a soft gray watercolor pencil to lay out the composition with light pencil lines. When complete, rub candle wax on the areas of the fish that you wish to highlight using the wax resist technique (see pp. 142–143).*

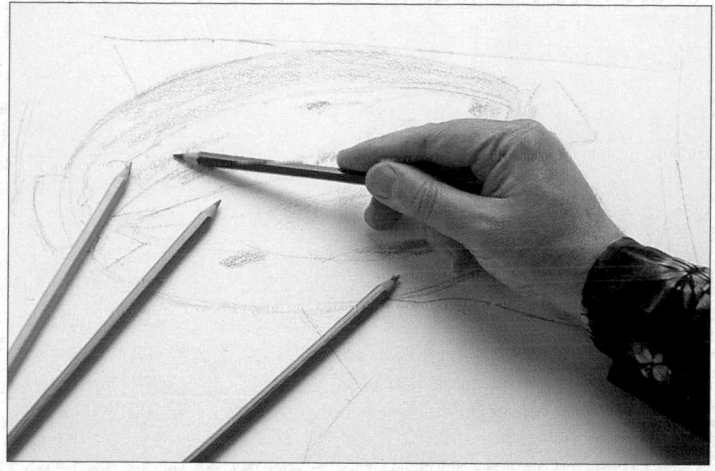

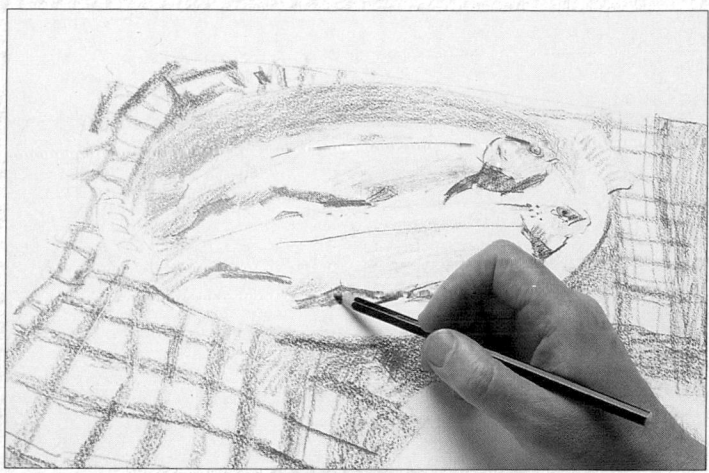

2 *Start applying color using the watercolor pencils. Use yellow and orange for the dish, adding the first touches of aquarelle blue to provide the shadow on the side of the dish. Use the blue and red to begin the description of the trout.*

3 *Search for the darker areas and tones. To get the true shades of the tones, you will have to overlay different colors: the warm yellowish gray of the dish, for example, is achieved by mixing yellow and black pencils with a little blue.*

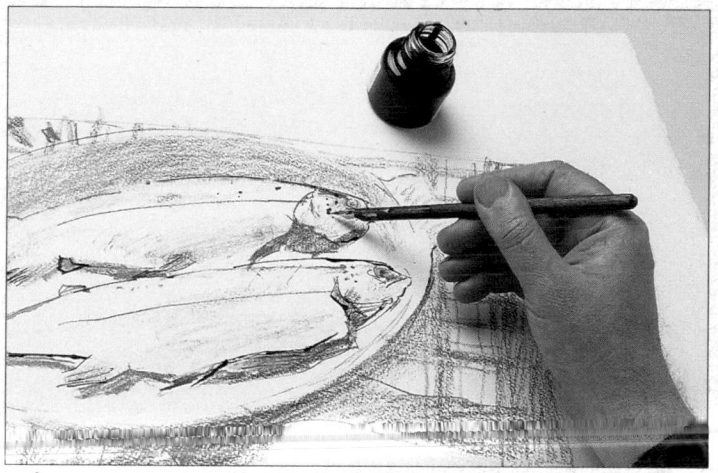

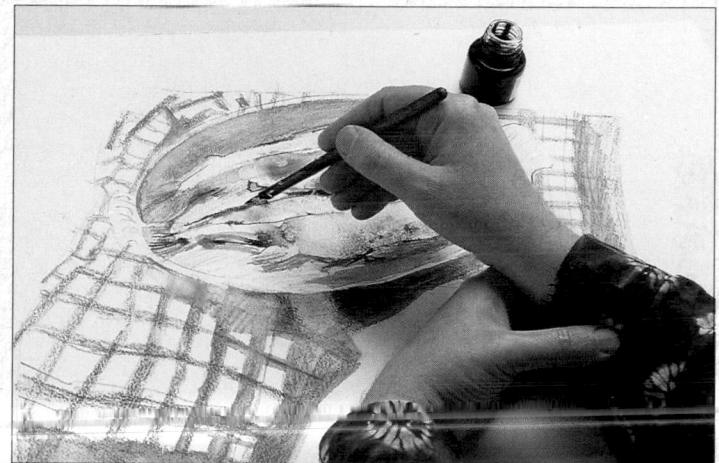

4 *Put in fine details using pen and ink — brown on the cloth and shadows under the dish, and black for definition on the fish heads and gills. For the intricate construction around the eye, hold the pen quite loosely, so that the lines do not become too rigid.*

5 *Dip a no. 6 brush in clean water, and brush it lightly over the colored pencil marks to blend them into washes. Support your painting hand by forming a bridge with your other hand to avoid smudging the drawn details.*

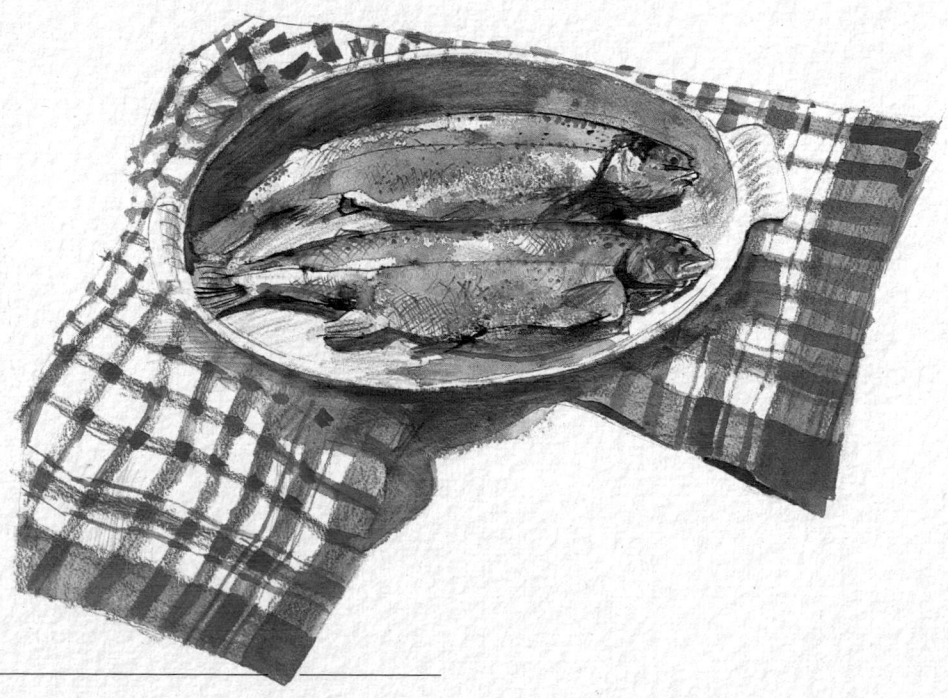

The Finished Drawing
Make the final details of the drawing in pencil. Use a hatching technique (see pp. 44–45) around the fish to simulate the pattern of its scales. Brush white gouache onto the lightest areas of the scales to echo their shiny appearance. The colored shadows are arrived at by adding touches of many different colors and then dampening them to make a wash. By laying the colors one by one, you can control the strength of the wash.

Indoor Flowers and Plants

ARTISTS HAVE ALWAYS BEEN INTRIGUED by the challenge of interpreting blossoms, leaves, stalks, and stems. Drawing flowers indoors has several advantages – not the least of which is that you are protected from the vagaries of the weather. You can also move the elements of the composition around much more easily. Choosing the right background is vital. A plain, flat background is the easiest, as it prevents any visual distractions.

There is far more to a flower than just the blossom, even though that may be what initially attracts your eye. The stalk and leaves are equally important. Before you start to draw, look at the way the leaves are attached to the stem: they grow out of it, and you must try to convey this feeling of growth in your work. Similarly, the flower head is not stuck on the end of the stem: the two merge together.

The most important thing is to get all the shapes and angles right. Many flower heads are basically circular – but if you are drawing a flower arrangement, rather than an individual bloom, you will be looking at some flowers head-on and at others from the side. Some will be circular while others will appear as ellipses. Make sure that you establish the basic shapes and lines of your composition before you start to put in the fine detail.

Few subjects demand as much thought about light sources and the direction of light. Flowers are complex organisms with many subtle gradations in tone, even within one bloom. Look carefully at the different areas of light and shade, and make sure that you put in the full range of tones to achieve a three-dimensional effect.

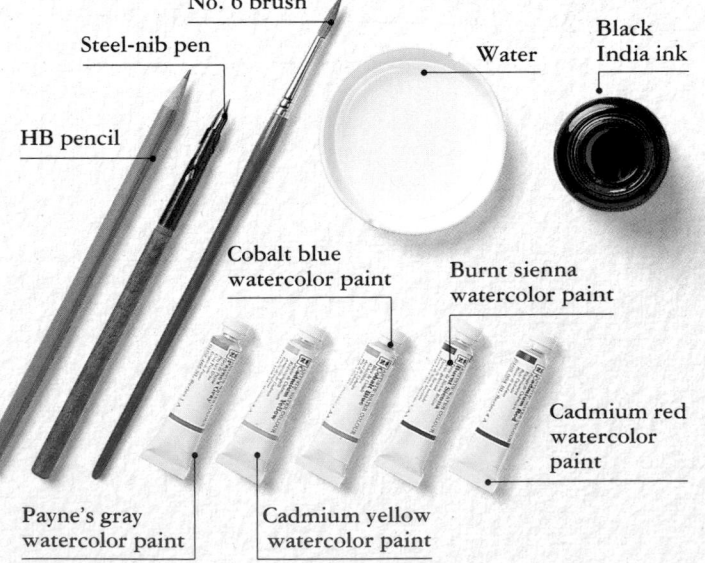

The Composition
Place the flowers randomly, at different heights and angles, so that they appear to be "springing" from the vase. This arrangement creates a lively composition with lots of detail to explore.

No. 6 brush

Steel-nib pen

Water

Black India ink

HB pencil

Cobalt blue watercolor paint

Burnt sienna watercolor paint

Cadmium red watercolor paint

Payne's gray watercolor paint

Cadmium yellow watercolor paint

1 *Use an HB pencil to sketch in the main lines and details of the flower group. Hold the pencil toward the top, with a loose grip, so that it is easier to apply broad lines. This prevents the drawing from looking too tight and mechanical.*

2 *To begin the descriptive stages of your work, use a steel-nib pen dipped in India ink. Hold it loosely toward the end. Use the previous pencil work only as a guide to your pen drawing, rather than tracing over it. This will help to ensure that your pen work looks freshly conceived. Examine your subject closely at every stage.*

3 *Place the hand that is holding the pen over your other hand to prevent you from smudging the details you have just drawn. Hold the pen more firmly to gain greater control over the placement of the lines. Note the contrasts in the thickness of the lines, achieved simply by varying the pressure you apply to the nib.*

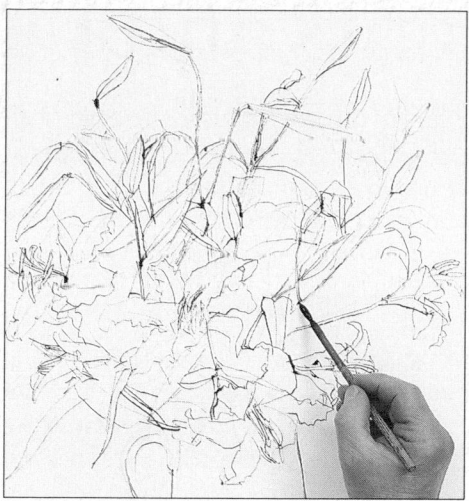

4 *Use long, general pen lines to draw the stems to link the separate details (leaves and flowers) from the edges of the picture with the rest of the drawing. The differences in the weight of the lines contribute to the three-dimensional effect as well as complementing the delicate character of the subject.*

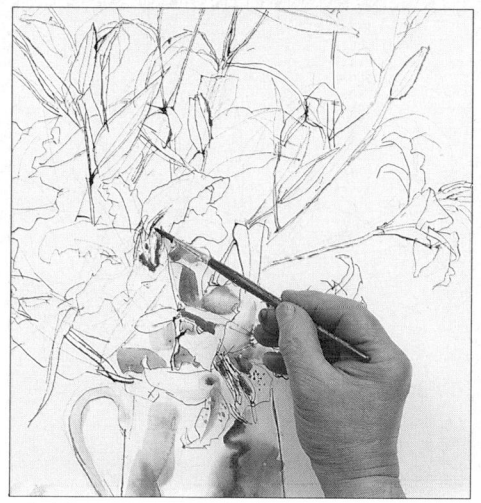

5 *Now start to apply the watercolors. Dampen the area of the pitcher, then use a no. 6 brush to apply the wash with broad strokes. This gives the pitcher a soft edge that blends into the shadows at the bottom. To give definition to the flower heads, apply the color washes on dry paper.*

The Finished Drawing
The finished drawing is fresh and full of life, with considerable detailing in the individual parts. By blending the darker edge of the pitcher into the shadows cast from the flowers and leaves, a contrast in scale and texture is achieved. Only a minimal amount of color is applied, but it is enough to suggest the color and tone of each flower, leaf, and stalk within the group. The strong horizontal line along the edge of the table stabilizes the composition.

Plants and Flowers Outside

UNLIKE INDOOR PLANT COMPOSITIONS, where you can easily move the different elements of your composition around, outdoors your subject is likely to be rooted (literally) to the spot. But this does not mean that your choices are limited. On the contrary, it can force you to adopt a more inventive approach by trying different viewpoints and eye levels.

Remember that you don't have to draw exactly what is there. If the background is cluttered, for instance, you can leave it out. You can also "improve" on nature by removing any dead flower heads or tucking a protruding leaf behind a feature that you want to emphasize.

The structure of the plant is one of the most important things to consider. Are the leaves simple or composite? Is there a single large flower at the end of the stem, or are the flower heads positioned along the length of the stem? Is the flower head circular or tubular? You don't need to elaborate every detail, but even if you are setting out to produce a moody, atmospheric picture rather than one that is botanically correct in all respects, you need to pay attention to the way the plant is constructed. This is what gives it its unique character and appearance.

Textures are as important as linear structures in drawing plants and flowers. Ridges separating the individual segments of a trumpet-shaped flower such as a daffodil, thorns on a rose stem, feathery grasses, the soft, velvety texture of geranium leaves: such features are essential not only in depicting the characteristics of individual plants, but also in helping to convey a three-dimensional effect.

Conveying a sense of the plant as a living thing is crucial. Plants are not static, immobile objects: they grow upward and outward from the center, reaching toward the sun. A low eye level can help to suggest a feeling of growth, but it does mean that you see a lot of the stalk and stems. Another suitable viewpoint is to look down on the plant from above, as this clearly shows the layering and overlapping of leaves around a central stalk.

You can combine a whole repertoire of techniques and media when drawing a complicated grouping. Remember, however, that the individual parts of your drawing are only a small part of it. Even when you are drawing intricate details, keep an eye on how the work is progressing as a whole. Check regularly to see that the individual parts relate correctly to each other.

4B pencil

HB pencil

Graphite pencil

Graphite stick

Plant Selection

Not only does this plant grouping offer an aesthetic subject, but the surrounding features also provide an interesting contrast of texture. The varieties of scale, tone, texture, and leaf shape are conducive to creating a three-dimensional effect, enticing the viewer into the drawing. The natural character of the plant is enhanced by the contrast with the human-made brickwork and roof tiles in the background of the arrangement.

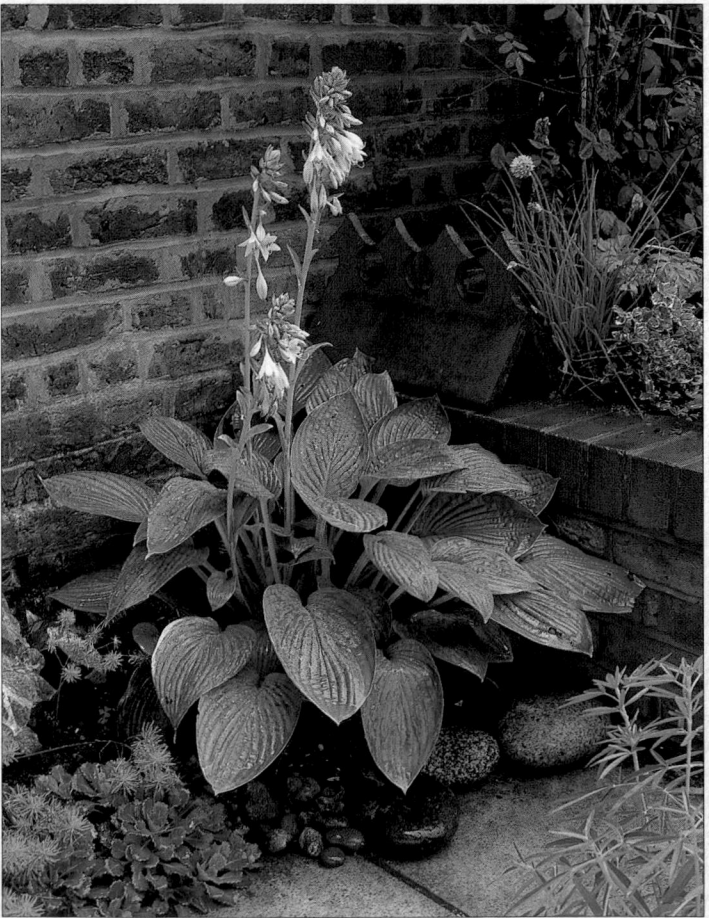

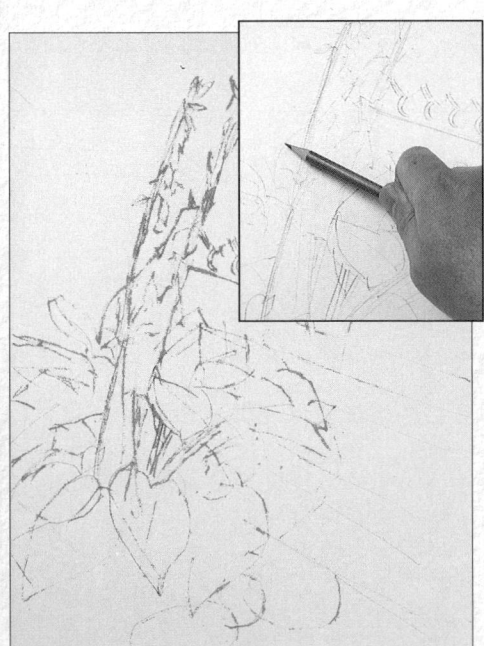

1 *Sketch in the basic shapes and forms of the plant using an HB pencil. Don't linger over any one area, but concentrate on the general understructure of your drawing. Inset: Hold the pencil near the top end of the shaft so that the lines you make are quite loose.*

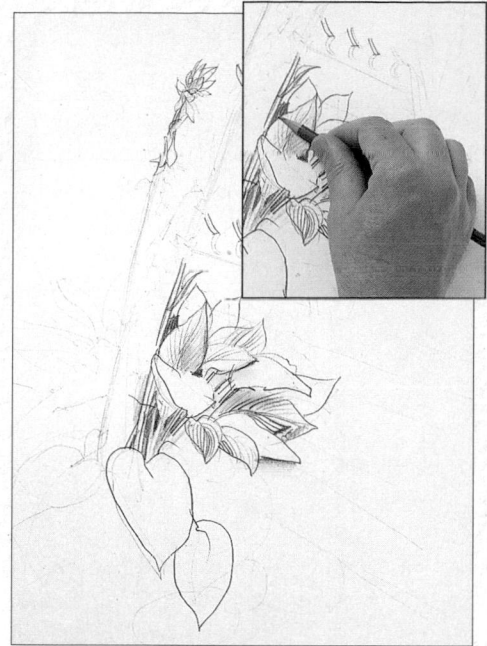

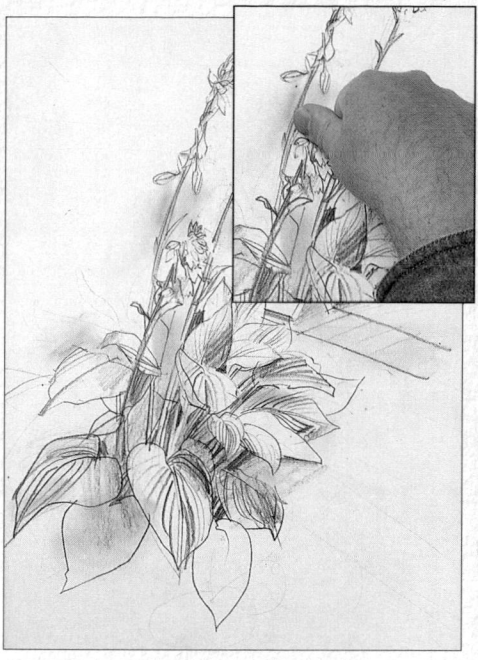

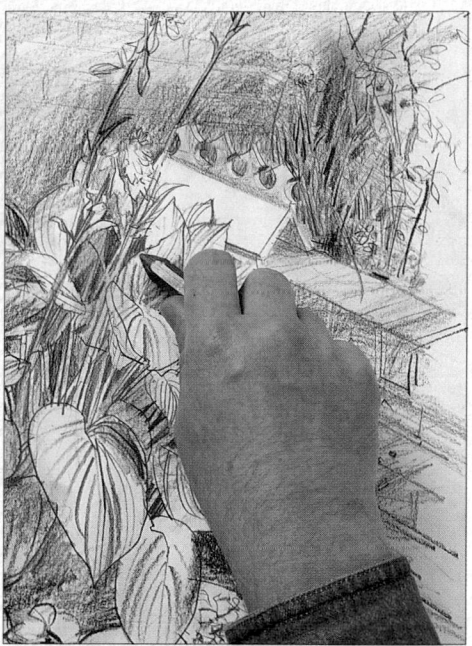

2 Once you have sketched in the plant, concentrate on giving the main stem greater emphasis. Inset: Use a 4B pencil held on its side to make broad, soft marks and also to put in darker areas of tone.

3 Begin to develop the plant's three-dimensional qualities, while keeping in mind its overall design. Inset: Use your thumb to gently rub the 4B pencil marks so that the lines blend into tones.

4 Use a soft graphite stick and a graphite pencil to put in the darker tones. The graphite is also useful for drawing the areas of light and dark that define the shape of some of the leaves and other features.

The Finished Drawing

The use of several different qualities of line, made with a range of pencils and graphite sticks, creates a tonal richness. The strong dark marks make the light areas stand out clearly from the background. This contrast draws the viewer into the picture. Note how the drawing is successful in echoing the spirit of life and growth.

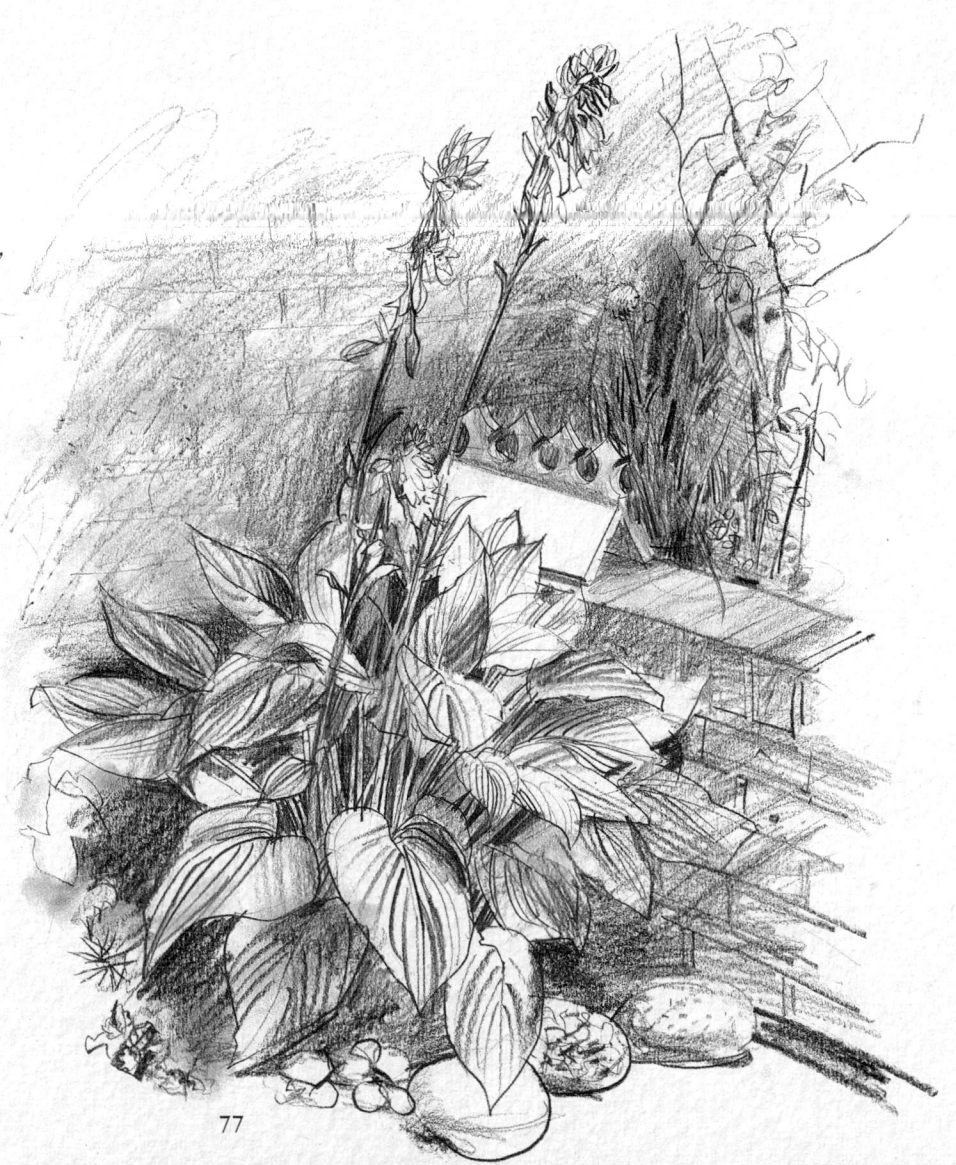

Simple Landscapes

WORKING OUTDOORS entails many practical considerations that are different from working in the studio. Any equipment that you take has to be lightweight and easily portable. Advance planning is particularly important: decide which pencils, pens, and brushes you are likely to use before you leave home, as there is nothing more frustrating than realizing that you need a different colored pencil when you are miles from home or the nearest art store. Take push pins or masking tape to secure your paper to the drawing board and prevent it from blowing in the wind.

Think about your personal comfort, too. Take a small folding stool to sit on – preferably one without arms, so that you can draw freely, with broad sweeps of the hand. If you are using an easel (see pp. 24–25), make sure that the stool is high enough for you to reach the easel comfortably. On sunny days wear a hat or try to sit at least partially in the shade to avoid getting sunburned.

Before you start drawing, check the direction of the light. It is best to draw with the light coming from your left (if you are right-handed), so that your body and drawing hand do not cast a shadow over the paper, making it difficult for you to see what you are doing.

Find a view with contrasts of scale and texture – towering cliffs above the sea or fields with furrows running in different directions, for example. Even when you have selected your subject, take time to think about how you could improve the composition (see pp. 34–35). You should try to lead the viewer's eye into the picture in some way – perhaps by showing the sweeping curve of a river or a meandering path leading up to your subject.

Often the simplest images are the most effective, so don't try to include too much in your picture. A landscape may consist of only sky, land, and a solitary tree, but even these three elements, when put together imaginatively, can produce endless variations.

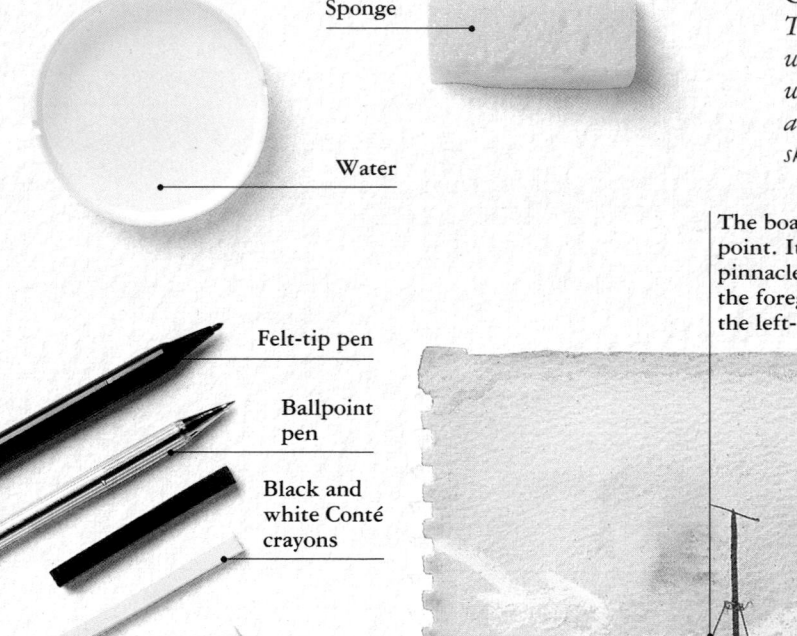

Sponge

Water

Felt-tip pen

Ballpoint pen

Black and white Conté crayons

Payne's gray watercolor paint

The basic shapes of the drawing are put in with black Conté crayon, and details are added with the Conté crayon as well as felt-tip and ballpoint pens. The strong lines of the felt-tip pen contrast with the finer lines of the ballpoint.

Gray Wash Landscape

The paper has been toned with a thin wash of Payne's gray watercolor paint. The sky occupies two-thirds of the composition, which normally creates a feeling of space, but because the hull and masts of the boat take up much of the picture area, the sky is of secondary importance.

The boat is a strong focal point. It leads the eye to the pinnacle of the mast, down to the foreground, and back to the left-hand corner again.

The neutral tone of the paper allows both dark and light marks to be seen. A white Conté crayon is used to create movement in the clouds.

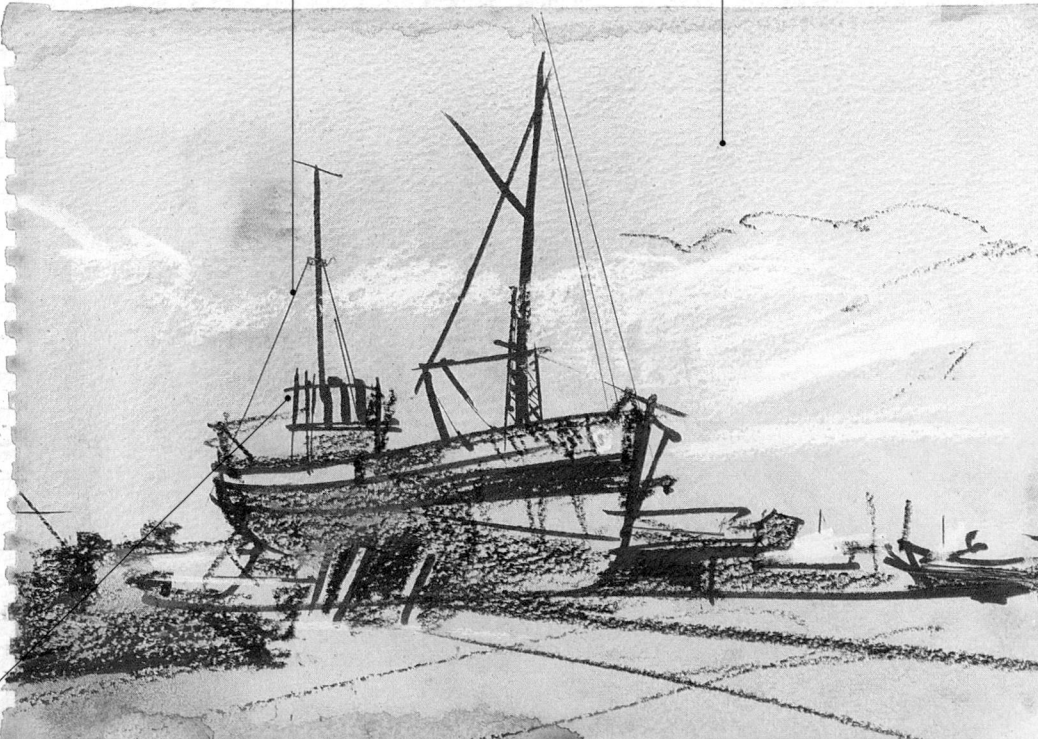

White Paper

This landscape, drawn on plain white paper, has tonal areas created with graphite powder. By increasing and decreasing the pressure exerted on the black Conté crayon, you can vary your marks. The use of red pencil adds variety and encourages the viewer's eye to move across the picture. These marks take the eye to the cliffs, along the horizon, and back to the shore. The horizontal line halfway down the picture creates a calm, peaceful feeling.

Blue Wash

The composition here emphasizes circular forms that lead the eye around and back into the center of the picture. A cobalt blue wash on the paper creates a strong, moody tone. Black Conté crayon is used to put in the main features, and graphite powder is spread with the fingertips to create the tonal masses. The use of white Conté crayon in several parts of the drawing suggests the bulk of clouds and the surface of the water.

Sienna Wash

Scale is a major concern in this landscape. The paper, toned with sienna watercolor paint, is mostly occupied by the sky. Interlocking wedge shapes in the land areas lead the eye in and across the composition. Clouds — made by dipping a fingertip into white gouache — form another wedge shape.

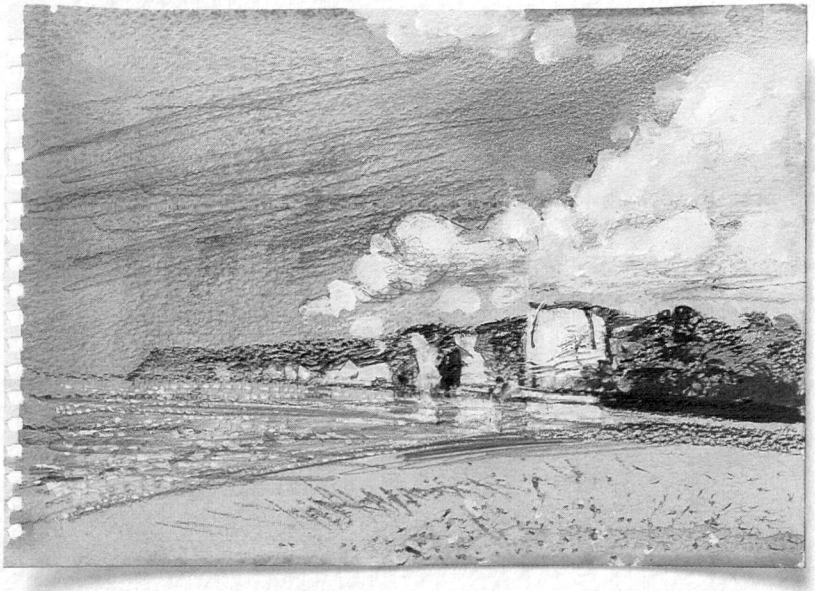

Panoramic Views

W E HAVE ALL SEEN PANORAMIC VIEWS that take our breath away through their sheer scale. "You can see for miles!" we cry. And that's the problem. You can see for miles, but you are looking at such a vast expanse that often there is nothing substantial enough for you to focus your attention on. Your beautifully drawn view can end up looking like an empty stage set waiting for something to happen.

Of course, the scale of the view is one of the things that attracts you to it in the first place, and following some simple guidelines can help you convey this. There are two things to remember: proportion and tone. Both are linked to perspective – that is, to the idea that objects appear smaller and lighter the farther away they are (see pp. 40–43). When drawing a panoramic landscape you must think about what proportion of the picture space you will allocate to foreground, middle, and far distance. Beginners sometimes divide a panoramic view into three horizontal strips of equal size. As a rough guideline – not an absolute rule – aim for a ratio of approximately 3:2:1 – that is, designate three-sixths of the picture area as foreground, two-sixths as middle distance, and one-sixth as far distance. Make the tones progressively lighter in each area, with contrast between light and dark in the foreground, a less pronounced contrast in the middle ground, and the least contrast in the far distance.

Take care to arrange objects in such a way that they lead the eye through the picture. When choosing your viewpoint, look for ways of linking the foreground and distance – such as a river winding its way into the distance. To help you determine your composition, you can make a simple viewing frame from two L-shapes of stiff cardboard. When you look at a view, hold the L-shapes in front of your eyes and overlap them to form a rectangle. You can alter the size of the rectangle in order to decide where to place the edges of your composition.

Remember that artists do not always draw landscapes as they appear in real life: a few adjustments may be necessary. You may decide to reduce the size of an area, or to move a tree or a clump of bushes forward or backward. You can even choose to delete certain elements from your composition altogether if you think that they will distract from your main subject.

One of the problems of working on a large-scale landscape is the amount of time involved. It requires long periods of concentration. Furthermore, weather and lighting conditions can change considerably, even within a short period. The Impressionists were fervent believers in working outdoors in order to document the changing effects of light on the landscape, and they learned to work very quickly. Other artists make sketches outside for visual reference and then work from these in the studio. Both approaches are valid: the choice is yours.

HB pencil

Steel-nib pen

Bamboo pen

Brown ink

Black India ink

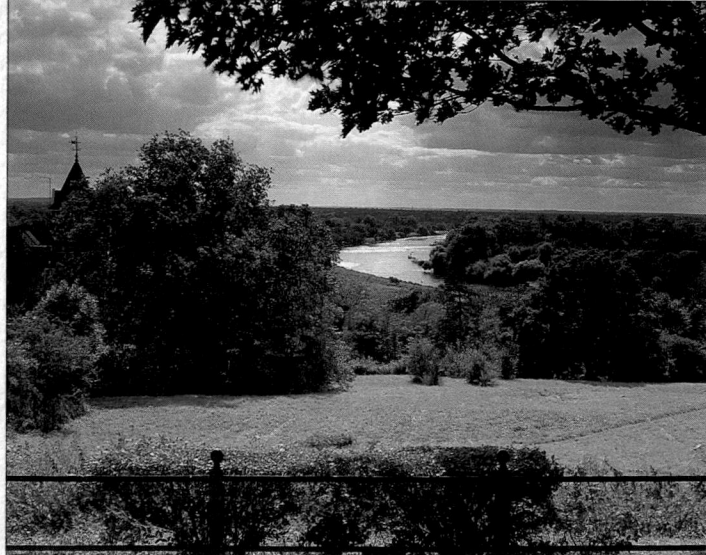

The View
This lovely vista on a bright but cloudy day reveals strong shapes and dark tones in the banks of shrubbery and trees. The clouds lie in lines parallel to the horizon and suggest a canopy over the scene.

1 *Use an HB pencil to lightly sketch the scene, placing the features carefully. Then dip a steel-nib pen in black India ink to put in details, tone, and strong lines where necessary. Don't concentrate exclusively on one area, but work across the whole surface.*

2 Now use the bamboo pen dipped in the black India ink to add tones and textures across the whole picture. Give each feature just enough detail for it to be recognizable.

3 Use the bamboo pen and black India ink to put in rows of dots and dashes to create the three-dimensional forms of the foliage. Put in the individual details in the bushes and trees.

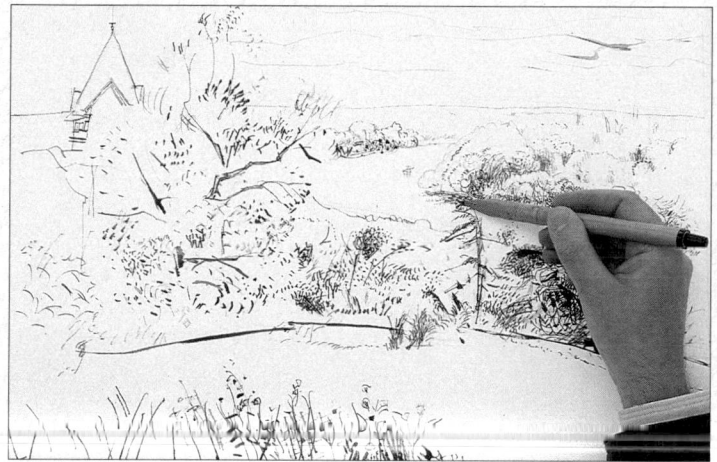

4 Now use brown ink to add further touches of detail and tone, to define the shape of the river and strengthen the character of the different types of tree. Keep a light tone over the whole scene.

5 Using a steel-nib pen, extend the row of dots and dashes to establish the bushes. Make these marks smaller and less frequent than those used to form the bulky groups of trees in front of this area.

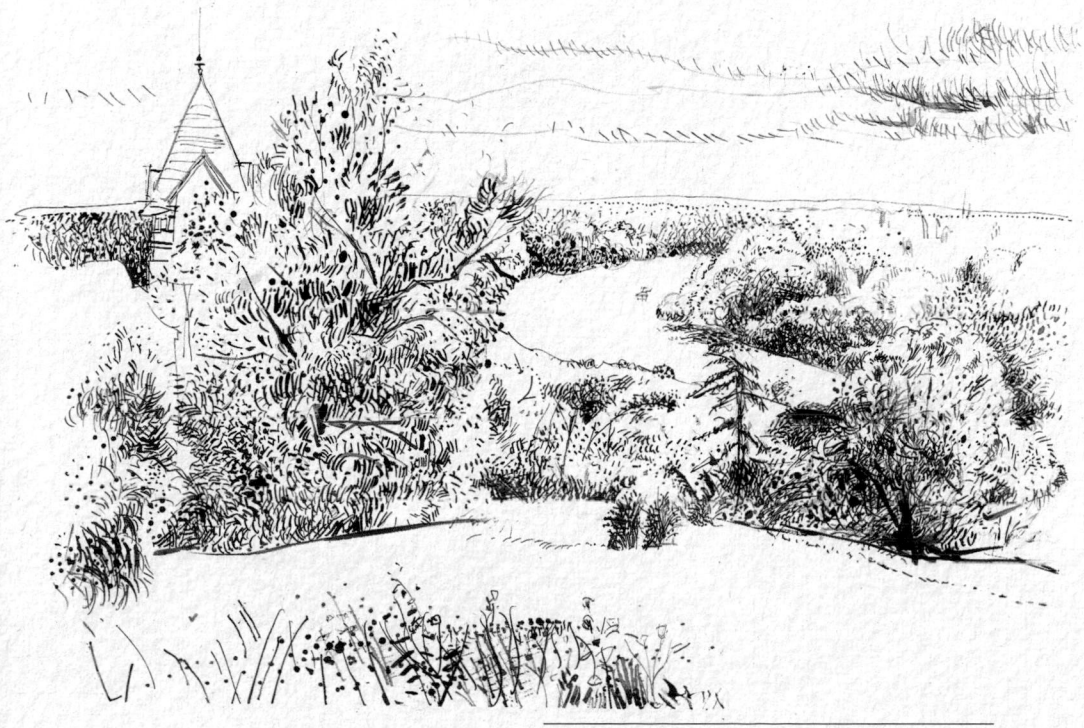

The Finished Drawing
The land mass with all its intricacies is completed with touches and strokes of ink. Dark areas are suggested by clusters of dots and marks that unite to create texture. These marks are also used to make tones — strong in some areas, subtle and delicate in others. The straight lines of the tower, with its pointed roof, contrast with the rounded forms of the trees and bushes. Enough cloud is put in to suggest both distance and the weight of the sky.

Clouds and Skies

SKIES CAN RANGE FROM the rich, bold blue of the desert to the pale skies of a cold, coastal winter; from delicate wisps of cloud drifting with the breeze to heavy, storm-laden skies that seem to weigh down on the land below. A good landscape picture almost always incorporates the sky as an important element. The English landscape painter, John Constable (1776–1837), was particularly aware of this. He made some wonderfully vigorous studies of clouds, so vivid that we can "see" the movement of wind.

Clouds are instrumental in giving the sky its character and mood, and certain materials are particularly suitable for interpreting them. By spreading graphite powder on paper with your fingertips, you can depict the movement of high clouds as they are blown by the wind. With broad general lines and marks in charcoal, you can suggest the weight of a foreboding, moody sky. Use a kneaded eraser to wipe away graphite powder and charcoal to produce highlight areas. Or, if you have to put in a sky with a watercolor wash, dampen a sponge with clean water to lift off lighter areas from a dark mass.

Always make sure that the sky works with the rest of your composition. If other elements intrude into the sky area – mountains jutting up above the horizon or strong shapes such as skyscrapers – then a simple, uncluttered sky is probably best. Conversely, if the sky is busy, with rolling cloud formations announcing an impending storm, then increase the drama of it by adopting a low eye level and allowing the sky to dominate the picture.

Because of the rules of perspective (see pp. 40–43), clouds appear largest when directly above you; they become smaller, and generally lighter in tone, as they recede toward the horizon. This shift is a useful device for indicating distance in your pictures.

Moving Sky

This drawing is made with a combination of pencil, pen, charcoal, and black India ink. Left: The paper is dampened in selected areas, and blobs of diluted black India ink are brushed on to describe the heavy, moving clouds.

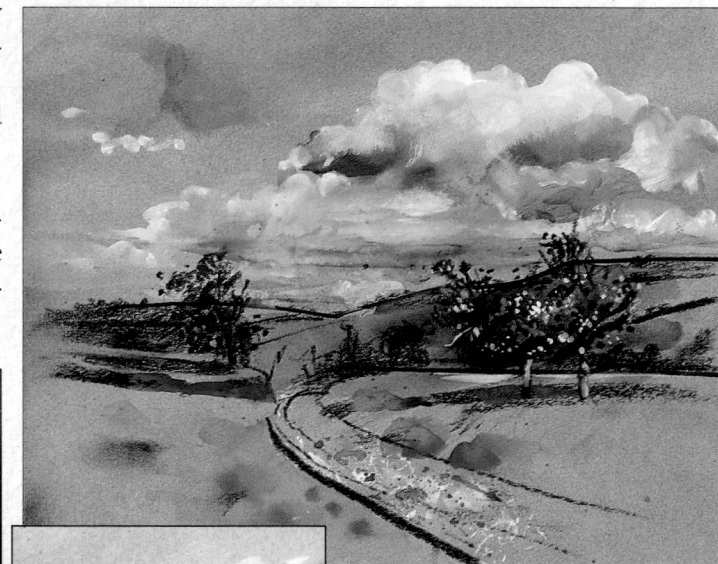

High, Stormy Sky

The drawing is done on gray paper. The land area is drawn with HB and 4B pencils. Graphite powder is used to put in the larger areas of tone. Left: The sky area of the paper is dampened with clean water and white gouache is brushed on to describe the billowing clouds.

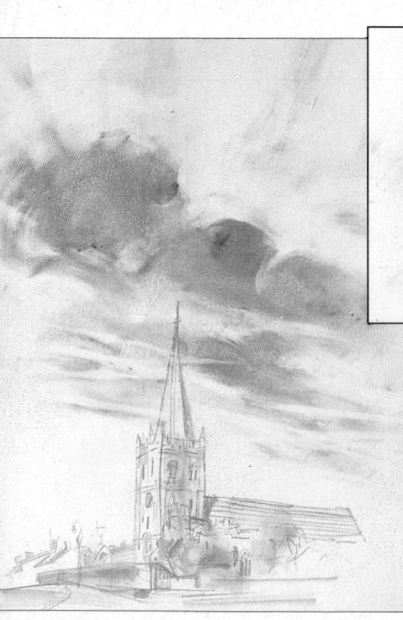

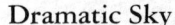

Dramatic Sky

The composition is arranged so that most of the paper space is given over to the sky area. The church is put in with 2B and HB pencils. Above: Graphite powder is spread generously over the sky area and rubbed in with the fingers and thumb.

A Cloud-flecked Sky

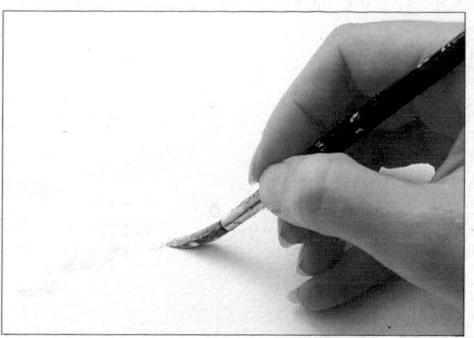

1 *Having sketched the scene using a black Conté crayon and an HB pencil, dip a no. 6 brush in masking fluid, and apply a series of short marks to the sky area to imitate the dashed appearance of the sky.*

2 *Allow the masking fluid to dry. Dip a piece of sponge in clean water and thoroughly dampen the entire sky area.*

3 *With the sponge, spread a wash of diluted black India ink across the dampened area. Turn the paper upside down so that the wash does not run down onto the land area.*

4 *Before the paper dries, use the sponge to put in smaller, more concentrated areas of tone to describe the shape of the clouds.*

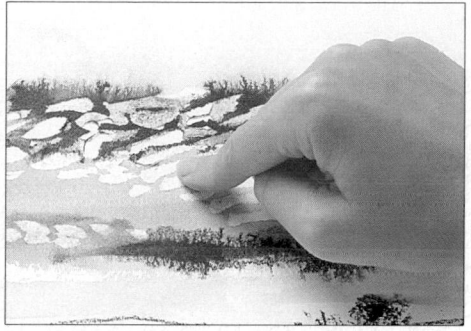

5 *When the ink washes are absolutely dry, turn the paper the right way round and remove the masking fluid by gently rubbing it off with your finger.*

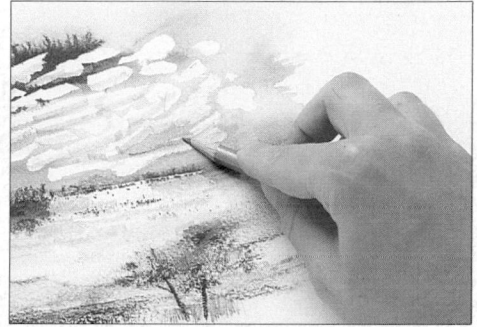

6 *Now use an HB pencil on its side to add tones and richness to the sky area, creating a three-dimensional quality.*

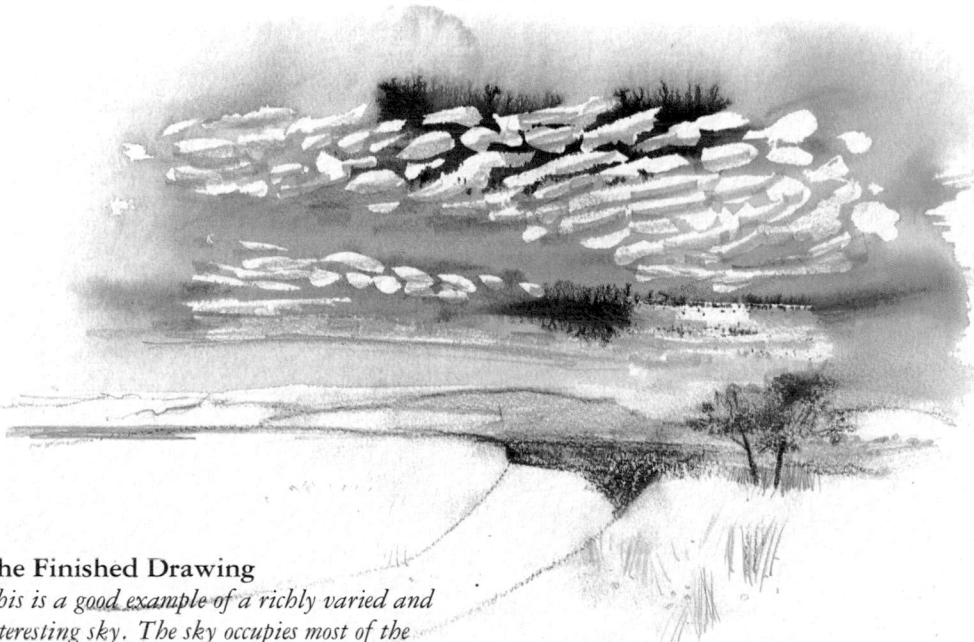

The Finished Drawing
This is a good example of a richly varied and interesting sky. The sky occupies most of the picture area, but the land is also important. The sweep of foreground complements the sky's shape. Different textures are provided by the use of Conté crayon and pencil work. The lines, washes, and tones combine to make a work full of atmosphere.

Black Conté crayon

HB pencil

No. 6 brush

Black India ink

Sponge

Distilled water

Masking fluid

Seascapes

SINCE TWO-THIRDS of the earth's surface is covered by water, it is not surprising that there is a long tradition of drawing and painting the sea. Some artists have gone to extraordinary lengths to make their marine paintings as atmospheric as possible: J. M. W. Turner (1775–1851) supposedly had himself tied to a ship's mast to experience a storm at sea and commit the spirit of it to his memory in order to paint the picture below.

The great fascination of the sea is that it is constantly moving – and changing. Speedy drawing is essential. You should also use a medium that enables you to cover the paper quickly – pen and wash or charcoal are ideal. Try to anticipate what will happen. Concentrate on a small area and watch how the waves break on the shore. You will soon recognize a rhythm – a crash, followed by a longer period of relative quiet as the water ebbs back into the sea.

But if the rhythm is regular, the movement itself is not. Look at how the water is forced to flow around large obstacles such as rocks. See the undulating line that marks where the wave hit the beach. Try to fix these rhythms and irregular movements in your mind before you start drawing.

Look for the shape of the movement. A rolling wave, for example, is basically a tubular form rolling back over on itself. Use a shoreline feature such as a boat or a tree as a point of reference to gauge the height of the waves.

To convey a three-dimensional feeling, try combining different pencil and shading techniques in the same drawing – perhaps a 4B pencil for the heavy shadowing under rolling waves with an HB pencil for the curved top of the waves. Vary your pressure on the pencil for different tones.

Above all, try to convey a sense of energy. Aim to capture the spirit and force of the sea rather than to produce a photographically accurate representation.

"Snow Storm: Steamboat off a Harbor's Mouth,"
J. M. W. Turner, 1842
The sense of movement allied to the violent, powerful mood of this masterpiece is typical of Turner's later works. Turner made a great many drawings and watercolor paintings of the sea in all its moods.

Dangerous Waters

Strong strokes of soft charcoal create the rolling waves, and a kneaded eraser is used to pick out the foam on top of them. A similar technique is employed in the sky, but the tones are lighter and their removal with the kneaded eraser is much less obvious. The cloud shapes are created by gently rubbing with fingers to lighten the thin layer of charcoal.

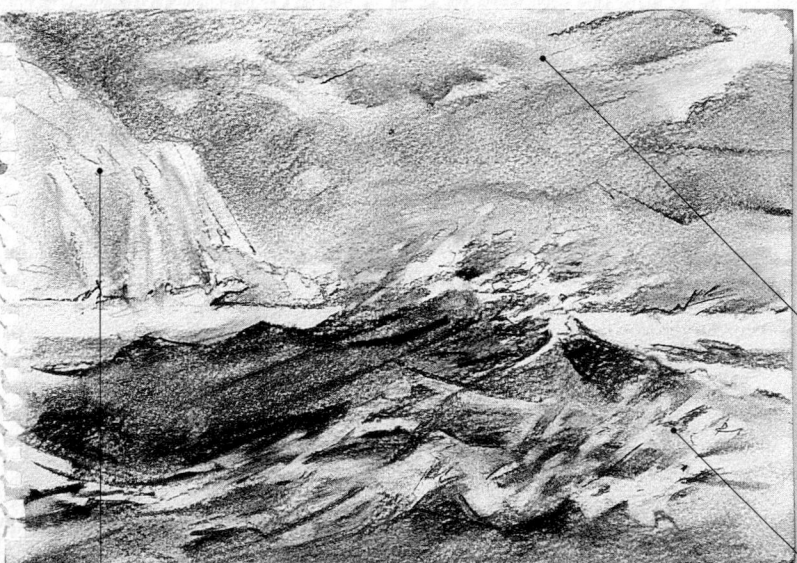

The lighter-toned parts of the sky are created by using the kneaded eraser to rub out the areas of charcoal that run along the upper parts of the clouds. The movement of the clouds reflects the feeling of motion seen in the waves.

The shapes of foam on top of the roaring waves are carefully picked out with a kneaded eraser.

The large diagonal cliff face, towering in from the top left-hand corner, leads the eye down to the sea. A diagonal such as this creates a sense of movement and urgency.

Charcoal

Kneaded eraser

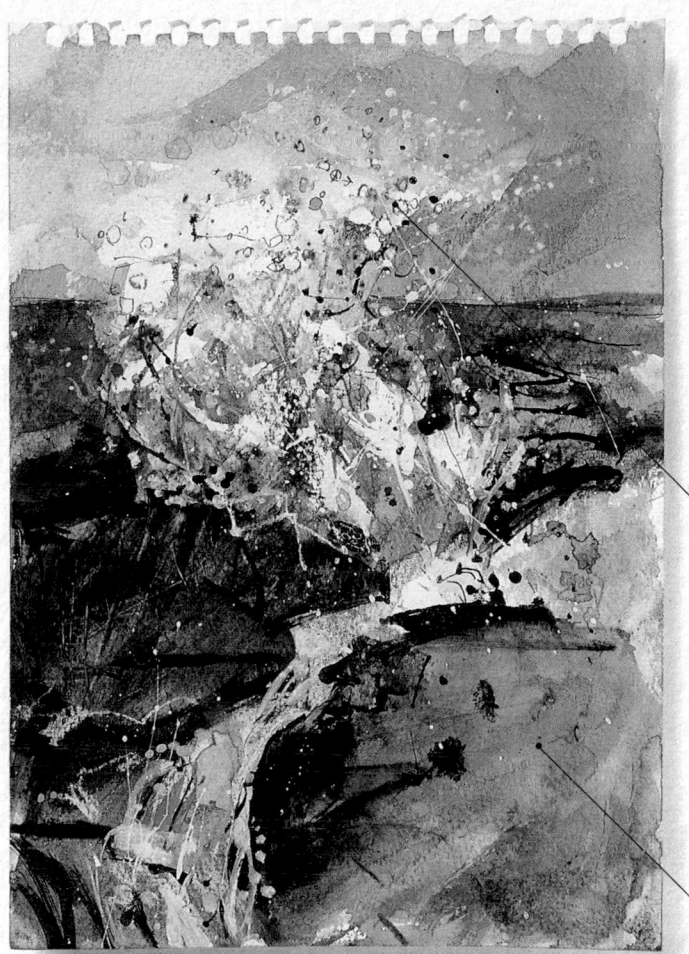

Waves on the Rocks

This sketch conveys the energy of the crashing waves bouncing off rocks. The rocks and sea are drawn with pen, black India ink, and cobalt blue and burnt sienna watercolor paints. The foam is created by dipping a no. 4 brush in white gouache and then spattering it onto the paper. A steel-nib pen dipped in the ink is used for line and to create stippling.

White gouache spattered onto the paper brings a sense of energy and immediacy to the drawing.

A diluted mixture of cobalt blue and burnt sienna water-color paint is applied to the paper in a random way, giving the paper both texture and tone.

Cobalt blue watercolor paint

Burnt sienna watercolor paint

White gouache

No. 4 brush

Steel-nib pen

Black India ink

Distilled water

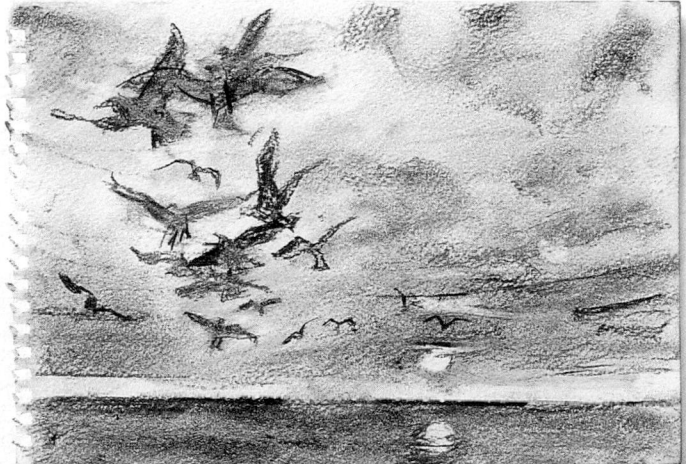

Low Horizon

A column of seagulls traveling down from the top of the paper to the horizon line of the sea is the focal point in this drawing made with charcoal on white textured paper. The small globe of the sun provides a counterbalance to the mass of birds on the left of the drawing and its reflection adds interest to the water. The clouds form a canopy over the sea. Their darkness accentuates the sun's bright gleam. The busy sky shapes in black and white create a feeling of movement and activity in contrast to the calm of the sea.

Shoreline

A diagonal shape travels down from the top left-hand corner of the paper to the cliffs where it meets the strong horizontal line of the sea. From the lower left-hand corner, the curve of the sea leads the eye to the focal point — the group of rocks breaking the surface of the water and the face of the cliff beyond. All this is drawn in charcoal on paper toned with a thin wash of cobalt blue watercolor paint. White gouache is used to pick out highlights and add extra interest and texture to the surface.

Interiors

NEVER OVERLOOK THE OBVIOUS when you are choosing a subject to draw. What seems commonplace, even boring, to one person can be exciting to another. Edouard Vuillard, a great 19th-century French painter, made magical pictures from what might seem at first glance to be the most unpromising material – simple, everyday domestic views. Indeed, the name of the group of painters to which he belonged – the Intimists – reflects this content. These artists invariably depicted ordinary, intimate interiors from their everyday lives. They showed that even something as mundane as a bathroom mirror and shelf or a fireplace can be transformed into an original and attractive painting. You, too, can create poetry from the prosaic if you keep your eyes open to possibilities.

Drawing one of your own rooms is a useful exercise. It may surprise you to discover how different things can look when you set about viewing them with a totally fresh eye and drawing them on paper.

Start by selecting a corner of a room or a cupboard, and try to imagine that you have never seen it before. We all have objects of sentimental value in our homes – photographs, ornaments, books, things people have given us as presents. To draw them successfully, it often helps to begin by trying to discard these emotional associations and see the objects simply as shapes and tones. A good way of doing this is to look at them with your eyes half-closed, so that the details are less distinct.

Drawing something just as it is, without moving or adjusting the various elements of the composition, is a useful exercise in picture making. It forces you to be inventive if you want your picture to be something other than a straight "record." You will have to experiment with different viewpoints and eye levels to get the best composition from the scene you have chosen. Start by trying out different approaches in a sketchbook (see pp. 26–27).

One of the advantages of drawing a domestic interior, however, is that – unlike landscape drawing – it is relatively easy to move things around in order to make a composition that you like. But resist the temptation to make everything neat and tidy – magazines scattered on the floor, an open book, or a cup of coffee on the table all contribute to the atmosphere of a room and tell you something about the person who lives there.

Room with a View
Although the fire and mirror occupy a large area of the room, it is the bookcases, with their brightly colored books and ornaments, that dominate this part of the room. It is a structured, fairly formal arrangement, with lots of interesting detail to explore.

4B pencil

2B pencil

HB pencil

Graphite pencil

Plastic eraser

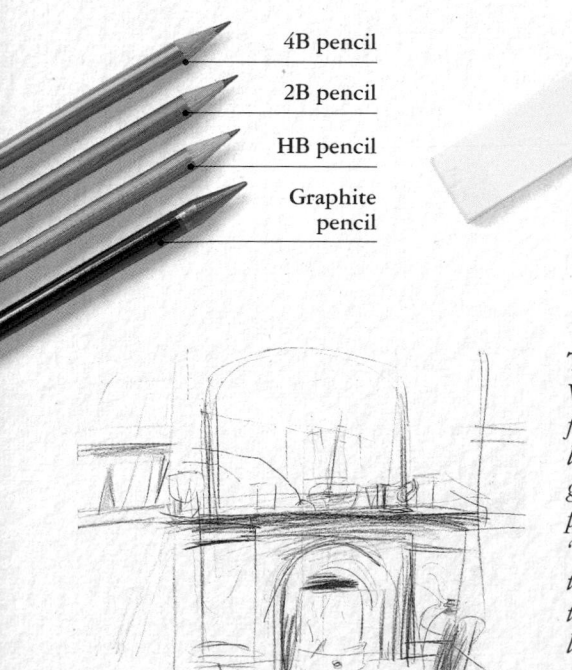

The "Rough"
With something as familiar as your own living space it is a good idea to make a preliminary sketch or "rough." Planning the composition in this way helps you to look at the scene with an objective eye.

1 *Use an HB pencil to make a broad, generalized interpretation of the scene. Decide what is to be kept or eliminated and where the emphasis will be. The emphasis here is on the fireplace and the mirror.*

2 Emphasize the main vertical and horizontal structures. As in the previous stage, use the pencil across the whole area of the drawing. Inset: Put in the dark areas of tone using a graphite pencil.

3 Use a 2B and a 4B pencil to give the structural lines in the shadowed areas more definition. The denser tone and stronger lines will help to create a convincing three-dimensional effect.

4 Use all the drawing tools to complete the full tonal and linear inter-pretation of the scene. The combination of rich, broad lines and finer pencil marks, with their variations in tone, makes this an interesting picture that has a sense of depth.

5 In the final stages, create lighter areas where necessary by using a plastic eraser to remove the grays of the pencil marks to reveal the whiteness of the paper beneath (see pp. 50–51). The shapes of the flames can also be made in this way.

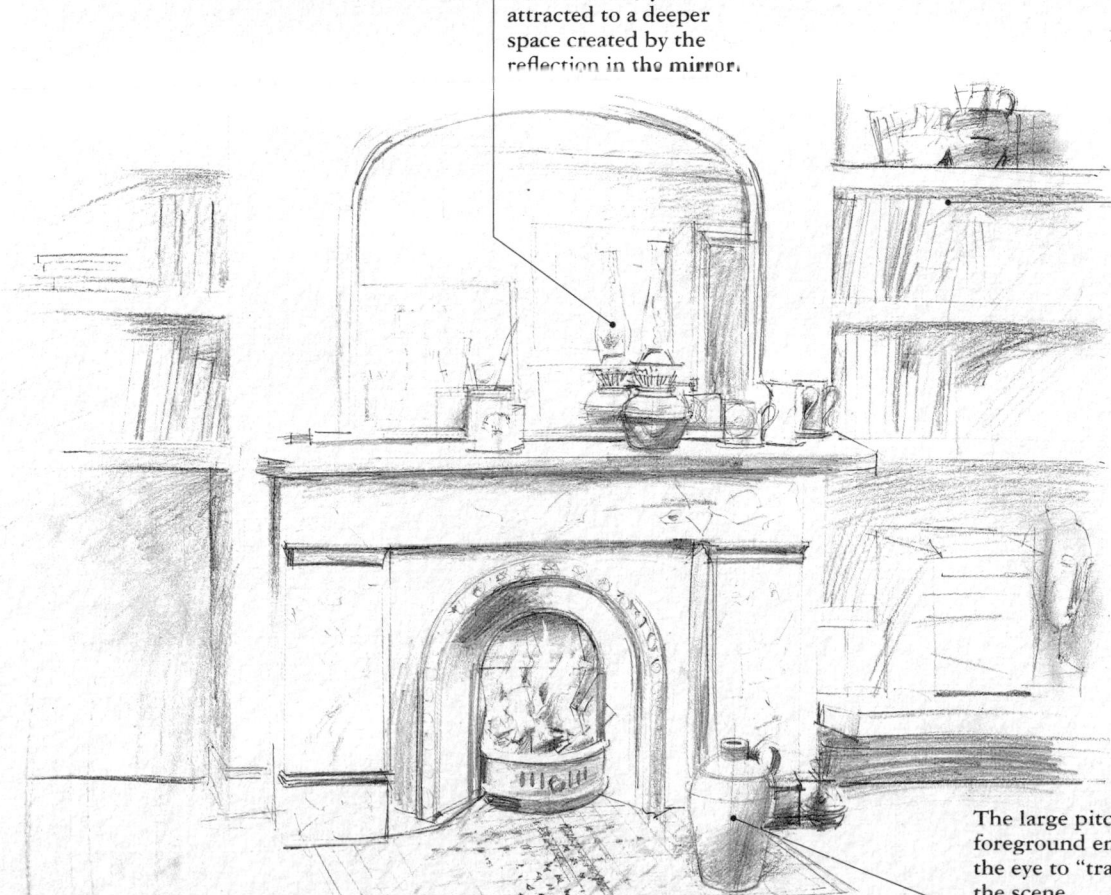

The viewer's eye is attracted to a deeper space created by the reflection in the mirror.

The bookshelves are used to give the fireplace an interesting and varied frame.

The Finished Drawing
The solidity of the marble fire-place and the finer details of the hearth combine to produce a subtle drawing full of interest. The gentle angle of the mirror adds dynamism to the reflection without disturbing the solid and gracious overall feeling of the drawing.

The large pitcher in the foreground encourages the eye to "travel" into the scene.

Townscapes

ALTHOUGH THE DEMONSTRATION on these two pages shows an archetypal view of Venice, you can readily find good subject matter from your own windows or on a visit to a local town or city. Don't be too ambitious to start with. Buildings can be quite difficult to draw, and it is better to start with a relatively simple scene – a store front or a single building – than a whole street. As you become more experienced, you might try including figures in your drawings. Towns are as much about the people who live there as the buildings.

It is perhaps better to think of a townscape as an "urban landscape" than as a distinct subject in its own right. There are many similarities between drawing urban and rural landscapes. With both, if you are working outdoors rather than from a photograph, you have to cope with the unpredictability of the weather. Both require easily portable equipment (see pp. 24–25). Both are likely to offer an enormous range of potential pictures in any one scene and your first step should always be to spend time deciding on the best viewpoint and eye level. A viewing frame, which you can make yourself from two L-shapes of stiff cardboard (see p. 80), can help tremendously.

Find a comfortable place to draw. Setting up your easel on a public street, under the gaze of passersby, can be a daunting prospect. A quiet window seat in a café, or a park bench, is just as good. You will also attract less attention if you surreptitiously jot down ideas in a sketchbook so that you can work them into finished drawings later.

The major difference from a rural landscape is that, for any drawing that features buildings, you need to have at least a basic knowledge of perspective (see pp. 40–43). As buildings are composed largely of parallel lines, you need to think very carefully about the implied vanishing points. You should always lightly sketch in a line to indicate your eye level (the horizon). Then you can work out the angles of the converging lines in relation to it and find the vanishing point on that line. But remember that the perspective will change if you alter your viewpoint or eye level – so if you stop for a break halfway through your drawing, make sure you come back to exactly the same place.

"The Grand Canal, Venice," Antonio Canaletto
The buildings receding into the distance draw the viewer's eye through the picture. Countless details contribute to a scene of everyday life.

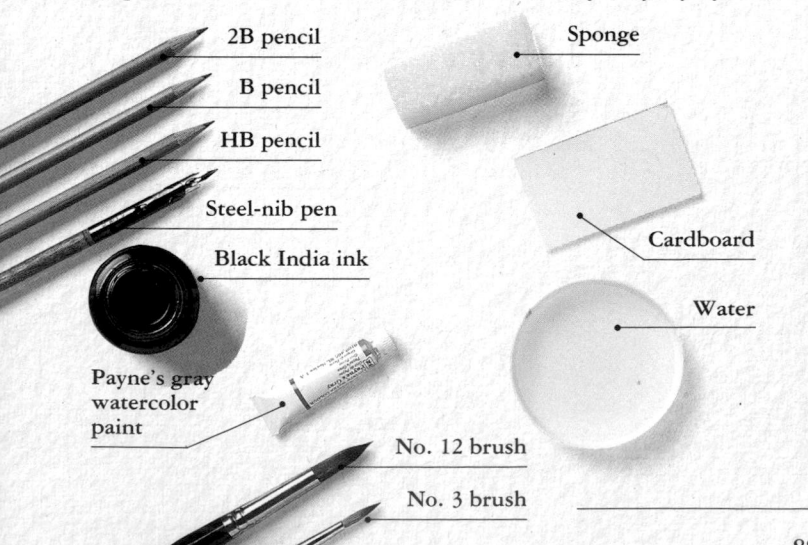

2B pencil
B pencil
HB pencil
Steel-nib pen
Black India ink
Payne's gray watercolor paint

Sponge
Cardboard
Water
No. 12 brush
No. 3 brush

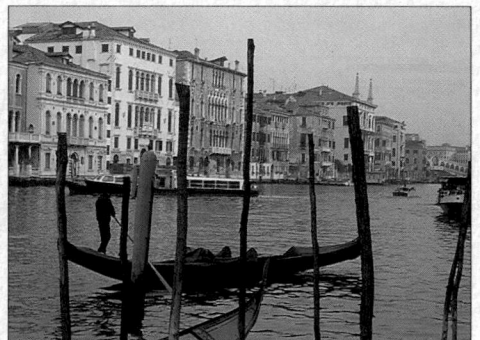

City of Riches
Venice offers rare beauties wherever you focus your eyes. Here, a broad view along the Grand Canal is selected as the main feature of the drawing.

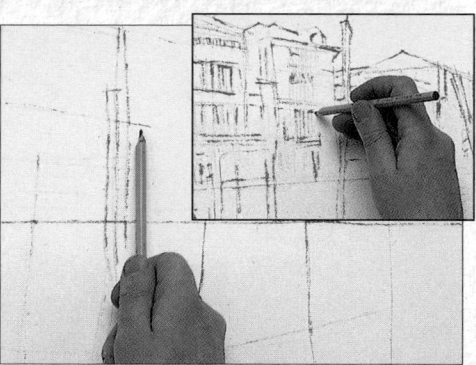

1 *First, use a pencil to judge the relative scales of the various buildings and foreground features (see pp. 36–37). Inset: Use an HB pencil to sketch in the whole scene.*

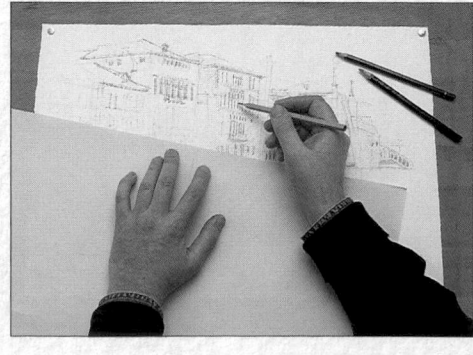

2 *Place a clean sheet of paper over your work to prevent your hands from smudging the pencil marks as the drawing progresses. Use B and 2B pencils to put in the stronger, broader lines and the darker tones of the buildings.*

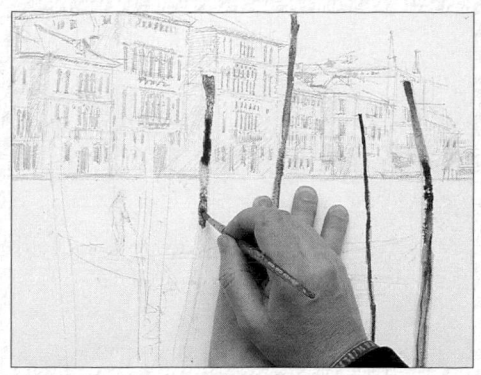
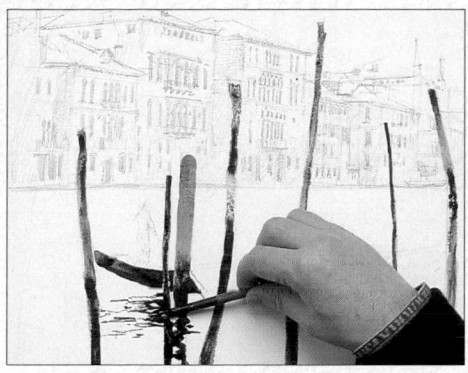
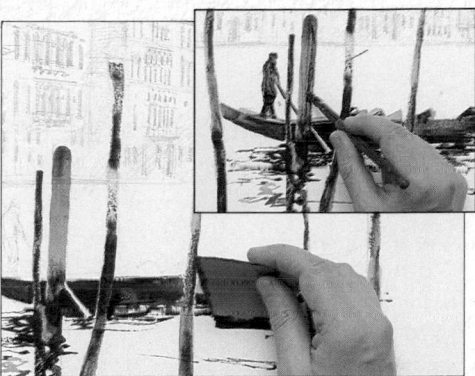

3 When satisfied with your sketch, use a no. 3 brush dipped in a strong wash of Payne's gray to draw the mooring posts and the other main forms. Wait for each wash to dry before applying the next.

4 Once the last wash has dried, use the back of the pen dipped in black India ink to introduce contrasting texture and bring a light touch to the reflections of the gondola.

5 Cut out a cardboard rectangle 4 in x 3 in (10 cm x 7.5 cm). Soak the edge of it in a more diluted wash of Payne's gray, and use it to print the ripples of the water. Once dry, use the pen again to add details.

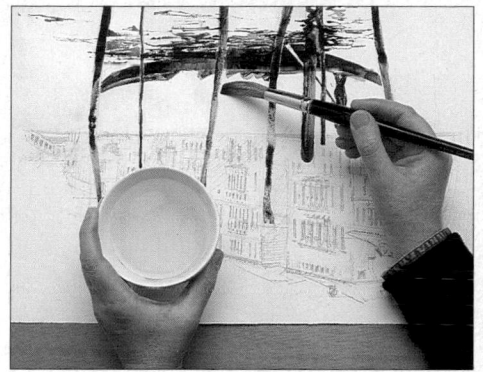
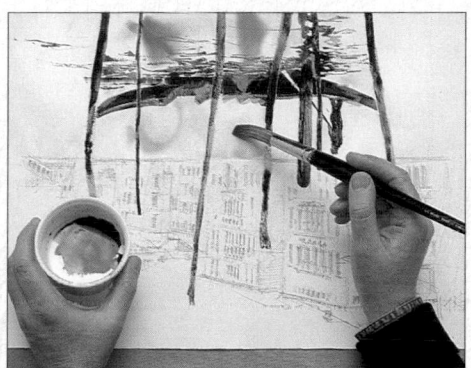
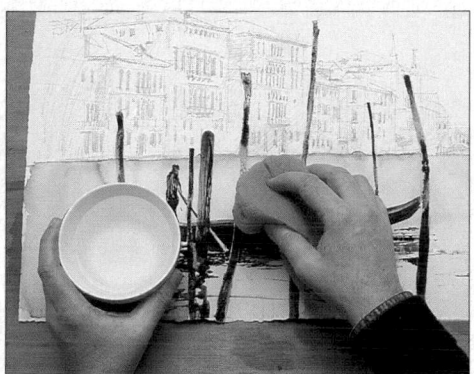

6 Turn the paper 180 degrees, and dampen it with clean water. Dip the no. 12 brush in the Payne's gray wash, and draw the reflections. Tilt the paper so that the wash trickles down, creating the appearance of flowing water. Put masking tape on the paper or use blotting paper to stop the wash from going too far.

7 Once the darker washes of the gondola and mooring post and the details in ink have dried, you can apply the light Payne's gray wash for the canal. Wait until the wash is fully dry before you work over it as this will ensure that it looks fresh.

8 Now turn the paper back to the original working position for a final appraisal. If some areas seem to be too heavily toned, dip a clean sponge in fresh water, squeeze it almost dry, and gently wipe out some of the wash.

The Finished Drawing
The finished picture combines the detail of fine pencil drawing with the subtle use of a watercolor wash and rich ink work.

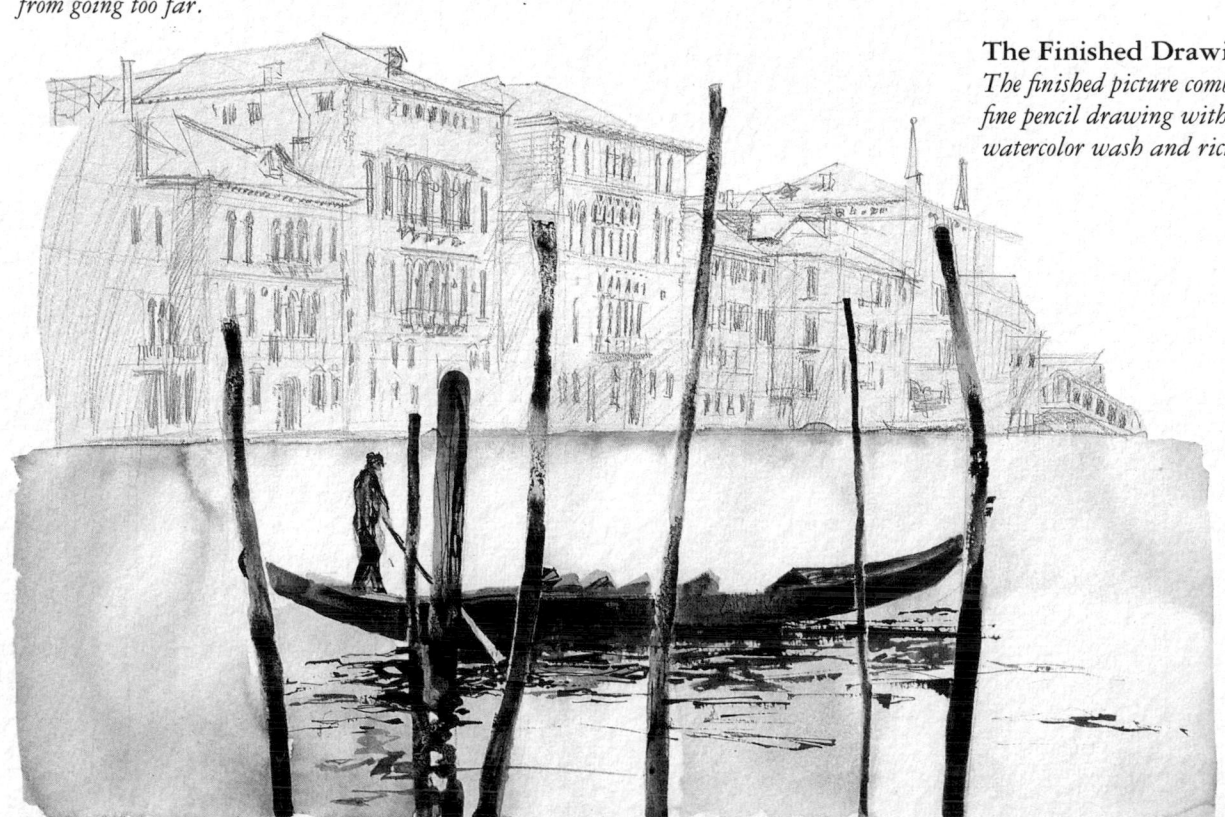

The light Payne's gray wash creates naturally varying tone, which imitates the flow of water, as opposed to the solid tone of the buildings, mooring posts, and gondola.

Architecture

FROM CLASSICAL GREEK TO POST-MODERNIST, few things reflect a historical period more than its architecture. Each country has its unique styles, too. A Mexican *hacienda* looks very different from an English manor house, even though the building's original function was the same in both cases. Whether you are on vacation and want to capture local color or are simply trying to see your hometown with a fresh eye, put what you see down on paper.

Think carefully about the original architect's intentions before you start drawing, and try to make sure that something of the same feeling comes through in your own work. When designing St. Paul's Cathedral, shown on these two pages, one of Sir Christopher Wren's aims was to convey a sense of reverence, just as the scale was intended to create a feeling of awe. An apartment block or a small country cottage would invite a very different response.

Consider also the context. Should you isolate the building from its surroundings through your choice of viewpoint or by deleting extraneous features? Or should you

HB pencil

incorporate other features to establish the environment? Think about these issues before you start work. There is nothing more frustrating than finding that a different approach would have served your drawing better – especially when the work is almost complete.

The first thing to decide is what viewpoint to draw from. Unless your intention is to produce a detailed record of the façade, it is rarely a good idea to draw a building head-on, as this tends to make it look flat – more like a painted piece of scenery for a very amateur theater production than a three-dimensional structure. Instead, move around slightly so that you can see two sides of the building. Including another feature – a lamppost or a tree, for example – in front of or behind your chosen building is another way of giving an impression of depth.

The eye level that you choose is also important. You can make an exciting picture by adopting a low eye level to draw a very tall building – through a curious optical effect, the building will appear to be toppling over. Or you could try looking down on the rooftops of neighboring buildings from a high vantage point such as a skyscraper or high-rise apartment building.

Whatever viewpoint and eye level you choose, bear in mind the basic principles of perspective (see pp. 40–43). Getting the perspective right is crucial to making your work look convincing.

Finally, think about the most appropriate angle of light. In the middle of the day, with the sun directly overhead, few shadows are cast. Buildings drawn in this light can look flat and two-dimensional. The best times of day to draw are early in the morning and late in the afternoon, when areas of light and shadow are distinct. A clear contrast between light and dark areas is a classic method of conveying form and creating a three-dimensional effect (see pp. 52–53).

St. Paul's Cathedral
Rich, solid, and impressive – St. Paul's Cathedral in London is one of the best-known buildings in the world. Taking advantage of the different levels of towers, spires, and domes, as well as other features, is a useful way of beginning to interpret such a building.

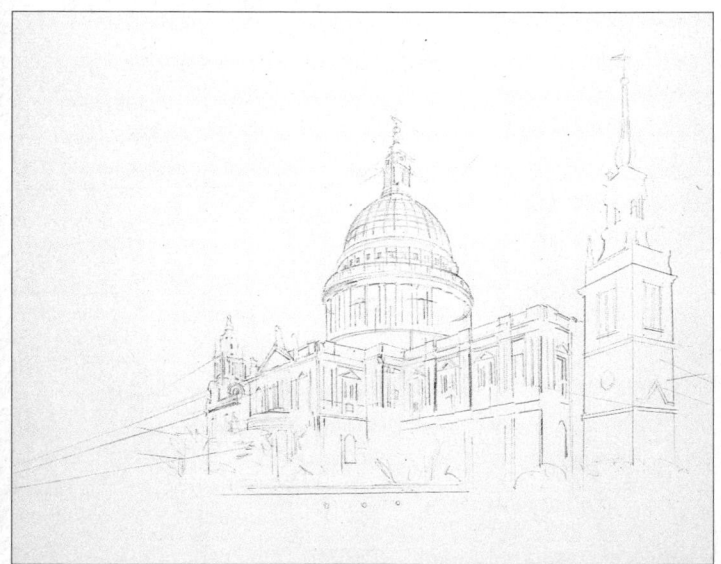

1 *Use an HB pencil to sketch in the basic construction – the strong, dynamic line of the building's silhouette is a great help. Draw the ellipses throughout the entire dome, making sure that they relate correctly to one another (see p. 41).*

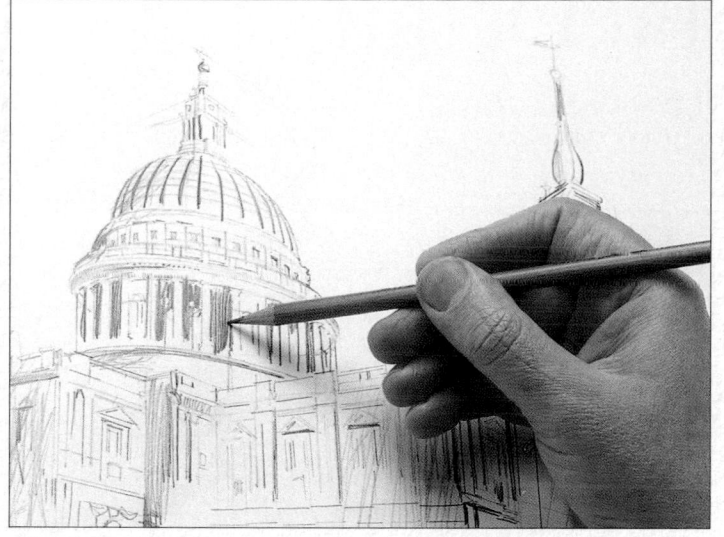

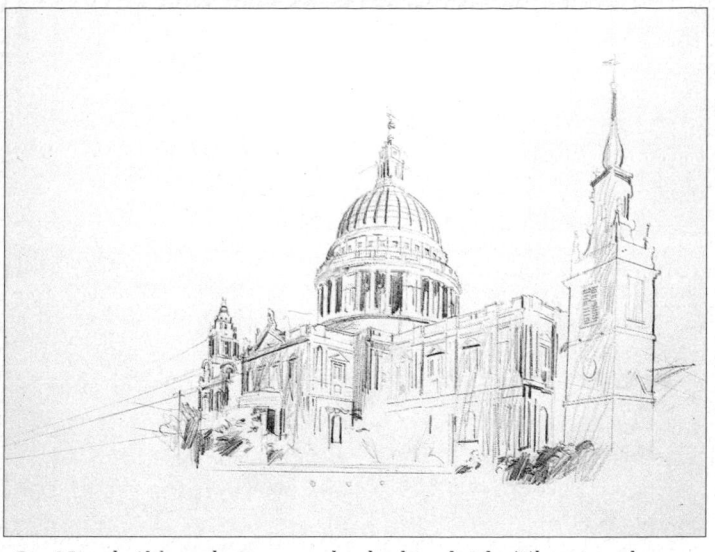

2 *Put darker tones into the shadowed areas between the columns around the upper story of the great dome. You don't need to change to a darker, softer pencil to do this – simply put greater pressure on the one you are using.*

3 *Now build up the tones on the shadowed side. There is a danger that such an elaborate subject could disintegrate into a series of finely detailed vignettes, but the use of tone across the whole drawing can help to unify the composition.*

The Finished Drawing

The rich tones and textures of the foliage that surrounds the building are put in at the end. The finished drawing shows a solid structure rising heavenward like an aspiring soul. The square tower at the right of the building is a very important final touch, leading the eye through to the main bulk of the cathedral. Emphasizing the baseline provides a firm foundation for the building.

The cross cuts into the skyline, offering a contrast to the massive bulk of the dome and creating a varied and interesting silhouette. Fine pencil lines are appropriate here.

The solid tower in the foreground helps to lead the eye into the picture and makes for an interesting composition and skyline. Putting in darker tones adds emphasis.

Strong dark tones at the base help to underpin the whole building.

Architectural Details

ARCHITECTURAL DETAILS can be structural (arches or columns) or purely decorative (gargoyles on the great medieval cathedrals of Europe or the exquisite tilework of the Blue Mosque in Istanbul). Even on small-scale domestic buildings there are countless interesting details. Porches, differently shaped windows and doors, doorknobs, and letterboxes: the list of potential subjects is almost endless.

A sketchbook is ideal for drawing architectural details. You can carry it around in your pocket and jot down interesting motifs wherever you happen to come across them. Rather than drawing details in isolation, try combining several features from the same building close together on the same page, to capture the essence of the building.

Sometimes architectural details are an integral part of the building as a whole. Although their basic appearance can vary considerably depending on when they were constructed, arches and columns, for example, are generally there to support the weight of the building, rather than for

HB pencil

decoration. If this is the case, then it is a good idea to imply that the drawing continues past what you have drawn on the paper. If you are drawing a door, for instance, draw it half open to hint at what lies beyond. Choose a viewpoint that allows you to convey a three-dimensional effect. Standing slightly to one side is usually best. Shading and tone are obviously important here, and you should choose the technique that best suits your subject.

Perspective, too, is something to consider (see pp. 40–43). If you are drawing a half-open door, for example, the line you use to indicate the top of the door will slope downward if the door is opening away from you, but upward if it is opening toward you. The bottom of the door will slope in the opposite direction. You should also think about how your viewpoint affects the shapes you are drawing: when sketching an arch or a dome, make sure that you draw the ellipses accurately.

Some subjects are best interpreted from a flat frontal viewpoint. This is generally the case when you want to concentrate on surface decoration rather than form – the sharply incised lines on a Corinthian column, for example, or carved reliefs on the tomb of an Egyptian pharaoh.

Subjects such as molded plasterwork fall somewhere between these two approaches. A head-on viewpoint allows you to investigate the intricate detailing on the surface, while tone and shading can be used to reveal the slightly raised profile of the molding.

Both the time of day and the direction of the light are crucial in emphasizing three-dimensional qualities (see pp. 52–53). Early morning and late afternoon light is ideal for revealing form.

Viewpoint

Selecting the viewpoint from which to draw is always important. Try different approaches until you are satisfied that you have found the right one. Use a low eye level for objects with features you want to emphasize or amplify; use a normal eye level for quieter investigatory studies.

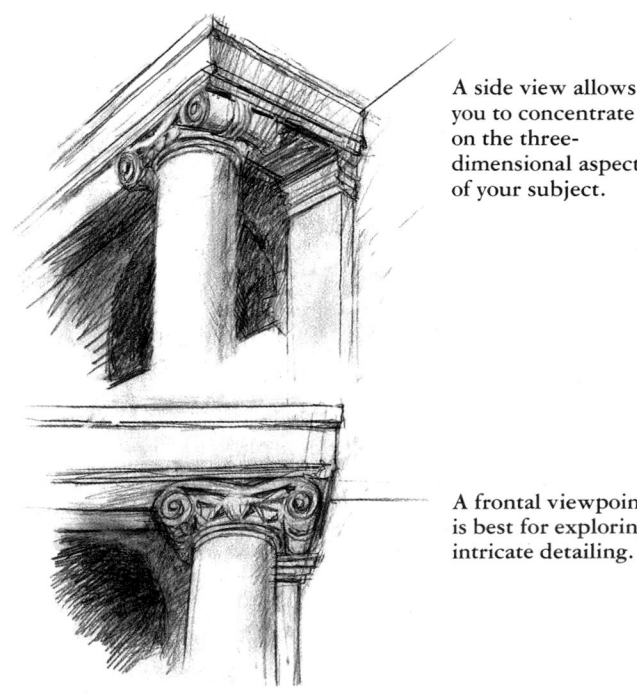

A side view allows you to concentrate on the three-dimensional aspect of your subject.

A frontal viewpoint is best for exploring intricate detailing.

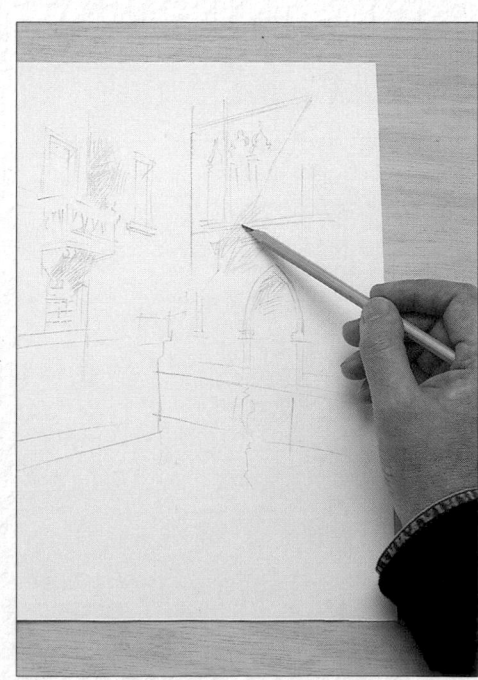

1 *Holding the pencil loosely near the top for a flowing, unrestricted movement, follow the lines of the general view. To start, put in only the most basic lines. These will form the understructure of the building and allow its interrelated angles to show through.*

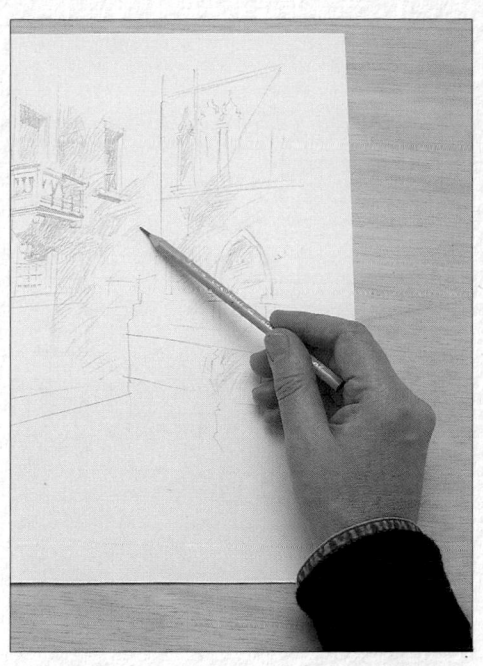

2 Put in the main structural sketch very lightly. Do not give any one part too much detail, but take care to indicate the relative positions of the columns of the balustrade and the angles of the two inter-relating buildings. This use of simple perspective gives the building a solid feeling and allows decorative details on the surface to be described convincingly.

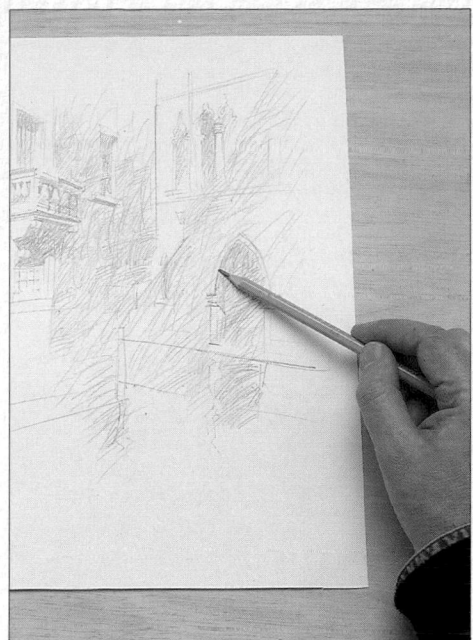

3 Holding the pencil loosely between your thumb and forefinger, carefully assess where tones are needed and put them in. To make sure the areas of tone relate correctly to one another, half-close your eyes. This tends to let you see the different areas of light and dark more clearly. Apply the tones with random lines, creating a general area of gray, but also retaining some liveliness within it.

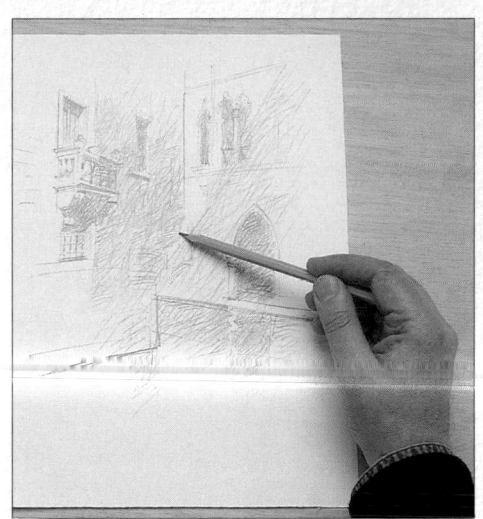

4 As before, work across the whole surface, never finishing one part before another. In this way you will enhance the feeling of unity — making all the different aspects of the scene fit together in harmony.

The Finished Drawing

The continuous, yet lively, tonal areas create an atmosphere that seems appropriate for the subject. The eye can travel across the surface, but it can also pause to examine the rich details. Note how the more heavily toned areas balance one another, so that no part of the wall stands out unrealistically. The whole drawing is anchored by the strongly drawn lower line, at the point where the buildings rise from their foundations, out of the canal.

Self-Portrait

S OME OF THE MOST TREASURED PICTURES in the history of painting are self-portraits. They suggest the character of the artist and, through period costumes and background details, give insight into the world he or she occupied. Rembrandt and Vincent van Gogh, for example, are renowned for their series of self-portraits, which show them at different times in their lives.

Self-portraits are a good subject for anyone interested in figure drawing and portraiture for several very practical reasons. The first is that you can use it as a way of building your confidence. When you first start drawing, the thought of asking someone to pose for you can be intimidating. Second, you are guaranteed to find a model who will sit still for as long as you like! Finally, it is an interesting challenge: we all tend to think we know exactly what we look like, but drawing a self-portrait involves looking at yourself very intensely. You may discover features and expressions you hadn't previously noticed.

The traditional way of drawing a self-portrait is to set up a mirror at a height that allows you to see your reflection comfortably from where you are working. One problem with this method is that by drawing your reflection you are really seeing your face in reverse. This is how we see ourselves, but it is not how other people see us, so to others the picture may not seem an exact likeness. To overcome this, some artists use a double mirror setup: they draw a reflection of a reflection, thus reversing the image back to the way it is normally seen by others.

2B pencil

Self-Portrait at the Age of 63 by Rembrandt
This picture was painted in 1662, toward the end of Rembrandt's life – he died in 1669. Typical of his work, the soft use of light and dark – called chiaroscuro – focuses attention on the face.

The Looking Glass
Looking into the mirror, the artist experiments with the angle of view – head tipped or lifted – and with expressions.

1 *Using a ruler and a felt-tip pen, he marks the top and right-hand side of the head on the mirror so that he can always get his head back in the same position.*

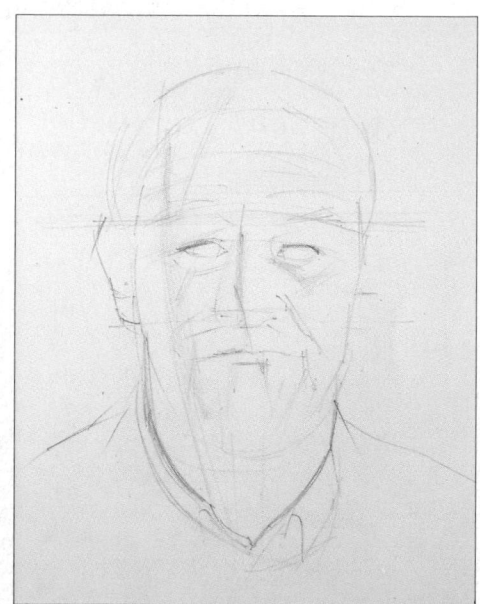

2 *Using a 2B pencil, the artist sketches in facial features, making sure that the eyes are balanced on either side of the central line that runs from the top of the head to the chin.*

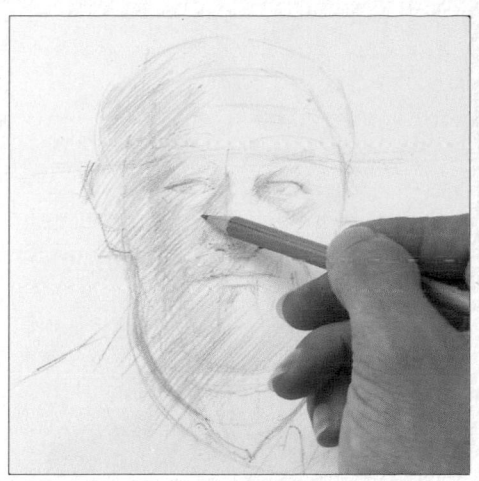

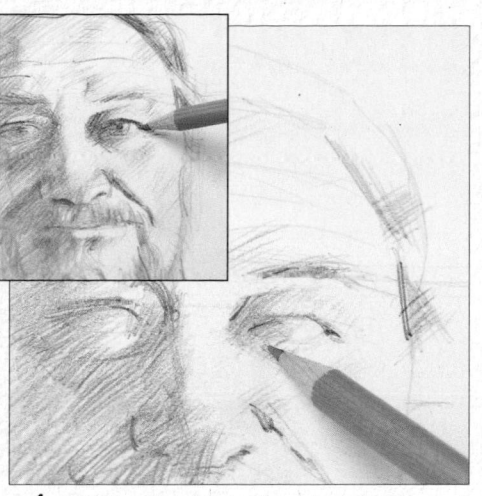

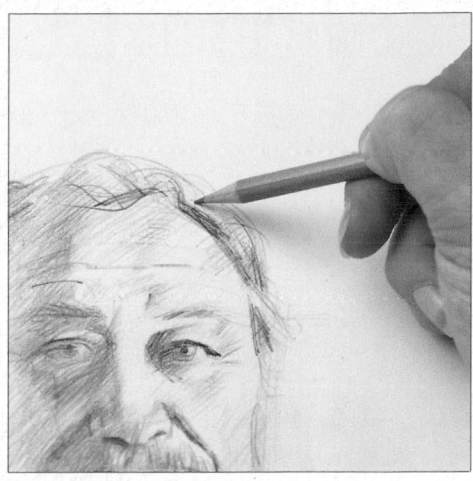

3 *Each time he looks in the mirror, he must adopt the same expression. This becomes easier as more marks are made on the paper. He puts in areas of tone on the side of the nose for a three-dimensional effect.*

4 *He then sketches in the spherical forms of the eyes and eyelids. Inset: He uses the 2B pencil to strengthen the shadows created by the thickness of the upper eyelid.*

5 *He must make sure the overall cap of the hair travels around the solidness of the head, allowing the hair to be seen as a mass covering the sphere of the cranium.*

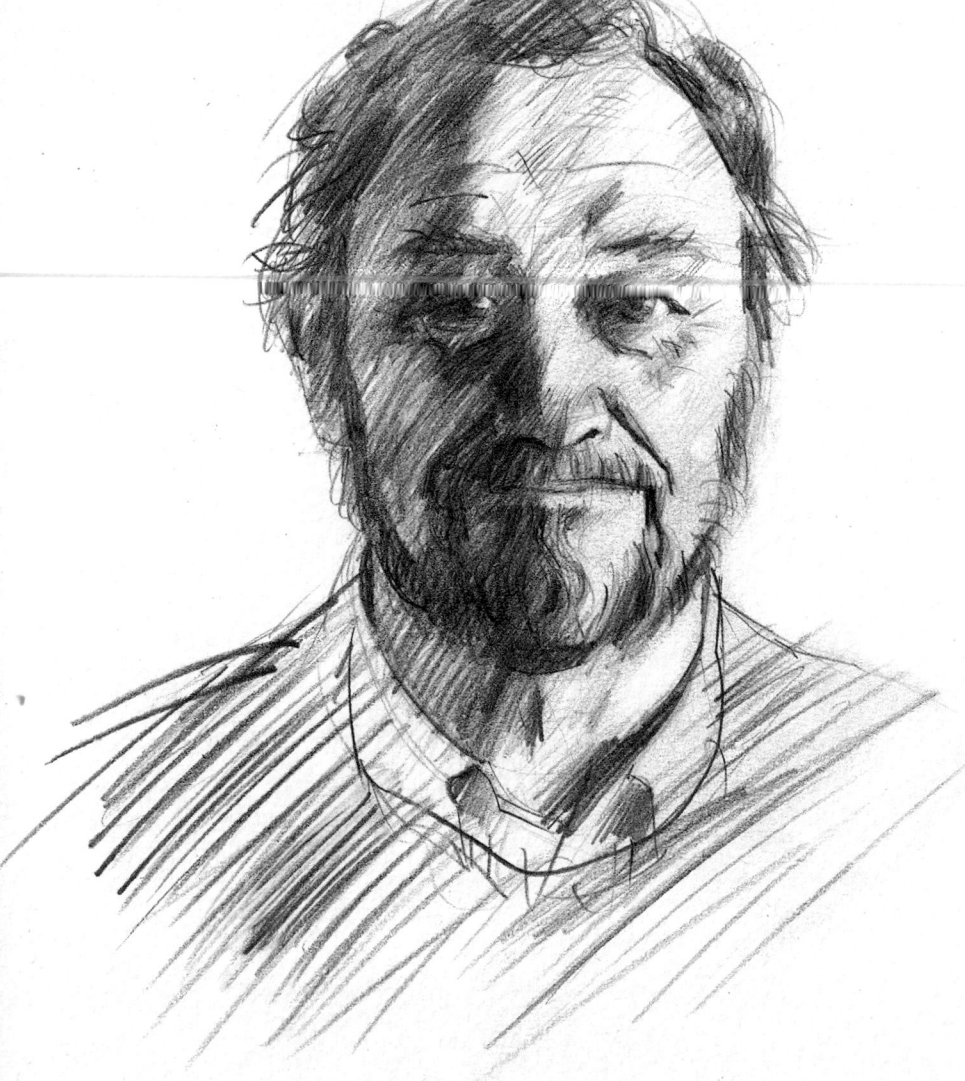

6 *The portrait is not only concerned with the face and hair. Here, he sketches in the tones on the shadowed side of the shoulder and chest. The areas of dark and light help to suggest a three-dimensional illusion.*

The Finished Drawing

The final work shows a range of tone. Some light is reflected back into the darker side of the face and the strongest area of tone moves down from the forehead to the collar of the shirt. Just enough tone is introduced to describe shapes within the beard and the creases in the light side of the face. This use of tone is a sure way of creating a convincing three-dimensional image – even if the subject betrays the ravages of time.

Portrait Using a Drawing Screen

THE DRAWING SCREEN shown on these pages is a more sophisticated version of the measuring system described on pp. 38–39. Like other measuring systems, a drawing screen uses a grid. The subject is placed behind it, and the horizontal and vertical lines of the grid serve as points of reference, enabling you to establish the relative size and position of elements within the picture space. One added refinement shown here is the inclusion of a plumb line. Set up the plumb line on one of the vertical lines of the grid, and arrange your subject so that an important feature (the edge of the face, or the outer corner of one eye) intersects the plumb line. By constantly referring to the plumb line, you can check that the model does not change position — and that you do not alter your viewpoint.

HB pencil

The drawing paper is also marked out as a grid. However, the two grids (on the drawing screen and on the paper) do not have to be the same size or contain the same number of squares. By making the squares on the paper grid smaller or larger than those on the drawing screen, you can decrease or increase the scale of your drawing.

Use drawings produced in this way as preliminary sketches, and then transfer them to a clean sheet of paper afterward. Using a drawing screen forces you to look intently at your subject matter. Once you have established the correct scale and relative positions of elements in your preliminary sketch, it should be relatively easy to repeat the process for the finished drawing. You can then elaborate the finished drawing, adding details and refining touches where necessary.

Making a Drawing Screen

For this particular drawing screen, set a sheet of glass in a solid wooden frame. Place small thumbtacks at equal distances along the top, bottom, and sides of the frame, then loop fine black thread around the tacks and stretch it taut to form the lines of the grid. Attach a plumb line to a horizontal bar at the top of the frame, making sure that it coincides with one of the vertical lines of the grid when the screen is viewed head-on. You can move the horizontal bar to any position on the top of the frame and adjust the position of the plumb line to suit the subject. The screen can be any size provided it fits comfortably in front of your subject.

The thumbtacks are located at equal distances on both the horizontal and vertical axes.

Place the plumb line to coincide with one of the main lines of the grid.

The plumb (or weight) can be at any height, provided it does not obscure the subject.

A secure base is essential – the drawing screen must be truly vertical.

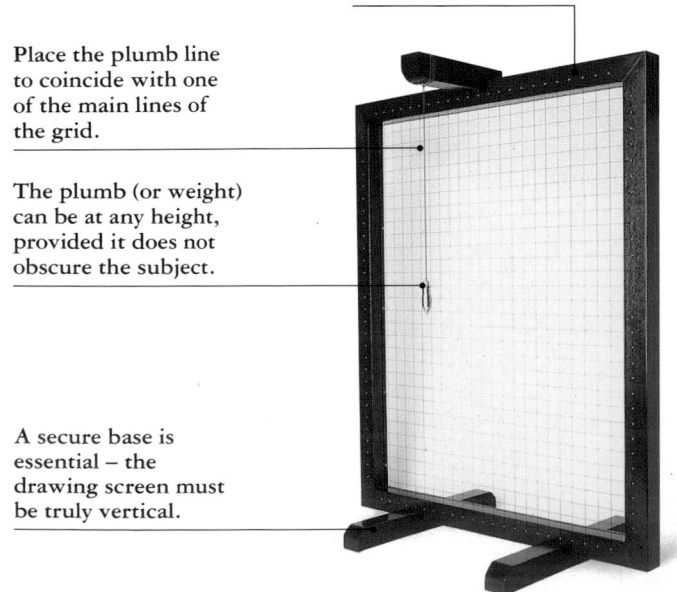

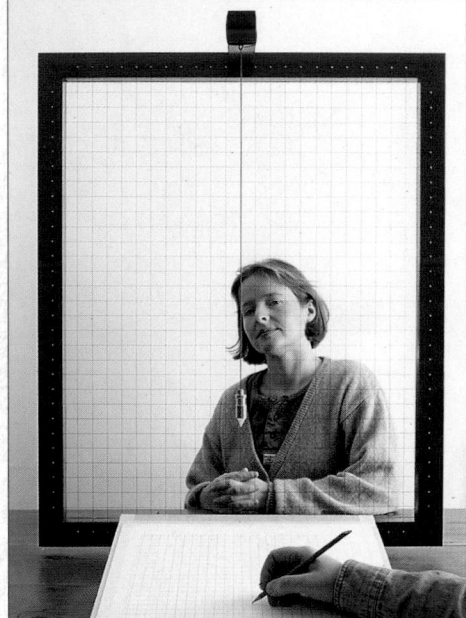

The Setup
Position your subject behind the drawing screen, checking that the screen is parallel to it. Move the plumb line to the desired position. Prop up your drawing board at a slight angle directly in front of the drawing screen, so that you don't look along it from the bottom to the upper edge. This view would distort the perspective, causing you to draw the head at the top too small in relation to the rest.

The Paper Grid
Using an HB pencil, lightly mark out a grid on your paper. Make the squares on the grid as large or as small as you like, increasing or decreasing the scale of your drawing. You can also subdivide the individual squares into smaller grids for drawing particularly detailed areas.

1 *Using an HB pencil and carefully counting the squares on the grid to make sure you get the placement right, sketch in the positions of the main features. Outline the face and hair, and indicate the eyes, eyebrows, nose, and mouth.*

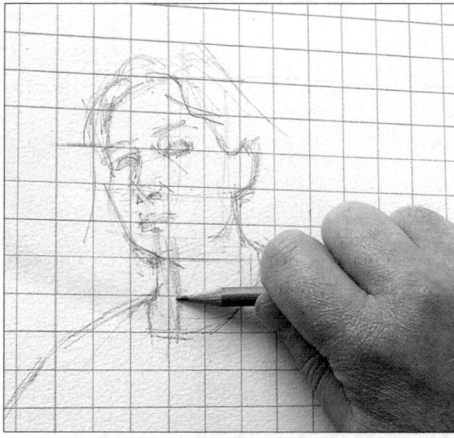

2 *Turn the pencil on its side to create long sweeping lines, and put in the angle of the neck and shoulder and the collar of the model's shirt and cardigan.*

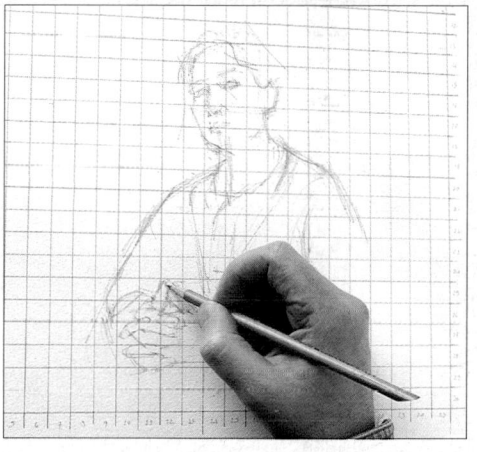

3 *Use broad, sweeping pencil strokes to outline the arms and the V neck of the cardigan. Count the squares down to locate the position of the hands. Sketch the shapes of individual fingers.*

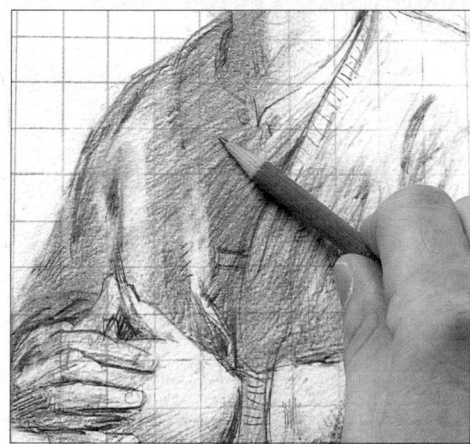

4 *Still referring to the grid, add shading to the darker areas and the folds and creases of the model's clothes. Half-close your eyes to see the different tones more clearly. Use the side of the pencil for loose shading, varying your pressure to obtain different tones.*

The Finished Drawing

All the model's features, as well as the variations in shading that make this drawing look three-dimensional, have been assessed and drawn in relation to the grid. Despite this apparently rigid, mechanical approach, the result is a sympathetic portrait that captures the model's calm, introspective mood.

The side farthest away from the light has the deepest shadows.

The horizontal line of the left arm resting on the table balances the composition and provides a strong base line.

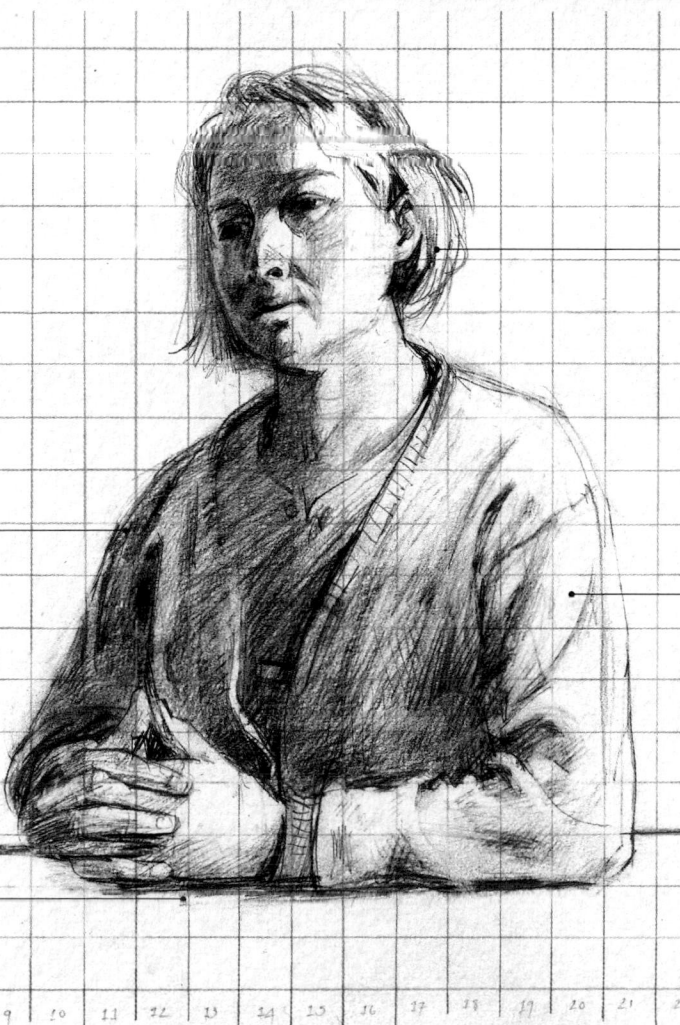

The hair is loosely drawn, not as individual wisps but with attention to the overall shape of hanks of hair.

Areas hit by particularly strong light are left untouched, apart from the outline that encloses them.

Portraiture

WHEN YOU FEEL CONFIDENT that you have mastered the proportions of the head and can place the facial features correctly, it is time to move on to more artistic considerations – capturing your subject's mood and character. Many great portraitists have seemed able to express "inner truths," revealing far more than their sitters could ever have expected. Keen observation and choosing a medium and technique that allow you to echo the mood of the sitter are the keys.

Portraits can look stiff and formal, as if the subject were rigidly sitting at attention and hating every minute of it. Keep the atmosphere as relaxed as possible – talk to your model while you work, or have music playing in the background. Drawing a portrait can be a lengthy process, so it is important to make sure your sitter is comfortable and that the pose is one that feels natural. If someone has a tendency to hunch his or her shoulders, then no amount of persuasion on your part will make a regal, erect pose look anything other than acutely uncomfortable.

In fact, body language can reveal as much as, if not more than, facial expressions. A happy, confident person is more likely to hold his or her head high and look directly at you, whereas someone who is feeling miserable will probably be slumped in the chair with rounded shoulders and downcast eyes. Look for clues such as this before you start to draw, and choose your medium and technique accordingly.

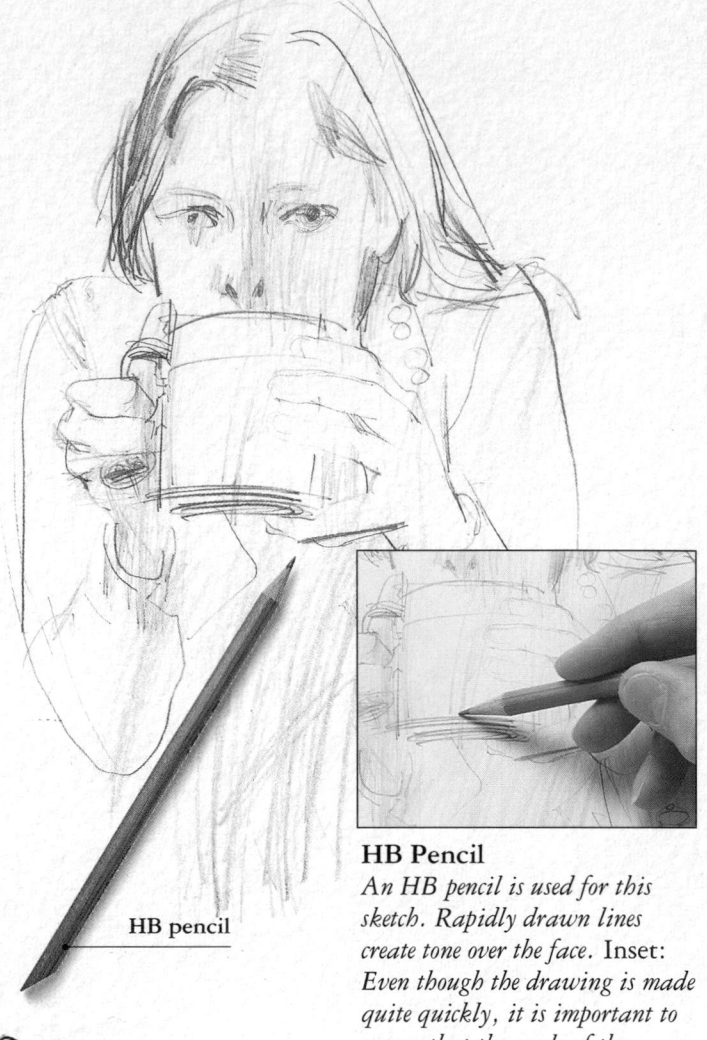

HB pencil

HB Pencil
An HB pencil is used for this sketch. Rapidly drawn lines create tone over the face. Inset: *Even though the drawing is made quite quickly, it is important to ensure that the angle of the ellipses in the cup is correct.*

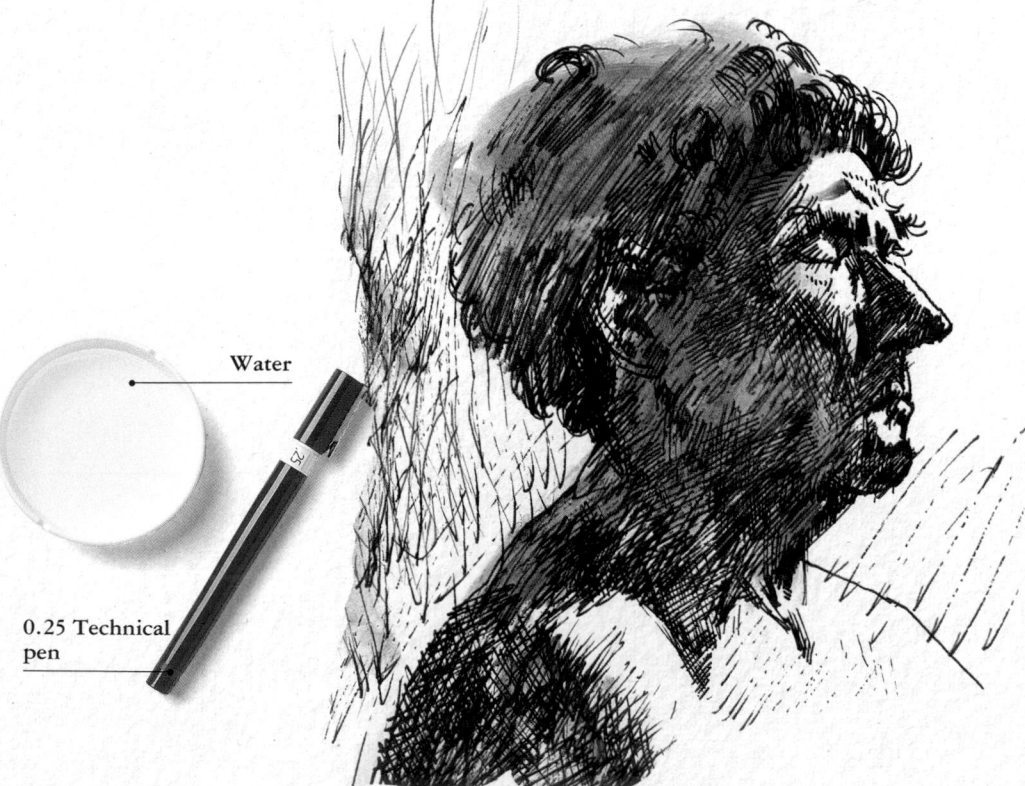

Water

0.25 Technical pen

Technical Pen
A 0.25 technical pen produces a scratchy line when used quickly, but a full steady line when used more slowly. Dip your finger in water to blend areas of hatching – on the cap of hair, for example. Inset: *Fine hatching (see pp. 44–45) creates small areas of tone around the eyes and nose.*

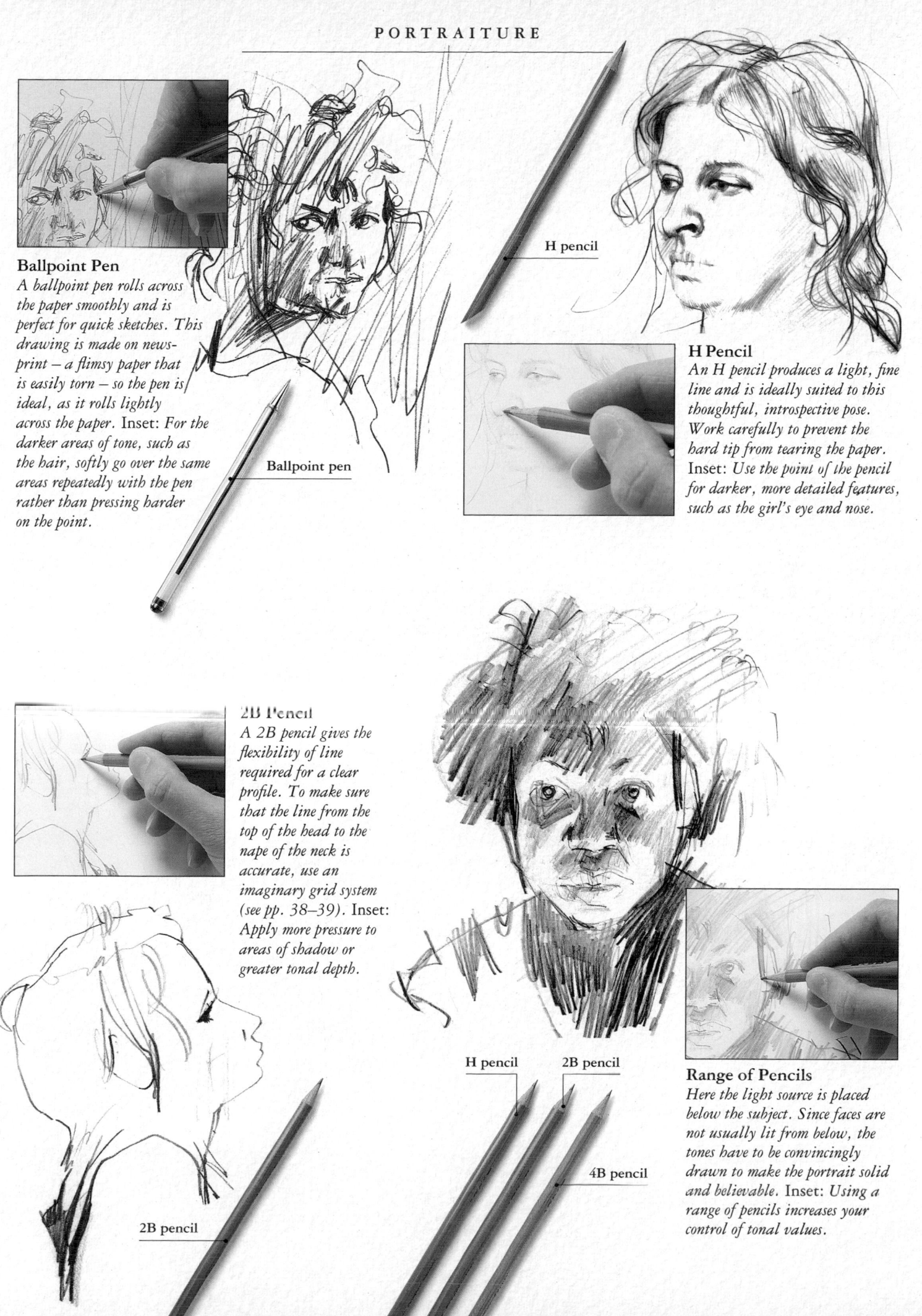

Ballpoint Pen

A ballpoint pen rolls across the paper smoothly and is perfect for quick sketches. This drawing is made on newsprint – a flimsy paper that is easily torn – so the pen is ideal, as it rolls lightly across the paper. Inset: For the darker areas of tone, such as the hair, softly go over the same areas repeatedly with the pen rather than pressing harder on the point.

Ballpoint pen

H pencil

H Pencil

An H pencil produces a light, fine line and is ideally suited to this thoughtful, introspective pose. Work carefully to prevent the hard tip from tearing the paper. Inset: Use the point of the pencil for darker, more detailed features, such as the girl's eye and nose.

2B Pencil

A 2B pencil gives the flexibility of line required for a clear profile. To make sure that the line from the top of the head to the nape of the neck is accurate, use an imaginary grid system (see pp. 38–39). Inset: Apply more pressure to areas of shadow or greater tonal depth.

2B pencil

H pencil 2B pencil

4B pencil

Range of Pencils

Here the light source is placed below the subject. Since faces are not usually lit from below, the tones have to be convincingly drawn to make the portrait solid and believable. Inset: Using a range of pencils increases your control of tonal values.

Children

WONDERFUL DRAWINGS OF CHILDREN were made by Mary Cassatt (1845–1926), an American artist who worked mostly in Paris during the late 19th century. Indeed, fine examples can be seen from the hands of many distinguished artists throughout the centuries. Amateur artists have also always enjoyed making pictures of their offspring and other children. Making a series of portraits at regular intervals as a child grows up, so that you can relive the memories in years to come, is a highly rewarding activity.

There are a number of factors unique to making drawings of children. One of these, unfortunately, is their inability to keep still for very long. You can go a long way toward overcoming this problem by pausing frequently to let them stretch their limbs. You should also make sure their pose is comfortable, as this will make them less likely to wriggle impatiently.

In addition to these practical matters, there are some special technical considerations. Our proportions vary greatly as we grow from babies to adults. The size of the head in relation to the rest of the body changes, as do the length of arms and legs in relation to the torso area. The neck is less supportive of the head in babies, but develops strength as the child grows. Long legs are a characteristic feature of the adolescent period. Note how the facial features of the very young occupy a smaller area on the head and are finer and less well marked than those of adults.

A final word: bear in mind that while children can make charming subjects for drawings, especially if they are related to you in some way, it is important to avoid being too sentimental in your approach.

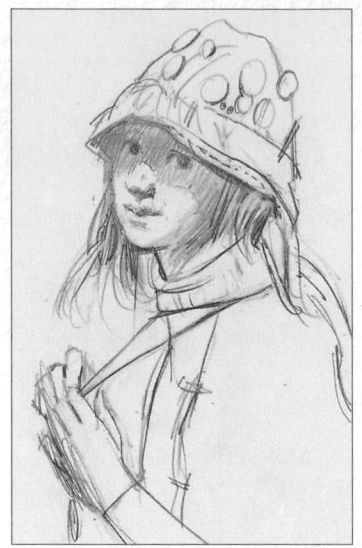

Girl in Hat
The girl's head is tilted, with the eyes looking straight at the viewer. Sketching the hands lightly reduces distraction from the face. Inset: Shading under the hat conveys a three-dimensional effect.

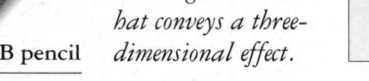
2B pencil

Children's Proportions

Here, you can see some of the basic changes in the relative proportions of children as they grow from babyhood to adolescence. Taking head measurements (see pp. 54–55) is one of the most useful ways of improving accuracy in portrait and figure drawing. Note also how the legs change in relation to the total body length. By the age of about 12, the figure is closer in proportions to the mature adult.

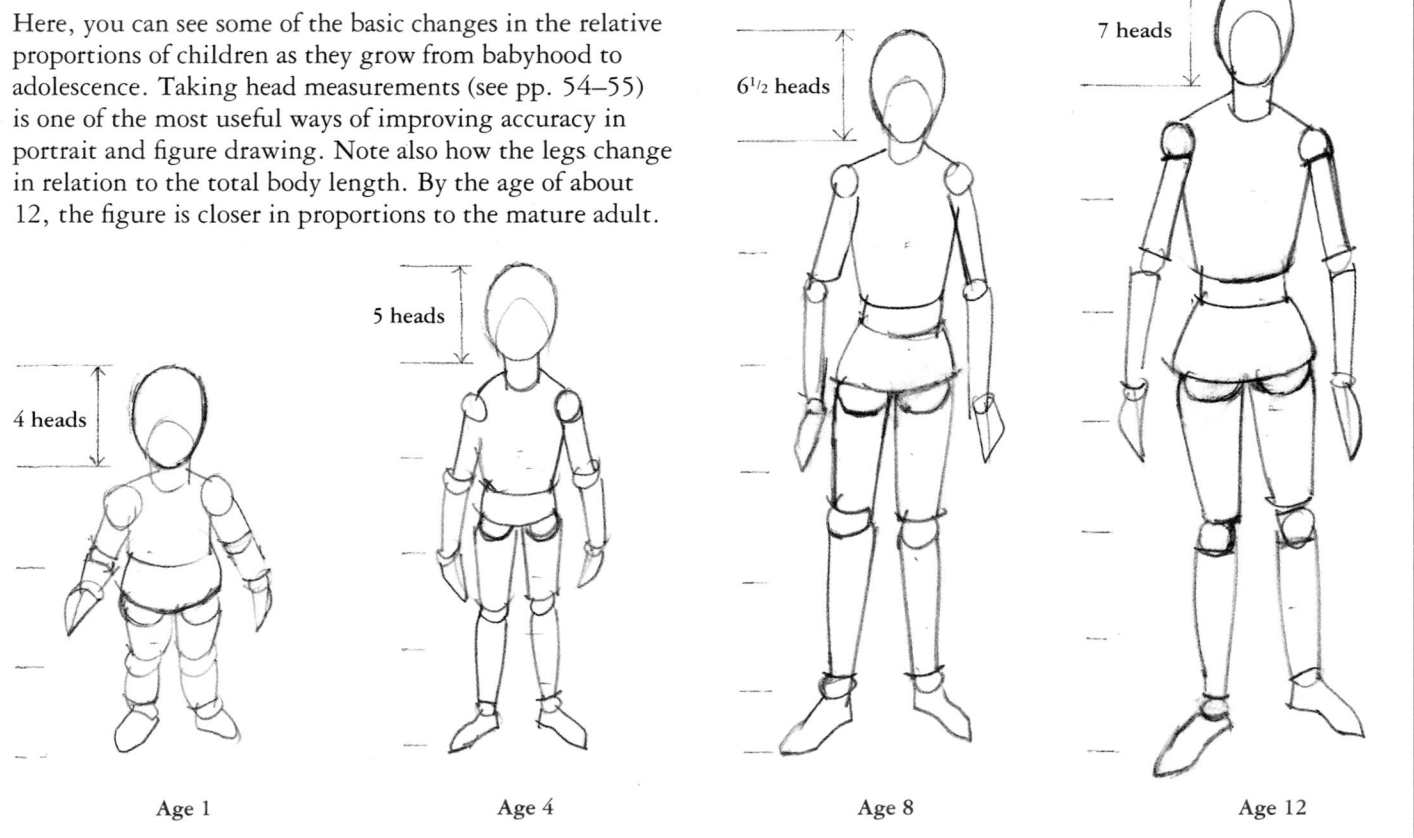

4 heads — Age 1
5 heads — Age 4
6½ heads — Age 8
7 heads — Age 12

Turpentine

Rag

Payne's gray
oil paint

Cadmium red
oil paint

Black
pencil

2B pencil

HB pencil

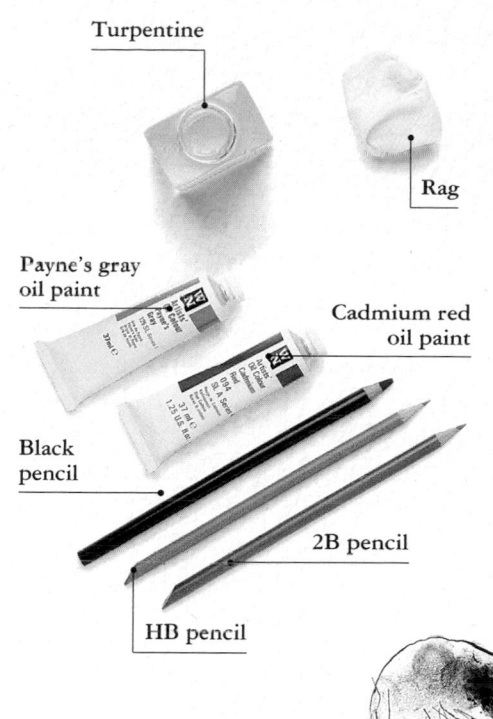

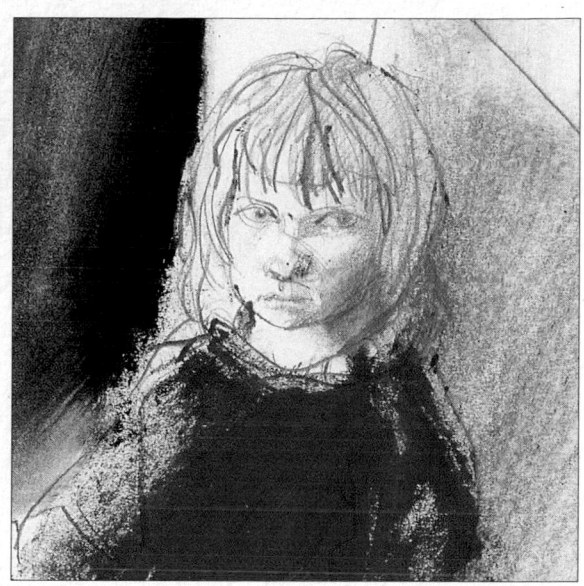

Girl Sitting Pretty

*Cadmium red oil paint is spread
with a rag to make the shape of
the sweater and a range of pencils
is used to draw the features.
Payne's gray oil paint diluted
with turpentine is spread with a
rag up to the edge of the hair.
Inset: The neck of the sweater is
drawn with a black pencil.*

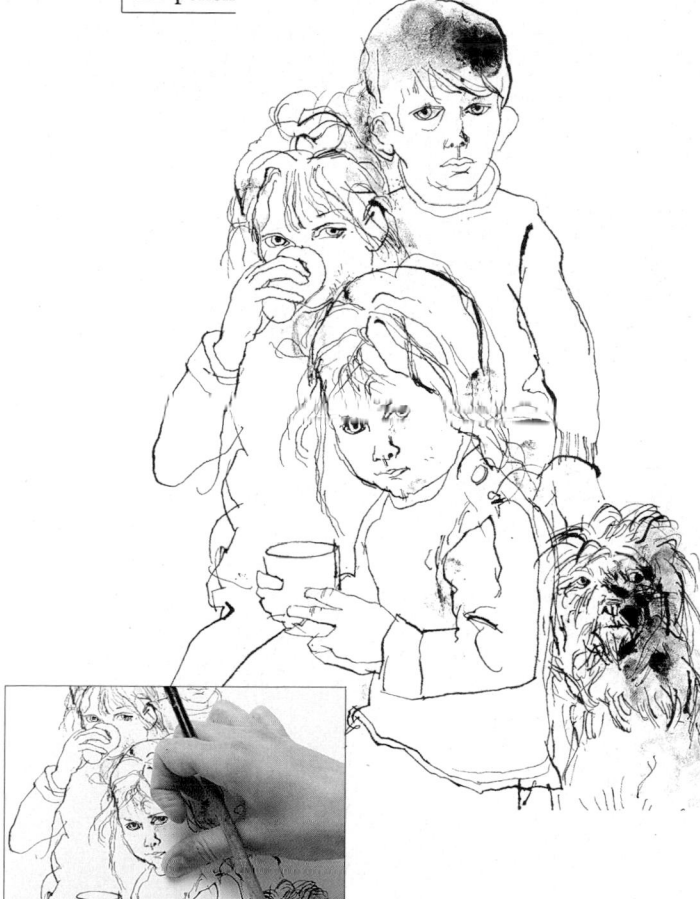

Colored pencils

HB pencil

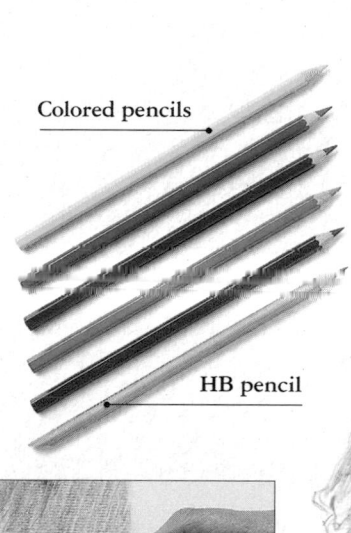

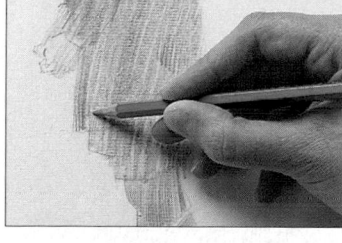

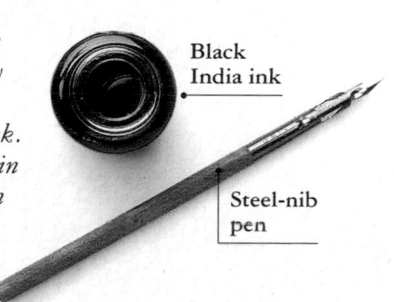

Group Portrait

*The contour lines around the
edges of the figures are loosely
sketched, using a steel-nib
pen dipped in black India ink.
Inset: The thumb is dipped in
ink to indicate shadowing on
the throat of the girl in the
foreground and the hair of
the boy in the background.*

Black
India ink

Steel-nib
pen

Girl in Profile

*The profile view – showing the long
legs, thin body, and small features –
was chosen because it demonstrates
the youthful elegance of a girl
approaching full adult proportions.
Inset: Fine lines are drawn very
close together as shading, forming a
mass of color. Always look for
touches of other colors within each color.*

Figure Drawing

THE HUMAN FORM has been considered a classic subject in Western art for centuries. Indeed, Michelangelo once called it "the highest object for art." Drawing the figure, however, may seem daunting at first. The trick is to train yourself to see the various parts of the body as simple geometric shapes (see pp. 54–55). Think of the upper and lower arms, and the lower leg and thigh, as interlinked cylinders. You can look at the breast and buttocks as variations on the sphere, and see the head as contained within a cube shape. Approaching your drawing in this way gives you a solid understructure. You can then elaborate on this by subtly altering the basic shapes to portray the musculature of the body and the body joints. Remember, however, the rules of perspective (see pp. 40–43). The basic shapes will vary depending on the angle from which you are viewing them and your eye level.

When drawing a nude, you must make sure that the flesh looks like flesh. To practice drawing soft, rounded forms, such as the breast, partly fill a balloon with water and place it against a harder form so that the balloon's shape is distorted. Sketching this will give you experience in drawing solids with variations in their forms, and you can apply this knowledge to drawing the nude figure. Harder forms such as knees or elbows require a different approach, as the contrasts of light and dark tones tend to be greater than in rounded forms.

HB pencil

The next stage is to think about how the body works. You don't need an in-depth knowledge of human anatomy: knowing the correct scientific name for various small muscles and tendons will not help you. Careful observation is the key. In your drawing make sure that the head and torso are not twisted in a way that looks unnatural, and that the limbs bend the right way. The balance of the pose is crucial – there are limits to how far a human being can lean in any one direction without falling over. Moving one limb even slightly will affect the rest of the body. You can prove this to yourself by studying your reflection in a full-length mirror. Stand with your feet apart, so that your weight is evenly distributed, and then shift your weight to your left leg. Your left hip thrusts upward while your right shoulder automatically slopes downward to compensate and enable you to maintain your balance.

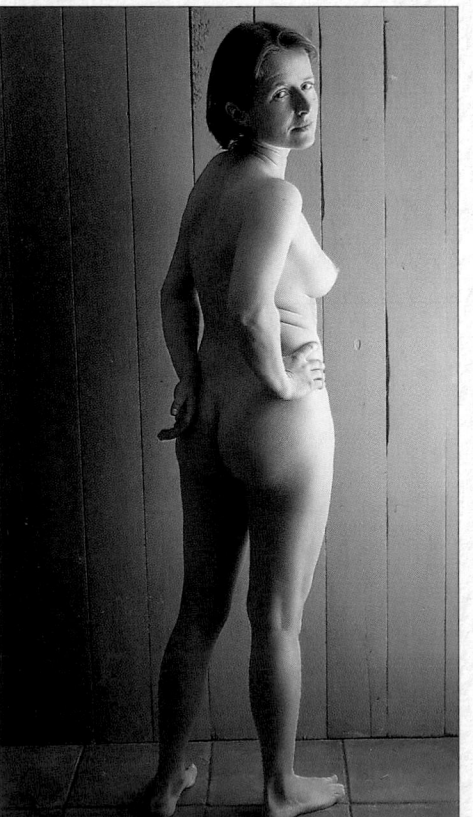

The Pose
The subject is posed against a plain background, with light coming from a window out of sight to her right. This setup provides a strong contrast between light and dark areas, allowing you to make good use of tone and shadow to convey a three-dimensional feeling.

1 *Holding the pencil at arm's length, use your thumb to check the size of the different parts of the body (see pp. 36–37). Lightly sketch in the outline of the figure, observing how the limbs link up as basic geometric shapes. Begin putting in the main area of dark tone on the back and buttocks, using loose hatching (see pp. 44–45).*

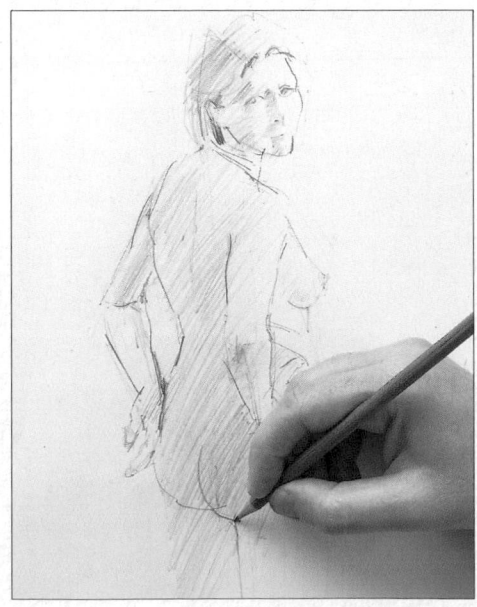

2 *Continue hatching around the hair, right-hand side of the face, shoulders, and back. Using the sharp point of the pencil, put in shading to describe the spherical form of the buttocks.*

3 Strengthen the outline of the hip and thigh, and add shading to the backs of the legs, using broad sweeping strokes. The fronts of the legs are in bright light, so put little or no shading on these areas.

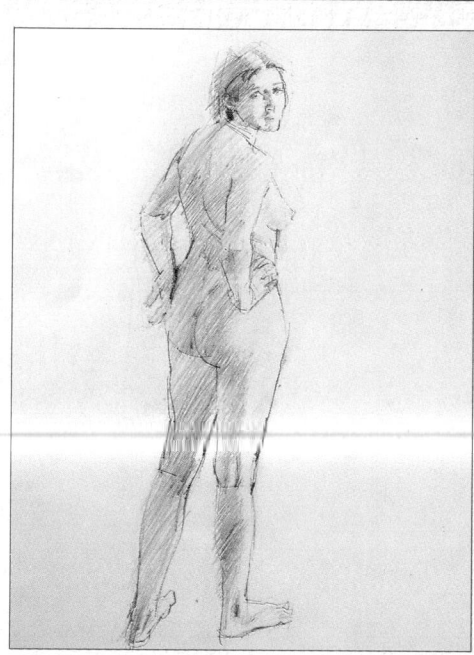

4 Once you have applied light touches of tone where necessary over the whole drawing, consolidate and darken these to the right intensity. The position and angle of the feet are important: they must appear to be on a solid base, supporting the figure.

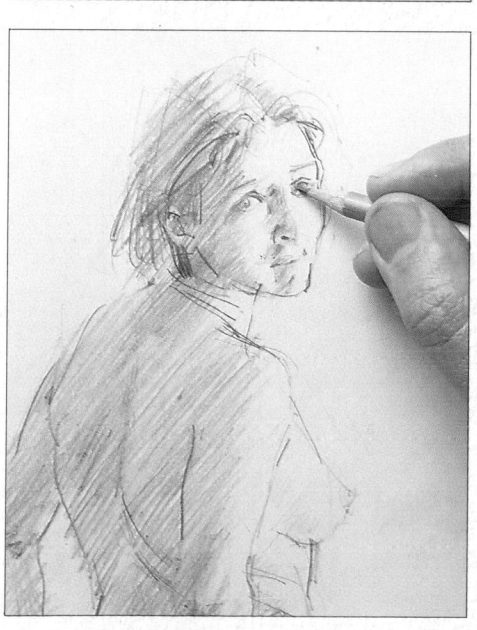

5 Put in the fine detailing and darker areas of tone where necessary. Take care not to make the tonal contrast too abrupt or the smaller details will leap out from the paper, destroying the unity of the image.

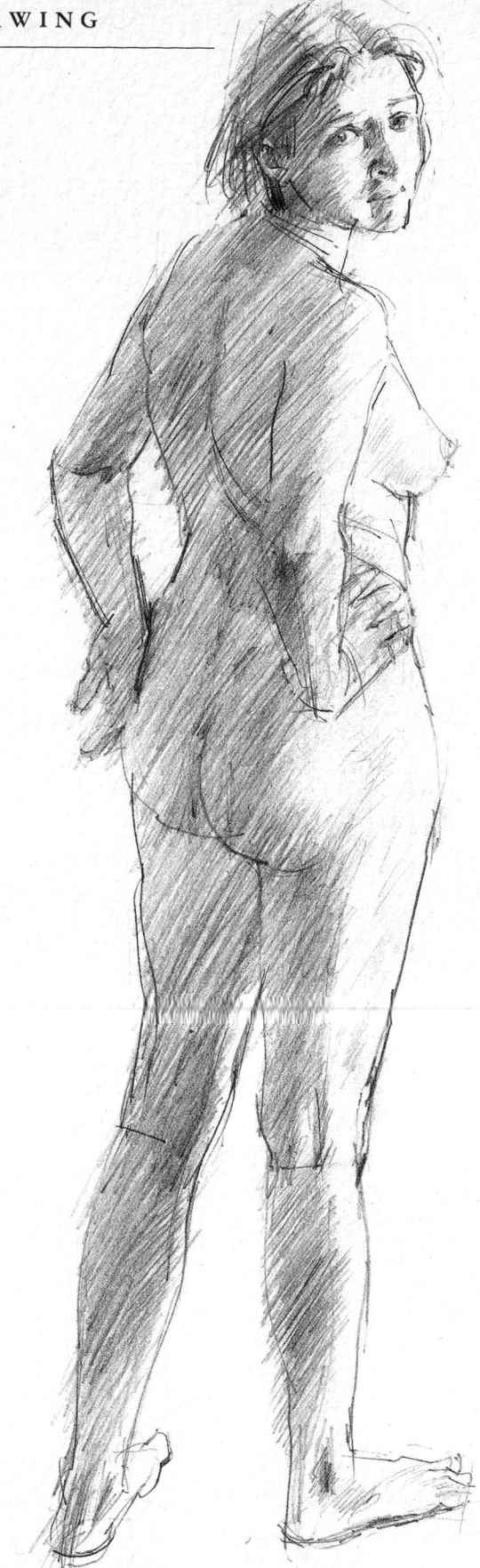

The Finished Drawing
Both the way the head turns slightly to look back over the shoulder and the way the shoulders contrast with the angle of the hips provide a necessary feeling of tension in this otherwise relaxed and natural-looking pose. Simple contrasts of light and tone bind the drawing together.

The easiest way to get the balance of the pose correct in a drawing is to drop a plumb line, real or imaginary, from the pit of the neck to ground level and see where the limbs or other body parts intersect it. If you are standing with your weight on one foot, the big toe of your supporting foot will be on or near the plumb line. If your weight is evenly distributed on both feet, the plumb line will touch the ground midway between your feet. You can then use any other grid or measuring system (see pp. 36–39) to draw the limbs and other features to the correct size.

Take care never to elaborate individual details such as fingers, toes or facial features, at the expense of the whole. If you give them too much emphasis, they are liable to dominate the drawing.

Give yourself plenty of room when drawing the figure – ideally, stand about 8ft (2.4m) from your subject. If you move closer, parts may appear distorted through a trick of perspective. You may, for example, make a standing figure's head too big because, as you are roughly the same height as your subject, the head is closer to you than any other part of the body and appears larger than it really is.

The human form is basically symmetrical – two arms, two legs, two eyes. Even when you draw the figure in perspective, so that the parts farthest away look smaller than those nearest to you, be aware of symmetry.

A hand mirror is an invaluable aid in drawing the figure. Hold one beside your drawing so that you are looking at a reverse image. This makes it easier to see minor faults in the balance of the pose or the positioning of the features.

Another tip is to turn your drawing upside down. The human figure is so familiar it is difficult to see faults in your drawings. Tricks like this, that force you to look hard at your drawings to make sense of them, are invaluable.

Rapid Drawing with Charcoal
It would be difficult to sustain this pose for any length of time. Charcoal is an ideal medium for a quick sketch. Use the point of the charcoal for sharply defined lines around the fingers, profile, and the edge of the foot. For broad areas of shading, turn the charcoal on its side and produce variations in tone by rubbing the charcoal with your finger. This picture is as much about light as about the pose. The figure is partially backlit, and the shadows of the chair make an interesting pattern.

Charcoal

Detailed Drawing with HB Pencil
An HB pencil is ideal for a detailed study such as this, as it can produce both fine marks and a wide range of tones. Note how the pencil lines run in different directions, setting up a feeling of liveliness. Leaving the light areas blank and adding tone around them creates a feeling of airiness.

HB pencil

Delicate Hatching in Pen and Diluted Ink

The harsh contrasts normally associated with pen-and-ink work might seem inappropriate for a delicate, intimate study such as this. Dilute the ink before you start work, and gradually build up the drawing from very light touches. Intensify the tones as you go by drawing over them and bringing the hatching lines closer together. This delicate touch is appropriate to the curved, almost embryonic, pose.

Steel-nib pen

Black
India ink

Lively Subject in Watercolor Pencil

Watercolor pencils can produce a clearly defined line, which is useful when you are coloring a restricted area such as the outline of the sweater. This medium can also be blended into a wash for wispy areas such as the child's hair. Note the careful contour lines used to describe the trousers — the creases of the cloth follow the underlying shape of the child's legs.

Linear Drawing in Black Conté Pencil

This linear drawing is made quickly with black Conté pencil, as the pose cannot be held for long. The weight of the model is on the left foot, so the left hip thrusts upward. The head is tilted to one side, adding to the many interesting angles within the pose. Basic cylinder shapes recur in the belt and clothes as well as in the underlying form of the model's body. Take care to draw the different ellipses accurately (see p. 41).

Water

No. 4 brush

Black Conté
pencil

Watercolor
pencils

The Clothed Figure

RAWING A CLOTHED FIGURE presents its own special challenges. You need to portray the figure and its pose, and to convey the feeling of the fabric. The key is to look at how the fabric falls and drapes around the body. Lightweight fabrics such as silk or cotton tend to fall in many thin folds, while a heavy velvet or tweed produces stiffer folds, farther apart.

The way garments hang also depends on the contours of the body underneath. Start by thinking about the anatomy of your subject. As always when drawing the figure, look for the basic geometric shapes that make up the under-structure of your drawing. Then look at how the creases and folds in the cloth indicate the figure underneath. Fabric has its own "anatomy," however. Few garments are so close-fitting that they hug every contour of the body. If your subject's arm is bent, for example, there will be creases in the sleeve around the elbow, but the way the fabric actually puckers will be dictated in large part by the weight and stiffness of the material.

Drawing fabrics that have a repeating pattern, such as spots or stripes, is a good way of training your eye to see how material hangs. Count how many times the pattern recurs over a given area, and make sure that you include the same number of repeats in your drawing. If the pattern is organized in rows, draw parallel lines to indicate these rows. Then it is easy to see how to change the direction of the pattern when the fabric folds or creases as it drapes over the contours of the body.

HB pencil

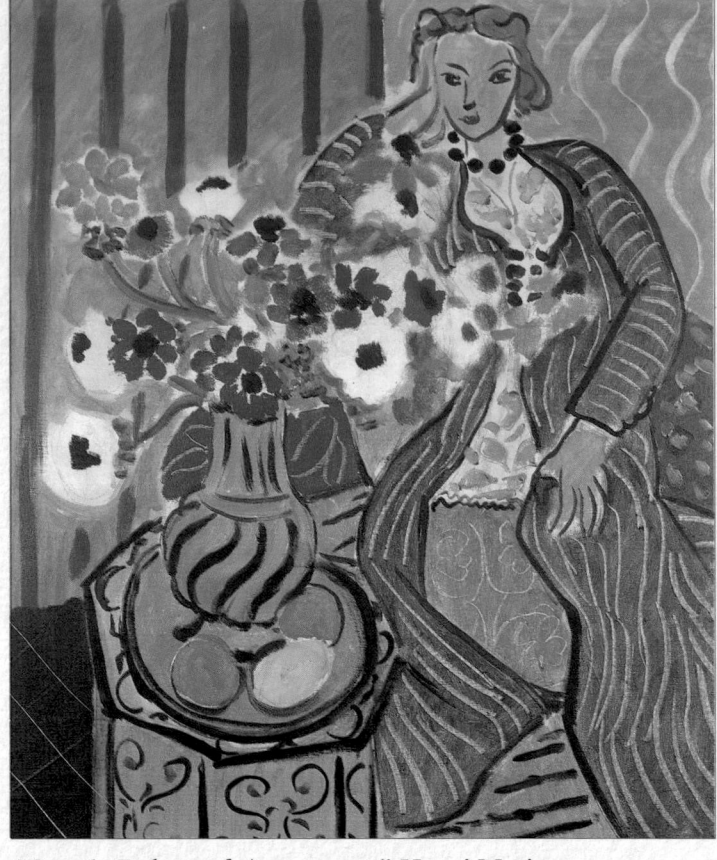

"Purple Robe and Anemones," Henri Matisse
This painting is a perfect example of how fabric follows the contours of the body. Note how the stripes change direction as the fabric drapes over the arms and legs of the model.

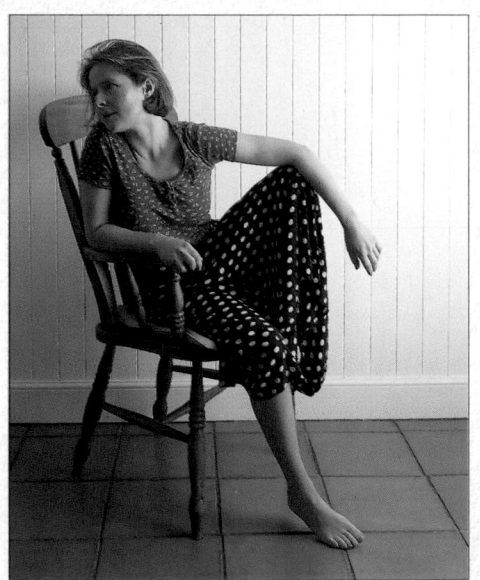

The Pose
In this energetic pose, the twist of the head and the outstretched right leg and left arm contrast with the parallel vertical lines on the wall and floor. The shadows are as important as the light areas in the overall composition.

1 *Using an HB pencil, lightly sketch in the basic composition. Drop imaginary plumb lines from the edges of the eyes to establish vertical reference lines and note which other features intersect them. Start putting in the fabric folds around the waist.*

2 *Travel down the figure, making sure that the angles of the figure relate correctly to the supporting chair. Put in the folds of the cloth over the knee – these folds convey both the weight of the cloth and the underlying body forms.*

3 *The basic sketch, with the right-hand side of the figure in shadow, is almost complete. Start putting in details, such as the dots on the skirt, drawing light guidelines to indicate the rows. Use an incomplete dot to indicate a fold in the material.*

4 *The guidelines make it easier to analyze how the material drapes over the knee. As the material drapes over the body, the dots appear as distorted circles and ellipses. Count the number of dots in each area, and put the same number in your drawing.*

5 *Build up the shading where necessary to accentuate the shadows in places where the cloth is draped in folds over the leg. Dark lines give a feeling of depth to the folds and creases, while light ones travel around the folds on the thigh and the knee.*

The nose catches the light and thus is visually separated from the dark plane of the face.

The breasts are implied by the creases in the fabric of the blouse.

The hands provide contrasts within the pose – the right hand is tense as it grips the arm of the chair, while the left hand hangs limply.

Shading at different angles enlivens what might otherwise be a large, boring area.

The Finished Drawing

In the finished drawing, a languid, rhythmic pose contrasts with the sturdy lines of the chair. Note how the legs of the chair firmly anchor the whole work. All the separate elements – from the top of the chair down to the model's feet – are unified by the broad strip of shadow traveling down the model's right-hand side. This strip of dark tone is also evident in the chair – firmly drawn with very dark tones to contrast the hardness of the wood against the soft cloth and flesh.

Hands

HANDS ARE EXTREMELY EXPRESSIVE and can convey a great deal about the character and mood of the person you are drawing. Think of a fist clenched in anger, two hands clasped together in prayer, or the outstretched empty palm of a beggar.

Start by looking at your own hands. Put your hand down on the table in front of you, with your fingers stretched out as far as they will go. The hand radiates out from the wrist in a fan shape. Note where the fingers leave the solid part of the hand. The little finger begins slightly lower down than the three central fingers – in fact, each finger begins and ends at a slightly different level.

The four fingers each consist of three small cylinders, with ridges and creases around the joints. There is also a slight widening of the finger at these points, as this is where the tendons are attached to the bone. The thumb is the same basic shape as the other fingers, although it has one less joint and is therefore shorter. Also note how the thumb is turned on its side, so that it works in opposition to the other fingers.

Now observe the creases in the skin on the palm of the hand, at the finger joints, and around the base of the hand at the wrist. You can use these creases to build a three-dimensional quality in your drawings. Watch how the creases deepen as you bend your fingers inward.

Then tightly clench your fist. You will see that a clenched hand makes a very rough cube shape. The skin is stretched taut over the bones, and the knuckles form a hard, undulating ridge running across the back of the hand. Look for these ridges: they will help you to convey a sense of real flesh and bone in your drawings.

Red Conté pencil

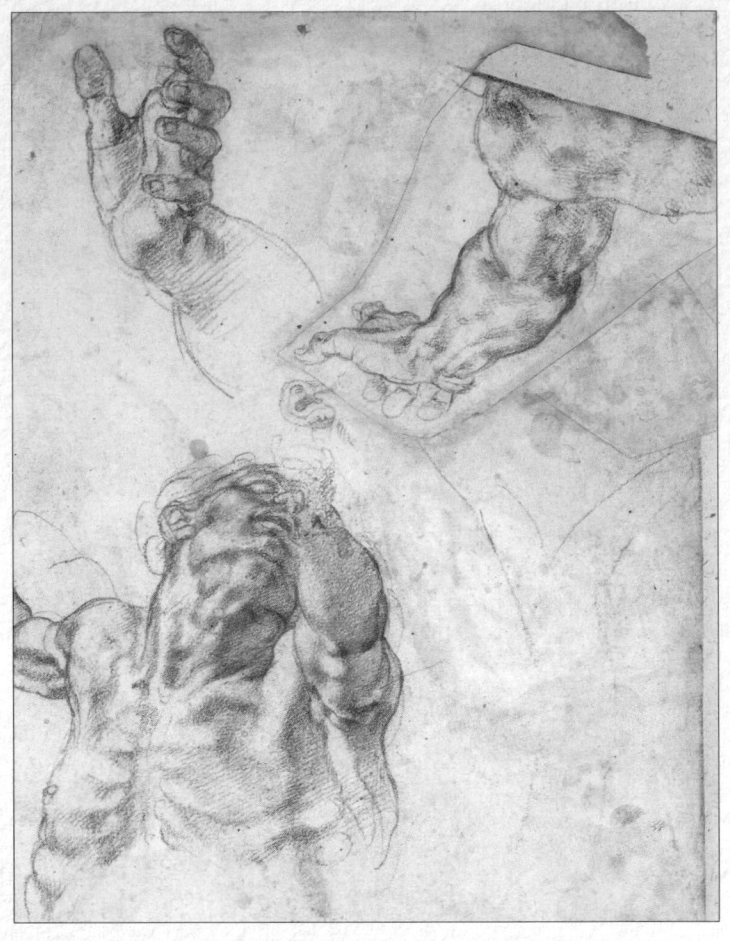

"Study for Haman in the Sistine Chapel," Michelangelo
This sheet of drawings, a preliminary study for the frescoes of the Sistine Chapel in Rome, demonstrates Michelangelo's consummate skill as a draftsman. These drawings are far more than technical exercises. They convey a sense of the living flesh.

The Structure of the Hand

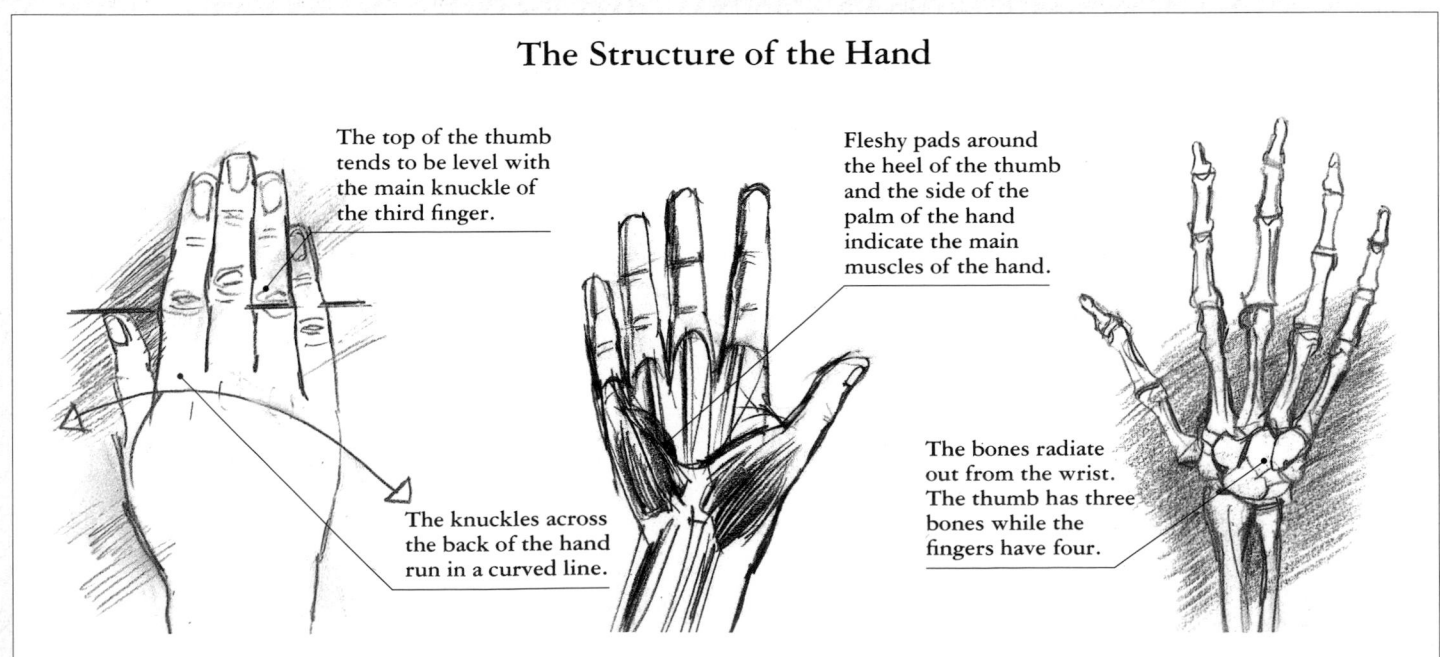

The top of the thumb tends to be level with the main knuckle of the third finger.

Fleshy pads around the heel of the thumb and the side of the palm of the hand indicate the main muscles of the hand.

The knuckles across the back of the hand run in a curved line.

The bones radiate out from the wrist. The thumb has three bones while the fingers have four.

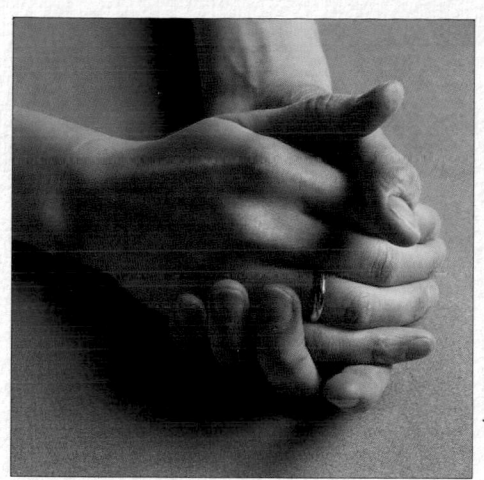

The Pose
Make sure that the light source is strong enough to offer clear contrasts of light and shade. Together the lighting and the relaxed pose will help you to read the overall shapes and the detailing in the individual fingers and thumbs.

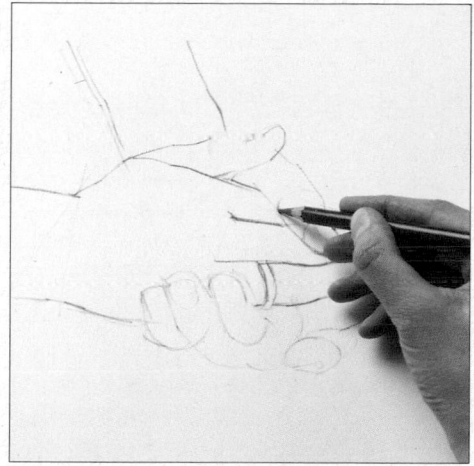

1 *Sketch in the basic forms using red Conté pencil, making the lines between the fingers stronger than the others. Draw the contour carefully, making sure that you render any changes in the direction or thickness of the line accurately.*

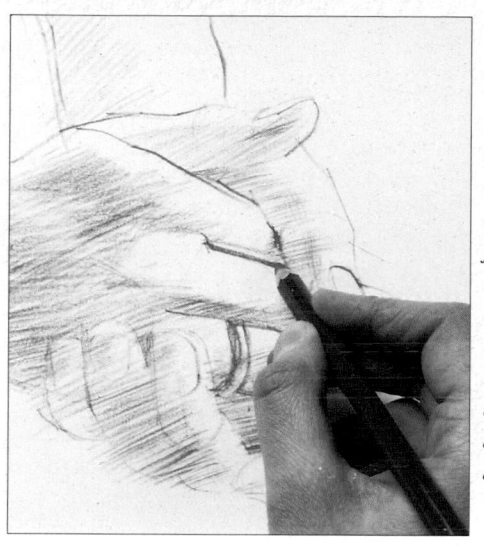

2 *Using loose hatching (see pp. 44–45), gradually build up the tones over the back of the hand and on the darker sides of the fingers. For very dark tonal areas, draw the hatching lines closer together. The hatching lines run in different directions: this helps to avoid too mechanical a feeling.*

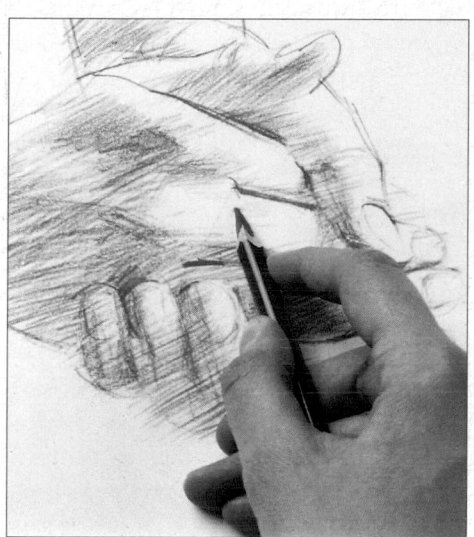

3 *Refine the basic cylindrical under-structure of the fingers so that they taper elegantly at the tips. Note how light is reflected back to hit the fingers of the cradling hand, playing an important part in the three-dimensional illusion.*

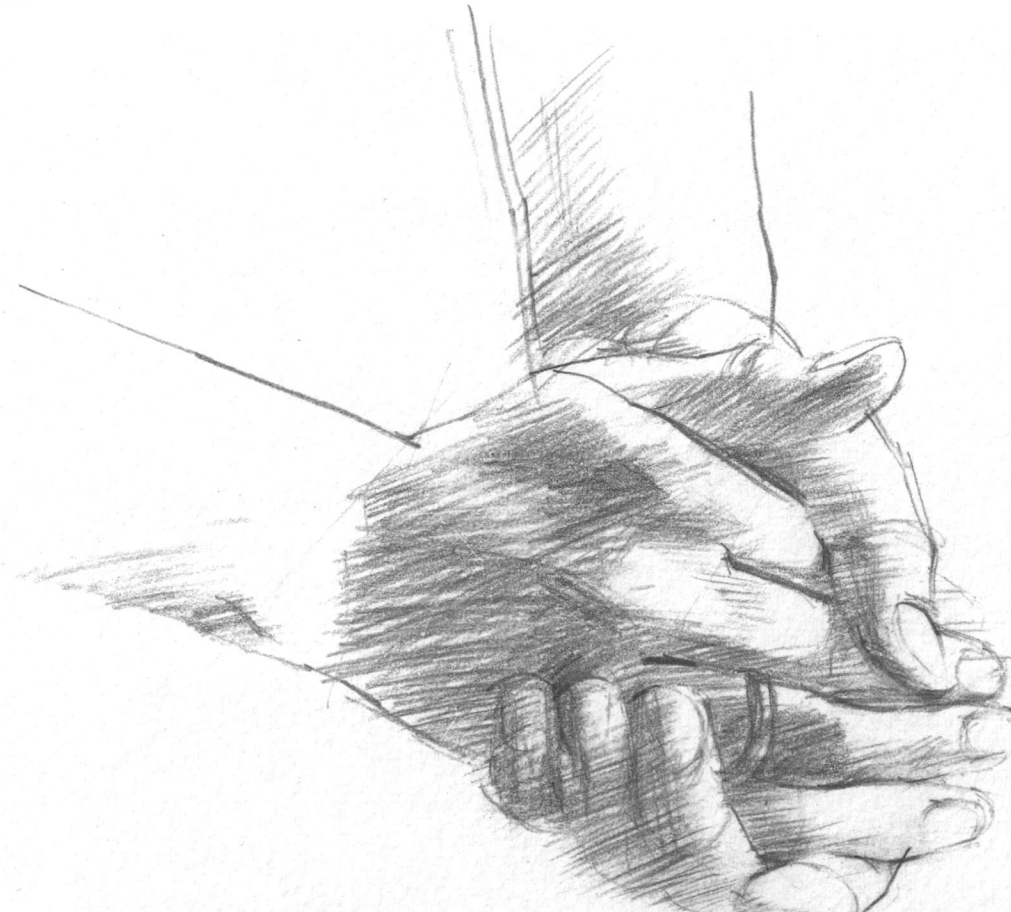

The Finished Drawing
Light and shade play a very positive role in this study: all the cylindrical forms have light, middle, and dark tones, and the use of shading and darker lines to indicate the individual fingers gives a strong three-dimensional feeling. Reducing elements to simple shapes is a great help in any study of hands. The angles – of the fingers in relation to each other and of the wrists in relation to the hands – are crucial. Note how the shadow cast by the thumb of the left hand falls over the fingers beneath it almost like a ring. This helps to reiterate and strengthen the drawing's sense of solidity.

Birds

BIRDS ARE BEAUTIFUL and fascinating creatures. Many species have been portrayed by John James Audubon (1785-1851), the American naturalist and artist whose work still provides a standard by which other natural history artists are judged.

Think about which feature is most characteristic of the bird you are drawing. A hummingbird, for instance, has a long beak, which it uses to extract nectar from flowers, and it hovers above the flowers with its tiny wings whirring incessantly. In a male peacock, it is the shimmering, iridescent colors of the tail feathers that catch the eye. Birds of prey have sharp beaks and talons to enable them to tear their victims apart. These are all aspects that you can easily focus on in your drawing without having any specialist knowledge of the bird's anatomy.

Drawing stuffed museum specimens is a good way to start. It is difficult to catch more than a fleeting glimpse of a bird in flight, but in a museum you can study the creature for as long as you like. Make sure, however, that any equipment you take with you is both easily portable and unobtrusive. Large easels and numerous pots of paint and water are out, for obvious reasons.

A sketchbook and a small box of crayons are ideal. Conté crayons, which are used in this demonstration, have several advantages: they are available in a brilliant range of colors, they are less crumbly and messy to use than pastels or chalk, they are easy to control and they can produce a firm line, and you can blend one color into the next simply by rubbing gently with the tip of your finger. However, you do need to fix the drawing (see pp. 152–153), or at least lay a sheet of tracing paper over it as a temporary measure to prevent the surface from smudging.

Feathers

Feathers have three main purposes: flight, heat retention, and sexual display. Think about the function of the individual blocks of feathers as you draw. If you intend to concentrate on drawing birds, it is advisable to gain an elementary knowledge of bird anatomy. Here you can see how the deep layer of feathers attaches to the skeleton. As with all drawing, however, there is no substitute for keen and intelligent observation.

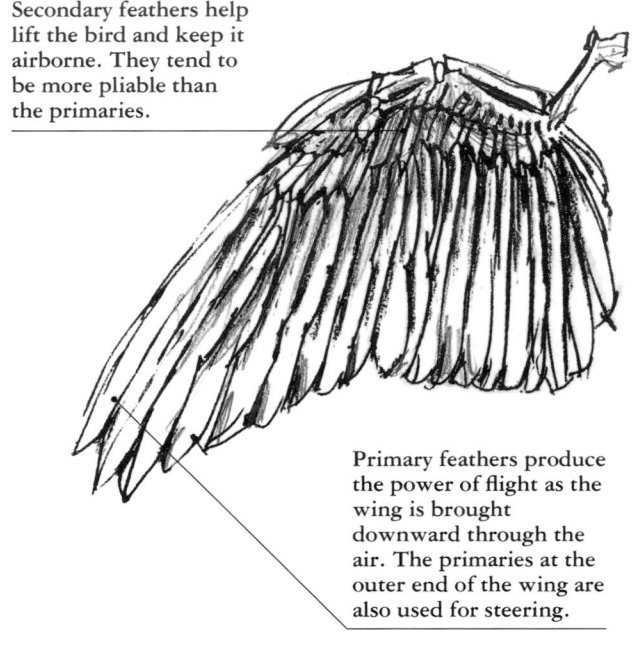

Secondary feathers help lift the bird and keep it airborne. They tend to be more pliable than the primaries.

Primary feathers produce the power of flight as the wing is brought downward through the air. The primaries at the outer end of the wing are also used for steering.

HB pencil

Conté crayons

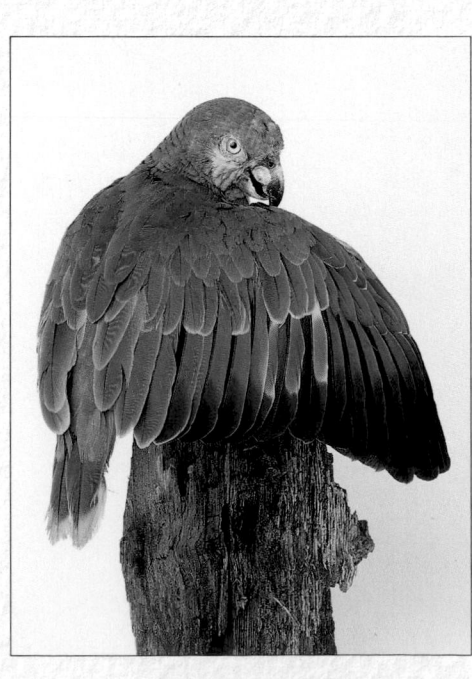

Selecting a Viewpoint
Make a few preliminary pencil sketches from different angles (far left) to decide which viewpoint works best. The strong, curved beak and piercing eyes are important in expressing the individual character of this bird. A profile view allows the beak to stand out against the plain background. Showing only one eye rather than two somehow increases the sinister, glowering mood.

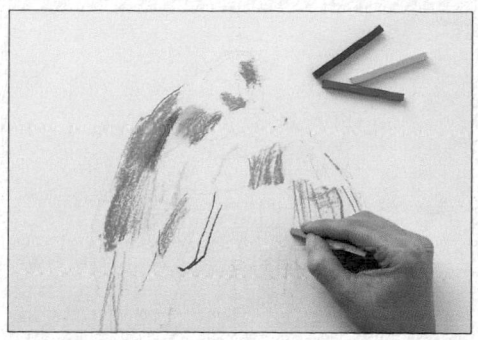

1 Sketch the outline very lightly with an HB pencil. Using blue, green, and purple Conté crayons, put in touches of color around the outline and individual parts of the bird.

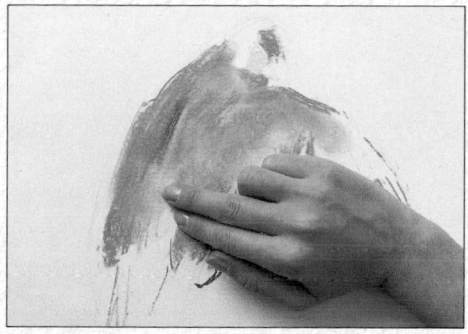

2 Gently smudge the crayon marks with your fingers to blend the colors, taking care to keep within the outline of the bird.

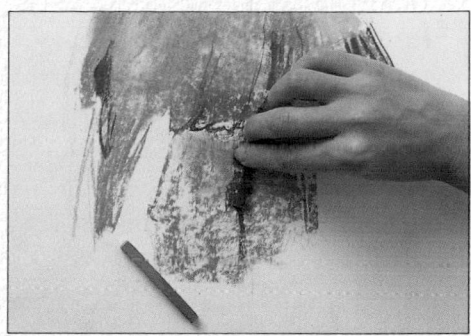

3 Add color to the head, wings, and beak. Drag the side of a sienna Conté crayon across the paper, pressing firmly. Use a darker brown for the shadow areas.

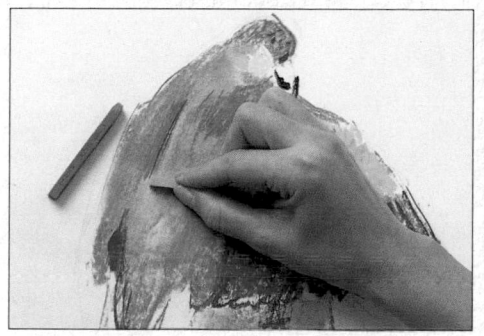

4 Build up the variations in the greens, using a darker green for the shadow areas and a yellow-green elsewhere to create a three-dimensional effect.

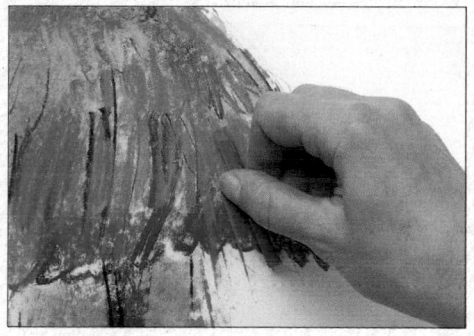

5 Press firmly on the tip of blue, black, and purple crayons to delineate the main blocks of feathers. Use the sharp side of a green crayon for long, sharp-tipped feathers.

6 Add detail and shape, overlaying yellow on green for the light green parts of the feathers. You can reduce the brightness by smoothing the yellow with your fingertips.

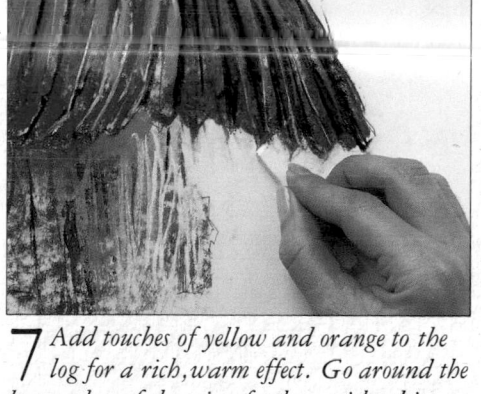

7 Add touches of yellow and orange to the log for a rich, warm effect. Go around the lower edges of the wing feathers with white Conté for a crisp outline.

The Finished Drawing

The "pose" is typical for this Amazonian parrot – one wing is outstretched, the beak almost touches the top of the wing feathers to begin preening, and one wary, almost confrontational, eye is fixed firmly on the viewer. The emphasis and detailing on the log have been minimized so as not to distract attention from the bird.

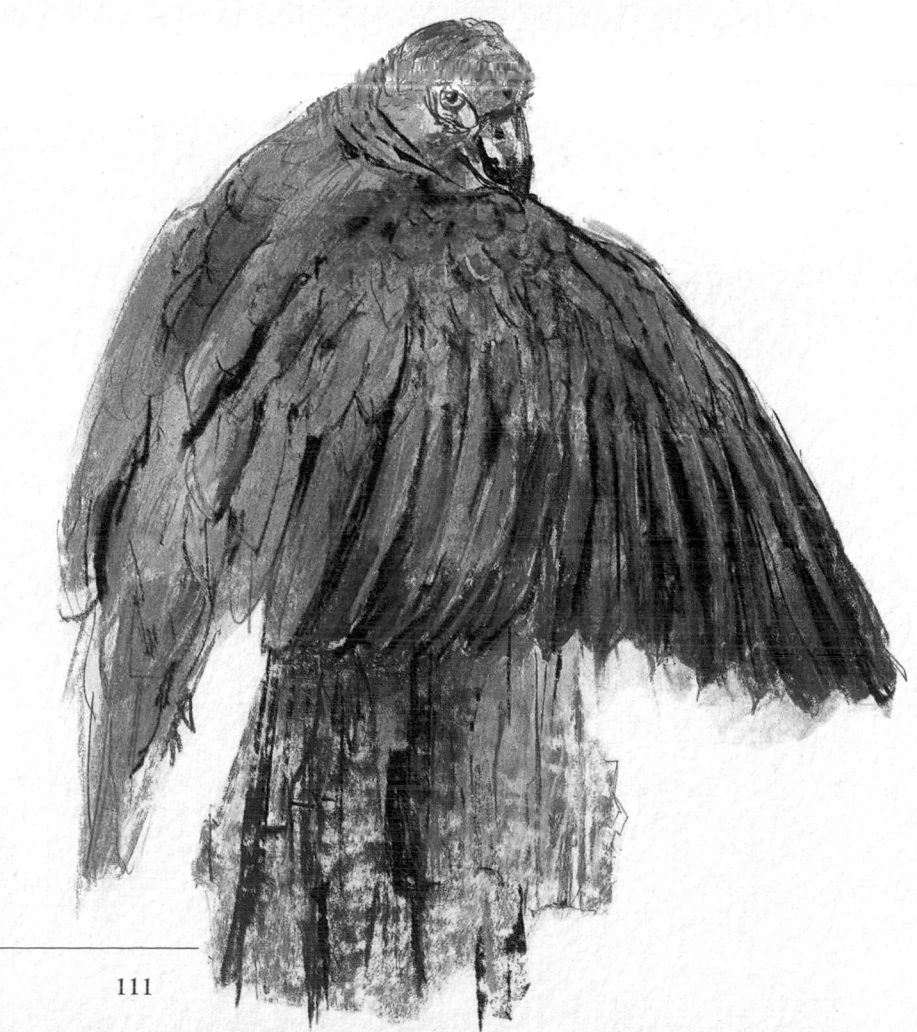

Animals

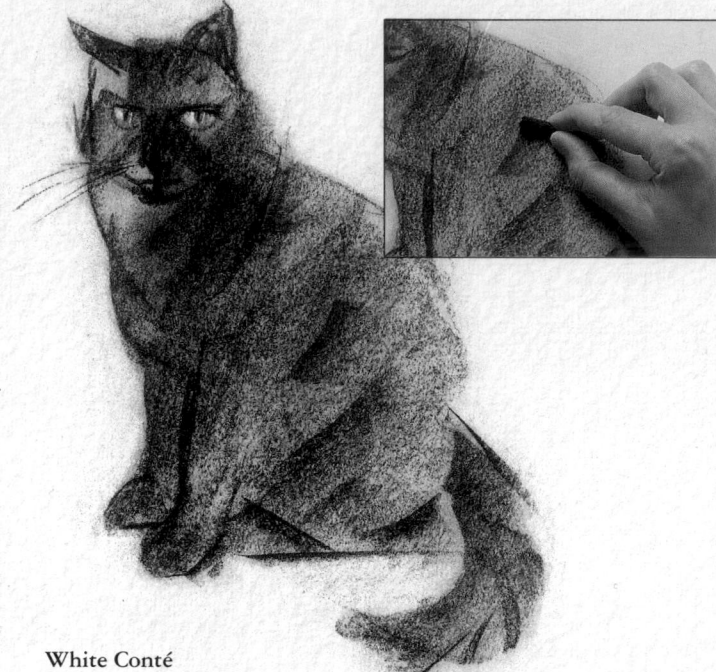

VERY FEW ANIMALS WILL SIT STILL long enough for you to make a detailed portrait, but there are a few "tricks of the trade." The skills and speed you have built up practising blind contour drawing (see pp. 32–33) will be a great help.

Before you start drawing, spend some time studying your subject. Watch how it moves. Does it take all four legs off the ground at once in a fluid bound? Does it use its tail for balance? Caged animals often prowl up and down, with a definite "rhythm" to their movements, which you can learn to anticipate. You don't need a detailed knowledge of animal anatomy – although there are plenty of good reference books available. Fast-moving animals such as the cheetah have large and powerful hind legs to propel them forward. Ferocious carnivores like the wolf have strong jaw muscles and sharp teeth to enable them to rip flesh apart. Think about what characteristics best typify each animal and then make sure that you emphasize these features in your drawing.

As when drawing the human figure, think of animal anatomy in terms of the basic geometric shapes – cubes, spheres, cylinders, and cones (see pp. 46–47). Look at how the light falls to see how you can use it to convey a rounded, three-dimensional image.

If you don't have easy access to live animals, you can practice drawing from television or video. But don't use the freeze frame; there is a risk your drawings will look static. It is far better to practice drawing quickly from life, in order to capture a sense of the animal's vitality, even if your early efforts are disappointing.

White Conté crayon

Charcoal

Kneaded eraser

Cat – White Conté Crayon and Charcoal

Charcoal can cover large areas quickly, so it is useful when speed is of the essence. The lighter tones are produced by removing charcoal with a kneaded eraser, and highlights in the cat's eyes are made with a white Conté crayon.

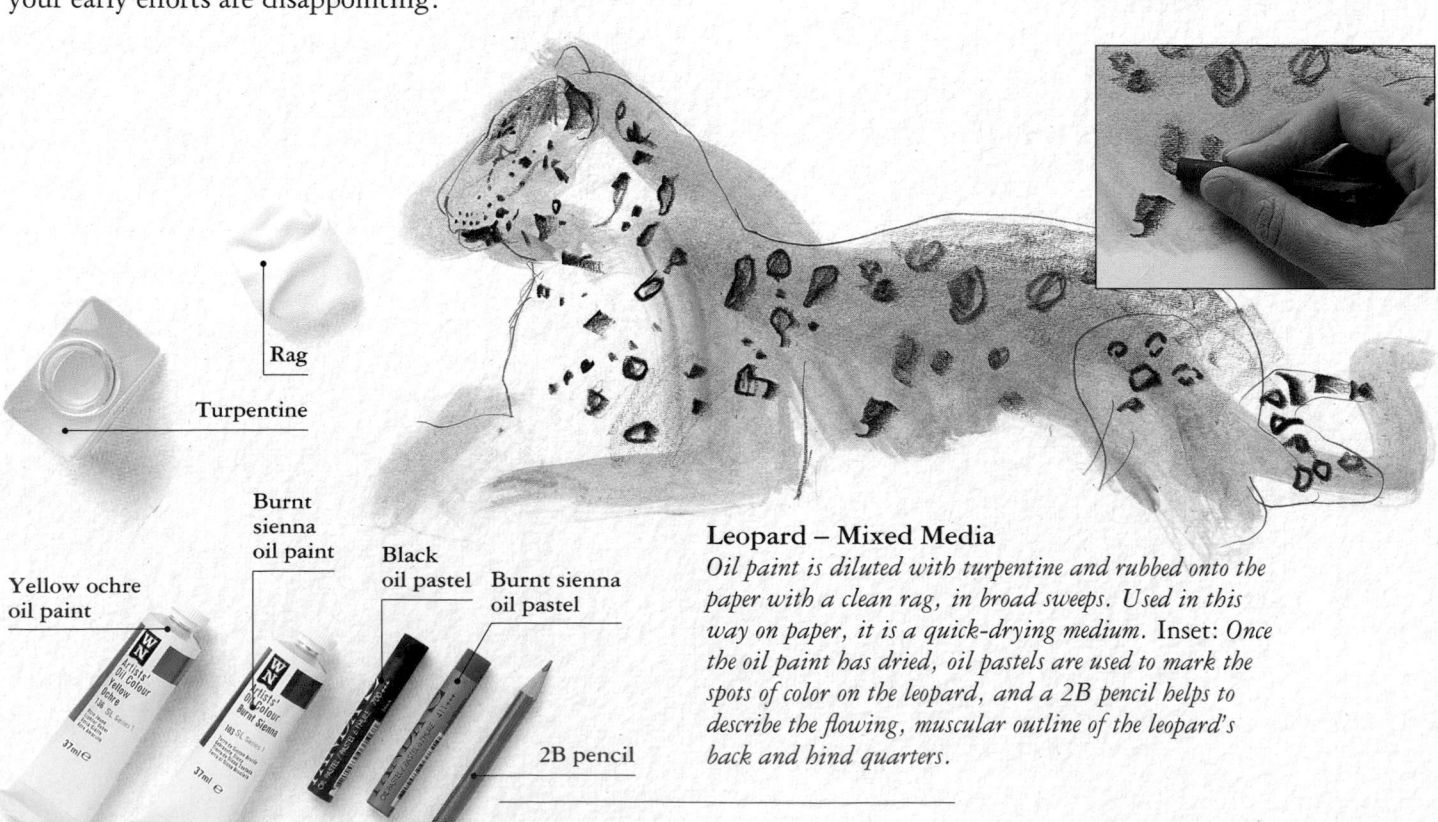

Rag

Turpentine

Burnt sienna oil paint

Black oil pastel

Burnt sienna oil pastel

Yellow ochre oil paint

2B pencil

Leopard – Mixed Media

Oil paint is diluted with turpentine and rubbed onto the paper with a clean rag, in broad sweeps. Used in this way on paper, it is a quick-drying medium. Inset: Once the oil paint has dried, oil pastels are used to mark the spots of color on the leopard, and a 2B pencil helps to describe the flowing, muscular outline of the leopard's back and hind quarters.

Lioness and Mate – Mixed Media

Yellow ochre and burnt umber acrylic paints are applied with a clean wet rag to give the basic shapes and colors of the animals. The paint dries quickly, so the details can be put in with a graphite pencil before the lions move. Inset: The graphite pencil is used to add the strong creases around the jowls of the lioness.

Water

Rag

Yellow ochre
acrylic paint

Burnt umber
acrylic paint

Graphite pencil

Owls – HB Pencil

An HB pencil is an ideal medium for this kind of finely detailed study as it can make a range of marks from strong and dark for important features like the eyes and beak, to delicate gray. Inset: The pencil is applied lightly to reinforce the fine, lightweight feather details around the owl's head.

Goose – 2B Pencil

A 2B pencil produces broad, sensitive lines – ideal for drawing the outline of the bird. Inset: The pencil is used with a lighter touch to form the contours around the goose's secondary feathers and tail.

2B pencil

HB pencil

Insects

RELIABLE VISUAL DESCRIPTIONS are essential to scientists studying the animal kingdom. Before the advent of photography, accurate drawings and paintings were the only way this information could be conveyed, and zoologists and artists alike cultivated the necessary skills. Captain Cook's expeditions in the 18th century always included someone who could record the flora and fauna of newfound lands, and in the 19th century Charles Darwin – who went on to develop the theory of evolution – was himself an accomplished artist, bringing back many drawings from his voyage aboard *HMS Beagle*. Even today, detailed and accurate line drawings are frequently used to illustrate journals and textbooks.

There are more different species of insect in the world than of any group of animals – at least one million, or three-quarters of all known species on Earth. Their diversity is amazing – from fruit flies so tiny that they can barely be seen with the naked eye to bird-wing butterflies the size

No. 6 brush

Watercolor pencils

Distilled water

Mixed Media
Use all the materials available to add richness and descriptive impact to your work. Here, a thin skin of pastel dust is massaged onto the darker "inked-in" shape of the beetle's body to echo the iridescent sheen so characteristic of the creature's wing case.

Black India ink

Brown ink

Steel-nib pen

Beetles
Fine detailing within the overall shape and camouflaging color make the beetle an exciting and challenging subject. The large body mass and wing cases contrast with the fine, often spiky, legs and antennae. Employing a range of watercolor pencils along with brown ink successfully echoes both these contrasts.

Felt-tip Pens
Some felt-tip pens have a very sharp, firm nib, producing fine lines. The generous amount of ink that sinks into the paper also contributes to the "velvety" deep color of the beetle's shell.

Felt-tip pen

Pencil
A 2B pencil is used to create a drawing that is a linear description. The paper also contributes enormously: rough surfaces give a darker, more intense quality to the work, whereas a smoother paper allows fine detailing.

2B pencil

of soup bowls, with every possible size, shape, and color combination in between. Insects offer the artist the chance to exploit the visual differences between the bulk of the animal's body and the delicacy of its limbs and antennae as well as incredible subtleties of color.

Leaving aside the larger moths and butterflies, most insects are relatively small. This forces you to study them very closely, often with the aid of a magnifying glass, to make sure you record all the intricate details of their anatomy – the way the wings are joined to the body, the different segments of the wing case, the length of the legs in relation to the rest of the body.

The medium you choose to draw with will, as always, depend on what you are trying to convey. The physical form of the insect is obviously crucial, but you should also think about other qualities. Are you drawing a fast-moving, aggressive-looking creature, with hard lines, such as a stag beetle? If so, a fine pen-and-ink drawing might be the most suitable approach. Or is it a delicate and fragile insect, with gossamerlike wings and sudden flashes of iridescent color, like a dragonfly? A combination of light pen work overlaid with a hint of watercolor pencil may be appropriate. Thin pen nibs, fine brushes, felt-tip pens, and pencils are all well suited to this work, but don't set yourself any hard-and-fast rules on what to use. Experiment with all the media and techniques at your disposal: you may well tap talents and ways of working that you didn't even know existed.

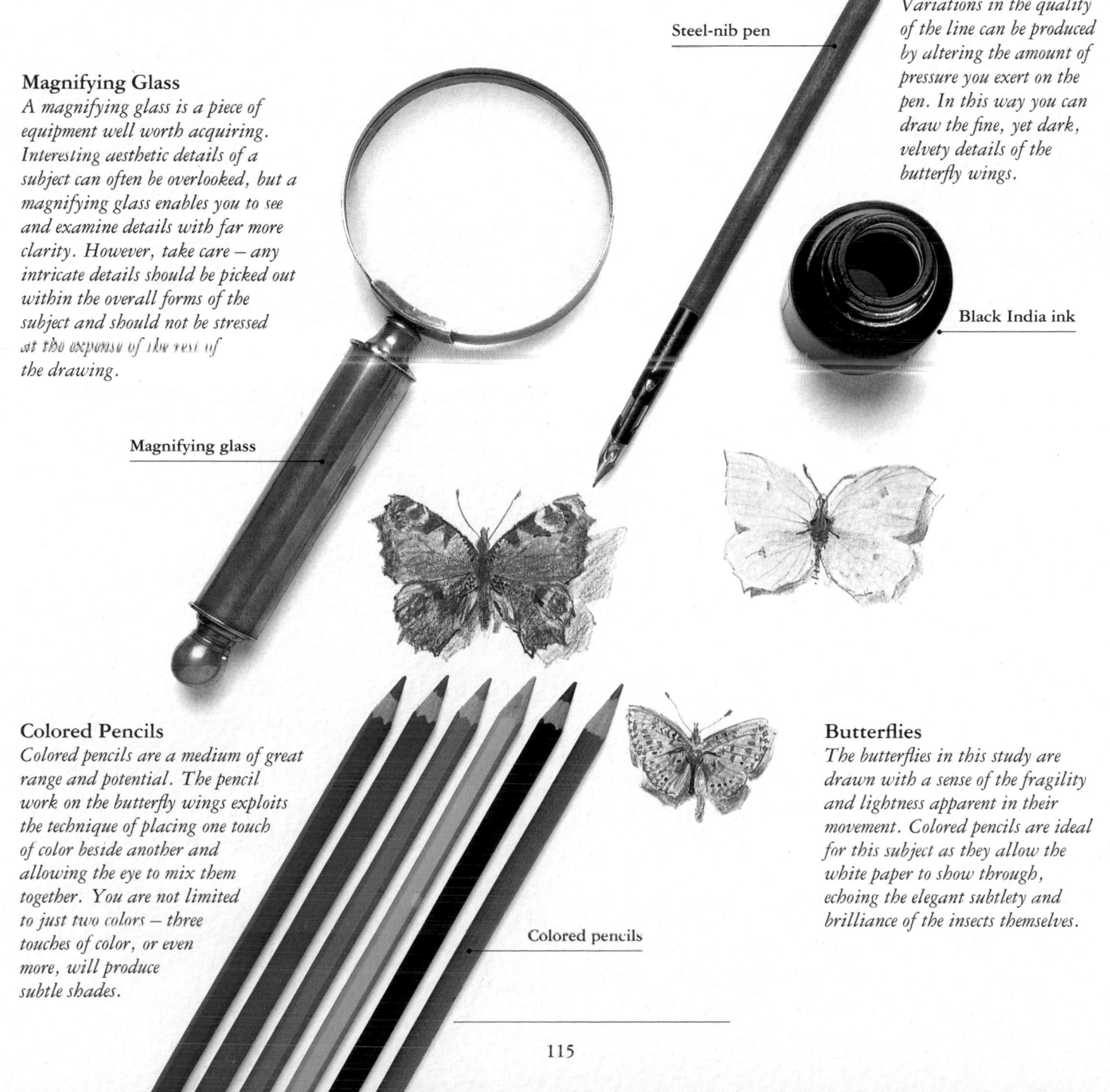

Pen and Ink
Variations in the quality of the line can be produced by altering the amount of pressure you exert on the pen. In this way you can draw the fine, yet dark, velvety details of the butterfly wings.

Steel-nib pen

Magnifying Glass
A magnifying glass is a piece of equipment well worth acquiring. Interesting aesthetic details of a subject can often be overlooked, but a magnifying glass enables you to see and examine details with far more clarity. However, take care – any intricate details should be picked out within the overall forms of the subject and should not be stressed at the expense of the rest of the drawing.

Magnifying glass

Black India ink

Colored Pencils
Colored pencils are a medium of great range and potential. The pencil work on the butterfly wings exploits the technique of placing one touch of color beside another and allowing the eye to mix them together. You are not limited to just two colors – three touches of color, or even more, will produce subtle shades.

Colored pencils

Butterflies
The butterflies in this study are drawn with a sense of the fragility and lightness apparent in their movement. Colored pencils are ideal for this subject as they allow the white paper to show through, echoing the elegant subtlety and brilliance of the insects themselves.

Simple Mechanisms

Any object that has moving parts is likely to prove challenging to draw. Try to find simple mechanisms to begin with, so that you can train your eye to interpret how the various parts interconnect.

The example on these two pages is a wire model of an airplane. Crudely made from bent and twisted pieces of thick wire, it nonetheless manages to convey a sense of energy and movement, which a more detailed, smoothly finished model might not.

The airplane is, in a way, a three-dimensional line model. As there is no tonal variation to contend with, a simple pen line seems a natural choice for tracing its contours. With pen and ink, it is easy to control the thickness of the line you are making and to move the pen freely over the paper. The nib is also fine enough to permit sudden and subtle changes in the direction of the line, allowing you to capture every twist and bend in the wire.

Although the subject here is interpreted loosely, you must give the drawing a strong understructure. Start by making a pencil sketch that is correct in scale, configuration, and general construction. This practice applies to figure and landscape drawing as well as to still life.

Black India ink

Steel-nib pen

HB pencil

Matching Technique to Subject
A model airplane might suggest a somewhat rigid, mechanical feeling to the drawing. However, it is important not to base your choice of medium and technique on any preconceived ideas you might have about how the object is constructed in real life, but to respond to the visual character of your subject. This model has a spiky, irregularly shaped appearance with tremendous energy, and pen and ink are ideally suited to putting this feeling across.

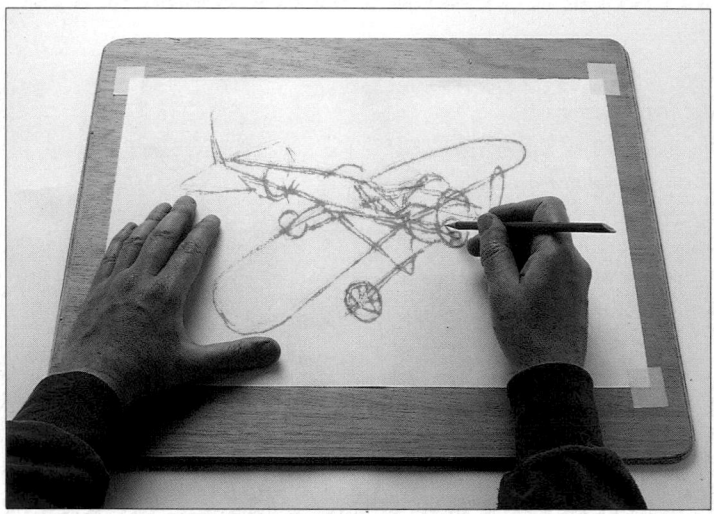

1 *For the underdrawing, hold an HB pencil firmly with your fingers, gripping the base of the shaft. Sketch in the general construction of the model airplane. Stand back from your sketch regularly to check that the scale and proportions are correct.*

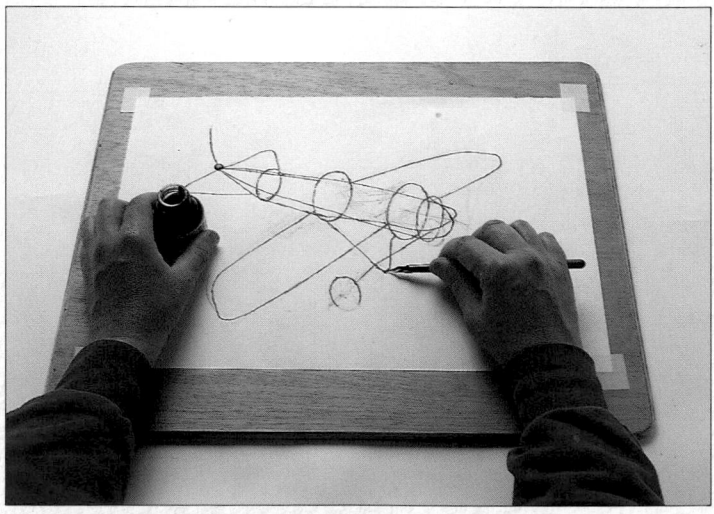

2 *Once the underdrawing is complete, begin the pen drawing. This time your grip should be fairly loose, so that you allow the loaded nib to trail across the surface of the paper, following the pencil line. Too tight a grip produces a rigid tracing.*

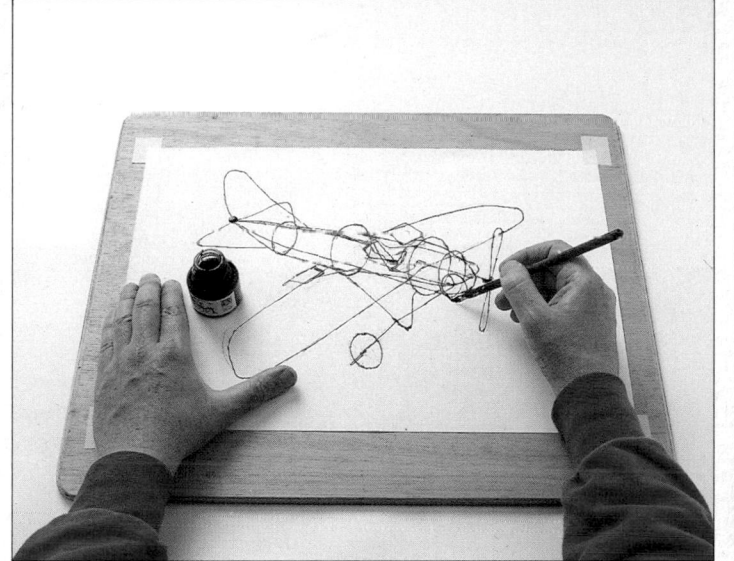

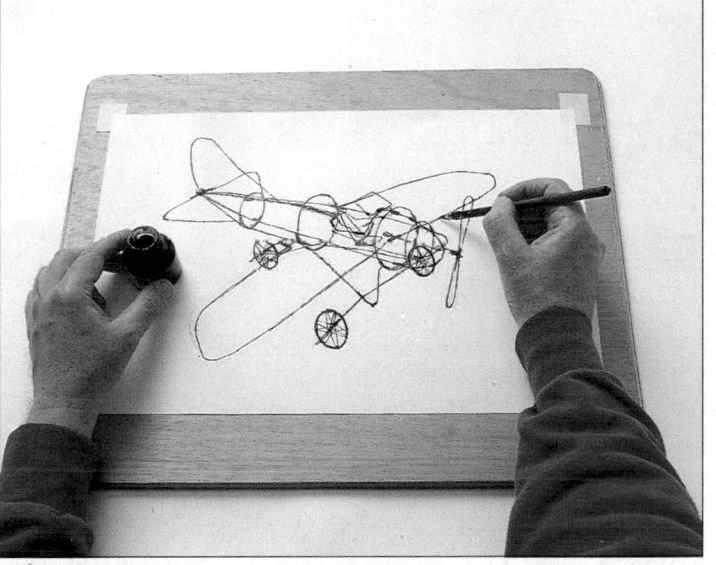

3 As you progress, the mesh of lines starts to develop the character of the subject. Apply a little more pressure on the pen in the lines closer to you – this will thicken them and help to suggest the three-dimensional effect.

4 Once you have completed the main forms of the airplane, start to put in the details. Concentrate on making sure that all the ellipses are drawn correctly (see p. 41) and on maintaining the flowing character of the pen line.

The Finished Drawing

Although this type of pen work would not suit all such subjects, the marriage of the technique with the character of the model airplane is fitting here. This drawing is an excellent example of how pen lines can be used to imitate the character of the bent wire. Even though tone has not been added, the varying thicknesses of the pen line create a three-dimensional effect.

Complex Mechanisms

WHEN YOU FEEL CONFIDENT ENOUGH, try drawing more complex mechanisms. It is a fascinating challenge – and one that has always attracted artists. The sketchbooks of Leonardo da Vinci, for example, contain many working drawings of inventions and mechanical implements, enabling us to see the components of the objects and how they were constructed.

Mechanical implements such as the ones shown on these two pages are made with great precision, their structure and function worked out to the very last detail. The same feeling of precision and exactness must come through in your drawing. Adopt a disciplined analytical approach.

The first stage is to think about how the device works. With small domestic items, such as the egg beater and corkscrew shown on these two pages, it is a useful exercise to hold the object in your hands and manipulate it to see how the different parts move. Doing this will give you a good idea of the main working parts. Next, look at the shapes of the various components. How do they relate to each other? Where do they overlap?

Then experiment with different arrangements, making sure that all the important working parts are clearly visible. Even if you emphasize the mechanical, formal feeling of your subjects, you can still make an aesthetically pleasing drawing. Find a viewpoint that allows you to incorporate shading to make it clear that the object is three-dimensional.

Think hard about the qualities you are trying to convey – sharp edges, shiny metal surfaces, the intricate detailing of cogs and wheels. You must find both a technique and a medium that allow you to do this.

One technique that is particularly appropriate for mechanical devices, when you often need to indicate bright highlights on sharp metal edges, is using a toned ground (see pp. 64–65). If you use white paper, you can only imply highlights by leaving areas of the paper untouched – you cannot draw them on a paper that is already white. With a toned ground, on the other hand, you can use white chalk or pastel to draw in the highlights on the objects exactly where necessary.

Plastic eraser

Black lithographic pencil

White Conté pencil

HB pencil

White Conté crayon

Charcoal

Shapes and Shadows

The corkscrew and egg beater are placed on a plain white surface, where nothing distracts from their shape. Although the arrangement looks simple, it is carefully contrived to allow all the working parts to be clearly visible. A table lamp placed at the top left of the arrangement casts long, crisp shadows that echo, but do not exactly replicate, the shapes of the objects. This lighting is useful in making the objects appear three-dimensional. It also presents an interesting artistic challenge: to make the shadows look like "ghost" images, far less substantial than the objects.

1 *Working on toned gray paper, use an HB pencil to sketch in the main construction lines of the objects and their shadows. Clean off any faulty work with a plastic eraser. Begin by sketching the skeletal construction and erase it later, once you are satisfied that the ellipses link up correctly.*

2 *Now use a black lithographic pencil and charcoal to strengthen the tones and place a touch of black on the base of the corkscrew. Use the same black pencil to put in some of the important dark tones along the metal blades of the egg beater.*

3 With the white Conté crayon begin to indicate the "negative" background – bringing out the silhouettes of the egg beater and corkscrew. Use your thumb to spread the white over the paper, up to the edges of the objects within the arrangement.

4 Use a sharpened white Conté pencil to put in the finer details, such as the spaces between the separate features of the egg beater. The range of tones should now begin to expand from dark to medium to light gray.

5 Start putting in the more precise details, such as the black part of the corkscrew. Use a sheet of clean paper as a hand rest, so that no grease from your hands rubs onto the paper.

6 Use the white Conté pencil to indicate the negative background and add any further highlights. Use the black lithographic pencil to make details of the drawing more distinct. Once these are added, they will give a brittle metallic surface to the objects.

The Finished Drawing

The finished drawing shows the hard metallic character of the corkscrew and egg beater against their softer shadows. Working the white background areas up to the edges of the main featured objects provides a simple yet strong three-dimensional effect.

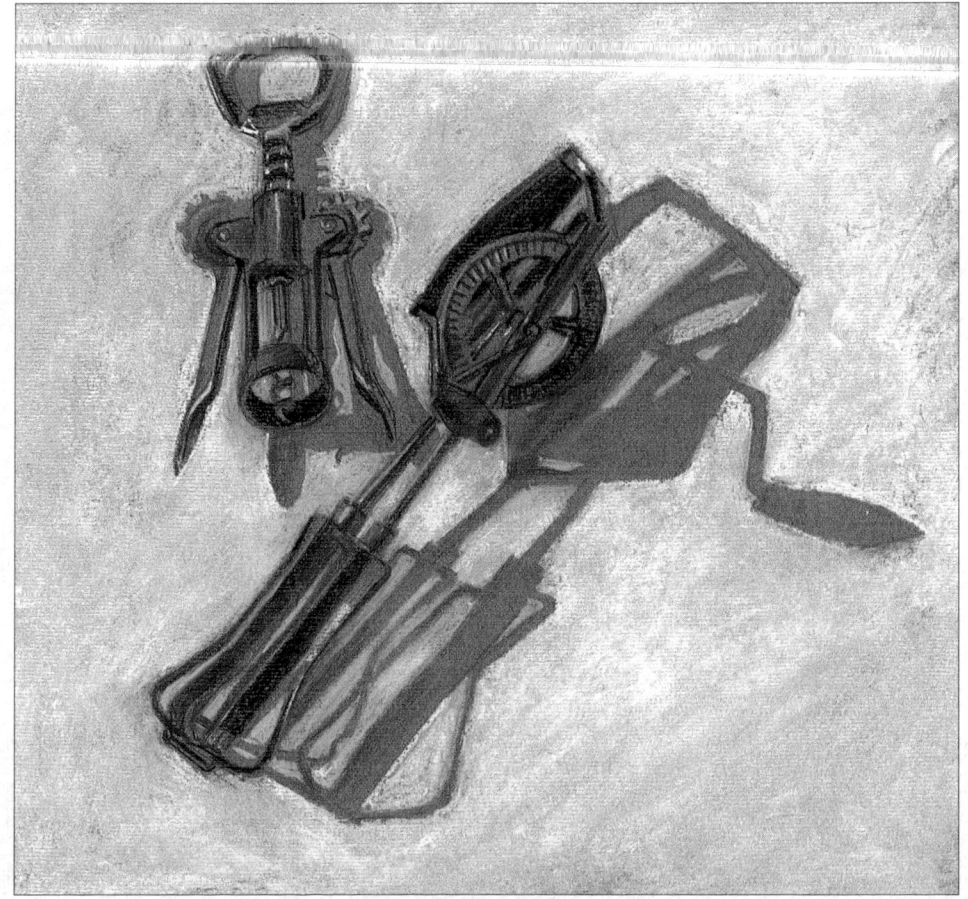

Advanced Techniques

Making a Blot Print

ALTHOUGH MANY FORMS OF ART are intense and demand great skill, there is always room for fun, and there are many ways of triggering your imagination. One way is to make pictures by blotting – using ink or paint to make a shape on a piece of paper and then printing this on another piece of paper. Alternatively, you can fold the paper over and press it down to get a mirror image of the ink shape. Depending on what subject is suggested to you by the blot, you can develop it into an image by adding ink with a pen, brush, or sponge. Look at the print from different angles – from the side, and even upside down – before you start drawing. Different viewpoints may suggest very different ideas.

Much of the fun of this type of work lies in discovering how different consistencies of paint or ink behave. Thick, "sticky" paint will leave a solid image when printed onto your drawing surface. Often the textures within such prints are particularly rich and varied, as can be seen in the "flowers" demonstration on the opposite page. By diluting the paint to a very thin wash, however, the print tends to be fainter and spreads outside the original shaped areas. Try using both ink and paint in the same picture. They have different consistencies and will produce interesting contrasts of texture. Experiment with color, too. Combinations that you might not expect to work together may spark a new idea when you see the blot print.

The type of paper, too, will contribute to your final picture. A smooth surface will allow every detail within the blot to show well, whereas a rougher surface such as cold-pressed watercolor paper (see pp. 22–23) will create a more general shape. Don't limit yourself to conventional drawing papers. Try using papers of different weights, distressed papers, or plain brown wrapping paper.

The idea is to encourage an experimental approach to your work. Respond to what happens on the paper and let your imagination run wild!

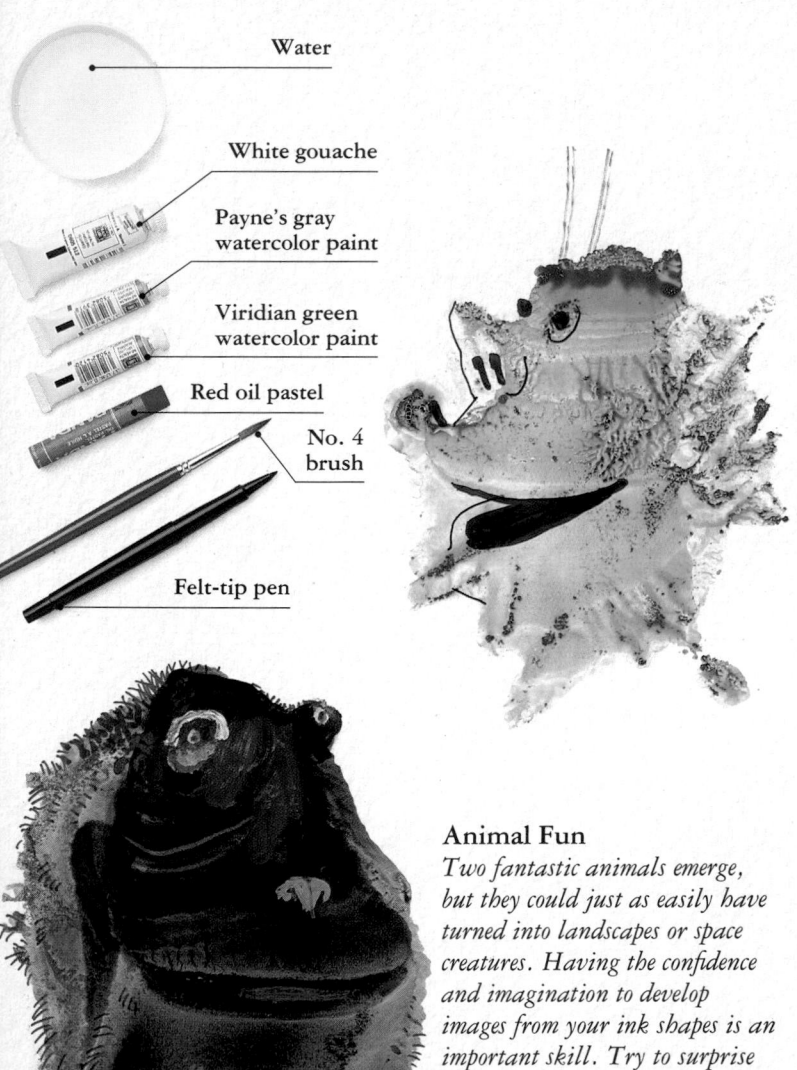

Water

White gouache

Payne's gray watercolor paint

Viridian green watercolor paint

Red oil pastel

No. 4 brush

Felt-tip pen

Animal Fun
Two fantastic animals emerge, but they could just as easily have turned into landscapes or space creatures. Having the confidence and imagination to develop images from your ink shapes is an important skill. Try to surprise yourself with the final result.

Making the Print
Spread viridian green watercolor paint straight from the tube onto the paper. Use a no. 4 brush to apply a blot of very diluted Payne's gray watercolor paint above the green blot. Then place a sheet of clean paper over the ink shapes and rub the back of it with your fingers. The two consistencies of paint produce very marked contrasts of texture in the blot print. Inset: Lift off the top sheet of paper in one clean move to avoid smudging the print. Examine the prints to see what ideas are suggested. Then use other media – white gouache, red oil pastel, felt-tip pen – to give the blots the identity you have chosen for them.

Blot on the Landscape

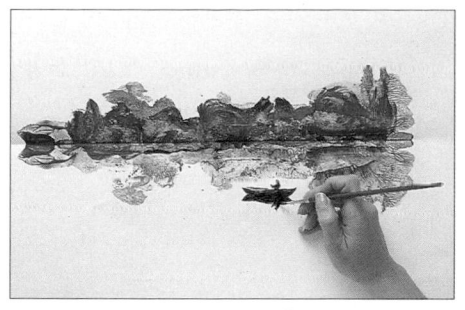

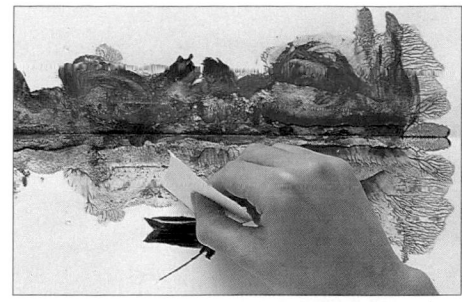

1 *Mix black India ink and viridian green watercolor paint together with a small amount of white gouache and water. Then use a no. 4 brush to paint the shape of a headland, making swirling movements with the brush to create texture.*

2 *Fold the paper cleanly in half along the bottom edge of the blob of paint, and rub it to make a "reflection." This mirrors the first blob in shape but is fainter in color. Use a clean no. 4 brush dipped in ink to draw in the boat and its reflection.*

3 *Use a small piece of cardboard dipped in ink to put in the fishing rod and its reflection. Then, with the no. 4 brush, put in the last details, such as the ripples of the river seen at the bow of the boat.*

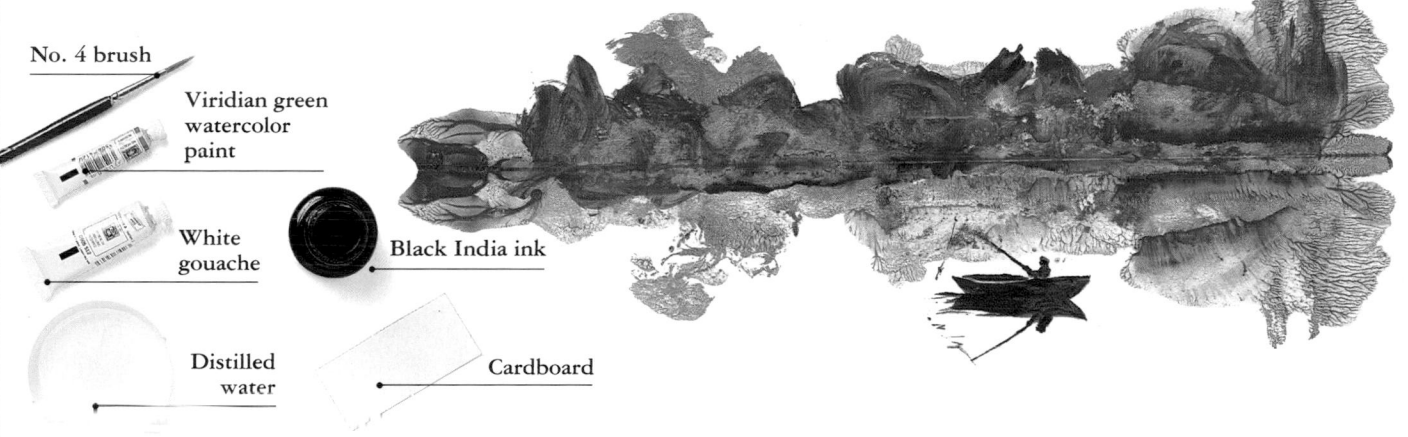

No. 4 brush

Viridian green watercolor paint

White gouache

Black India ink

Distilled water

Cardboard

Flower Blots

The paper you choose for blotting has a great effect on the quality of the images. In this case, because a smooth, glossy paper is used, a lot of the ink is lifted off when you remove the top strip, bringing extra texture to the image.

Brown ink

Steel-nib pen

Black India ink

1 *Put a blob of brown ink on a strip of glossy paper. Place the paper face down on a larger sheet of the same paper, and apply pressure. Lift the top strip off cleanly, and see what you have beneath.*

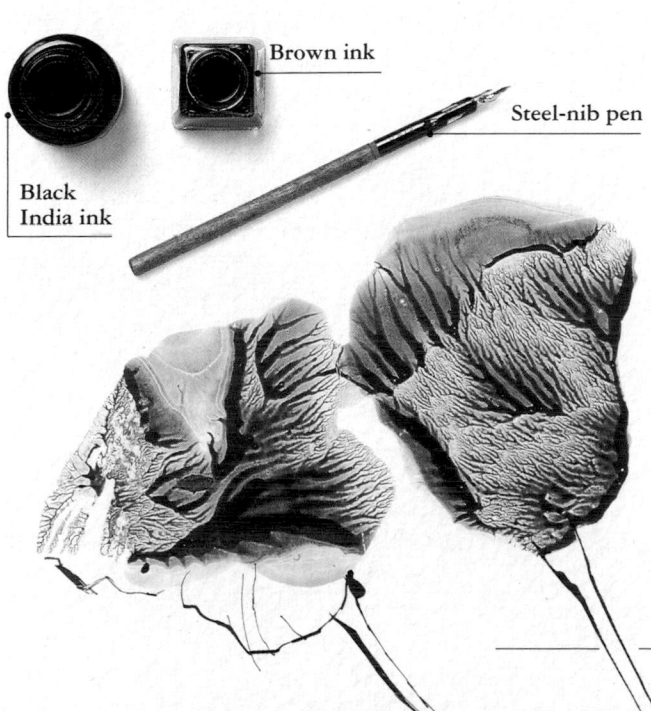

2 *Put a little more ink on the first blob and then make another print. Use a steel-nib pen dipped in black India ink to draw in the stems and leaves and to enhance the flowers' identity.*

Reflections

INCORPORATING A REFLECTION of your subject somewhere in the picture, or making the reflection itself the focal point, opens endless possibilities for interesting compositions. You can offer a "double-take" on the same subject, with one view a straight-forward mirror reversal of the other. Or you might draw two contrasting views of your subject – showing the front and back, or the front and one side, depending on where you position the reflective surface. A mirror is the most obvious reflective surface, but it is by no means the only possibility. In a city-scape, experiment with drawing scenes reflected in a modern, glass-fronted building. For a landscape, include the reflection in the still waters of a lake. At home, set up a still-life composition in which objects are reflected in a stainless-steel tray or a silver picture frame.

Some surfaces are more reflective than others. A mirror, with its silver-coated backing, gives the clearest reflection of all and is ideal when you want crisp, sharp detail in both the subject and its reflection. A reflection in a lake may be disturbed by ripples in the water, while a reflection in a metallic surface such as copper may be quite dull, merely hinting at the object's general shape and color. All, however, can add interest and variety to your picture.

Whatever reflective surface or subject you choose, there are certain factors common to drawing all reflections. You are obviously looking at the object and its reflection from somewhat different angles, as the object and the reflective surface cannot physically occupy the same space. There is also a change in scale, however slight, from one to the other. Conveying these changes in perspective accurately is crucial to the success of your drawing (see pp. 40–43, 58–59). The most important thing, however, is to make sure that the object and its reflection work together to make a strong composition.

You could also try presenting just the reflection. It is generally best, however, to give at least some hint of the "real" world – a riverbank or part of a tree trunk at the edge of the picture, for example – in order to provide a context for the reflected image. A reflection alone can look abstract and surreal. There are occasions when this approach works. The choice is yours.

The Pose
The model is in the center of the picture space, but the focal point (the reflection in the mirror) is on the right, positioned almost one third of the way into the picture space (see pp. 34–35). The viewer's eye is led along the left shoulder and past the head to the reflection.

Distilled water

No. 4 brush

Steel-nib pen

Black India ink

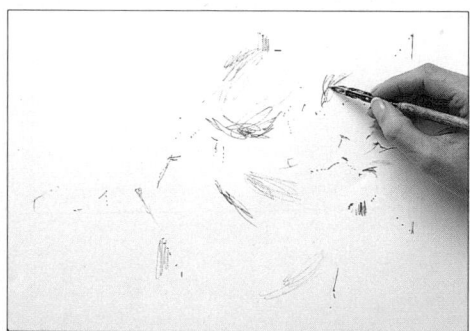

1 *Using a steel-nib pen dipped in diluted black India ink, lightly mark in the positions of the main features – the back, the rear of the head, and the edge of the face reflected in the mirror.*

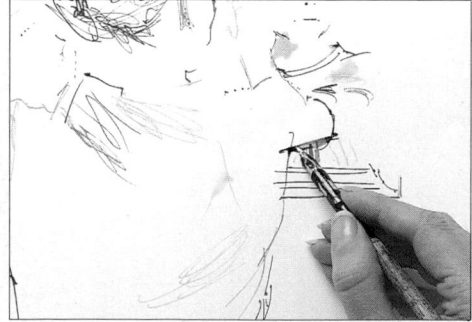

2 *Holding the pen firmly near the nib, so that you can control it, start to build up the understructure of the drawing, consolidating the pen lines.*

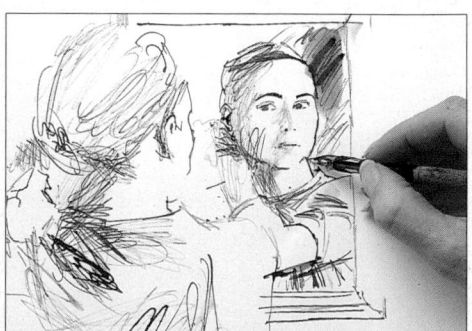

3 *Using a stronger dilution of ink, sketch in the shoulder and the creases in the upper arm of the sweater and strengthen the outline around the profile of the reflected face.*

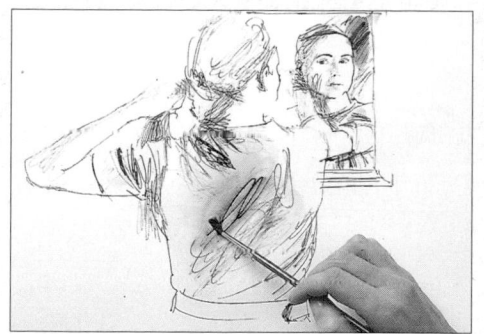

4 Using a no. 4 brush dipped in clean water, indicate the shape of the sweater. Put a blob of very dilute ink in the center of the dampened area. The ink will spread randomly to the edges of the dampened area.

5 Put a blob of a slightly darker dilution of ink in the center of the dampened area. The ink will again spread randomly, stopping when it reaches the outer edges of the dampened area.

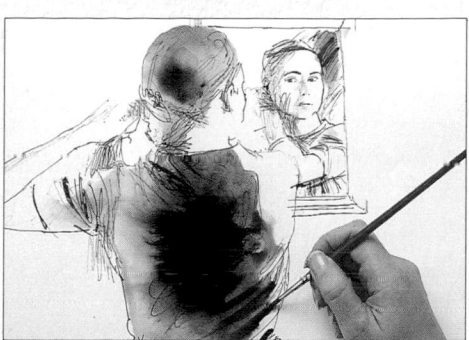

6 Apply a wash to the hair in the same way as in steps 4 and 5. Use the tip of the brush to put in the folds and creases on the back of the sweater.

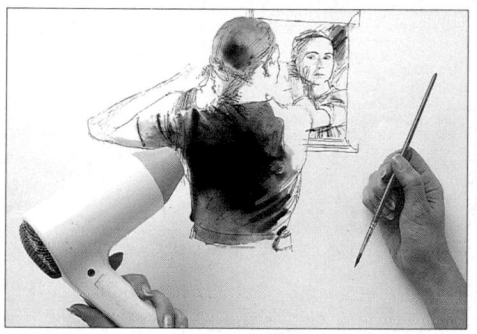

7 Use a hair dryer on a very low setting to dry the wash. If the wash is spreading too far, you can also use the hair dryer to blow ink back into the desired area.

8 Using diluted India ink, put in the dark tone along the outer edge of the model's left arm and elbow.

9 Using a steel-nib pen, indicate how the hair has been combed back off the face and pulled to the side of the head.

The Finished Drawing

The inclusion of the reflection has made it possible to draw the same head from two different perspectives. The two "halves" of the image overlap just enough for a link to be established between them, while each part remains clearly visible. Contrasts and echoes of shapes abound: the rounded forms of the head, elbow, and shoulders contrast with the hard rectangle of the mirror frame, while the triangular shape made by the model's left hand and arm is repeated in the right hand and arm in the reflection. The viewer is led through the picture in a strong diagonal line from the left elbow to the eyes in the reflection — the focal point.

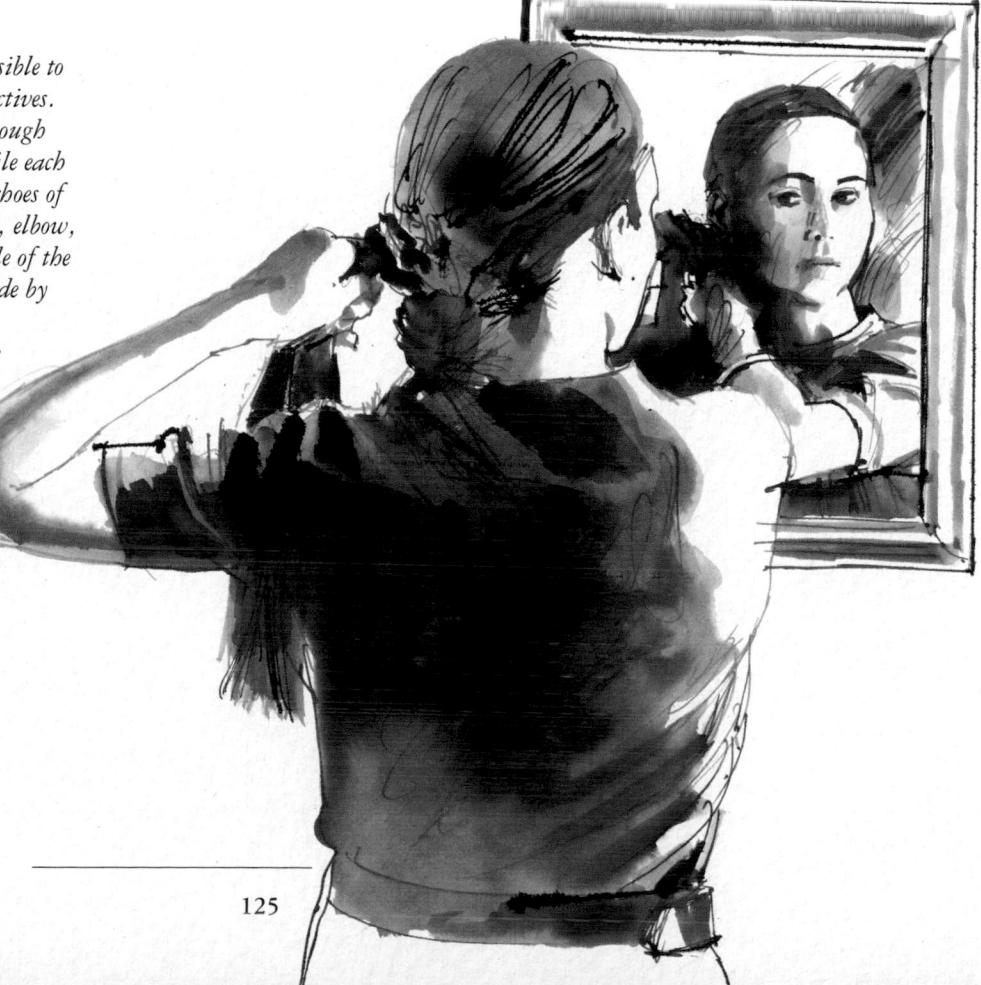

Using a Toned Ground

THE PAPER ON WHICH YOU DRAW need not be a plain white sheet. Indeed, toning the ground before you begin is a long-established technique used for drawing (see pp. 64–65). Giorgio Vasari, who wrote about the lives and techniques of the great Renaissance painters, makes reference to such a ground preparation.

There are many good reasons for choosing a toned ground. Color creates mood: blue is cool; pink is warm. The color you choose will be your own personal preference, but it is important to use a middle tone, capable of contrasting with white marks, a series of grays from mid through dark, and black. Colored papers can be used, and some lovely surfaces are widely available, but toning your own brings a great sense of satisfaction.

Any colored ground will influence the black used on it – reds tend to intensify it, dark blues thin it down. Dark lines and tonal areas can be applied with charcoal or soft pencils, and the highlights achieved by rubbing out the relevant areas with an eraser (see pp. 50–51) or by drawing them in with white chalk or Conté crayon. White, used to heighten detail and describe light, can be varied from pale to strong by varying the amount of pressure you exert on the chalk or crayon. White gouache is ideal if the ground is watercolor. It can be diluted or used as a solid, adding subtlety to highlighting. Take care not to overstate the highlights, particularly in the initial stages of your work, as a stroke of harsh white can be very difficult to erase later.

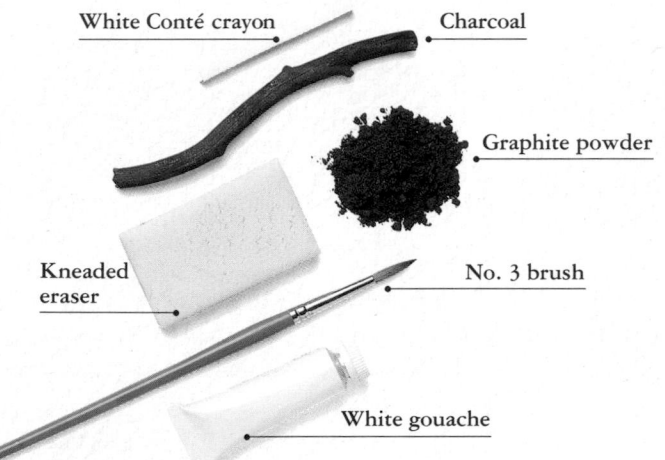

White Conté crayon — Charcoal

Graphite powder

Kneaded eraser

No. 3 brush

White gouache

1 *Stretch the paper and tone it with a thin cobalt blue watercolor paint wash applied with a sponge (see pp. 64–65). Rub graphite powder onto the surface to suggest the major block of tone. Use charcoal to sketch in the shapes of the head, hat, and main features of the face.*

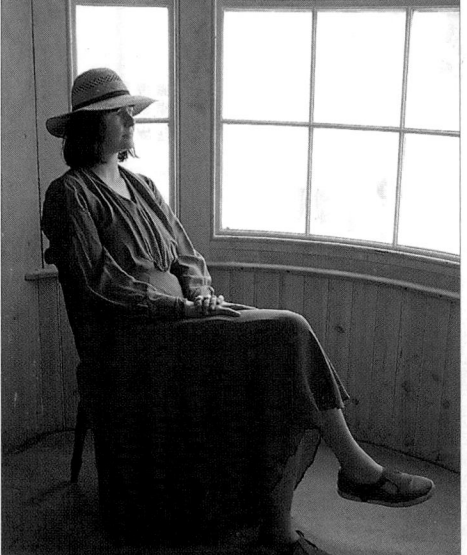

Main highlight area in window panes

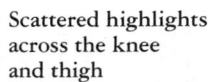
Scattered highlights across the knee and thigh

General mid-tone of the wood-slatted wall

Deep shadow under the skirt and chair

Tonal range
With a wide range of tones, start from a middle ground, work back to the light areas, and add tone for the shadows.

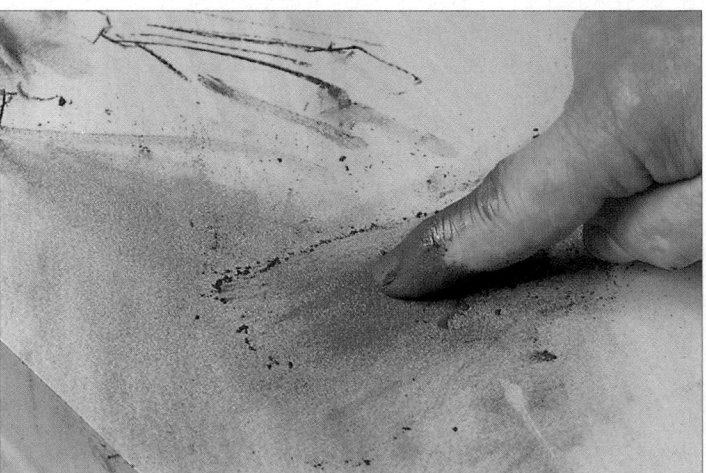

2 *Controlling the spread of graphite powder with your finger, bring in larger areas of tone. Work across the surface and avoid focusing on one part exclusively. Keep a general overall view of the subject and background at all times.*

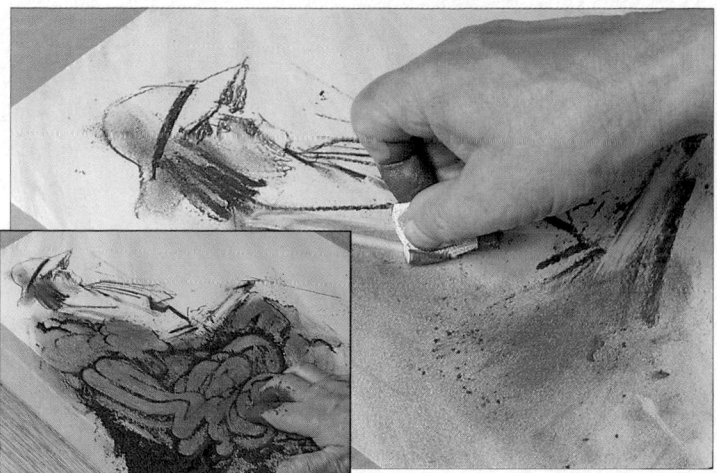

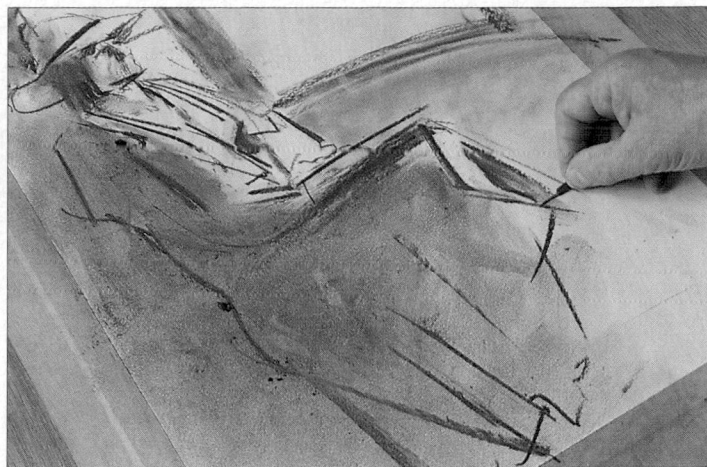

3 Introduce the lighter tones using a kneaded eraser to refine and wipe out some of the charcoal work (see pp. 50–51). Inset: A further application of graphite, generously spread, will make a broad, dark tone, creating a vertical plane from the knee to the floor.

4 Use line and tone together to suggest the heavy hang of the skirt and to draw in its lower edge. Make sure that the total image of the figure and window fits well on the paper. Allow space for the legs and feet to be drawn in below the skirt.

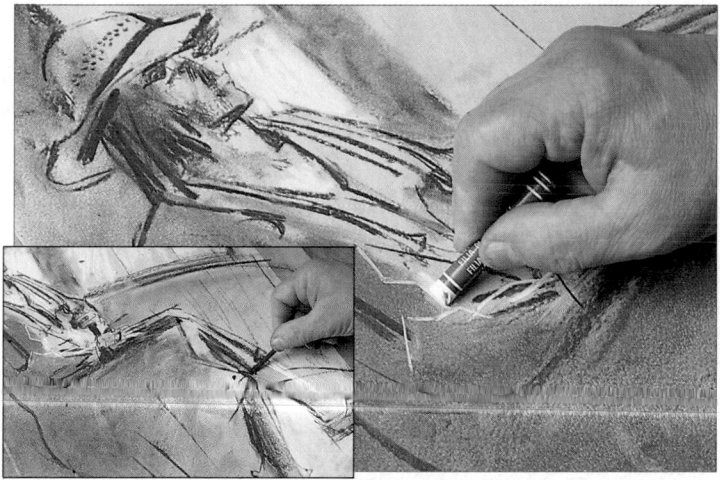

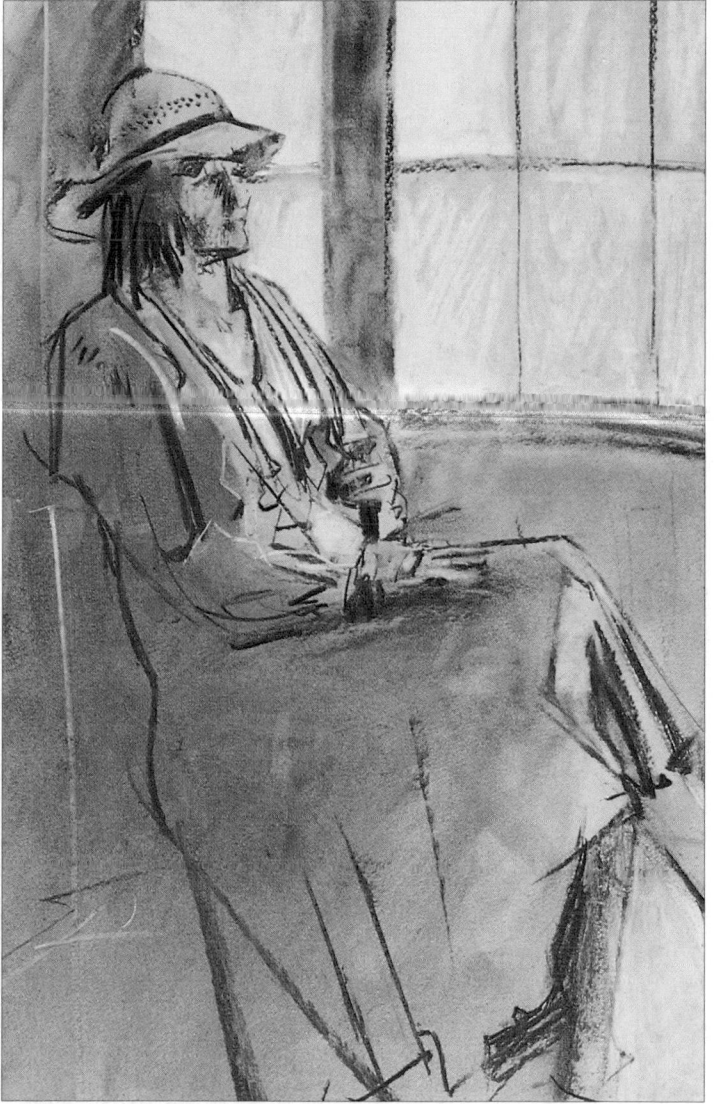

5 Use a white Conté crayon to put in the lighter tones on the figure and behind the profile of the face. Inset: Continue applying the lights, at the same time laying stronger tone on the darker areas, such as the point where the skirt meets the lower leg.

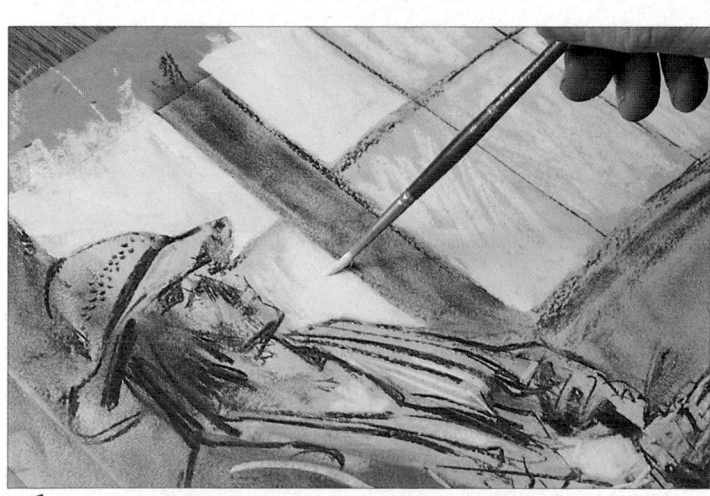

6 Use a no. 3 brush and white gouache to put in the areas that receive the most light, such as the window panes and the woman's chest. This helps to consolidate the three-dimensional illusion.

The Finished Drawing
The backlit, semi-silhouetted figure and the bright area of the window complement each other well. Starting from a middle ground prevents the tonal contrasts from being harsh.

Charcoal Deletion Drawing

CHARCOAL IS ONE OF THE OLDEST and most versatile drawing materials. Early cave dwellers drew on cave walls with charred sticks – such a simple idea. But what is important to remember is the flexibility of this apparently basic tool for drawing and the sophistication of its manufacture and selection.

Charcoal is the drawing medium most like painting. It is a monochrome instrument capable of a range of marks, from broad areas of deep, velvety black to finely detailed line work. Charcoal enables you to add shade and tone to large areas, and it can be easily modified or removed with a cloth, your finger, or a kneaded eraser. An alternative to the kneaded eraser is a piece of white bread gently massaged in the fingers until reduced to a paste-like consistency. These deletion techniques are useful for creating angles of light and bringing out highlights in dark and toned areas. Furthermore, charcoal can be dusted off the paper with a cloth, enabling the artist to rework or alter the image at will. This is especially useful when planning an elaborate composition of landscape or figures. Pablo Picasso used charcoal to sketch in dimensions and proportions, as did John Constable and Henri Matisse.

Experiment with the different colors and hardness of each type of charcoal. It is sometimes better, for example, to combine the brownish vine stick with a richer beech one, which is altogether blacker and very strong in its marking value. Generally, the softer the charcoal, the stronger and darker its mark.

In the example shown here, the general middle tone of the charcoal ground controls the surface. The toned ground, mid- to dark-gray lines, and blocks of tone combine with the light areas and highlights to bring a sense of unity and completeness to the drawing.

Charcoal

Kneaded eraser

The Arrangement
Creating a work of art from a commonplace item is a good habit to cultivate – so long as it is treated with originality and skill.

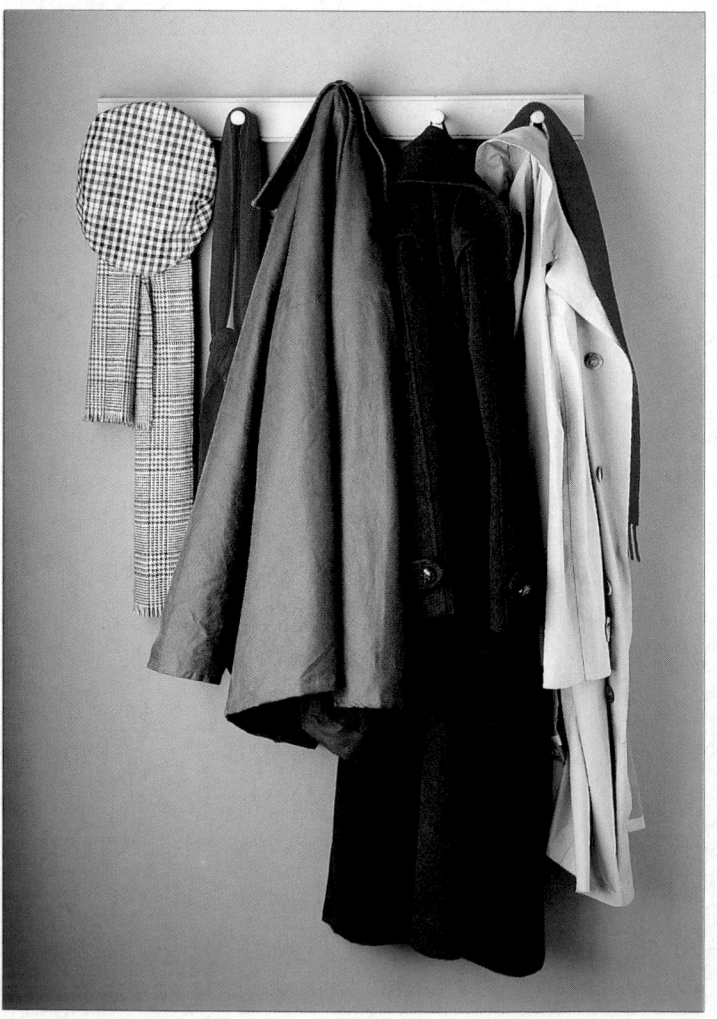

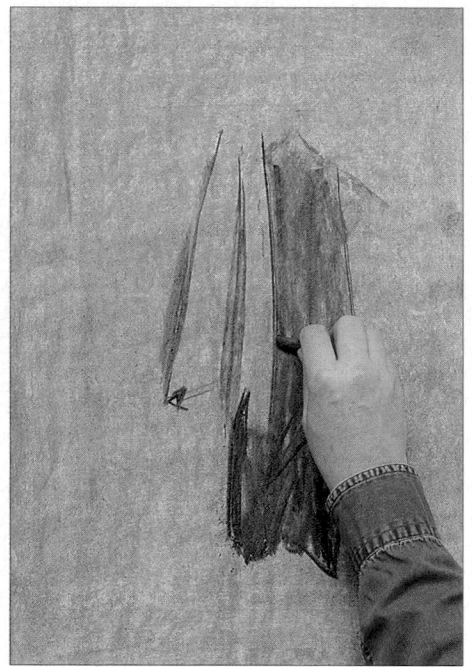

1 *The ground of this heavy drawing paper has been toned with the side of a piece of charcoal (see pp. 64–65). Begin by using total black to indicate shadow between two of the coats. Use the side of the charcoal stick as well as the end. Continue the buildup of tones to create form. To increase your awareness of the tonal contrast, you need to squint your eyes slightly.*

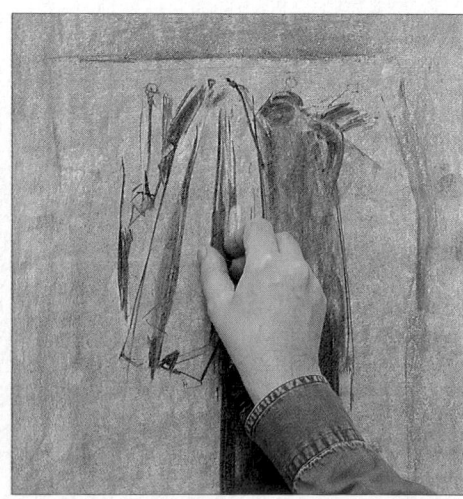

2 *Use simple lines alongside broad tonal areas to build up the basic shapes. A strong horizontal line indicates the board supporting the coat hooks, in contrast to the dominant vertical lines of the hanging folds. Keep your eye and hand moving across the paper.*

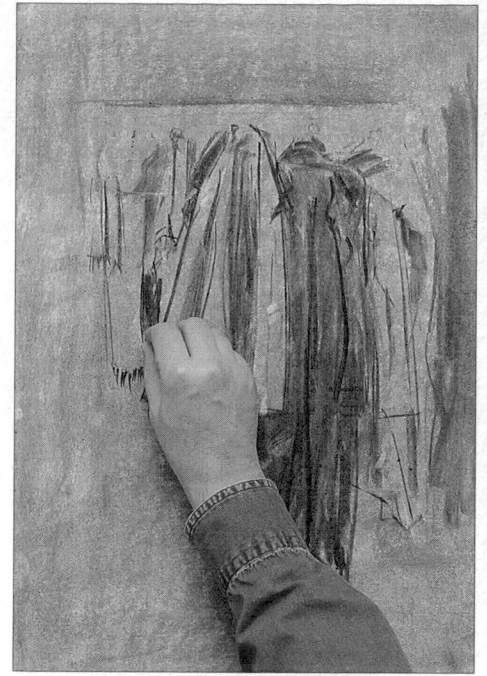

3 Continue the process of stressing shadows. Maintain the horizontal and vertical references. Exploit the different lengths to make the picture interesting. Fill in to suggest the dark blue color of the long coat.

4 Draw in the checkered pattern of the scarf with finer lines. Draw carefully so that you don't lose the rounded form of the hanging cloth, despite its superficial pattern.

5 Use a small slice of kneaded eraser to create highlights by wiping off the gray-toned surface. It may look crude at first, but you can make subtle refinements once the guidelines are established.

6 Look at the image from a distance to get an impression of the overall effect. The *detailing of the textured cap and scarf patterns* brings a new dimension to the surfaces. Make further refinements to the surface, wiping more light and mid-tones out of the dark ground.

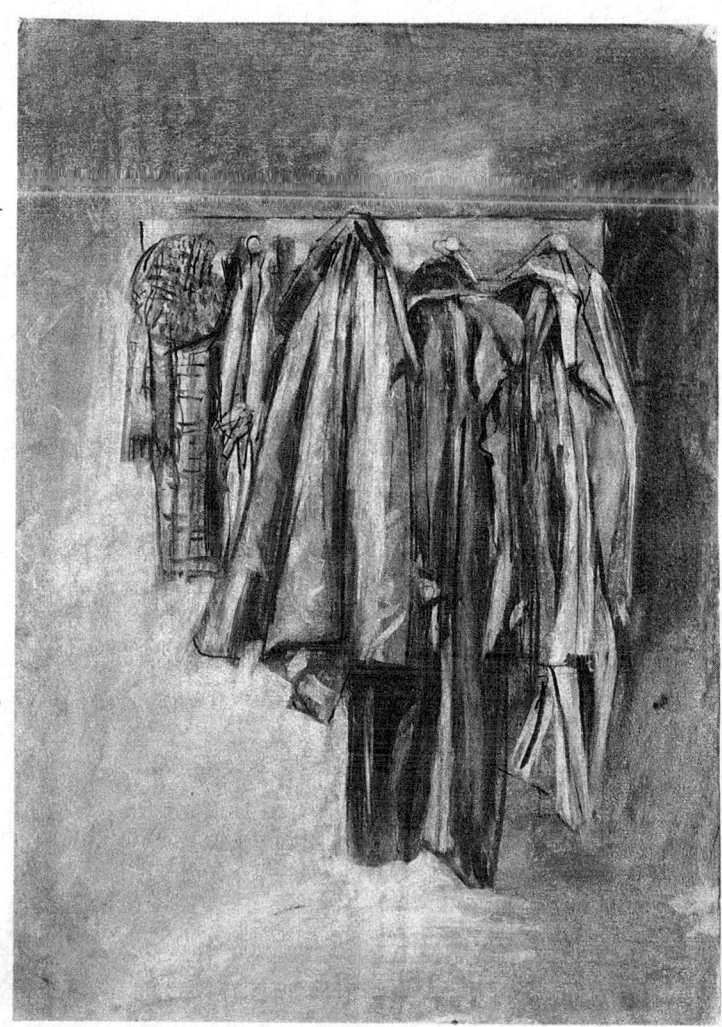

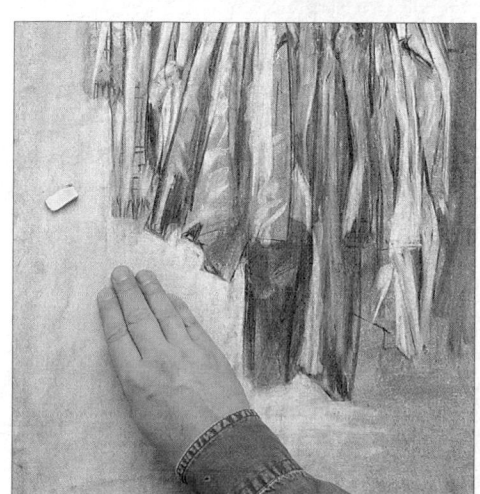

7 Use your finger-tips to blend the areas of tone behind the coats to a middle tone. Rub away other areas of light. Finally to keep the surface from smudging, spray it with an ozone-friendly fixative (see pp. 152–153).

Capturing Movement

STUDYING HOW PEOPLE AND ANIMALS MOVE is a relatively new science. If you look at pictures made before the late 19th century, you will see that the movements depicted sometimes look strange, if not anatomically impossible. Eighteenth-century prints of horse races or battle scenes, for example, showed horses jumping over fences with their legs stretched out almost horizontally in front of and behind them. It was not until the advent of photography, which allowed actions to be frozen in time, that it became possible to study intricate movements in detail. The photographer Eadweard Muybridge (1830–1904) was a pioneer in this respect: his photographs of a galloping horse proved conclusively that a horse does not lift all four legs off the ground at once and demonstrated for the first time the sequence in which the legs move.

Nowadays, we see photographs of people and animals in motion all the time. Thanks to these images, and to slow-motion and time-lapse sequences on television, the average person probably knows more about the mechanics and rhythms of movement than he or she realizes – even though this knowledge is, for the most part, subconscious. A few basic facts, combined with careful observation, are all that is needed to bring this knowledge to the surface.

As we saw in Figure Drawing (see pp. 102–105), balance is crucial. Human beings and other animals correct their balance instinctively as they move so that they do not fall over. In general, the movement of a limb on one side of the body produces a corresponding movement in the opposite direction on the other side. Angles to look for are the angle of the head as it counters the movement of the shoulders, and the line across the shoulders, which runs counter to the line through the hips.

These angles can also give you a clue to the strength and speed of the action. Generally speaking, the farther forward

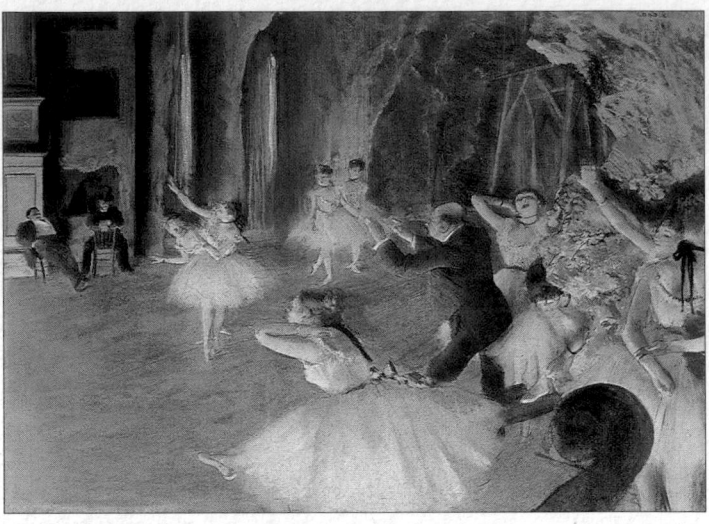

"The Rehearsal on Stage," Edgar Degas
The strong diagonals of the composition produce a sense of tremendous energy and vitality. The dancers' poses are precarious: you feel that you are glimpsing a split-second in a scene of ongoing movement.

Drawing from Television
Drawing a sporting event on television is a good way to practice. Watch the action for a while before you start to draw, and try to fix the rhythm in your mind. Look at how angles within the body change as the action progresses.

Charcoal pencil

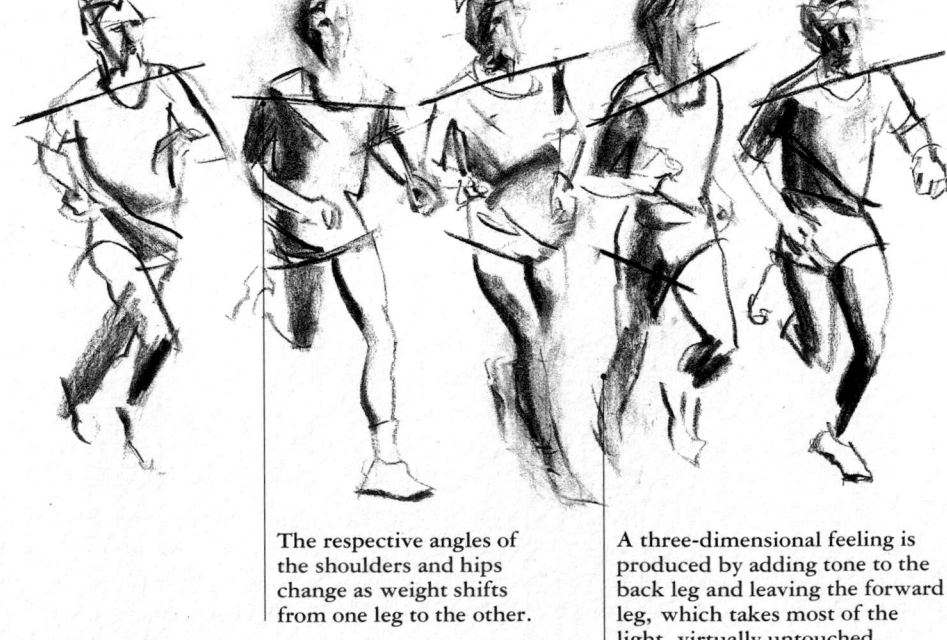

The respective angles of the shoulders and hips change as weight shifts from one leg to the other.

A three-dimensional feeling is produced by adding tone to the back leg and leaving the forward leg, which takes most of the light, virtually untouched.

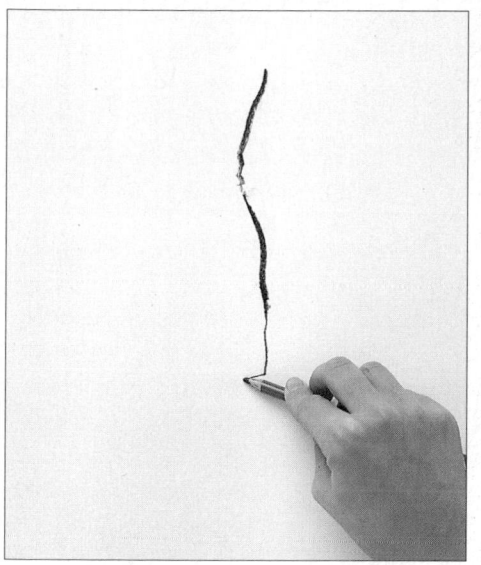

1 Look for a line that emphasizes the main thrust of the running figure — in this case, the left side of the runner's chest, thigh, and calf. Draw this line with a charcoal pencil, varying the pressure on the pencil to thicken the line and stress the more rounded muscular regions.

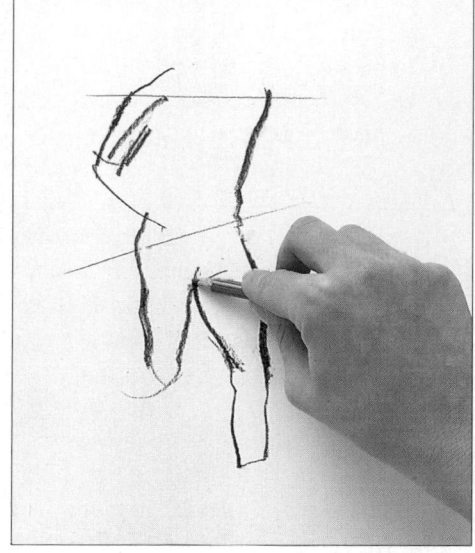

2 Draw light lines for placement of the shoulders and hipbones to make sure you get the angles right. Draw the right-hand side of the torso, from shoulder to knee, and indicate the main folds in the right sleeve. Use a strong line for the inner thigh of the left leg to imply that it is farther forward than the right leg.

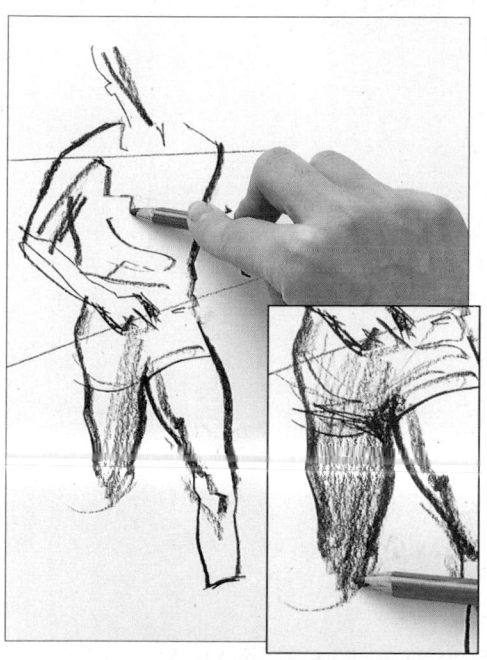

3 Draw the right side of the head, taking care to get the angle correct, and the right arm and hand. Put in the main folds on the running shorts and t-shirt: these imply the stretching of muscles on the body underneath. Inset: Darken the inner right thigh to introduce a three-dimensional feeling.

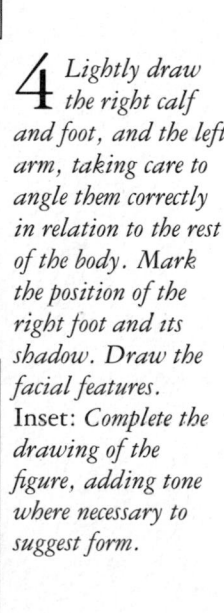

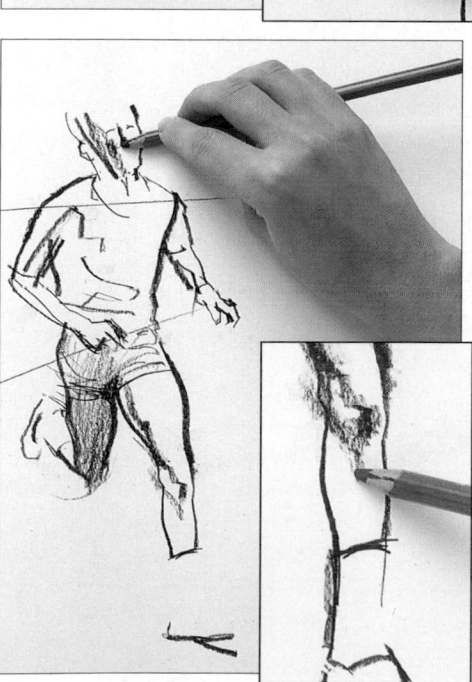

4 Lightly draw the right calf and foot, and the left arm, taking care to angle them correctly in relation to the rest of the body. Mark the position of the right foot and its shadow. Draw the facial features. Inset: Complete the drawing of the figure, adding tone where necessary to suggest form.

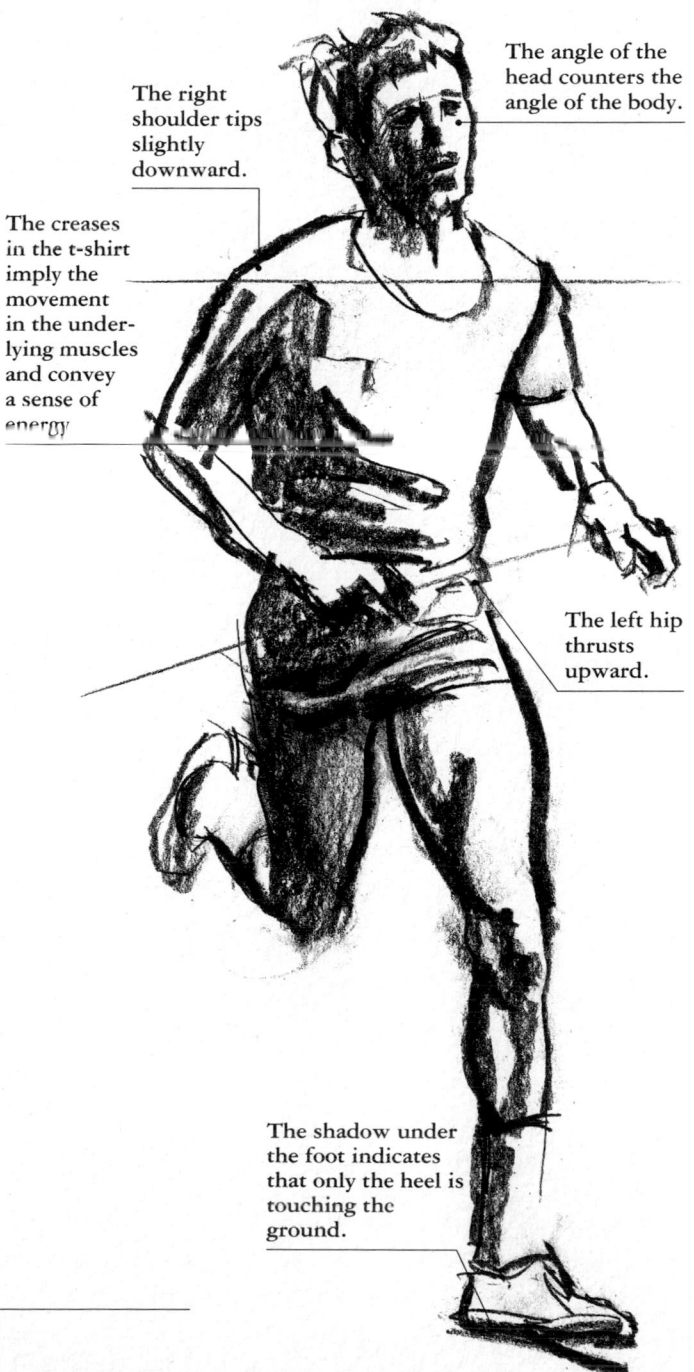

The right shoulder tips slightly downward.

The angle of the head counters the angle of the body.

The creases in the t-shirt imply the movement in the under-lying muscles and convey a sense of energy

The left hip thrusts upward.

The shadow under the foot indicates that only the heel is touching the ground.

a figure leans, the faster and more intense the action. Think of a sprinter pulling away from the blocks at the start of a race: if you were to draw a vertical line up from the athlete's heel and then a diagonal line from the heel to the front of the head, the angle between the two lines would be quite wide. Drawing the same lines in an upright, motionless figure would result in a much narrower angle.

All actions consist of a series of many individual movements joined together, and often this series is repeated over and over again. A runner, for example, or a freestyle swimmer, maintains the same basic rhythm and repeats the same actions throughout a race. Even in team sports, the same actions recur periodically if you watch for long enough. Think, for example, of the dynamic upward spring of a basketball player dropping the ball into the net. Concentrate on following the entire action through, rather than on freezing one split second as the action reaches its peak. Try to fix the rhythm of the movement in your mind's eye before you start drawing.

A useful way of practicing drawing movement is to watch a sporting event on television or video. Video is particularly helpful, as you can play short sequences over and over again to imprint the rhythm of the movement in your mind. Do not be tempted to freeze the frame, however. The point of drawing something in motion is to capture the essence of the movement – the straining muscles of a sprinting athlete, the balance of a pirouetting ballerina, the violent blows of a boxer – rather than to delineate a motionless pose. Above all, you must convey the feeling that the movement is ongoing.

Speed is extremely useful in drawing moving figures, and here the training-the-eye exercises (see pp. 32–33) should stand you in good stead. Choosing drawing media that enable you to work quickly is also important: charcoal, very soft pencils, and washes overlaid with inkwork are all possibilities.

Muscles are the powerhouse of the body: all movement stems from them. Professional athletes tend to have very pronounced muscles. Track athletes and dancers, for example, display highly developed thigh muscles, while weightlifters and swimmers possess prominent upper arm muscles. Use these muscles to create a three-dimensional illusion. Also examine how the clothes drape around the figure (see pp. 106–107). Look for forms (from creases) in the fabric that denote the muscles straining underneath.

Colored pencils

HB pencil

Pulling off a Boot

This drawing was made rapidly, using colored pencils, so that the model did not have to hold an uncomfortable pose for long. The rounded shoulders as she leans forward and the creases in the left leg of her trousers as she tugs at the boot indicate the effort involved. Inset: The gray pencil marks accentuate the creases in the leather and enhance the three-dimensional effect.

Black India ink

Bamboo pen

Boxers

The violence of the blows is echoed in the violence of the scratchy, bamboo pen lines. The shading follows the strong diagonal lines of the poses. Note how the left side of the body of the boxer striking the blow tilts with his left shoulder tipping downward, as he uses his right hand to deliver the full force of the blow. Inset: The bamboo pen is used to block in strong tones around the head.

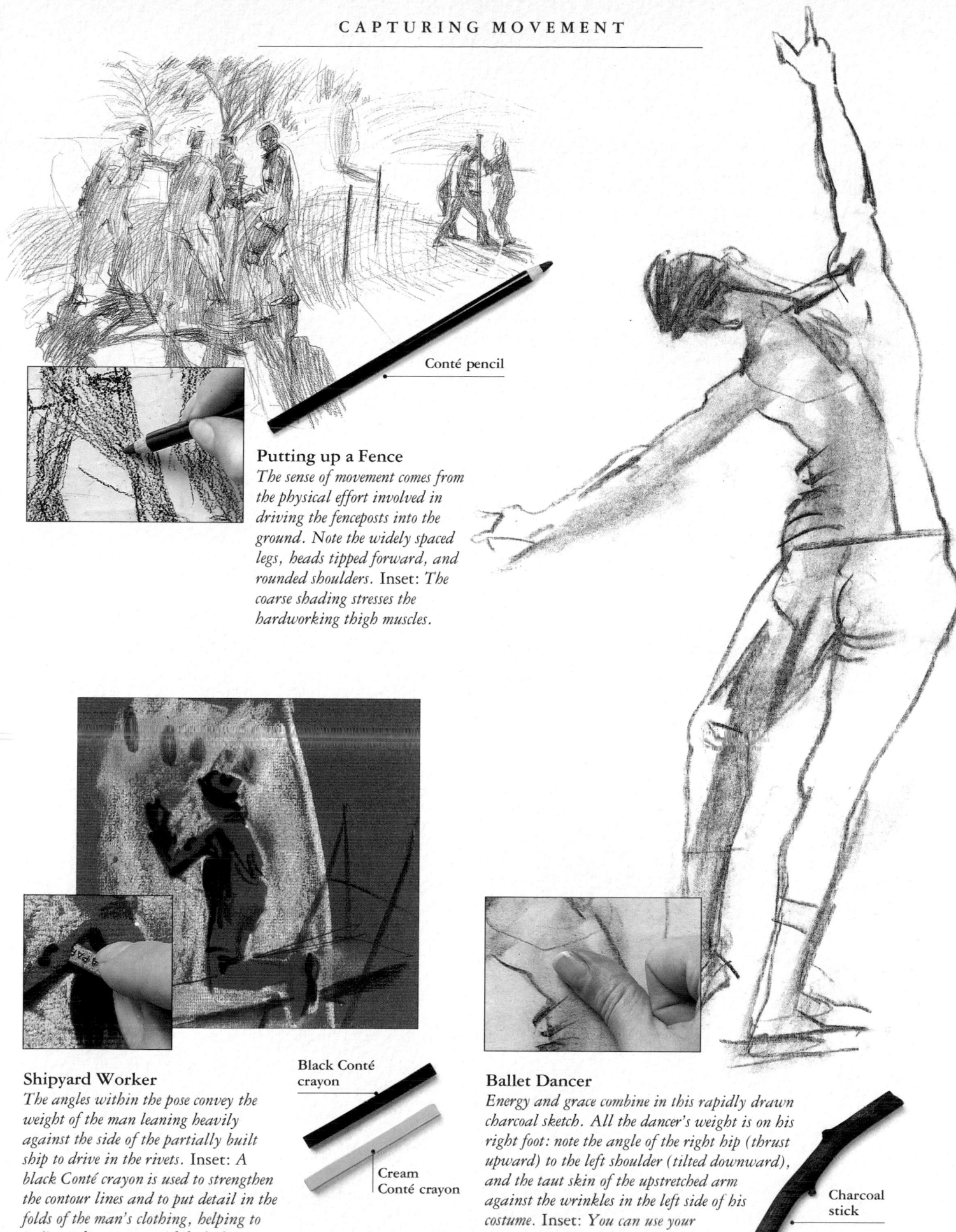

Conté pencil

Putting up a Fence

The sense of movement comes from the physical effort involved in driving the fenceposts into the ground. Note the widely spaced legs, heads tipped forward, and rounded shoulders. Inset: The coarse shading stresses the hardworking thigh muscles.

Shipyard Worker

The angles within the pose convey the weight of the man leaning heavily against the side of the partially built ship to drive in the rivets. Inset: A black Conté crayon is used to strengthen the contour lines and to put detail in the folds of the man's clothing, helping to indicate the movement of the body beneath the clothing.

Black Conté crayon

Cream Conté crayon

Ballet Dancer

Energy and grace combine in this rapidly drawn charcoal sketch. All the dancer's weight is on his right foot: note the angle of the right hip (thrust upward) to the left shoulder (tilted downward), and the taut skin of the upstretched arm against the wrinkles in the left side of his costume. Inset: You can use your thumb to soften tone, making it more subtle and varied.

Charcoal stick

Line Drawing

ONE OF THE MOST SOPHISTICATED concepts in the visual arts is that of line drawing – not to be confused with outline drawing (see pp. 48–49). Outline drawing cannot give a subject form, but the technique of line drawing that describes the contours and shapes of objects can, in turn, create a three-dimensional image. It is a skill with a long history, stretching back as far as Ancient Greece and Egypt and seen to perfection in the work of more recent master draftsmen, such as John Ruskin and Edgar Degas.

The aim of drawing in line is to describe a solid object using pen, pencil, brush or chalk. It is extremely simple, but you must look at your subject intensely and measure its separate parts carefully. Vigorous line can capture the rhythmic energy of a ballet dancer; a sharp, probing line can illustrate the beauty of nature. Whatever the context, the line needs to be sensitive. Follow the contour – the edge that turns the corner to describe form. A simple tracing of the shape of such a solid, however, would appear flat, lacking energy and the illusion of solidity. Vary the pressure, perhaps by using more than one grade of pencil or by applying extra pressure to the pen nib, in order to achieve thicker and thinner line qualities. Try to imagine the whole object; walk around it and try to imply what is on the reverse side too. Making use of the subject's creases or other features across and around its form will help with this method of drawing, as will the interlocking and over-laying of secondary forms.

Using Line to Convey Form

The lobster is a beautiful object and makes a good subject for line drawing. It can be visually reduced to a simple tube-like shape with segments interlinking along it. Attached to this central form is a complex of jointed legs, again a series of cylinders, locking into each other and to the main tube. Pen is suitable for line work, but some artists prefer brushes. Your choice can be determined by the subject as well as the effect desired.

Conveying Form

Conventionally, three-dimensional form is conveyed by the use of graded tone – as in this interpretation in line and wash. It is this three-dimensional quality that needs to be captured in any line drawing.

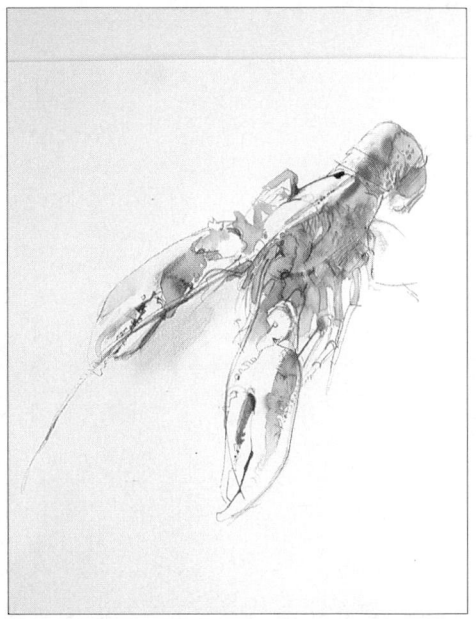

3B Pencil

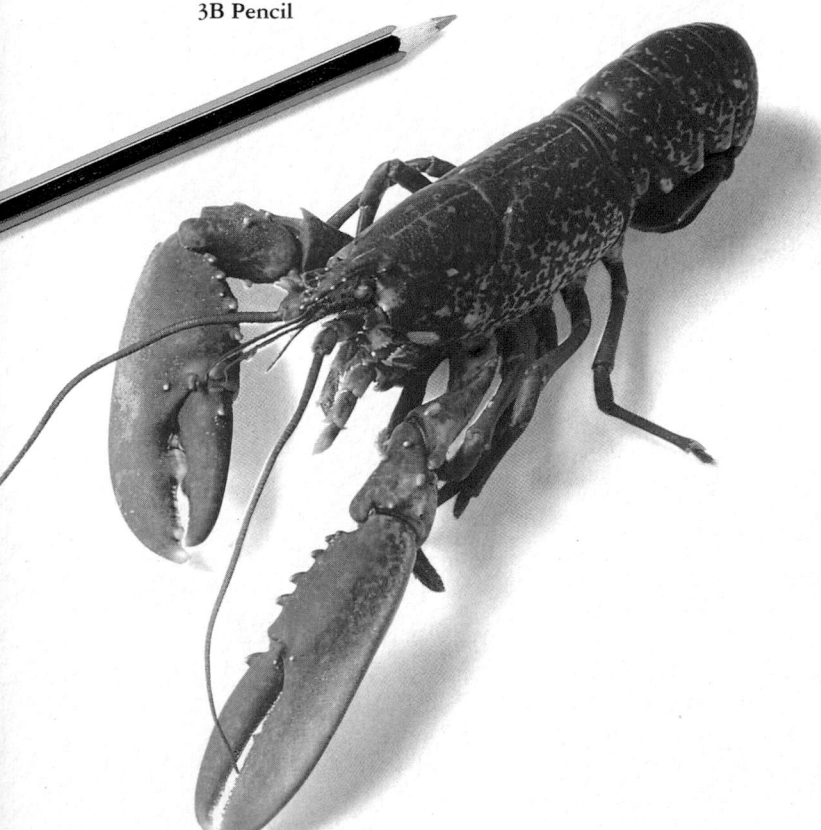

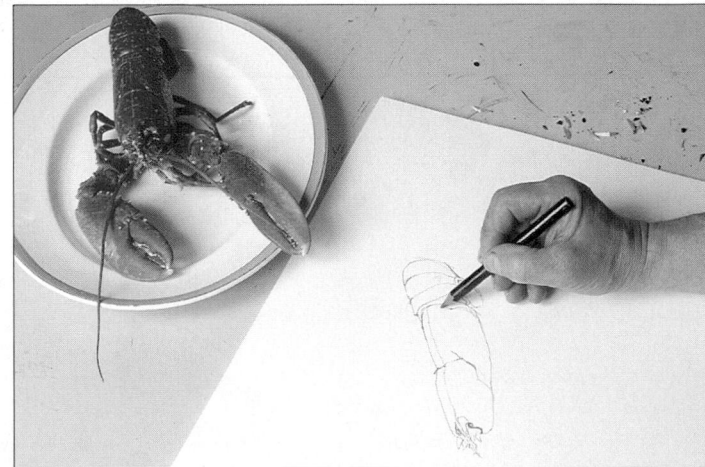

1 *Begin by lightly drawing in the forms with a 3B pencil. View the overall shape in relation to the paper size to make sure you have allowed enough space.*

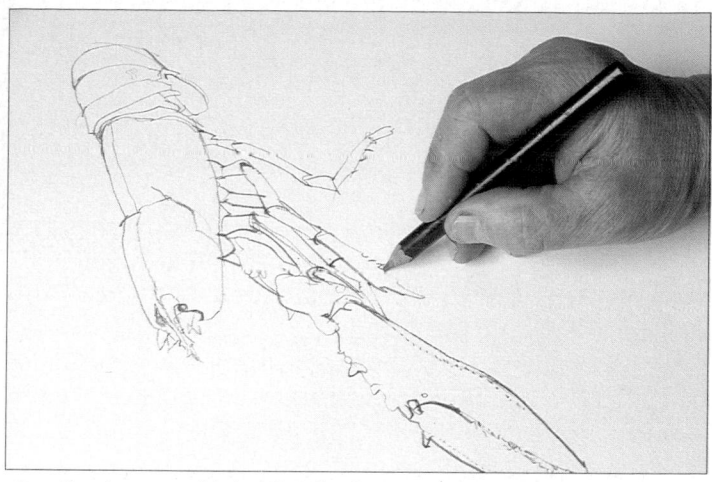

2 *Think of the simplest geometric equivalent to each form and make the segments interlock. The body will appear cylindrical and solid. Vary the pressure, increasing it as you go from light to dark.*

3 *Continue to add detail. The discipline of looking hard is very important. By this stage, line is used to describe the legs and to create the solid, three-dimensional character of the lobster. The crustacean should appear to stand out from the paper.*

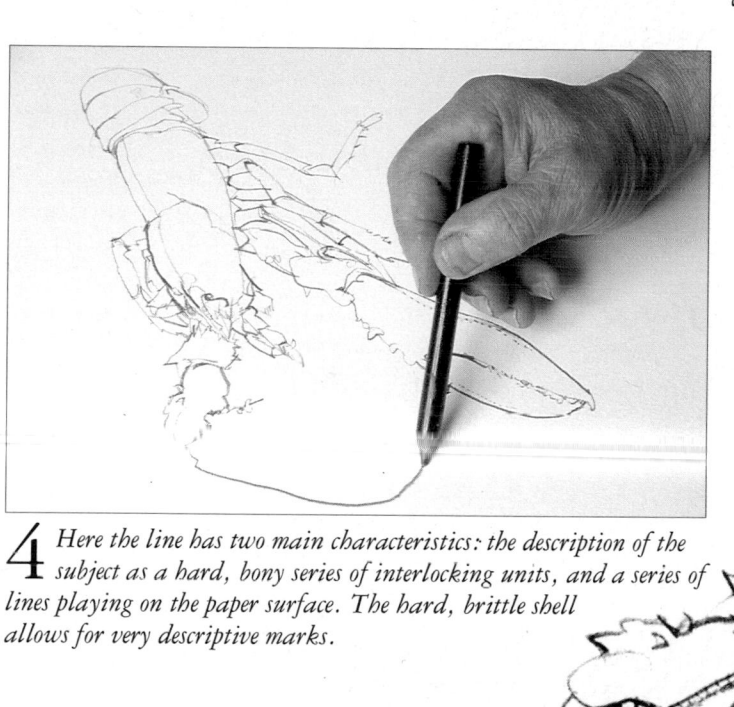

4 *Here the line has two main characteristics: the description of the subject as a hard, bony series of interlocking units, and a series of lines playing on the paper surface. The hard, brittle shell allows for very descriptive marks.*

Lines traveling around the cylinder suggest solidity

A finer line contrasts with stronger foreground lines

Note dark tones of line where one simple cylinder form enters another

To help the illusion of 3D, use texture in the foreground only

The Finished Drawing
The completed drawing shows the flexibility a 3B pencil has in creating a varying density of line. Those parts of the lobster closest to us are darker and coarser, the result of a greater pressure being applied to the pencil. Finer lines require a lighter touch. Complicated areas combine both these techniques with lines that are gentle and hard, subtle and strong. The result is a fresh, uncluttered piece of work.

Use softer pencil to achieve a darker emphasis in the line

Simple Monoprints

As the name suggests, monoprinting is a means of making a single (mono) print of a drawing. There are three main ways (see also pp. 138–139), and all involve printing, or offsetting, the image you have drawn on another surface. Oil-based printing inks are commonly used – usually black – but you can also try colored inks. The exciting thing about monoprints is that, in transferring the image to a surface other than the one on which it was made, you introduce new textures and qualities – such as fuzzy, broken lines not achievable with conventional drawing techniques.

The simplest form of monoprinting is similar to using carbon paper. Take a sheet of paper and rub Conté crayon all over it. (Graphite powder or chalk work equally well – the important thing is to use a powdery drawing medium.) Place this paper, Conté-coated side down, on a clean sheet of paper and draw your image on the reverse side of the

Conté-coated paper. Through the pressure of the pencil or pen, the Conté marks are transferred to the clean sheet of paper beneath. Lift off and discard the Conté-coated paper. The image underneath will have the same lines as your original drawing, but a much softer quality.

In the second method (shown here), the differences between your original drawing and the offset print are even more marked, as the printed image is the reverse of the original drawing. For this method, you need a very smooth, hard surface such as a sheet of glass or a piece of plastic laminate. Cover this surface with oil-based ink, spreading it evenly with a roller. (The reason for using oil-based, as opposed to water-based, ink is that it takes longer to dry, so you don't have to work quite so quickly in order to make a print. Moreover, it does not soak into the paper in the same way as water-based ink and has a lovely tacky, textural quality.) Lay a piece of paper over the inked surface and then draw on the reverse side of the paper, using a hard point such as a sharp pencil or a ballpoint pen. The ink is transferred to the paper wherever you have pressed on it. In addition to relatively hard lines, you can pick up softer areas of tone by rubbing the paper gently with your finger or a smooth implement. Peel the paper off in one fluid movement to avoid smudging.

It is hard to predict exactly how your monoprints will turn out, but that is part of their excitement. Ink may smudge, or finger marks – where you have accidentally pressed on the paper while drawing – may show up on the print. Have the courage to learn from what may seem like an unfortunate accident, and exploit it to your own ends.

Ballpoint pen

Black oil-based ink

Roller

Chimpanzee
The chimpanzee is having lunch – eating a banana in such a fastidious fashion that he keeps still for long enough to enable a drawing to be made. Although the basic technique is the same in the lion sketches (see pp. 112–113), here some pen-and-ink drawing has been added. This is useful for refining the details and increases the three-dimensional feeling of the drawing.

1 *Put a generous blob of oil-based ink onto a sheet of plastic. Use a clean roller to spread the ink evenly over the whole sheet in a thin layer – rolling up, down, and from side to side.*

2 *Carefully drop a piece of paper over the inked surface, making sure it falls flat. Take great care to put the paper down in one clean movement – moving the paper will cause smudging.*

3 *Use a ballpoint pen to start copying the sketch. Use the pen's point only, and exert as little pressure as possible to reduce the risk of making accidental marks.*

4 *Elaborate the drawing, holding the pen upright to keep your fingers clear of the paper and prevent you from accidentally pressing on the paper and making a mark in the finished print.*

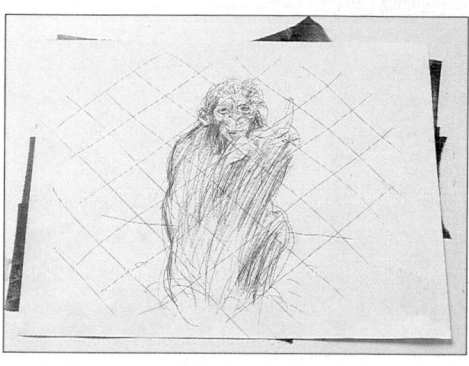

5 *Step back and evaluate whether or not you need to add more detailing, but take care not to overwork the drawing — the final offset print will look much richer in tone.*

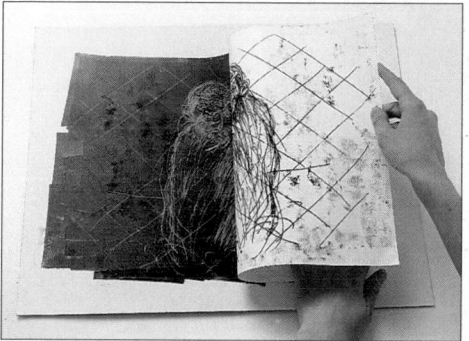

6 *Once you are happy with the drawing, peel the paper off the plastic sheet, cleanly and precisely. Take care not to smudge the inked surface.*

The briskly drawn lines of the wire enclosure have the same freshly laid-down feeling as the rest of the drawing.

The finger-pressure marks seen here bring a softer tone to the surface. Marks made with too much pressure would have intruded into the image of the chimpanzee, but these light touches show how the unexpected can also contribute to the picture.

The Finished Print

The strength of the finished print is the rich, hazy quality of the lines. The highly textured surface conveys a spirit of liveliness, which matches the sense of imminent movement by the chimpanzee. Note how the lines vary and that some texture is created by the smudges resulting from finger-pressure marks. Although faint accidental finger marks can be interesting, try to avoid making them as they can easily dominate the picture.

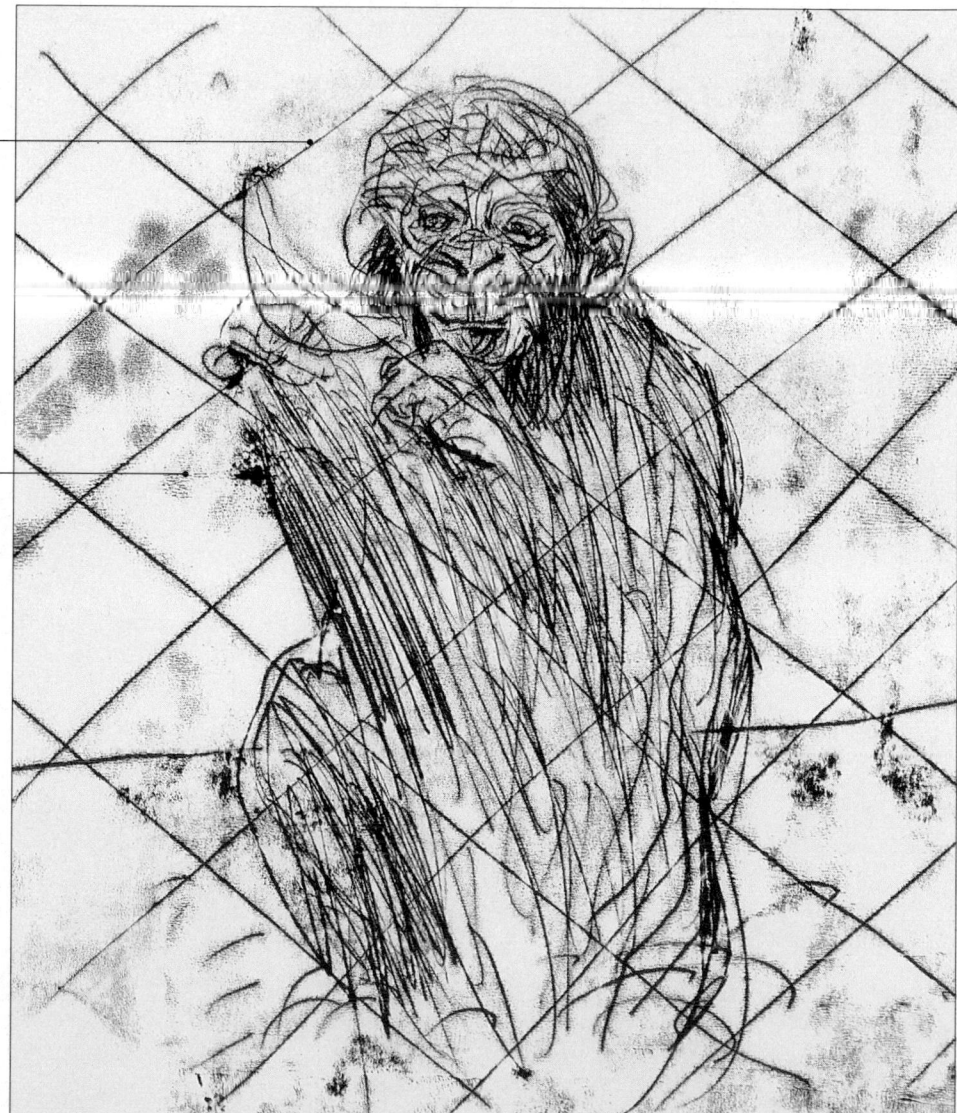

Elaborate Monoprints

I N THE MORE COMPLEX type of monoprint, the image is made on the inked surface rather than on the reverse side of the paper. Instead of drawing a dark line on a light or medium-toned ground, as you do in most types of drawing, you are starting with a dark ground and wiping out areas of ink to get back to gray or white.

As in the type of monoprint demonstrated on the previous two pages, start by covering a smooth, hard surface with oil-based ink. "Draw" your image by wiping off ink to create white areas, leaving ink where you want dark lines to appear in the final print. You don't have to remove the ink completely: if it is appropriate, you can simply wipe off most of the ink in certain areas, so that it will print as a less

dense area of tone. You can also get some very interesting effects by experimenting with different tools to remove the ink. Gently dabbing a small piece of rag or dry sponge over the surface will leave a stippled texture, while scraping off the ink with a flat-bladed plastic knife will produce sharp areas of white. You must work quickly. You will not be able to make a print once the ink has dried, so make sure you choose a technique that allows you to do this.

When you have finished your image, carefully position a piece of clean paper over the inked surface and run a roller over it to transfer the image to the paper. As in the example on the previous two pages, the print will be the reverse of your original image.

Monoprinting, arguably more than any other drawing system, is unpredictable, but it is this random quality that makes it so fascinating. Many artists have made monoprints, but it was Edgar Degas (1834–1917) who elevated the technique to the realms of great art. If you need to be convinced of the potential of this method of picture making, look no further than his work.

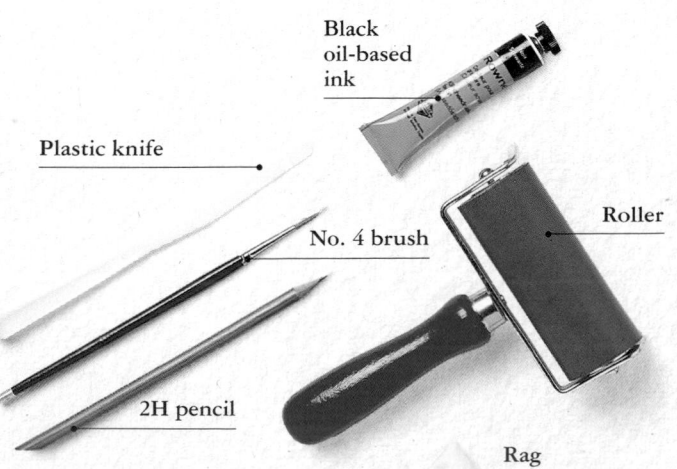

Working from a Photocopy

Here we have a photocopy enlarged from a vacation snapshot (inset) featuring one of the world's most famous scenes — the Rialto Bridge in Venice. Because the photocopy is black and white, the areas of dark and light are already clearly defined, which makes your task even easier. Monoprinting produces a reversed image, which is not advisable when drawing an instantly recognizable landmark such as this. But there is a simple way to ensure that the final image is the correct way around. First, trace the image, then transfer it to a sheet of plastic. The transfer is a reversed image, so any monoprint made from it will be reversed again, appearing the correct way around.

Black oil-based ink

Plastic knife

No. 4 brush

Roller

2H pencil

Rag

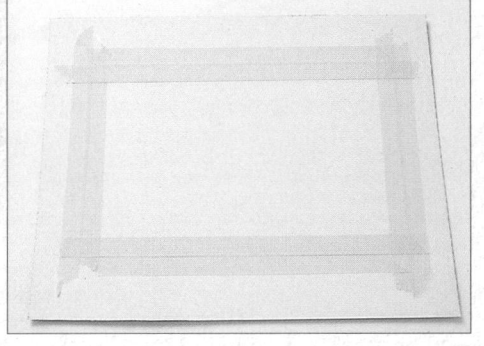

1 *Place a rectangle of masking tape onto a sheet of white plastic. The tape creates a clean edge on the work and keeps the picture within its border. Make sure the corners are at right angles.*

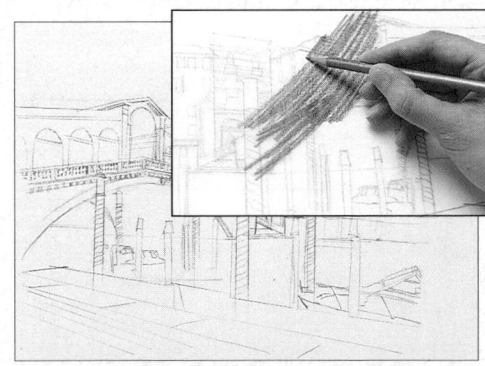

2 *Trace the picture, and then place the tracing face down on the prepared rectangle. Inset: Rub a 2H pencil across the tracing paper to transfer the lines of the sketch onto the plastic sheet.*

3 *Once you have rubbed all over the sketch, remove the tracing paper and carefully paint in the generalized masses of tone, using black oil-based ink and a no. 4 brush.*

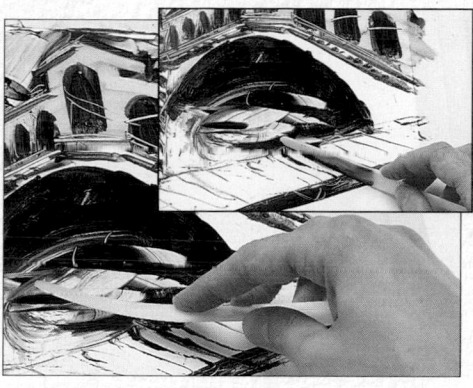
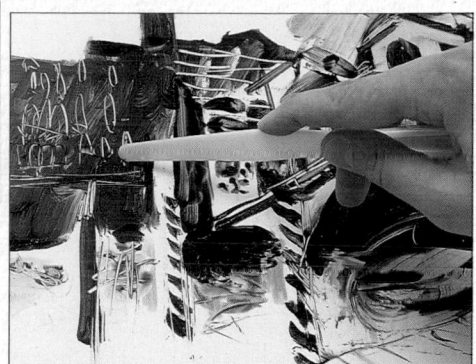

4 Use a rag to gently wipe off ink where necessary, as in the front of the super-structure on the bridge. Do this very quickly, before the ink can dry.

5 Use a plastic knife to scrape some areas clear of ink and to create textures in the water of the canal. Inset: Use both the flat of the blade and the thin edge to give variety to the marks.

6 Still using the knife, scratch out the shapes of the windows on the building beside the canal. Note how a rich complex of tones in the original scene is reduced to a thin outline in the monoprint.

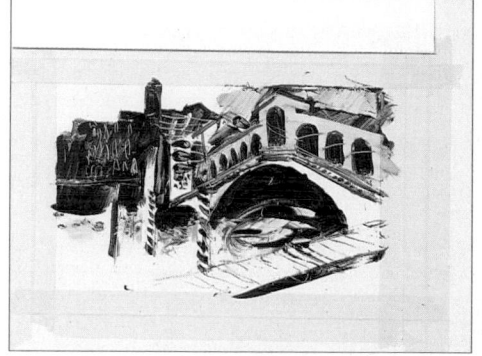

7 The range of textures, areas of tone, and strength of lines combine to create the image. The surface of the paper should still be quite tacky to the touch, so that the ink is able to make a print.

8 Place a sheet of good-quality drawing paper onto the masked area on which the drawing has been made. Use a clean roller to apply pressure to the paper firmly and evenly.

9 With care and precision, remove the paper in one smooth movement. Roll the paper back from the bottom to the top of the piece of work. Do not print.

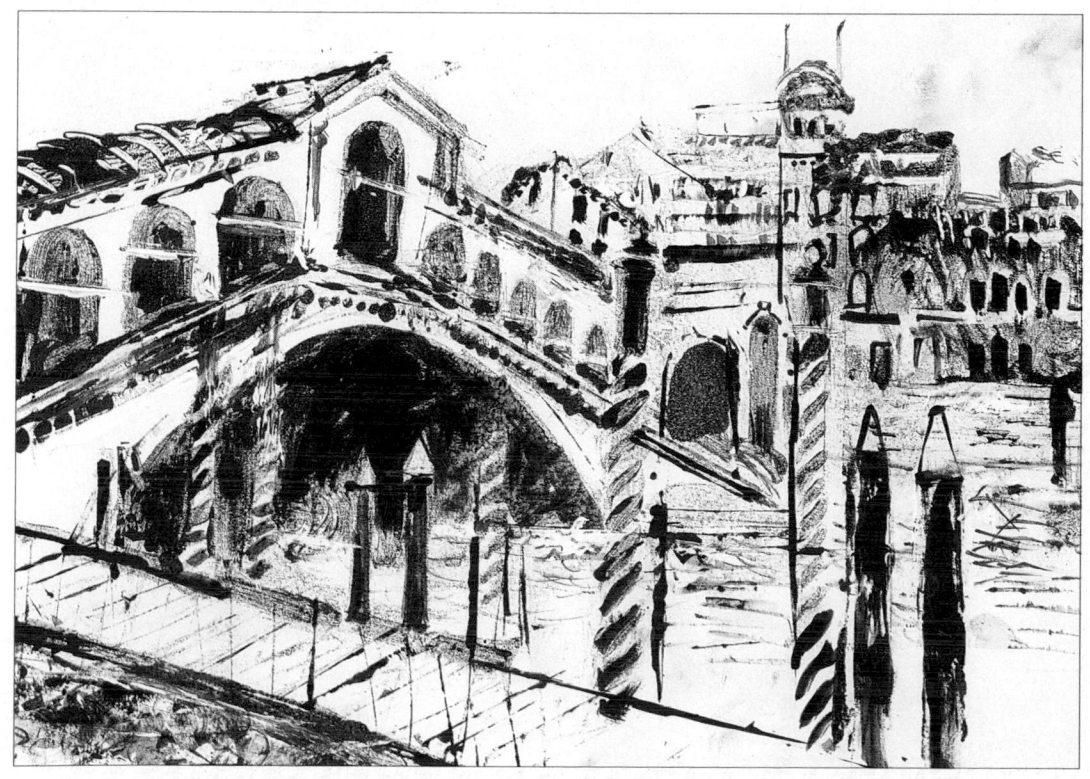

The Finished Print

The print has a striking freshness and immediacy because it was made entirely in one prolonged session — before the ink dried. The solid black areas have broken edges, yet keep the approximate shape of the original sketch. The varied tones of gray are the result of scratching into the ink as well as leaving white gaps between the black lines. The use of the brush, rag, and plastic knife has enhanced the depth and texture of the image. The result is a new interpretation of the subject rather than a mere copy of the initial photographic image.

Altering Paper Surfaces

CHANGING THE SURFACE of the paper is an old trick used by watercolor artists and draftsmen. Different surfaces introduce new qualities, and the texture of the paper greatly affects the finished painting. One common technique is distressing the paper. Most papers are coated with sizing to seal the surface and make it less absorbent. By breaking the sized surface of the paper or board, you can introduce other qualities – either regularly across the sheet or in a more random way. Preparing your own surface will present a challenge and encourage you to adopt a wide variety of approaches.

One well-used system of distressing is to break the surface of the paper by rubbing it with sandpaper or pumice powder so that it is no longer resistant to the absorption of washes and pens and brush lines. With practice you will be able to treat specific areas, leaving small undisturbed areas for contrast. Scoring with a craft knife can also make for exciting "crunchy" surfaces – still controllable but with an unusual freedom and originality. Only the best quality papers and boards can be given this treatment; inferior material would probably disintegrate.

There are also ways of masking a surface so that washes and solid tones can be overlaid, leaving the masked areas untouched. Such maskings are known as resists. Crisp, sharp maskings can be made by using rubber solutions and tracing paper, although masking tape is more readily available. Tearing the edges helps to counterbalance the mechanical feel of the tape. Masking fluids can be painted on and gently rubbed off when dry. Use an old brush, as it may be damaged even if you wash it immediately after use.

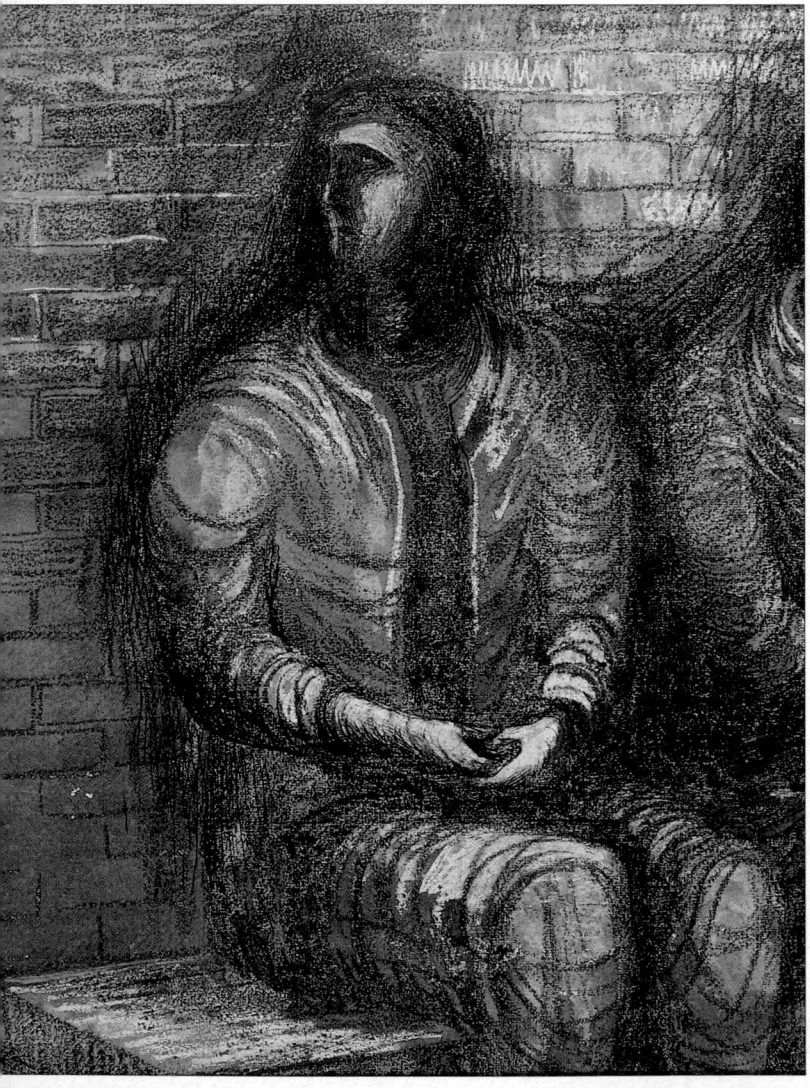

"Two Apprehensive Shelterers" (detail), Henry Moore
Henry Moore used a wax resist technique for this work. When ink or paint was applied, it rolled off the wax and stained the rest of the paper, leaving the color of the wax as an integral part of the drawing.

Using Resists

Masking fluid, applied with a brush or pen, is useful for very fine work and selecting highlights. It will discolor the paper if left on too long. Masking tape leaves sharp surfaces. Make sure the overdrawing is dry before peeling away the tape. Oil pastel makes a good resist, with the advantage of color. Candle wax leaves a broken surface.

Masking fluid

Oil pastel

Masking tape

Candle wax

Distressing a Surface

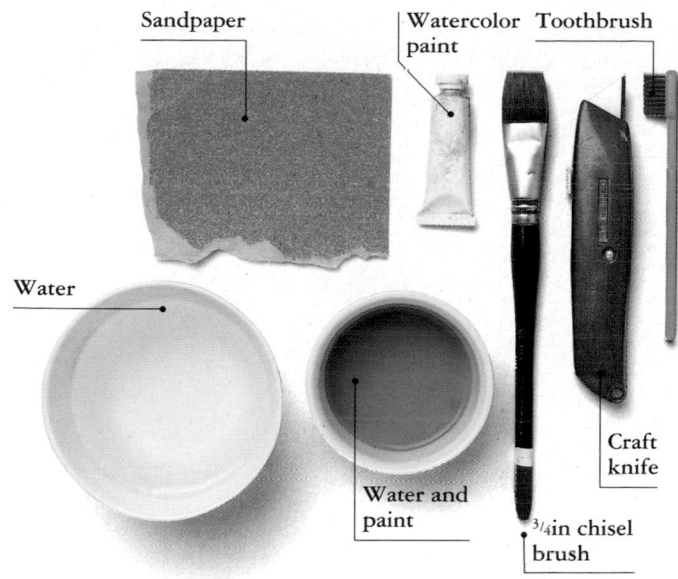

Sandpaper

Watercolor paint

Toothbrush

Water

Water and paint

Craft knife

¾in chisel brush

1 *Gently rub coarse sandpaper over the surface of heavy-weight drawing or watercolor paper. This breaks the surface so that when you apply a wet wash it will be absorbed into the paper rather than evaporate. Here, only a section of the paper is distressed in this way.*

2 *Scratch the surface using the side of a blade. Craft knives are specifically designed to be used without the fingers coming anywhere near the blade. A large range of blades is available, and several can be used to achieve this effect.*

3 *Using diluted watercolor paint and a ¾in chisel brush, lay a wash over the distressed area. The hatched lines made with the craft knife take in the paint and give a rich texture to the paper.*

4 *Break the surface with sandpaper as before. With a toothbrush, rub paint over the area in a circular movement. Keep old tooth- brushes specifically for this purpose. They can be used to lay textures, create spattering, and apply thin but textured paint and ink.*

5 *Several different marks are created on one sheet of paper. Experiment with these ideas, and combine the techniques. The results will be both surprising and rewarding.*

Wax Resists

OVER THE CENTURIES a great deal of thought has gone into finding interesting ways of visually interpreting the world — often going far beyond merely making marks with brushes, charcoal, chalk, and pencils. One simple yet extraordinarily effective technique is the use of a "resist" — a term refering to any substance that is used to protect the paper from the medium you are working with. This technique endows surfaces with a richness of texture unobtainable in any other way.

Using wax resists — putting a thin layer of candle wax on the paper — is a time-honored technique, used by J. M. W. Turner and other great 19th-century watercolorists to great effect. Because wax and water do not mix, water-based ink or paint will not adhere to any area of paper where wax has been applied.

To use the technique effectively, you need to train yourself to think "in negative." In most types of drawing, you put in the dark outlines first. With wax resists, however, your first step is to decide which areas you want to highlight and mark them on the paper with candle wax.

White candle wax is the medium most commonly used as a resist, although colored candles can give some interesting results. The greater the texture or the brighter the highlights you want, the more pressure you should use on the candle. Do remember, however, to leave some areas free of wax, so that the water-based ink or paint has something to adhere to.

1 Once you have assembled your collection and found an arrangement of the fruits and vegetables that you are happy with, use a steel-nib pen dipped in black India ink to lightly sketch in the outline of the main forms.

2 After you have sketched in all the main forms, start applying the candle wax. Working in negative, select areas that you want to highlight or add texture to, and mark them on the paper with a small piece of the wax.

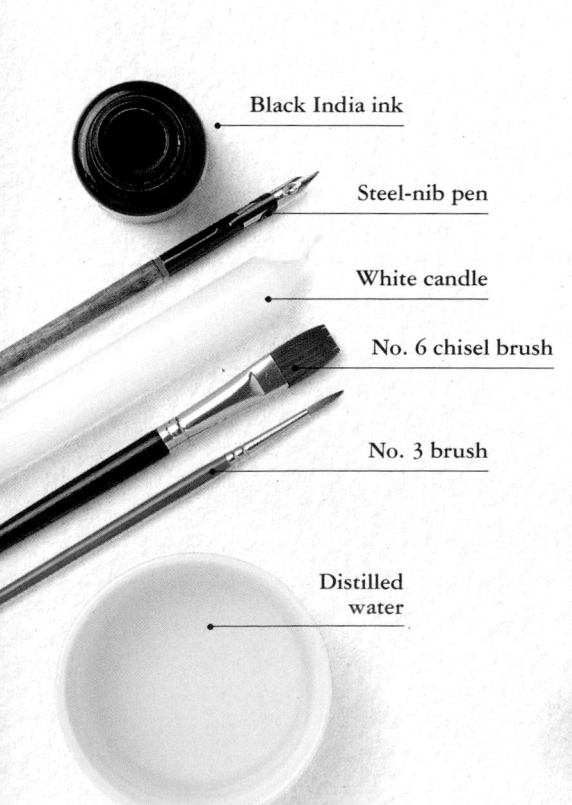

Black India ink

Steel-nib pen

White candle

No. 6 chisel brush

No. 3 brush

Distilled water

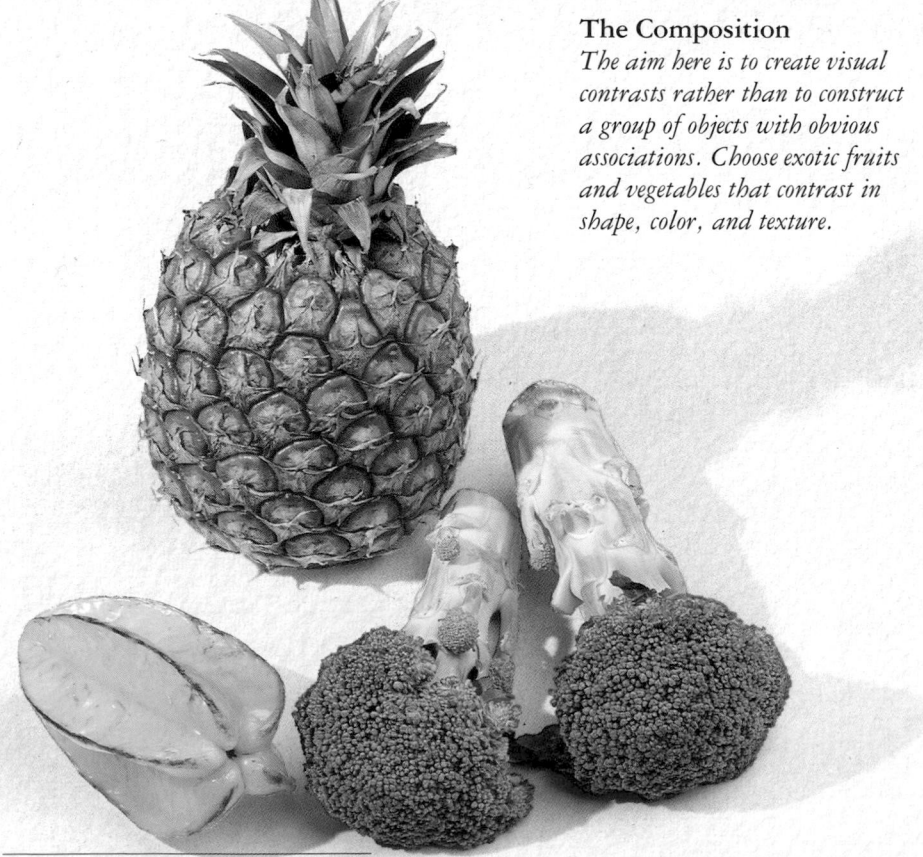

The Composition
The aim here is to create visual contrasts rather than to construct a group of objects with obvious associations. Choose exotic fruits and vegetables that contrast in shape, color, and texture.

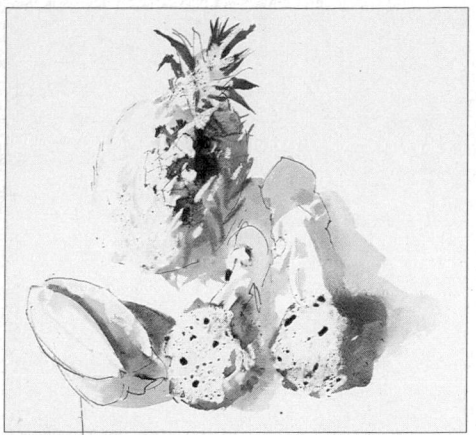

3 Using the no. 6 chisel brush, carefully apply the diluted black India ink over and just beyond the waxed areas to describe the outline of the broccoli. The ink runs off the waxed areas, giving a stippled look.

4 Continue using the diluted ink over the rest of the drawing, using a slightly darker mix on the shadowed areas. Never totally complete one item of the composition before the others.

5 At this stage – after a no. 3 brush dipped in ink has been used to finalize small areas of shadow and tone – the tonal and textural description is almost complete. If you want ink to adhere to areas where too much wax has been applied, add soft liquid soap to the ink.

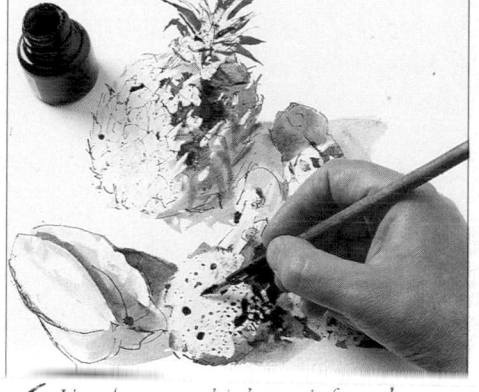

6 Use the pen and ink to reinforce the contour lines and define the edges. Finally, still using the pen and ink, introduce enriching touches, such as the starfruit details. You can create white areas or lines by scratching through the ink to the wax.

The Finished Drawing

This is much more than a mere visual description. The contrasting textures of the elements within the group are just as important. Note how brushing diluted ink under the fruits and vegetables suggests shadows and indicates that they are sitting on the same surface. Color is implied by varying the dilution of the ink and also the pressure of the pen line, producing lighter or darker tones, as well as by using both the front and the back of the pen's nib.

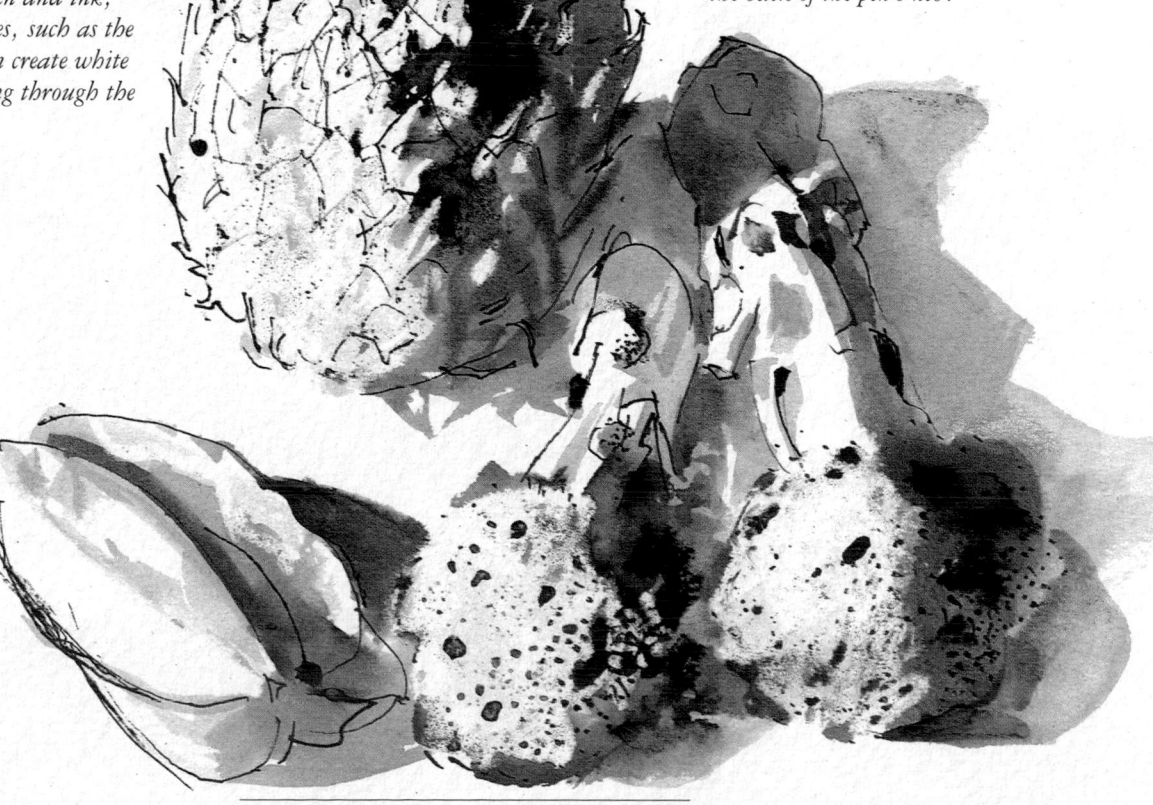

Using a Distressed Surface

THERE ARE SEVERAL WAYS to distress, or roughen, the surface of the paper to create an interesting texture or tone. You can rub it with an eraser, steel wool, or sandpaper, or scratch it with the edge of a blade (see pp. 140–141). A more random method is to crumple the paper in your hands. Doing this breaks the surface of the paper so that it absorbs more paint along the crease lines, but you cannot control or predict the effect. You can exploit this random quality by toning the crumpled paper and allowing the texture and coloring of the paper to suggest a subject to you.

The technique works best with a lightweight paper, which is easy to crumple. If the paper is too thin, however, it will disintegrate when you immerse it in the color wash. Crumple the paper into a ball, soak it in a wash of paint, and lift it out. Handle it carefully at this stage: the wet paper may tear under its own weight. Then lay it flat on absorbent paper towels, smoothing it out carefully, to allow excess paint to drain off. Lay it on a drawing board or other hard surface, put gummed tape strip along the edges as you would for stretching paper (see pp. 22–23), and leave it to dry. (Use gummed tape, as opposed to masking tape, because it will stick to the wet surface of the paper.) If you happen to rip or damage the paper when lifting it, do not despair. When it is dry, you can mount it on a piece of stronger paper or board; the tears will not show and you can make your drawing in the normal way.

You can use several colors of paint at once – as in the demonstration on the opposite page. In this example, several blobs of different colors of watercolor paint were placed in a large dish of water, and the dish was swirled a little to allow the colors to mix at their edges. (Do not mix the colors too much or you will end up with a muddy, indistinct shade.) As you become more experienced, you will find that you can control both the extent to which you distress the paper and where that distressing occurs. As a general principle, however, it is a good idea to distress and tone several pieces of paper at the same time – perhaps varying the type and weight of paper that you use in order to achieve different results.

Cut Melon

Steel-nib pen

No. 6 brush

White gouache

Yellow ink

Black India ink

Viridian green ink

Crimson ink

The Paper
Crumple the paper loosely, then dip it into raw sienna watercolor paint. The resulting orange-brown color and the uneven texture suggest the skin of a melon – a good subject for an interesting drawing.

The Finished Drawing
Put in the overall shapes of the half melons with a steel-nib pen dipped in black India ink. Flood yellow and viridian green ink over the paper, up to the edges of the melon shapes, taking care not to allow the creases created by crumpling the paper to fill in. Draw the sectional lines of the melon with a steel-nib pen and black India ink. To create the shadows and a three-dimensional effect, brush crimson, yellow, and black ink up to the edge of the fruit. On the cut face of the melon, mix the inks with white gouache to create an opaque finish and an interesting contrast in texture.

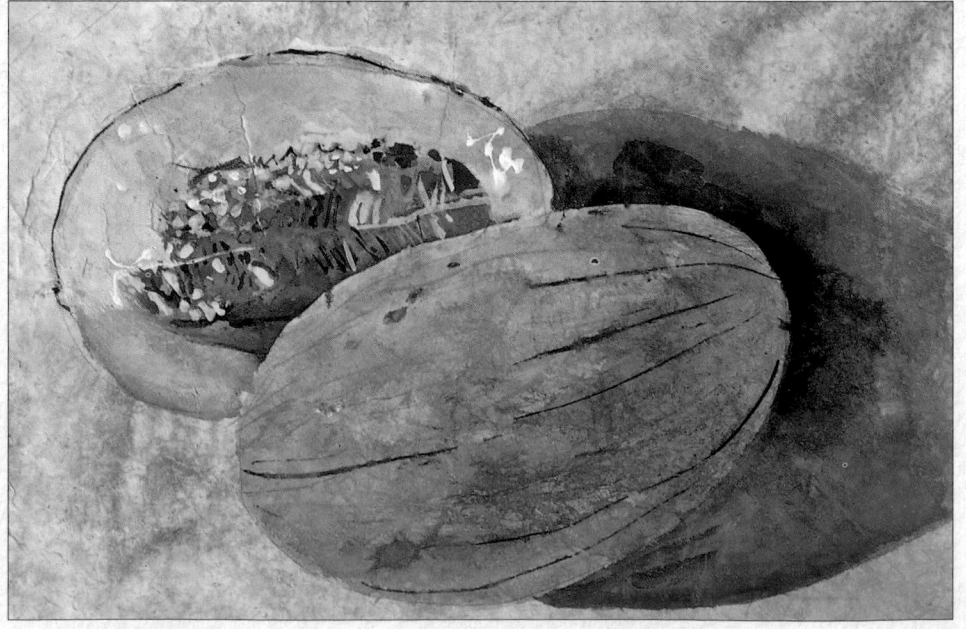

Impressionistic Discovery

Chinese ink

Chinese brush

Cadmium orange ink

The Paper
Crumple the paper and put enough water in a dish to cover it. Add blobs of Payne's gray, alizarin crimson, and cadmium yellow watercolor paints, and gently swirl.

1 *Place blotting paper on the distressed paper to prevent your painting hand from dragging on the surface and smudging the colors. Using a Chinese brush and ink, draw a duck's silhouette in the lightest area.*

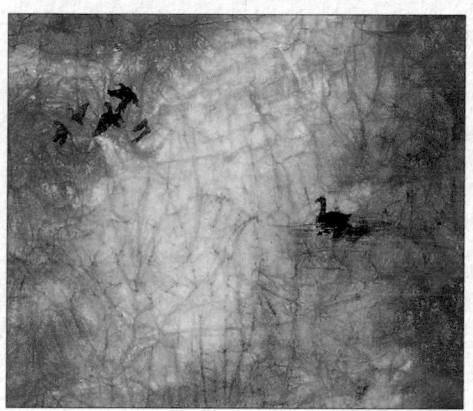

2 *Holding the Chinese brush vertically and keeping your fingers clear of the paper, draw the reflection of the duck. You may find it easier to turn the paper 90 degrees.*

3 *Turn the paper the right way up, and add another group of birds to the top left to provide a more balanced composition.*

4 *Dip the brush in cadmium orange ink, and draw the globe of a setting sun together with its reflection.*

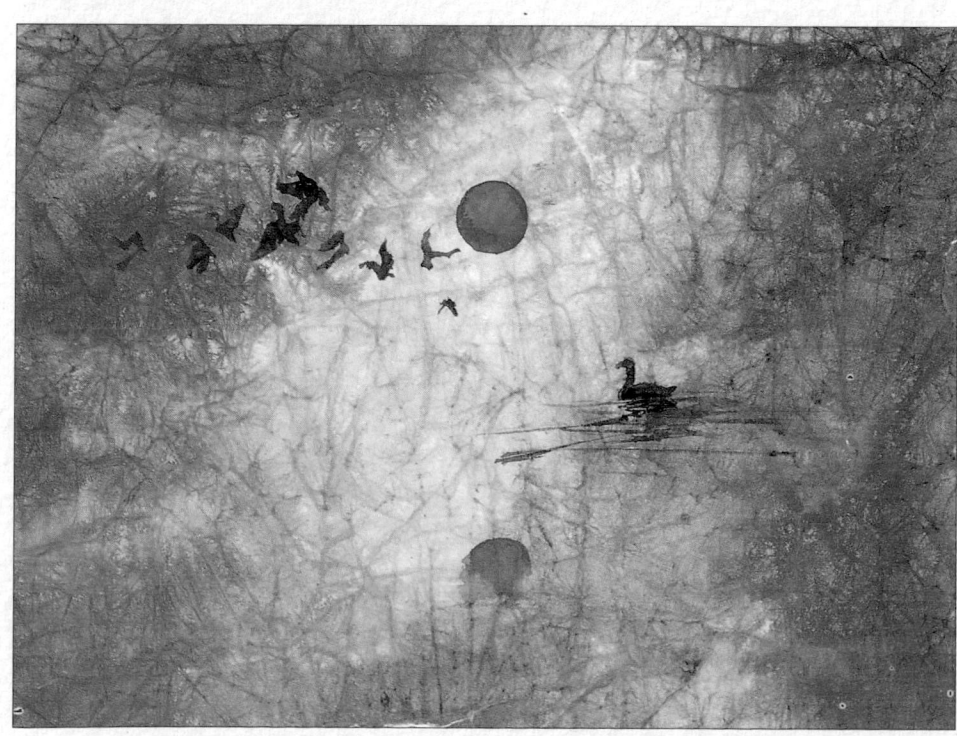

The Finished Drawing
The entire scene of the finished drawing is suggested by the characteristics of the distressed paper — by rich colors that evoke the warm glow of evening light and the transparency of the watercolor paint that was used to tone the paper.

Foreshortening

THE TRUE MAGIC OF GOOD DRAWING is the ability to portray the illusion of reality convincingly. Foreshortening creates such an illusion by deceiving the eye into accepting that one part of the drawing is closer than other parts; the two dimensions on the paper become three dimensions to the eye. Foreshortening can be used in a variety of cunning and effective ways. Once mastered, the compositional possibilities become endless.

The most important thing to remember is that you must believe the measurements you take rather than relying on the known scale of things. Many people make the mistake of refusing to believe what they see, even when they use one of the well-established measuring systems such as holding a pencil at arm's length and checking off the relative lengths and widths of the items within their composition or gridded paper (see pp. 36–39).

Use stronger tones in the foreground and lighter ones in the background. The darkest tone is laid on the items closest to the eye. Shading, too, whether in pencil or ink washes, helps create this optical illusion: finely detailed features in the front tease and entertain the eye, whereas a simplified delineation of receding material will help achieve the desired effect. Color adds to the drama, as does the use of light and shade, but the beauty and the sense of being an interloper on a real event truly begins with the drawing.

"Supper at Emmaus"
In this strong and theatrical composition, Caravaggio used a wonderful example of foreshortening to express a dramatic incident.

Relative Scale
The part of the subject nearest to the viewer will always appear larger than the rest. In the photograph below, the hand advancing toward the viewer looms as an enormous feature – quite disproportionate to the head behind it and the other hand well behind that.

HB pencil

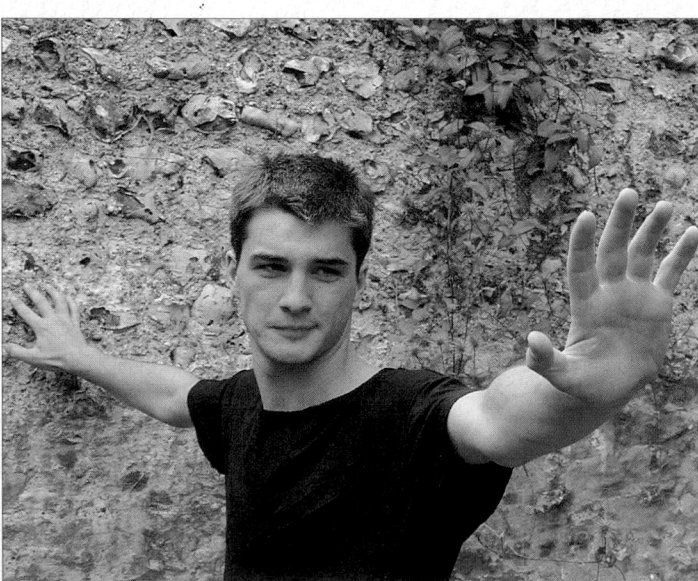

1 *Begin by relating one part to another. Choose a starting point (in this case, the left eye). Trace a horizontal line to discover which feature divides that line on the other side of the face.*

2 *Sketch in some vertical lines to form a simple grid. Gridding (see pp. 38–39) is a proven means of establishing the relative sizes, shapes, and angles of the subject. Establish the basic shapes and scale.*

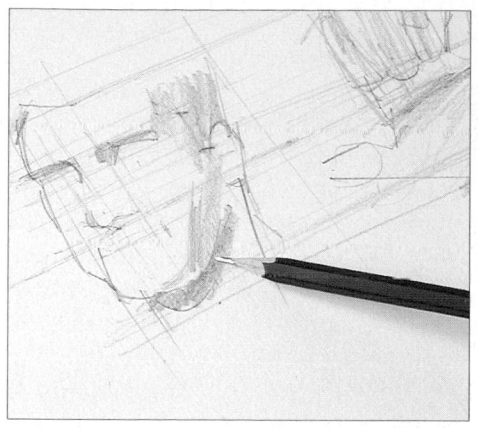

3 Build up areas of tone to create the illusion of solidity. Use the gridding system to make sure that the dark and mid-tones are in the right place.

4 Technique should not take over the drawing. Your personality will give the work its true character. Here, the tones, soft lines, and firm marks begin to give the drawing an individual quality.

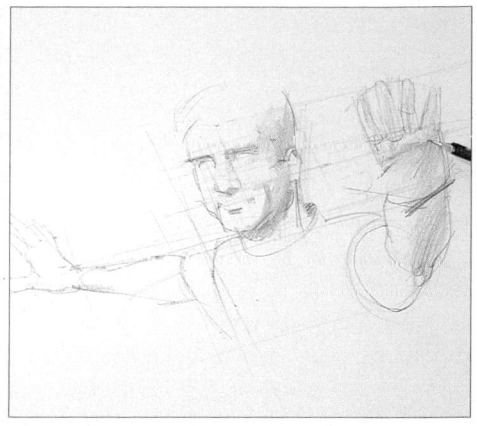

5 Sketch in the nearest arm and hand with a harder touch. This accentuates the three-dimensional effect.

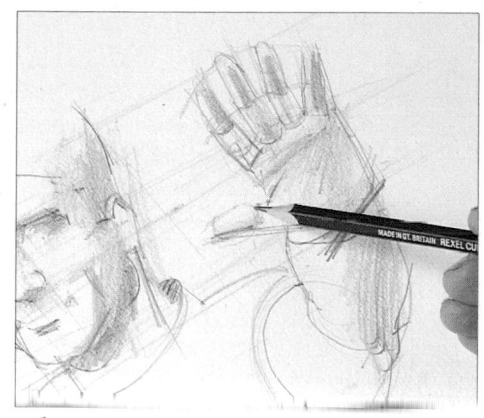

6 Strengthen the tones so that the objects closer to the foreground are stronger in tone and greater in contrast. Light almost always strikes from above. Here, shadows are cast under the eyes and chin.

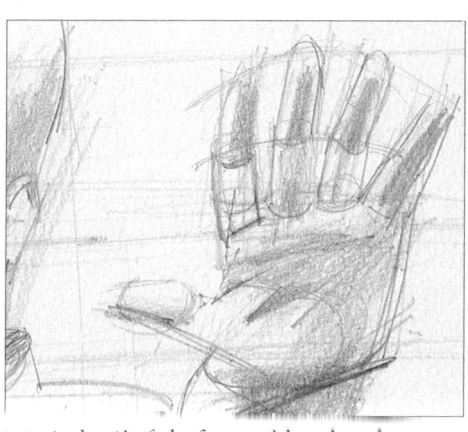

7 A detail of the forward hand and arm demonstrates how natural forms can be analyzed as geometric forms – in this case, a series of cylinders.

8 Holding a mirror to the drawing allows you to see the image in reverse. Do this frequently throughout your sketch to check that the forms work properly.

The Finished Drawing
The sketch completed. The eye is indicated as a solid form. Note the creases in the T-shirt. All clothes have a contribution to make in suggesting the basic form underneath.

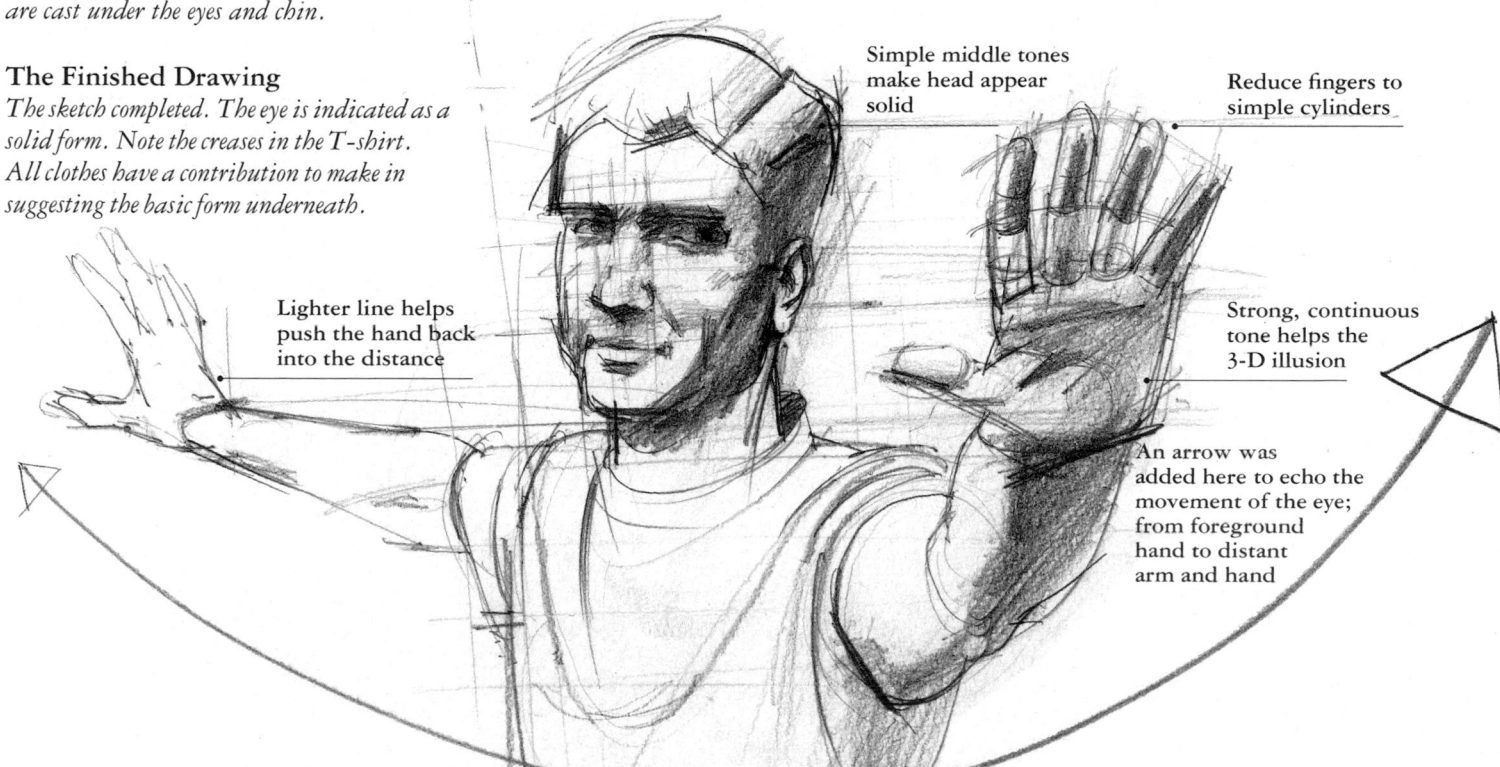

Simple middle tones make head appear solid

Reduce fingers to simple cylinders

Lighter line helps push the hand back into the distance

Strong, continuous tone helps the 3-D illusion

An arrow was added here to echo the movement of the eye; from foreground hand to distant arm and hand

Rescuing Lost Causes

A LOT OF WORK goes into producing a good drawing, which makes it very frustrating when things go wrong. Often the flaws are minor and can be corrected during the drawing process. If for any reason this isn't possible, however, don't just pick up a clean sheet of paper and start again. Try switching to a different medium or technique. Sometimes you may be able to cover the problem area with a wash of ink or watercolor paint, or even a thicker layer of acrylic paint, and then draw over it when the paint has dried. The important thing is to be flexible: you may start out with a specific intention, but there is no point in doggedly pursuing that course if it isn't working. If something goes wrong, run through other techniques and media at your disposal

and look for alternative approaches. Being forced to adopt an unconventional approach, rather than the one you first thought of, can often work in your favor.

A common mistake is to find that you haven't left enough space on the paper to complete your drawing. You may have started your drawing too close to one edge of the paper, or you may not have assessed the relative sizes of elements within the picture and lightly indicated all the major parts on the paper before beginning. Running out of space may seem like an insurmountable problem, but it is actually easy to attach another piece of paper and extend your drawing (see below). If you do this, always try to complete the drawing immediately so that you can maintain a continuity of line.

Sometimes finished drawings are damaged in transit or in storage. If you don't apply fixative to your draw-

Masking tape

Craft knife

Adding Paper

The Problem
This drawing was originally intended as a torso portrait, but it seems a shame not to include the model's long, flowing skirt. Unfortunately, there is not enough paper to add to the drawing.

1 *Turn the drawing over and place it face down on a drawing board. Tape a sheet of identical paper to it, taking care to butt the edges together so that they match perfectly.*

2 *Turn the paper right side up and fix it securely to the drawing board: there is now space for you to complete the drawing. Do so immediately so that you can maintain a continuity of line.*

The Finished Drawing
A good drawing has been produced from one that looked truncated and unbalanced. The slight crease where paper has been added does not mar the overall effect and will barely be visible when the drawing is mounted and framed.

Repairing a Torn Drawing

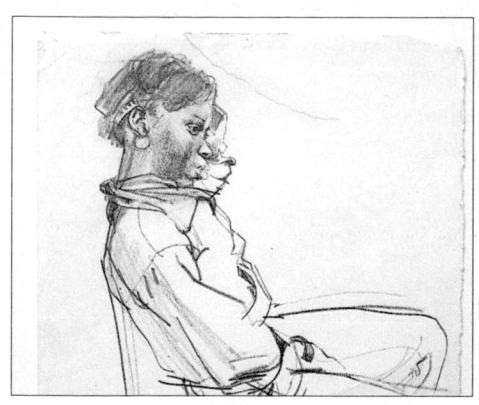

The Problem
The drawing has been badly damaged in transit: there is a jagged tear in the paper to the right of the model's head, although fortunately the tear does not extend into the drawing itself.

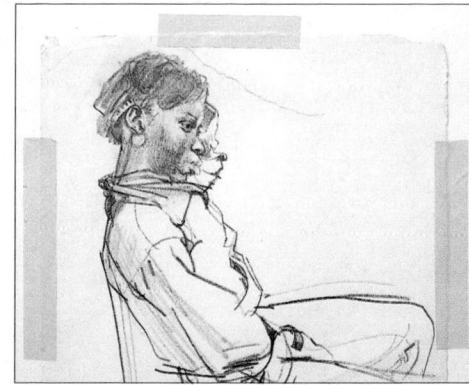

1 *Firmly fix a sheet of identical paper to a cutting board, making sure that it is stretched taut and there are no creases. Tape your drawing securely on top.*

2 *Using a craft knife or other sharp cutting blade, carefully cut around the outline of your drawing. Cut through both your drawing paper and the paper underneath.*

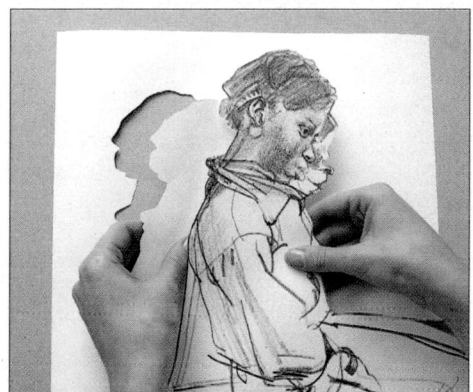

3 *Carefully lift out the two cut shapes. You now have an untorn piece of paper into which you can slot your drawing, as if you were fitting a piece into a jigsaw puzzle.*

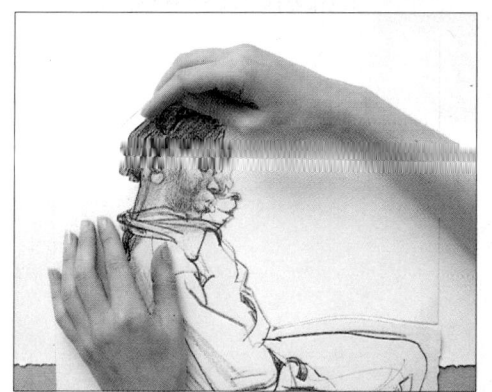

4 *Carefully place your drawing in the hole. Then turn the paper over and fix the drawing in place with drafting tape. Alternatively, spread rubber cement over a thin piece of paper and place the cut-out paper and your drawing on top.*

The Finished Drawing
The finished drawing is now ready for mounting and framing. This technique is most suitable for drawings that have a clear outline around which you can cut. You can use this method to splice in areas of clean paper and then redraw parts that you are not happy with (see p. 151).

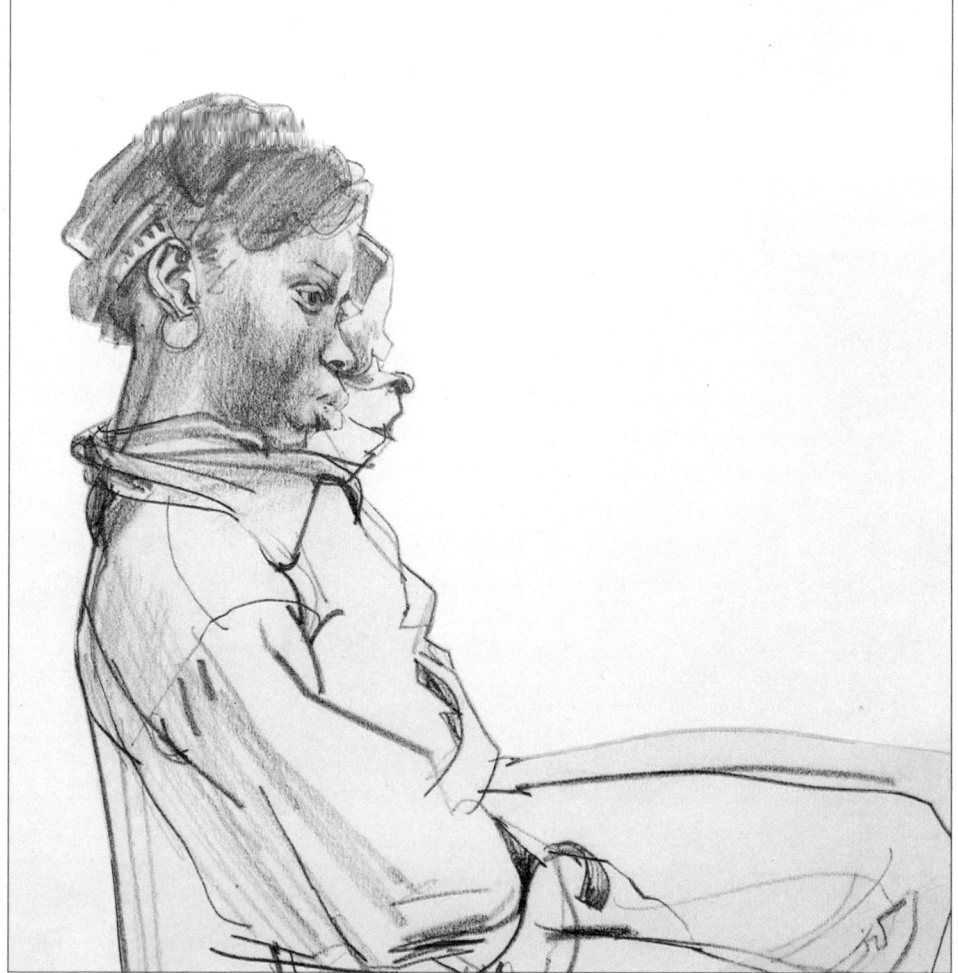

ings immediately (see p. 152), for example, the pencil or charcoal may smudge. You may be able simply to erase the worst of the smudge marks, but there are also more drastic remedies that you can take to restore the paper to its original pristine whiteness (see p. 150). Sometimes these techniques involve redrawing part of the picture after you have removed the offending marks; if this is the case, it is a good idea to trace your original drawing before you start to clean it up so that you can redraw it accurately. Alternatively you could take a photocopy for reference and redraw from that rather than from memory.

Often the circumstances that inspired a drawing – a once-in-a-lifetime vacation, a special event, or your children at a particular stage in their development – cannot be repeated. It is heartbreaking to find that a drawing of such a subject has been torn or damaged in some way. But you can usually repair or disguise the damage. The demonstration on page 149 shows how to disguise a tear in the paper. The same technique could be applied to a drawing that has been wrinkled or crumpled.

What if you are unhappy with only a small part of your drawing, but can't erase the marks? The answer is simple: cut out the offending area; replace it with blank paper of the same type, weight, and color; and redraw the missing part. To do this, you need a clearly defined line to cut around – and strong nerves and a steady hand! This may seem like a drastic option, but if only one element is spoiling an otherwise satisfactory drawing, why not give it a try? If you are feeling really ambitious, you could use the same technique to combine elements from several drawings in a collage.

Some people believe that techniques like these are cheating. Nothing could be further from the truth! All professional artists, including the great masters of drawing and painting, have used techniques like these at some stage in their career, so you are in very good company. You may find that solving problems forces you to adopt techniques that you might not otherwise have considered. Keep one thing in mind: never throw a drawing away until you have at least tried to reclaim it.

Cleaning an Unfixed Drawing

Craft knife blade

Hard eraser

Fine sandpaper

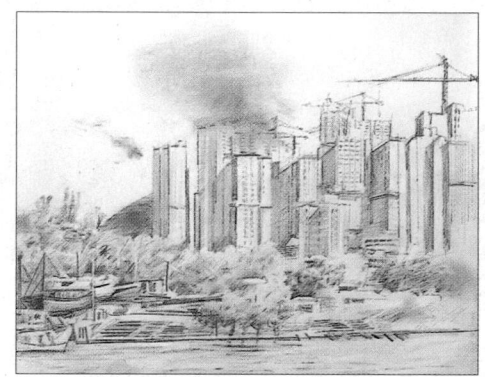

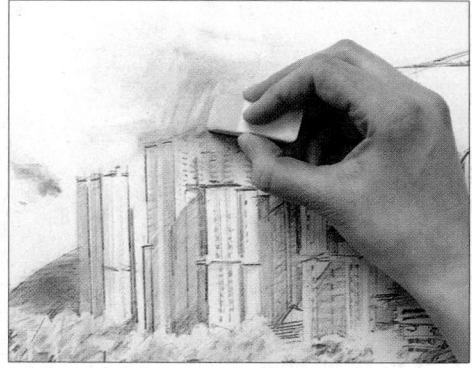

The Problem
This charcoal sketch was not fixed and has smudged. There are several solutions. Use one or a combination of the following methods, depending on how dirty your drawing is.

1 *Use a hard eraser to clean around the edges of the subject. Gently stroke it over the surface of the paper and blow or shake off any loose paper dust.*

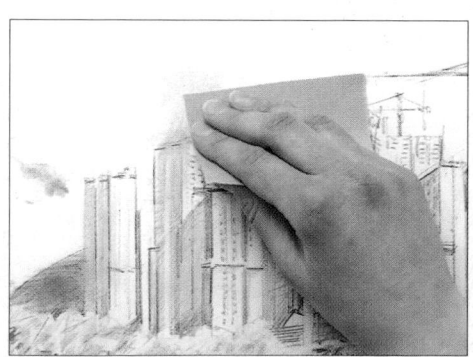

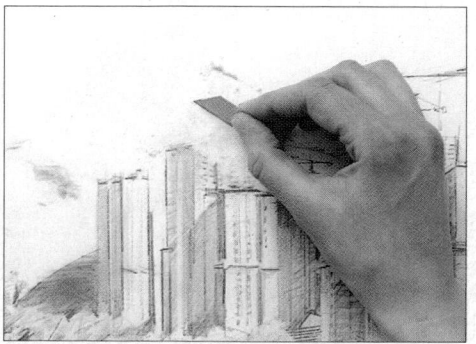

2 *Gently rub very fine sandpaper over the surface to get back to white paper. Rub the sandpaper over a larger area than is required to avoid a harsh delineation.*

3 *Gently stroke the edge of a craft knife blade over the surface of the paper so that you scratch off the top layer and, with it, any unwanted marks. Wrap the blade in tape to protect your fingers.*

The Finished Drawing
The subject has been redrawn. With no distracting dirty marks on the paper, the silhouette of the buildings and cranes is now crisp and clean.

Removing Distracting Elements

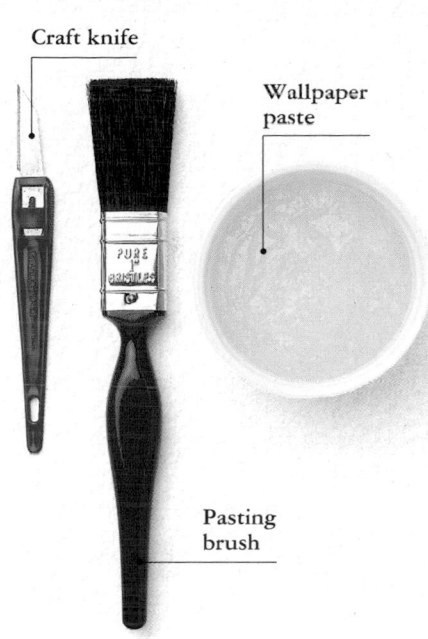

Craft knife

Wallpaper paste

Pasting brush

The Problem
Too much detail and color have been put in at the base of the drawing: the rich brown of the table and the little blue dish dominate the picture and distract the eye from the relatively light colors of the main subject.

1 *Using a craft knife, carefully cut around the edge of the main subject and discard the distracting lower area.*

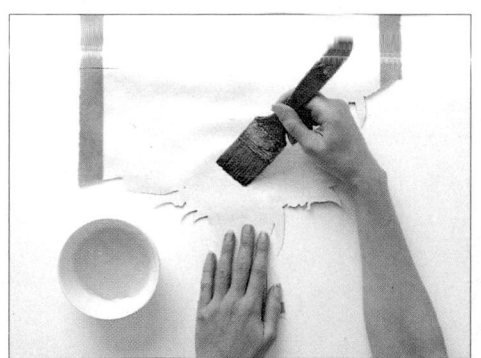

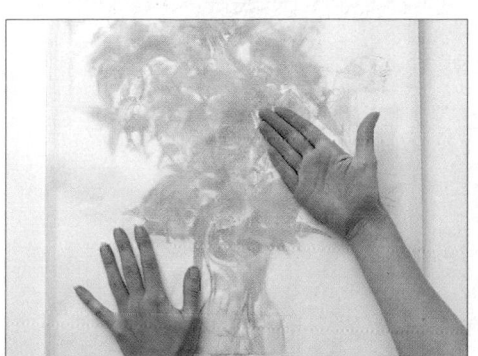

2 *Brush the back of your drawing with wallpaper paste (top). Above: Place a sheet of identical paper on top, with a thin sheet of protective paper over that. Gently smooth out any air bubbles or wrinkles.*

3 *When the paste has dried, turn your drawing right side up. With the new paper in position, you can redraw the lower area of the picture.*

The Finished Drawing
The table, redrawn with a 2B pencil and pen and ink, provides a solid foundation for the picture. Yet it is light enough to allow the viewer's attention to focus on the main subject.

Taking Care of Your Drawings

So MUCH EFFORT goes into producing good drawings that it is well worth you taking the time and trouble to learn how to care for them.

If you are using a chalky or powdery drawing medium such as charcoal, Conté, graphite powder, or graphite or colored pencil, one of the most important things is to fix the drawing as soon as possible so that it does not smudge. Fixative can be bought from art supply stores either in an aerosol can (check the label to make sure that it is environmentally friendly) or in a bottle with a separate spray diffuser. Hold the can 12 to 18 inches (30 to 45 cm) away. If you spray too close to your drawing, you will drench the paper. Starting in the top left corner of your drawing and working across and down, spray the fixative onto the paper in a fine, even mist. Be sure to keep the can in motion. With certain drawing media, you may cause the lines to run and smudge. It is far better to apply two or three thin coats of fixative than one heavy one – but make sure the fixative is dry before you apply the next coat.

The problems don't end when you have fixed your drawing. Make sure you never leave drawings in direct sunlight, or they will soon start to fade. This is particularly true of colored drawings. Always store drawings flat to prevent them from getting bent or curled.

It's very satisfying to produce a drawing that you feel is good enough to be displayed, and good presentation is very important. Most art supply stores and framers stock a wide range of mounts and frames and are only too happy to advise you on what is most appropriate.

Fixing and Storing

Fixing
Starting in the top left corner, steadily work across and down your drawing, covering the paper evenly in a fine spray of fixative. It is better to apply two or three thin coats of fixative than one heavy one. Allow the fixative to dry before applying the next coat.

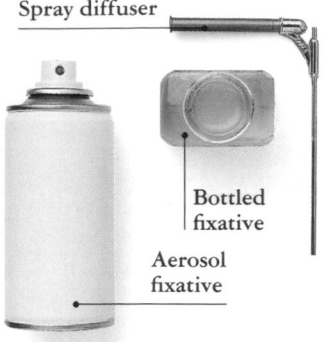

Spray diffuser

Bottled fixative

Aerosol fixative

Storing
Always store your drawings flat to prevent bending or curling. If you don't have a flat file or a portfolio case, you can store your drawings on top of a large cupboard or under a bed. For added protection, separate drawings with sheets of thin protective paper – tracing paper is ideal.

Types of Frames

Choosing a Frame
Frames both enhance a drawing and protect it. Choose one that complements your drawing: a fine pen line, for example, needs a delicate-looking thin frame; a charcoal sketch can take something heavier. Think about the color, too: a brightly colored frame can overpower a pencil sketch. If possible, take your drawing with you when you go to buy a mount or a frame – it will be much easier to visualize the finished result and choose an appropriate color and style.

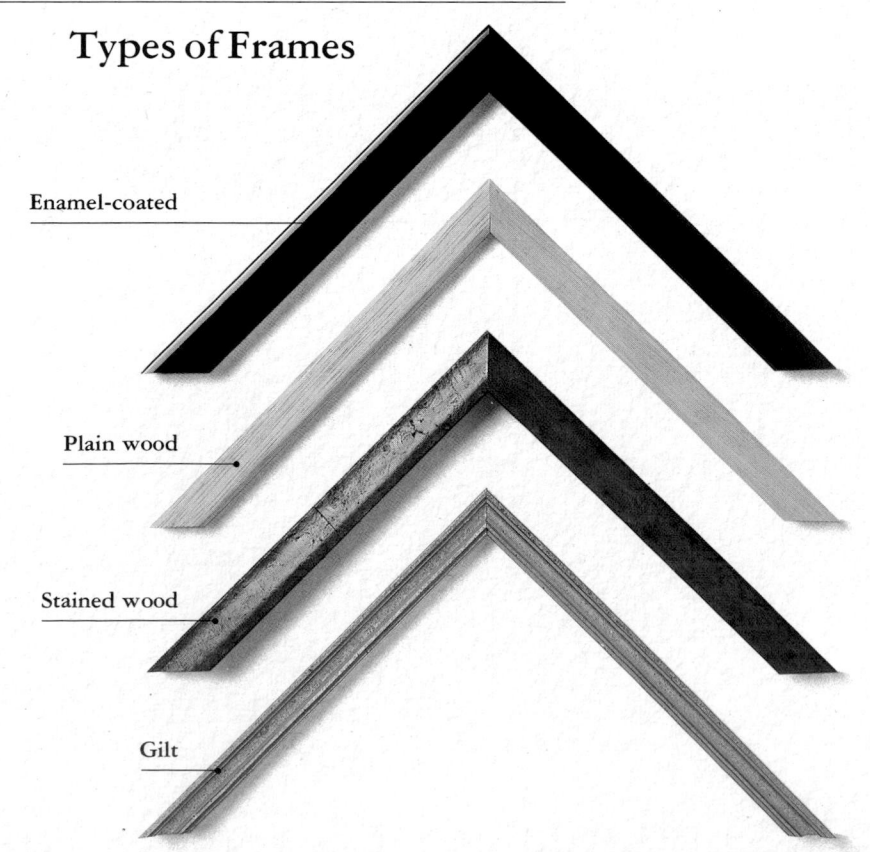

Enamel-coated

Plain wood

Stained wood

Gilt

Mounts

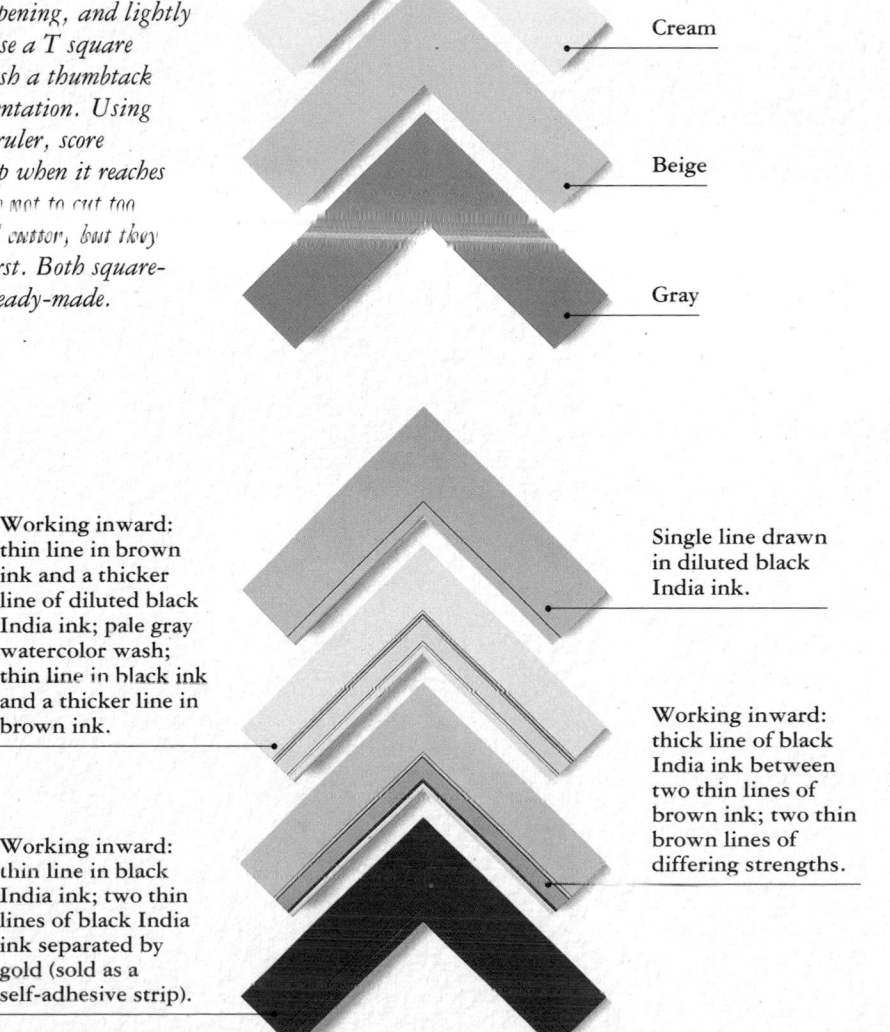

Proportions
Traditionally, more space is left at the bottom of a mount than at the top. It gives a better balance to the picture. Through an optical illusion, if you allow the same amount of space all around, the picture looks closer to the bottom of the mount than to the top.

The conventional proportions are in the ratio of 1:2 or 2:3 – that is one at the top and sides to two at the bottom or two at the top and sides to three at the bottom.

Colors of Mounting Board
Mounting board is available in a huge range of colors. Choose one that works with both the colors in your drawing and the color of your drawing paper. A drawing on brilliant white paper, for example, does not look right on an off-white or cream mount.

Black

White

Off-white

Cream

Beige

Gray

Square- and Bevel-Edged Window Mounts
You can cut window mounts in two ways – with square (straight-sided) or bevelled (angled) interior angles. Square-edged mounts are by far the easiest. Mark the four corners of the opening, and lightly draw the rectangle that you want to cut out. (Use a T square to make sure the corners are at right angles.) Push a thumbtack into each of these corners so that it leaves an indentation. Using a sharp craft knife and a metal straightedge or ruler, score along the pencil lines. The craft knife should stop when it reaches the indentation left by the thumbtack. Take care not to cut too far. For bevel-edged openings, you need a special cutter, but they can be difficult to use. Practice on scrap board first. Both square- and bevel-edged window mounts can be bought ready-made.

Mounts with in-lining
Window mounts with a line or lines drawn in a range of styles and colors around the opening can look very effective. They can be bought ready-made or made to your requirements by a framer. If you want to attempt this yourself, follow the guidelines for marking out a square-edged window mount (above). Always choose a color that complements your drawing and mount, and think carefully about how thick or thin the drawn line should be. A very heavy line, for example, may dominate a delicate pen-and-ink drawing. Draw the line closer to the opening than to the outer edge of the window mount.

Working inward: thin line in brown ink and a thicker line of diluted black India ink; pale gray watercolor wash; thin line in black ink and a thicker line in brown ink.

Working inward: thin line in black India ink; two thin lines of black India ink separated by gold (sold as a self-adhesive strip).

Single line drawn in diluted black India ink.

Working inward: thick line of black India ink between two thin lines of brown ink; two thin brown lines of differing strengths.

Glossary

Acrylic paint: a fast-drying, matt paint made from pigment suspended in a synthetic resin, usually polyvinyl acetate (PVA), and emulsified in water. Often used as an alternative to oil, it can be thinned to the consistency of watercolor paint with water or other mediums. Its drawing time may be slowed down with a retarding medium.

Charcoal: a black drawing medium, made from a form of carbon created by heating organic matter in the absence of air.

Composition: the placing of separate elements within a picture, usually creating a sense of balance and harmony.

Conté: a hard drawing medium, available in pencil and crayon form, made of clay and graphite. Named after the 18th-century French chemist, N.J. Conté.

Contour: the defining, and often curving, outline of a mass such as land or a figure.

Contour drawing: the depiction of solid objects using lines but no shading. A contour drawing often includes lines that go across and around the object to help represent it. The lines represent both the internal and external edges of the subject.

> **Blind contour drawing:** a method of drawing without looking down at the paper. The eye remains focused on the object as the hand traces its outline on paper.

Deletion drawing: using an eraser, or a piece of bread massaged until it becomes soft and pliable, as a drawing tool in its own right to work back from dark areas to light, creating highlights and gradations of tone.

Distressing: the roughening of paper to create interesting textures or tones. This can be done in a variety of ways such as rubbing with an eraser or sandpaper, scratching with the edge of a blade, and crumpling paper in your hands.

Drawing screen: one of many measuring systems, a drawing screen uses a grid set in a frame. The subject is placed behind the screen and the horizontal and vertical lines of the grid act as points of reference, enabling the artist to establish the relative size and position of elements within the picture space.

Ellipse: a closed, conic section shaped like a flattened circle. When a circle is drawn in perspective it becomes an ellipse.

Eraser: a tool used to delete marks made with a soft drawing medium such as pencil or charcoal.

> **Kneaded eraser:** a soft, pliable eraser that may be formed into different shapes, such as points, enabling the artist to make minute changes to detailed areas. Known as putty rubber in the UK.

> **Plastic eraser:** a hard eraser, useful for obtaining a crisp outline or to create highlights.

Eye level: over the centuries artists have used different eye levels to create particular moods and effects. A "normal" eye level, that is from the height of an average person, can be used for quiet, descriptive pictures. A high eye level separates various elements in a scene from one another. From a low eye level, elements tend to overlap.

Foreshortening: the effect of perspective in a single object or figure, in which a form appears considerably altered from its normal proportions as it recedes from the artist's viewpoint.

Geometric (simple) shapes: most objects can be reduced to basic shapes, be it a cylinder, sphere or cone. By doing this, it becomes easier to gauge how and where the light falls upon them, and how to make them appear three-dimensional.

Gouache: an opaque watercolor paint.

Graphite: a form of ground crystallized carbon mixed with ground clay and water, which is molded into strips before being fired in a kiln. It is then encased in wax and glued into its casing to make a pencil. The relative proportions of carbon and clay determine how hard or soft the pencil is.

Graphite powder: a by-product of graphite that can be used to create a toned ground or to build up tonal areas.

Grid system: a method by which proportions and perspective may be accurately rendered. A grid is drawn on the paper before the artist begins work. While working, the artist then mentally superimposes the same grid on the subject.

Ground: the prepared surface on which a drawing is made.

Hatching: *See* **Shading.**

Highlight: a light area, usually created by leaving areas of white, or by removing color with an eraser.

India ink: traditionally used with a steel-nib dip pen, India ink dries with a slight gloss. The ink may be diluted with water to create softer color and greater fluidity. Known as Indian ink in the UK.

Light, reflected: sometimes light from the main source carries beyond the object, glances off other things and bounces back, leaving a lighter strip against the edge on the darker side of the object. This is known as reflected light.

Line drawing: a technique used to describe the contours and shapes of objects and create three-dimensional images.

Mask: a material used to cover areas of a picture while working, ensuring that no marks touch the paper underneath.

Modeling: the use of tone or color to emphasize light and shadow areas and convey a three-dimensional impression.

Monochrome: black-and-white drawing work. Charcoal is a monochrome instrument, for example, and is capable of a range of marks, from broad areas of deep, velvety black to finely detailed line work.

Monoprint: a simple and very direct method of printmaking that involves taking a print from an image created on an impervious hard surface using ink or paint applied with a roller. Usually only one print can be made.

Mount: a piece of cardboard on which a picture is placed for display purposes. Traditionally, more space is left at the bottom of the mount than at the top to give a better balance.

> **Window mount:** a piece of cardboard in which a window has been cut that is often placed over a picture prior to framing. Window mounts can be cut with square (straight-sided) or bevelled (angled) interior edges.

Negative shapes: the spaces between objects in a drawing, often suggesting what is happening in the background. *See also* **Positive shapes**.

Outline drawing: not to be confused with line drawing, an outline drawing offers a basic rendition of the objects in the picture, without giving it three-dimensional form.

Palette: the flat instrument generally made of wood, plastic, or cardboard upon which the artist mixes paints. The word also refers to the selection of colors made for a certain work of art or the range of colors characteristic of a particular artist.

Perspective: systems used to convey an impression of depth on a two-dimensional surface. There are three main points to remember: objects appear smaller and lighter the farther away they are; parallel lines appear to converge as they recede from you into the distance; and shapes and angles of the same object vary depending on where you are in relation to them.

> **Aerial perspective:** as the eye travels from the foreground to the horizon over a landscape scene, close objects appear darkest in tone, those in the middle distance lighter, and those on the horizon far paler. Colors also change from bright, warm hues in the foreground to more dull, cool ones on the horizon. The reason for this is that water vapor in the air partly obscures colors and forms lying at a distance. This device of graduated tones is one way of conveying a sense of distance in works of art.

> **Single-point perspective:** this occurs with elements that are parallel to the picture plane. Objects appear to diminish in scale the farther away they are, and parallel lines at 90° to the picture plane converge while lines parallel to the picture plane remain parallel.

> **Two-point perspective:** if you can see two sides of an object, you must use two-point perspective. Each side is at a different angle to you and has its own vanishing point. Parallel lines, which converge at a vanishing point, will slant at different angles on each side.

Picture plane: the flat, level surface area of the picture.

Positive shapes: features, figures or other objects in a drawing or painting that often comprise the subject or focal point of the work. *See also* **Negative shapes**.

Resist: a material that prevents one medium from touching the paper lying beneath it.

Rough: a preliminary planning sketch.

Scale: the accurate representation of all elements within a drawing in exact proportion to one another.

Shading: the method by which objects are made to appear three-dimensional. The simplest practice is to vary the amount of pressure exerted on the pencil or charcoal to vary the density of the ensuing marks.

> **Classical shading:** parallel lines drawn at 45° angles over the area to be shaded. The closer the lines, the more dense the shading appears. A method much used by Renaissance artists such as Leonardo da Vinci and Michelangelo.

> **Cross-hatching:** criss-crossed lines used to create density.

> **Hatching:** a series of parallel lines, drawn at any angle, used to indicate shadow areas. By varying the length, weight, straightness, or distance between the lines, a variety of shading effects may be achieved.

Sight-size drawing: by taking direct measurements from the subject before beginning a portrait, the artist marks in the exact position of all main features – eyes, nose, mouth, hairline – with a pencil on the paper. This ensures that the proportions are accurate when the drawing is created.

Sighting with the pencil: the method of holding the pencil vertically, at arm's length, in order to measure the length of objects and distances between one feature and another. The measures are marked on the pencil with the thumbnail before being transferred onto paper.

Tone: the overall effect of the color values and gradations of light and dark in a picture.

Viewpoint: the position or angle chosen by the artist from which to paint a scene or object. By changing the position, a number of alternative compositions may be attempted.

Index

Picture Credits and Acknowledgements

Picture Credits

The publishers are grateful to the following for permission to reproduce copyright illustrations:

Page 7 (top): Chester Dale Collection, National Gallery of Art, Washington; page 46 (bottom left): Hermitage, St Petersburg (Bridgeman Art Library); page 52 (top): The Dayton Art Institute, Ohio; page 66 (top): Van Gogh Museum, Amsterdam; page 66 (bottom): Musée d'Orsay, Paris (Giraudon/Bridgeman Art Library); page 84 (top): The Tate Gallery, London; page 88 (top left): Christie's, London (Bridgeman Art Library); page 90 (bottom left): Andrew Butler; page 94 (top): National Gallery, London; page 106 (top): The Baltimore Museum of Art © DACS; page 108 (top): Teylers Museum, Haarlem; page 130 (top): Metropolitan Museum of Art, New York (Bridgeman Art Library); page 140 (left): Henry Moore Foundation, Perry Green; page 146 (top): National Gallery, London.

All other illustrations are the copyright of Stan Smith.

Acknowledgements

The author would like to thank Kate Gwynn for research and assistance, Ian Howes for photography in the early stages, Patricia Monahan for help and research and Jasper Smith for assistance. Special thanks go to Stuart Stevenson for his generosity and advice and for supplying a wide range of art materials and to Green and Stone for supplying the mounts shown on page 153.

Publisher's Note

Drawing is a subject of international appeal. As this book is being distributed and sold all over the world, we have had to make a decision on which spelling style to adopt. We have opted for American spellings as being those in most common usage worldwide. Some equipment is also known by slightly different names in different English-speaking countries. Again, we have used American terms throughout and have indicated alternative terms in the glossary.

40-557-2